PELICAN BOOKS

A Short History of Africa

Roland Oliver was born in 1923 at Srinagar, Kashmir, and educated at Stowe and King's College, Cambridge. In 1948 he was appointed to a Lectureship at the School of Oriental and African Studies, in 1958 to the Readership in African History and in 1963 to the Chair of African History in the University of London. He has travelled in most parts of Africa, and has held visiting appointments in the University of Ghana (1957), the University of Brussels (1961), Northwestern University (1962) and Harvard University (1967). In 1966 he won the Hailé Selassié I Prize Trust Award for African Research. He has written *The Missionary Factor in East Africa* (1952), *Sir Harry Johnston and the Scramble for Africa* (1957), *Africa since 1800* with A. E. Atmore (1967), and edited *The Dawn of African History* (1961), *A History of East Africa, Vol. 1* with Gervase Mathew (1963) and *The Middle Age of African History* (1967). He and John Fage were the founding editors of the *Journal of African History*.

John Fage was born in 1921 and educated at Tonbridge School and Magdalene College, Cambridge. During the Second World War he saw service in Africa and Asia and with the R.A.F. From 1949 to 1959 he lived in West Africa, first as a lecturer and later as Professor of History at the University College of Ghana. In 1957 he was Visiting Professor at the University of Wisconsin, and in 1962 at Smith College, Massachusetts. He returned to England in 1959 to become a lecturer in the history of Africa at the School of Oriental and African Studies, University of London. He is now Director of the Centre of West African Studies and Professor of African History in the University of Birmingham. He is author of *An Atlas of African History* (1958), *Ghana: a Historical Interpretation* (1959), and *History of West Africa* (1969).

ROLAND OLIVER AND J. D. FAGE

A Short History of Africa

Penguin Books

Penguin Books Ltd, Harmondsworth, Middlesex, England
Viking Penguin Inc., 40 West 23rd Street, New York, New York 10010, U.S.A.
Penguin Books Australia Ltd, Ringwood, Victoria, Australia
Penguin Books Canada Ltd, 2801 John Street, Markham, Ontario, Canada L3R 1B4
Penguin Books (N.Z.) Ltd, 182–190 Wairau Road, Auckland 10, New Zealand

First published 1962
Reprinted 1962, 1964, 1965
Second edition 1966
Reprinted 1968, 1969
Third edition 1970
Fourth edition 1972
Reprinted 1973
Fifth edition 1975
Reprinted 1977
Reprinted with revisions 1978
Reprinted 1979
Reprinted in Pelican Books 1984
Reprinted 1985

Made and printed in Great Britain by Richard Clay (The Chaucer Press) Ltd
Bungay, Suffolk
Set in Monotype Plantin

Contents

CONTENTS

List of Maps

Editorial Foreword

The twentieth century, with its wars and revolutions, has shifted the centre of the world. For five hundred years before, the contending states of Europe had stretched across the seas, planting colonies, grasping materials and markets, transforming or destroying whole civilizations in their economic advance. Throughout these five hundred years, they radiated outwards, into the surrounding world. They saw history as they affected it, not as a process of which they were merely a part. With their mastery of the sea and the superior technology of their industrial growth, they erected Western civilization – Christian was an optional epithet – into an over-riding value.

And then the centre shifted. Japan borrowed their technology to become the first imperial power outside the European consensus since Islam had burst suddenly out of the desert more than a thousand years before. Within a mere seventy years, vast regions of Africa and Asia shook off the political grasp of the West. Peking and New Delhi, Cairo and Accra joined London and Paris, Lisbon and New York as international capitals.

With the shift in power has come too a shift in history. Asia has always been granted – however condescendingly – a history beyond European intrusion. But Africa was a dark continent, lit only by the flashes of foreign penetration. This is no longer so. The changes in political power have corrected the vision of a European-centred world. And research itself has excavated civilizations that had been beyond Europe's reach and so beyond her recognition.

Africa has had its own rich sweep of events, outside those which European conquest and settlement have recorded. The

era of European dominance is short even within the thin margin of human history. Long before, in the evolution of man himself, Africa had helped shape history. And while the centres of European culture flourished, decayed, and sprouted in their turn, empires in Africa rose, ruled, resisted, and succumbed. Scholars studied and disputed in Timbuctu as in Paris, and what the Italians accomplished with pigment, the artists of Benin achieved with bronze. The cultures were different, but only on the horizontal. The vertical, the separation into superior and inferior, was a product of conquest.

Much of Africa's past has now been excavated from ignorance and error. Yet the study of African history has hardly begun. Those who have undertaken it are the explorers of an unknown human heritage. Their discoveries are of much more than African moment. They must enrich man everywhere.

RONALD SEGAL

Acknowledgements

The authors wish to express their gratitude to Messrs Chatto and Windus for generously agreeing to a delay in the completion of a much larger work on the same subject, in order that this small book might be written; and to Edward Arnold Ltd for permission to reproduce maps 1, 15, 17, and 18 from *An Atlas of African History* by J. D. Fage.

They also wish to acknowledge with thanks the valuable help and advice which they have received from Professor Phillip Tobias of the University of the Witwatersrand; from Professor Desmond Clark of the University of California, Berkeley; from Dr A. A. Boahen of the University of Ghana; from their colleagues, Professor Bernard Lewis and Dr Richard Gray of the School of Oriental and African Studies, University of London; and from the editor of this series Mr Ronald Segal.

1 The Hunters

The first popular idea about Africa is also the first major misconception. The notion of Africa as the Dark Continent is a parochial European idea, which gained currency because Africa was the last of the continents to be opened to the gaze of the outside world, and because it was the last to experience that full impact of European people, ideas, and techniques which was so marked a feature of world history from the sixteenth century till the early twentieth. At the beginning of this modern period of history, however, Africa was far from the most backward of the continents. The Australians, for example, when they were discovered by the Europeans, were still living as hunters and gatherers, and were using stone tools comparable with those of the upper palaeolithic cultures abandoned by most European and African peoples from six to nine thousand years before. Again, the more advanced of the sixteenth-century American Indians were neolithic or 'New Stone Age' cultivators, using polished stone tools. A very few of them were just beginning to learn the use of metals. But many more were still mesolithic hunter-gatherers. The Africans of the same period, on the other hand, with few exceptions, were farmers equipped with tools of iron – and there were in consequence many more of them. Throughout the northern third of the continent most of them belonged to the urbanized civilization of Islam. Even in the southern two-thirds of the continent, most of the African peoples were organized into states and communities powerful enough to deter invaders and migrants from overseas until late in the nineteenth century. True, much of Africa was unhealthy and inaccessible, but not more so than Panama or Peru. The real reason why the Europeans did

not go inland and seize the gold mines of West Africa or Southern Rhodesia, for example, was that the Africans there were already well enough organized to exploit these resources themselves and to keep the overland trade in their own hands. It was in large measure the progress already made by the Africans in earlier centuries that enabled them to resist the modern age for so long.

In historical times, therefore, the backwardness of Africa was always a backwardness relative only to the mainstream of human development in the more favoured parts of Europe and Asia. In *pre*-historic times – at least through all the long millennia of the palaeolithic or 'Old Stone Age' – Africa was not even relatively backward: it was in the lead. Archaeologists today are increasingly sure that it was in Africa that man's ancestors became differentiated from the other primates. The fossilized remains of *Proconsul* – an erect, ground-living creature, the least specialized primate yet known to science – was found by Dr Louis Leakey on Rusinga Island in the north-east corner of Lake Victoria, in a geological stratum datable to some twenty-five million years ago. The currently agreed distinction between man and other primates is that man makes and uses tools. Judged by this test, *Proconsul* was not a man; but on physical grounds he might be accounted an ancestor of man. The earliest toolmaker known so far is a type of hominid called Australopithecine. A living-floor inhabited by these creatures some two million years ago was discovered by Leakey at Olduvai Gorge in northern Tanzania. Earlier examples, dating to three and four million years ago, have since been found in Ethiopia, in the valleys of the Omo and the Awash. The thick skulls and heavy jaws of the Australopithecines make it clear that they were more accustomed to using their teeth than their fingers. Nevertheless, they selected small stones and 'pebbles', and in a rough way split and shaped them to serve their purposes. According to the agreed definition, therefore, they were men.

Thousands of generations of selective evolution were needed, however, before this earliest toolmaker could come to resemble the modern man known to science as *Homo sapiens*, whose brain is more important than his physical strength, whose hands do

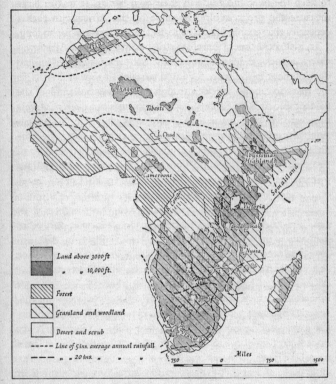

Land above 3000 ft
" " 10,000 ft.

Forest

Grassland and woodland

Desert and scrub

---- Line of 5 ins. average annual rainfall
--- " " 20 ins. " "

Miles
750 0 750 1500

1. Africa: principal geographical features and vegetation

more work than his jaws. And there is little doubt that throughout all but the last small fraction of this long development of the human form, Africa remained at the centre of the inhabited world. Though some very early men are known to have lived as far afield as Indonesia and China, all the true 'pebble tools' yet found have been discovered in or very near to Africa. The sites extend from the Vaal River in the south to Morocco and southern Palestine in the north, and the centre of their distribution appears to be the woodland savanna region of tropical Africa.

Well over one million years ago these earliest human tools began to be superseded by that mysterious pear-shaped stone implement misleadingly called the 'hand-axe'. No one knows exactly what it was used for. Certainly it was not an axe. Professor Desmond Clark, after much practical experiment, has described it as an all-purpose skinning-tool and meat chopper. At all events, it was the most standard and the most characteristic of man's artefacts for more than three quarters of a million years. It has been found all the way from India to Spain and from England to the Cape of Good Hope: of the parts of the globe inhabited at this period, only the Far East and Central Asia escaped its influence. The successive techniques employed for making the 'hand-axe' have been named, in accordance with the perversity of archaeologists, after the two French villages of Chelles and St Acheul, where the 'type-sites' were established. But Europe was not the centre of these industries. The Chellean-Acheulian sequence is consistent in Europe, Asia, and Africa, and there is little doubt that the centre of its development was in Africa. Far more 'hand-axes' have been found in Africa than anywhere else. Two of the richest 'hand-axe' sites in the world are at Olorgesaile, forty miles south of Nairobi, and at Olduvai gorge, just across the Tanzania frontier from Olorgesaile. Only in East Africa, and at one site in Morocco, is it possible to observe the evolution of 'pebble tools' and 'hand-axes' as a single continuous process.

Round about a hundred thousand years ago man embarked upon a series of great changes in his life-style and his material equipment, which coincided with the final stages of his physical

development into modern man. In Africa, as in the neighbouring parts of the Old World, he extended his territory and occupied it more intensively. He adapted himself to a wider range of environments. In earlier editions of this book great stress was laid on the significance of fire, which was thought to have come under man's control at about this period. This theory is now discredited. It has been established that, in Africa as in Asia, fire was in use much earlier, and it is even thought possible that man may have controlled fire almost from the time when he began to kill animals for food. Modern knowledge suggests that, rather than to any single great discovery, the changes of a hundred thousand years ago should be attributed to a threshold stage in the physical evolution of man himself, in which the most important element may have been the growing ability to communicate by means of developed language systems.

In terms of material equipment the changes which occurred at this period mark the transition from the 'lower' to the 'middle' palaeolithic. Everywhere the old Acheulian hand-axe, and the rather indeterminate smaller tools that had accompanied it, gave way to one or other of a series of new tool-kits, each adapted to a particular range of environment. These kits were not exclusive: there was a great deal of overlap between one set and another. But in Africa it is possible to distinguish three broad, regional traditions. The first, comprising all of Africa north of the Sahara, is called, like its northern Mediterranean counterpart, Mousterian. The second was a heavier, woodland tool-kit, designed more for grubbing and grinding than for hunting. It is usually called the Sangoan, and it belongs to the woodland regions surrounding the equatorial forest, from southern West Africa to the Congo-Zambezi watershed. The third was an open-country tool-kit, the Fauresmith, used from northern East Africa to the Cape of Good Hope.

During most of the middle palaeolithic the characteristic tools from all these regional traditions consisted of stone 'flakes' of various shapes and sizes, first struck from a large 'core' and then 're-touched' by chipping around the edges so as to produce tools appropriate for different purposes, such as the killing,

skinning, chopping and scraping of meat, bone, skin and sinew, the grubbing and grinding of roots, and the working of wood and other materials. Much later on, towards the end of the middle palaeolithic, came the appearance of 'blades', produced by striking off slice after slice from a carefully prepared core. These marked a great advance in the efficiency of cutting tools, such as chisels and gouges, knives and razors. And this in turn led, round about thirty thousand years ago, to the stage of material culture called 'upper palaeolithic', of which the most important characteristic was that most of the stone artefacts were 'microliths', that is to say, they were the small, sharp components of composite tools made of stone and wood and various kinds of ligatures. At this stage tool-kits became even more closely adapted to particular environments, but the three broad traditions of the middle palaeolithic can still be detected. The Mousterian tradition had developed into the Aterian, the Sangoan into the Lupemban and the Fauresmith into the Stillbay. In all of them the increasing range and complexity of tools was accompanied by a decline in stone-shaping techniques, but with the new utilitarianism came an inventiveness which greatly enriched the scope of man's material and imaginative life. With the bone needle came the beginning of the tailor's art. With string there came the possibility of the bow: Aterian arrow-heads were perhaps the first to be used anywhere in the world. Again, it was in upper palaeolithic times that men and women used the first cosmetics, the tell-tale stains of red ochre witnessing to a self-consciousness and sophistication which might perhaps be equated with 'the knowledge of good and evil'.

It was during the period of territorial expansion and regional specialization represented by the Mousterian, the Sangoan and the Fauresmith traditions of material culture and their upper palaeolithic derivatives, that man's physical development in Africa, as in the rest of the inhabited world, was reaching the 'sapient' stage. There is no need, today, to postulate any war to the death in which rival 'species' of man were extinguished. Rather, we should visualize a long drawn out process in which 'sapient' characteristics spread by genetic means. However, at

the same time as more fundamental differences were being eliminated, specialization towards particular environments was having its own genetic consequences in producing differences of a less fundamental kind, which can best be thought of in terms of 'race' or 'physical type'. Here, as with traditions in material culture, it always has to be remembered that there are no hard frontiers. Where races meet there are large areas of interaction, and the stereotypes merge into imperceptibility at the edges. Nevertheless, following this caveat, four broad categories of African population may usefully be distinguished, which probably had their origin during the middle and upper palaeolithic. First and most distinct from the others, were the peoples living to the north of the Sahara and to the east of the Nile, whose nearest affiliations were with the other peoples of the Mediterranean and Red Sea basins. Of medium height and brownish complexion, these were the 'Caucasoids' or 'Hamites'. Second, there were the peoples of the sub-Saharan savanna and forest fringes, who during wet climatic phases penetrated northwards into Saharan latitudes. Tall, lightly built and dark of hue, with woolly black hair, these were the Negroes. Third, there were the peoples adapted to conditions of true forest. Short in stature and pale in complexion, these were the Pygmies. Fourth, there were the peoples of the eastern and southern savannas. Of medium height and yellowish, with hair growing in separate tufts, these were the Bushmen. Though very different from each other in outward appearance, the last three types have a very similar pattern of blood-groups, which are the most strictly genetic of all human physiological characteristics. They may therefore be thought of as three variants of a basic African stock which became divergently specialized towards different geographical environments. The Caucasoids, although like the rest of mankind they were ultimately of African origin, had undergone much of their long evolution towards the sapient state outside the African mainstream: for this the existence at most periods of the Saharan desert zone is a sufficient explanation.

Nevertheless, the Caucasoids or Hamites of Africa, despite their comparative geographical isolation, had an important role

in African history as the main human link between Africa and
the outside world. Obviously, this role was most significant
during the exceptional periods when, for climatic reasons, the
desert zone was at its narrowest, and when populations from the
north and south of the desert could most easily meet and inter-
act. Such a period did in fact occur towards the end of the upper
palaeolithic, and during it the stage was set for the greatest of all
economic revolutions, namely the transition from hunting and
gathering to food production. This was the period when the
monsoon rain-belt was shifting northwards into the African and
Arabian deserts, converting them temporarily into parklands,
rich in game and with streams and rivers flowing north and
south from the mountain massifs of the central Sahara. Not only
was it a period of unrivalled opportunity for the hunter: it also
saw a great new development in one of the patterns of a hunting
and gathering existence, namely fishing. Throughout the northern
half of Africa, significant elements of population gathered along
the river banks and by lake shores, and began to lead a kind of
life that was almost sedentary – a life based upon fishing, in
which hunting and gathering had become only marginal
activities.

In these exceptional circumstances the river lines and sea
coasts of northern Africa took on a great significance, and they
were lines which provided easy communication between the
Hamitic and Negro populations, by which development in the
new 'aquatic' way of life could spread across the whole region.
The Red Sea coast offered one avenue, the drainage system of
the Nile another. The eastward-flowing tributaries of the upper
Nile were separated by a narrow watershed from the rivers
flowing westwards to Lake Chad, at this time a vast inland sea
covering most of the central part of the modern Tchad Republic
and emptying westwards into the Benue and the Niger. At the
peak of the wet phase, around 7000 B.C., the Nile was probably
connected by its Sobat tributary with Lake Rudolf and the
northern lakes of the East African Rift Valley. In this last region,
the sites of people who lived mainly by fishing are associated
with a remarkable industry of 'blade tools' known as the 'Kenya

Capsian'. The Capsian blade, especially when made of the natural, volcanic glass called obsidian, had a cutting edge as sharp as any steel knife or chisel. It was admirable for working bone, and bone harpoons soon became one of the hallmarks of late upper palaeolithic fishing communities all the way from the Kenya Rift Valley to the tributaries of the upper Niger. Somewhere along the line, perhaps in some central area such as the upper Nile valley, there occurred the stupendous invention of pottery – certainly the earliest pottery in Africa. This 'Wavy line' pottery of early African fishing communities, like their bone harpoons, was made and decorated in a nearly standard pattern throughout the drainage systems of the Niger and the Nile, thus illustrating how easily new ideas and techniques could spread among communities which in other respects had very different material cultures and ethnic origins.

Seven or eight thousand years ago, therefore, at the end of man's purely parasitic existence as a hunter and gatherer, and at the dawn of the settled life of agriculture and stock-raising, Africa was already inhabited by the ancestors of the four main racial types recognized as indigenous in historical times – Bushmen and Pygmies, Negroes and Caucasoid Hamites. Of these four types, the most widespread at the end of the upper palaeolithic was probably still the Bushman, who seems to have inhabited all the open savanna country to the south and east of a line drawn from Somalia to central Angola. In the forested country to the north-west of that line were the Pygmies, who were perhaps nearer to being forest-adapted Bushmen than forest-adapted Negroes. The Negro at this period seems to have been essentially a man of the woodlands and savannas to the north of the equatorial forest, from the Atlantic to the foothills of the Ethiopian highlands. It may indeed be that at this period the Negro was more a man of the open country than of the woodland, for some of his earliest identifiable remains have been found far out in Saharan latitudes, and it is significant that the waterside fishing variant of the hunting life which he favoured did not at this stage penetrate the forest reaches of the Congo drainage system or down the line of the great lakes. So long as

the wet phase lasted, the most open frontier of Negroland may have been that with the Hamitic peoples to the north and, especially, to the east. Certainly the Hamites and the Negroes were geographically the best placed to profit from the stupendous developments that were to come with the domestication of plants and animals, and in this great mutation the Negro's apprenticeship as a fisherman-hunter-gatherer and a maker of pottery was to give him a huge advantage over peoples living further to the south.

2 The Farmers

As we have seen, it was some four or five million years ago that man's ancestors became recognizable as hominids practising a hunting and gathering economy, and some hundred thousand years ago that they were approaching the stage of physical development known as 'sapiency'. In contrast, it was only some ten thousand years ago that 'sapient' man at last began to cultivate, and thus started the third great revolution in human history. Food production – the deliberate selection and cultivation of edible plants previously merely gathered or grubbed in their wild state, and the taming and breeding of certain animals which had till then run wild – made possible the settled life of the village as opposed to the hunting-camp. It made possible the accumulation of material equipment on a scale which would have been merely embarrassing to the nomadic hunter or gatherer. Above all, it made possible for the first time population densities expressible in terms of men to the square mile rather than square miles to the man. This, of course, does not mean that the food-producing revolution was everywhere a sudden one. In Egypt it certainly was so. We now know that the dynastic period in Egypt was reached little more than a thousand years after the first food crops were planted; but this was due to the unique potentialities of the flood-plain of the Nile. Elsewhere in Africa the transition was much more gradual, and the beginnings of agriculture and stockbreeding were for a long time an alternative to, rather than a replacement for, the older hunting and fishing economies. All the same, there can be little doubt that in Africa, as in the rest of the Old World, it is from the spread of the food-producing revolution that the basic population patterns of the historic period derive.

The food-producing revolution seems to have affected Africa in three main stages. Beginning in the fifth millennium and gathering momentum in the fourth, it was responsible for the emergence of a really dense and mainly Caucasoid population in the lower Nile Valley. Secondly, south of the Sahara, beginning perhaps in the third millennium B.C. but probably gathering momentum only during the second and first, it brought the Negroes decisively into the lead all the way along the savanna belt between the desert and the equatorial rain forest. In the third stage, which seems to be linked with the Indonesian contacts of the early Christian era, sparse populations of Negroes in Guinea and in sub-equatorial Africa underwent a great expansion and became the main populations of these regions also. We must now look at these three stages more closely.

Archaeologists today are fairly confident that both the first cultivation of cereals and the first domestication of animals occurred in south-west Asia, and more precisely among the descendants of those Natufians whose cultural affinities with the 'proto-Hamitic' Capsians of Kenya and with the Negroes of the sub-Saharan belt have already been mentioned. At Jericho, by a perennial spring at the edge of the Jordan valley, a society using flint and bone tools of clearly Natufian tradition founded the first of a series of food-producing settlements some time during the eighth millennium B.C. At the Belt Cave, by the southern shores of the Caspian Sea, another hunting and fishing society using a Natufian assemblage of tools and weapons began to reap grain crops and to slaughter sheep and goats around the turn of the seventh and sixth millennia. At Jarmo, a little further south in the Kurdish hills, early food-producing settlements have been clearly dated to the sixth millennium. All these remains are considerably earlier than those of the earliest African food-producers, which occur around the edges of the Nile Delta in sites of the fifth millennium. By this time the Palestinian cultivators had already learned to make pottery and to grind and polish their stone cutting-tools. They had passed in fact into the neolithic stage. The earliest cultivating communities in Egypt used neolithic tools from the start. There is thus no real doubt that

agriculture spread from Asia into Africa across the Isthmus of Suez during the earliest phase of the neolithic age.

The earliest Egyptian cultivators had their settlements not on the valley bottom, where swamp and jungle would still at this period have presented great difficulties, but on the high terraces at the edge of what is now desert and was then dry steppe, especially beside the courses of the tributary *wadis*, now dry but then seasonally flowing. The classic early neolithic sites at Deir Tasa, Badari, Merimde, and al-Omari are all situated on the margins of the valley and the Delta, and not in the flood-plain itself. The most revealing of all the early sites yet excavated are those of the northern Fayum, a natural depression once connected with the Nile Valley, with a lake-covered floor, its sides showing a series of former shorelines falling from nearly three hundred feet above the present level. The steadily falling lakeshores were occupied by palaeolithic hunters, and they continued to be occupied off and on until Roman times; there is no question, therefore, of the earliest neolithic sites having been overlooked. Neolithic men built their first settlements by the lake when it stood 180 feet higher than it does today. By the radiocarbon method, their occupation has been dated to the second half of the fifth millennium B.C. The surviving tools include ground stone axes and serrated stone sickles set in wooden shafts, while sunken silos lined with straw matting contain grains of barley and emmer wheat. The elaborate storage arrangements show that the communities were permanently settled. Hunting was practised with bow and arrow, and the remains of bone fishing-tackle recall that used by the Natufians of Palestine. The neolithic people of the Fayum used a coarse undecorated pottery and could weave linen. They imported shells from the Red Sea coast and amazonite from the borders of Libya to make pendants and beads. That they were an intrusive group is shown by the fact that upper palaeolithic hunters continued to frequent the depression after their arrival. Eventually the two elements fused, the newcomers taking to some of the 'flake' tools and tanged arrow-heads of the hunters, who in their turn adopted the cultivating tools of the food-producers.

It is clear from all the sites that the early Egyptian cultivators of the valley margin soon began to suffer from the steady desiccation of the climate during the late fifth and early fourth millennia. It was the encroaching drift sand of the desert which stimulated the Tasians and Badarians of middle Egypt to move down and clear the flood-plain, with results so startling for the history of the world. From that moment onwards the remains of the predynastic period indicate a phenomenal growth of population. Twenty thousand people would probably be an extreme estimate of the population of hunter-gatherers the Egyptian section of the Nile valley could have supported at the end of palaeolithic times. The population of the Old Kingdom two thousand years later has been variously estimated at from one to six millions. The physical types found in predynastic and early dynastic burials are remarkably consistent, and show that the ancient Egyptian cultivators were of a short and rather lightly-built race indistinguishable from the modern Beja of the Red Sea hills or from the Danakil and Somali of the Horn of Africa. Their language, we know, was of the Hamito-Semitic or Erythraic family, distantly related to the Berber languages of north-west Africa on the one hand or to the older Cushitic languages of Ethiopia on the other. The Asiatic introducers of the food-producing revolution need not, therefore, have been numerous. The increase in population which followed was essentially a natural increase of the pre-existing Caucasoid population of north and east Africa, an increase due to the fantastic growth of food supplies made possible by wheat and barley, and also by the perennially rejuvenated soil of the Nile flood-plain.

Along with wheat and barley, domesticated goats, sheep, pigs, and cattle existed in Egypt from the earliest neolithic times, and also flax and various vegetable and forage plants. It was the wheat and barley, however, which certainly exercised the most revolutionary influence; and it was upon the discovery of alternative cereals to wheat and barley, suited to more tropical conditions of climate, that the spread of the food-producing revolution to the rest of Africa really depended. The Nile valley alluvium, however, had no equivalent elsewhere.

Significantly, it was in the form represented by the late neo-lithic of the Fayum, in which polished stone farming tools are found in association with a flaked hunting kit of upper palaeolithic tradition, that the Egyptian neolithic spread westwards and south-westwards to the oases of Siwa and Kharga, and also to the highlands of Cyrenaica. This was a development of the late fifth or early fourth millennium. Further west, in Algeria, Tunisia, and Morocco, the earliest neolithic tools developed out of the North African Capsian tradition, and it is at present impossible to say at what period the Caucasoid people of this region became food-producers, although it is certain that hunting remained the predominant element in the economy until at least the second millennium B.C.

Moving up the Nile into Negro Africa, it is clear from the carbon-dated site at Shaheinab near Khartoum that the riverside communities of the upper Nile were by the late fourth millennium making neolithic tools similar to those of upper Egypt, but although they were herding domestic goats, they had as yet no cultivated food-plants. Further west, it was certainly in the form of pastoralism that the practice of food production crossed the Sahara. The evidence of this comes mainly from rock-shelters, painted and engraved with pastoral scenes, the associated deposits dating to the fourth and third millennia B.C. This was towards the end of the Saharan wet phase, and by the late third millennium pastoralists were migrating southwards into the sub-Saharan savannas. Almost certainly the pastoralists had been familiar with domesticated cereals in the north and began to experiment with the wild cereal grasses which they encountered to the south of the desert.

The oldest cereal crops of sub-Saharan Africa were the millets,[1] but in West Africa west of the great bend of the Niger there was also the rice *Oryza glaberrima*. All these grains are native to sub-Saharan Africa and, more narrowly, to the light woodland savanna which stretches from the Senegal to the upper Nile and

[1]. Especially the many species of *Sorghum* (guinea corn or great millet), *Pennisetum* (bulrush or pearl millet), and *Eleusine corocana*.

thence south-eastwards into northern Uganda and parts of Kenya. There are those who would argue the case for an original and independent invention of agriculture in this sub-Saharan region. Against this, however, there is at present a lack of any firm archaeological evidence for the existence of truly cultivating communities to the south of the Sahara earlier than the later second millennium B.C. And the only advanced neolithic agricultural civilization yet identified in the Sudanic region is that associated with the Nok figurine culture of northern Nigeria, for which the carbon dates suggest an origin very early in the first millennium B.C. and a development continuing into the early Iron Age, which reached this part of Africa about the fourth or fifth century B.C. The Nok Negroes certainly lived in villages, and in addition to making stone tools and jewellery of a high standard, they developed a remarkable tradition of terra cotta sculpture, which was probably associated with the cult of ancestors. No doubt the lack of earlier evidence is due in part to the very inadequate state of archaeological information; but given the probable absence of cultivation at early neolithic Khartoum, it would seem likely that the food-producing revolution spread to the savanna belt of sub-Saharan Africa during the second or third millennium B.C., as a result of the diffusion of neolithic techniques and botanical knowledge, which had then to be applied to the cereal plants native to the new region and climate.

The sub-Saharan savanna, however, though it stretches from the Atlantic in the west to the Ethiopian highlands in the east, forms a belt seldom more than six hundred miles wide, which is transitional between the aridity of the desert to the north and the high humidity of the equatorial region to the south. Only in northern East Africa, where highland plateaux traverse the equatorial belt from north to south, is there a narrow corridor of open country connecting the northern savannas with those to the centre and south of the sub-continent. In this corridor archaeologists have so far identified with certainty only one set of Stone Age food-producers, the originators of the neolithic Stone Bowl culture of the Kenya Rift Valley. These people lived during the first millennium B.C. They were undoubtedly stock-breeders,

and the fact that they made stone platters, bowls and pestles suggests that they may also have grown cereals, though this has not been proven. Physically, the Stone Bowl people were tall and slender, like the Kenya Capsians who preceded them. Probably they were the southerly representatives of an Ethiopian stock, originally Caucasoid, but by now much mixed with Negroid elements from the Sudanic area to the west. Probably they spoke Cushitic languages from the south-eastern branch of the Hamito-Semitic family. We do not know how far south into East Africa the Stone Bowl people may have penetrated, but it seems likely that from central Tanzania southwards the main populations were still hunter-gatherers of Bush stock.

South of the Sudanic belt, however, and west of the East African plateau, lay the equatorial forest with its fringes of humid woodland, where the problems of food production were entirely different. Here there was not enough sunlight for the Sudanic cereals, while trypanosomiasis and lack of fodder prevented the keeping of domestic animals. Here therefore the transition to food production depended on vegeculture rather than agriculture, on planting rather than sowing, on roots and fruits rather than on grains, on clearing rather than on hoeing, and on the combination of these activities with fishing rather than with hunting. In these circumstances the beginnings of food production, being almost indistinguishable from gathering, probably antedated in some sense the beginnings of agriculture and stock-raising in the north and east. However, progress towards a mainly food-producing way of life seems to have become noticeable only during the first millennium B.C., and even then to have been severely handicapped by the limited range of indigenous forest food crops. Several species of small yams were undoubtedly indigenous; also the oil-palm, the shea-butter tree, the kaffir potato and various kinds of beans and peas. But it is a remarkable fact that all the really important forest food-plants of modern Africa originated in other continents. The staple crops of the Guinea and Congo forests and their humid fringes are today maize and cassava, both of which came to Africa from South and Central America during the sixteenth and seventeenth

centuries A.D. These late arrivals from the New World were preceded in the same areas by those of South-East Asia – the banana, the Asian yam (*Dioscorea*) and the Coco-yam (*Colocasia*). It is unlikely that these South-East Asian plants reached Africa much before the beginning of the Christian era. Thus, in West and West-Central Africa the coming of food production seems to have been a fairly precarious development until it was fortified, perhaps almost simultaneously, by the introduction of the South-East Asian food plants and by the coming of the Iron Age. In East-Central and southern Africa, from southern Tanzania, Moçambique and Malawi to Zambia, Rhodesia and South Africa, the food-producing revolution seems to have been, from beginning to end, an event of the Iron Age.

These conclusions about the spread of food-production not only reconcile the existing views of archaeologists and botanists. They are also in some important respects consistent with the findings of comparative linguists about the relationships of different groups of African languages. These show that, apart from the Hamito-Semitic languages of the mainly Caucasoid peoples of the north and north-east, and the click languages of the Bush and Hottentot peoples in the east and south, there were two main categories of languages spoken by the Negroes: those formerly called Western Sudanic, but nowadays usually Niger-Congo; and those formerly called Eastern Sudanic, which today may be called Nilo-Saharan. Most of the Niger-Congo languages are spoken in West Africa between the Senegal and Lake Chad, although one Niger-Congo sub-grouping has spread across the same latitudes as far east as the Uele, while part of another sub-grouping has spread south-eastwards from the Cameroons across the whole of sub-equatorial Africa: this part includes all the languages called Bantu. Most of the Niger-Congo languages, including often those spoken in adjacent areas, are widely differentiated one from another – so much so that in the view of many linguists it would be reasonable to suppose that they have been growing apart for at least five thousand years, that is to say for at least as long as their speakers have been food-producers. In sharp contrast to these ancient differences, however, the

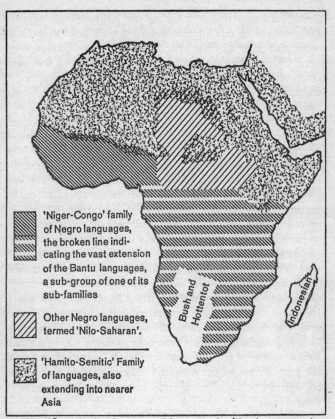

Map legend:

'Niger-Congo' family of Negro languages, the broken line indicating the vast extension of the Bantu languages, a sub-group of one of its sub-families

Other Negro languages, termed 'Nilo-Saharan'.

'Hamito-Semitic' Family of languages, also extending into nearer Asia

Bush and Hottentot

Indonesian

2. Simplified distribution map of language families in present-day Africa

Note: The scheme is essentially that proposed by Professor J. H. Greenberg, but there have been departures from his terminology so as to suit a historical text. Greenberg adds a small group of languages in Kordofan (not shown above) to 'Niger-Congo', and thus arrives at the term 'Congo-Kordofanian' for this major family. Greenberg uses 'Khoisan' for 'Bush and Hottentot'. He also proposes 'Afro-Asiatic' instead of 'Hamito-Semitic'; an alternative name is 'Erythraic', i.e. the language family astride the Red Sea.

Bantu languages spoken today by the Negroes over most of Africa south of the Equator are so closely related to each other that they are generally agreed to have been growing apart for a very much shorter period. As little as two thousand years ago Bantu may have been a single language spoken in an area very much smaller than that occupied today by its descendants.

The linguistic pattern certainly suggests that the Niger-Congo languages were originally concentrated in West Africa west of Lake Chad, from where they have expanded at the expense of the Nilo-Saharan languages to the east of them, as well as south-eastwards across the Bantu sphere. The likely implication would seem to be that the Negroes living in the western half of the Sudanic belt were more successful in the transition to food-production than those living in the eastern half, and so were able to press in with expanded numbers upon the territory of the second group. Probably the basis of this population growth was established in the savanna belt to the north of the equatorial forest during the third and second millennia B.C. The expansion of food-producers into and across the forest belt came much later, probably only in the first millennium B.C., with the evolution of near-neolithic clearing tools. Even then, it came in the form of a rather specialized form of vegeculture combined with fishing, following sea coasts and river lines. The establishment of the proto-Bantu in the woodland savanna to the south of the equatorial forest was, no doubt, a comparatively late result of this process.

Since the Bantu dispersion seems to have coincided closely in time with the coming of the Iron Age to Africa south of the Sahara, it is natural to ask how far the two events were connected. There are, for example, undoubted resemblances between the earliest Iron Age potteries of much of eastern and central Africa, which would be consistent with the very sudden expansion of an early Iron Age population formerly concentrated within a much smaller area. On the whole, however, it looks more and more as though the nuclear Bantu-speaking population must have been already established in Africa south of the

Equator before the end of the Stone Age, and as though the knowledge of iron-working had reached them in time to assist their expansion throughout the area rather than to cause their first penetration of it. The distribution of the Bantu languages is so complete that it must be assumed to be the result of repopulation rather than of conquest; and on the other hand the economic revolution which produced the expansion of the Bantu population was a 'planting' and not a 'sowing' revolution. It would seem in fact to have been in large measure a result of the introduction into Africa of the South-East-Asian food-plants – notably the banana and the Asian yam – which for the first time made possible the growth of dense populations in the moister and warmer regions of the east coast and the Zambezi valley, the Congo basin, the fertile crescent of the great lakes, and the perennially watered valleys surrounding the great mountains, such as Ruwenzori, Elgon, Kenya, and Kilimanjaro. The intensive occupation by the Western Sudanic Negroes of the heavily forested areas of the Guinea coast may equally have been subsequent to the arrival of the same plants.

The Bantu dispersal, therefore, was not a simple southward extension of the food-producing revolution already in operation in the savanna belt. The evidence from the internal classification of the Bantu languages indeed suggests that the final stage in the dispersal took place from a nuclear region rather south-of-centre of the present Bantu sphere. Tentatively, therefore, it might be inferred that the proto-Bantu were a group of late Stone Age vegeculturalists and fishermen, who had migrated by the waterways from the northern to the southern margins of the equatorial forest, who first learned to use iron and soon afterwards adopted the cultivated plants of the earliest traders and migrants from South-East Asia. These last were no doubt a part of the same movement of Indonesian peoples which colonized Madagascar some time during the first five centuries of the Christian era. In view of the wide distribution of some Indonesian cultural influences in the forest regions of both East and West Africa, it seems at least possible that some of these migrants not only colonized the mainland of the east coast, but conceivably even

circumnavigated the Cape of Good Hope and planted settlements in west central Africa and in Guinea.

At all events, we must picture a great expansion and dispersal of Bantu farmers, working steadily outwards from a nuclear area to the south of the Congo forest, towards the beginning of the Christian era. In the course of this dispersal, early Negroid and Bush stocks were absorbed, save in the deepest recesses of the Congo forest and in the most inhospitable deserts of the south-west. Right down the highlands of eastern Africa the descendants of the Caucasoid 'Hamites' held their own for a long time against the expanding Bantu Negroes, some of them becoming cultivators, others specializing as pastoralists on the dry ranching lands of the central plateaux. As late as the end of the first millennium A.D. they probably extended deep into east-central Africa. Increasingly, however, they were absorbed by the more rapidly expanding populations of Bantu cultivators, so that today Caucasoids speaking Hamito-Semitic languages are not found further south than north-central Tanganyika, although Caucasoid physical features survive among many now Bantu-speaking peoples on the eastern side of Africa. Again, to the south of the main Bantu nucleus, in Rhodesia and South Africa, there are many indications that the older click-speaking Bush and Hottentot populations were absorbed only slowly by the expanding Bantu. There are clear traces of both Bush and Hottentot clicks in the phonetics of the south-east Bantu languages.

3 The Townsmen

It was only in one small corner of Africa that food production led directly to urbanization. When the Tasians and Badarians moved down into the flood-plain of middle Egypt, probably in the early fourth millennium, they quickly became the inhabitants of permanent villages such as those revealed by the excavations under Petrie at El Amrah and Naqada. The cemeteries there already reveal a revolutionary growth in population. Villages were fortified, and the paintings on Amratian pots show captives with their hands tied behind their backs. They also show large papyrus boats, which were probably used for comparatively long-distance trading and raiding. It is certain that the Amratians imported gold and copper from the Red Sea hills, as well as obsidian, which perhaps came from as far away as the Ethiopian highlands. Jars and vases of carved alabaster and basalt make it likely that there were already whole-time specialists and craftsmen. The dead were buried with a wealth of grave-goods, showing an acute preoccupation with the problem of the after-life.

By the middle centuries of the fourth millennium, when the Amratian civilization was succeeded by the Gerzean, the larger villages were already growing into small towns, and rectangular houses with mud walls and strong wooden doors and window-frames began to resemble those of many a modern Middle Eastern town. The trade relations of Gerzean Egypt were very extensive. The Nile Valley was probably in steady contact with the other rapidly developing centres of civilization in Mesopotamia. Metals like silver and lead were regularly imported from the Aegean islands. Shipwrights were building vessels for sixty oars. Gerzean cemeteries show that great differences in wealth had

developed. A specialist stone-worker might now spend a whole year grinding out a single vase in polished porphyry to adorn a rich man's house or to furnish his tomb.

It is clear that in density of population, as in economic and artistic achievement, pre-dynastic Egypt of the late fourth millennium had already travelled further than almost any other part of Africa was to travel during the next five millennia. In a sense, therefore, much of the history of ancient Egypt is irrelevant to that of Africa as a whole. What is least irrelevant, however, is the body of politico-religious ideas which developed with startling suddenness at the beginning of the dynastic period. Widely opposing views have been held about where those ideas originated. It is significant that none of the excavation carried out at Gerzean sites has revealed anything that can be regarded as ancestral to the dynastic royal tomb. On the other hand, the latest chronological evidence places the earliest royal dynasties of Mesopotamia at a period contemporary to the Fifth Dynasty of Egypt: there are thus great difficulties in the theory of Asian origin, of which Flinders Petrie, for example, was an ardent exponent.

It seems on the whole most likely that the Egyptian idea of kingship emerged in Egypt itself, and that it developed very rapidly following the political unification of the country by the First Dynasty. This would seem to be the clear lesson of the archaeological record. The earliest dynastic tomb – that of Narmer at Abydos – was a brick-lined shaft measuring twenty-six feet by sixteen by ten. Even so, it was a striking development on the wealthiest Gerzean tomb, especially in that the body of the Pharaoh was accompanied by those of human victims killed and buried with their master in order that they might continue to serve him in the next life. The First Dynasty tomb of the Pharaoh Zer contains half as many burials as a whole public cemetery of Amratian or Gerzean times. The Third Dynasty tomb of Zozer, with ten thousand stone vases, was more elaborately furnished than any pre-dynastic town cemetery. And with the Fourth Dynasty, the great pyramid of Gizeh, built for the Pharaoh Khufer, only about five hundred years after the reign of Narmer, was 481 feet high, and consisted of some two million

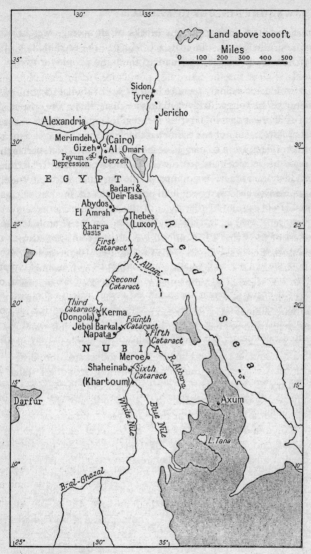

3. The Nile Valley

three hundred thousand stone blocks of an average weight of two and a half tons, and cost, according to the credible tale of Herodotus, the labour of a hundred thousand people for twenty years.

It would accordingly seem to be the organizational triumph of the early Pharaohs which was mainly responsible for the elaboration of divine kingship, Egypt's eventual legacy to so much of the rest of Africa. It has been estimated that Egyptian peasants of the third millennium B.C. may have been able to produce perhaps three times as much as their own domestic requirements. Under a harsh system of servile exploitation, the surplus could be turned to impressive account not only in public building, but also in the support of large noble, priestly, and official classes, the leaders of which developed an increasingly elaborate court life around the person of the living Pharaoh and around the tombs of his predecessors. Political unity was the final and vital stage in Egypt's amazingly rapid development from a jungle-filled, swampy valley to the scene of a complex and coherent society comprising several million people. It is surely only reasonable to infer that politico-religious ideas and practices, which later became very widely distributed, had their origin and growth in this uniquely fertile soil. Later, much later, they would be exported, directly to Nubia, and, at tens and hundreds of removes, to more distant parts of Africa, where migrants establishing 'conquest states' would try in absurdly different circumstances to apply some already greatly modified form of the Egyptian idea of the state. So it would come about that four thousand years and more after the Old Kingdom had reached its peak, a Monomatapa ruling to the south of Zambezi would marry his 'Queen Sister', or that on his accession an Omukama of Bunyoro in western Uganda would ceremonially 'shoot the nations' by firing arrows to the four points of the compass. At the time when these customs were evolved in Egypt, Uganda and Rhodesia were still uncultivated by any tool more advanced than the primeval grubbing-stick, and human societies must have been far too small and dispersed to need any leadership more extensive than that of the family patriarch.

The relevance of ancient Egypt to Africa is thus something fundamentally different from its relevance to Europe. It is something which can only be studied in the light of the historical and archaeological evidence about Egypt's relations with the lands to the south. The earliest contacts were certainly those of trade. As we have seen, the exploitation of Nubian gold from the hills between the Nile and the Red Sea was already in progress in pre-dynastic times. From the beginning of the dynastic period at least, there was regular contact with the coasts of Eritrea, Somalia, and southern Arabia, where grew the incense which was burnt in such prodigious quantities in the temples of Egypt. From the end of the third millennium occasional large expeditions went by sea; but the land routes through Nubia were certainly much older, and these, using the valleys of the Nile and the Atbara, already touched the land of the blacks. Probably it was the traders of late pre-dynastic Egypt who introduced goats and ground stone axes to the Negroes of Shaheinab. Certainly by early dynastic times Egypt had exhausted its own supplies of ivory and hardwoods, and had to seek these and other raw materials from the black south. An inscription of about 2275 B.C. tells how one Herkhuf, a servant of the Pharaoh Merenra, made four great expeditions to the south, from the last of which he returned with three hundred asses, laden with incense, ebony, ivory, skins, and boomerangs, and even with a pygmy to delight the heart of his master. Probably, therefore, he had ascended the Blue Nile into what is now southern Ethiopia; just possibly, he had followed the White Nile and the Bahr-al-Ghazal to the confines of the Congo forest. The boomerang, or throwing-stick, is still the characteristic weapon of the ancient Negro stocks living both east and west of the White Nile above Khartoum.

Trading expeditions such as those of Herkhuf doubtless had their effect upon the material culture of a wide region. Probably the Egyptians took with them both animals on the hoof and vegetable seeds to sow in the rainy season. Probably it was through such contacts that many hunting and gathering peoples received their first initiation into the ways of food-production. Probably even at this stage an Egyptian musical instrument, or a piece of

decorated basketry, would be bought and copied by those who came to exchange a tusk or a leopard-skin at the traders' camp. The deeper influence of Egyptian beliefs and social organization was, however, certainly confined until a very much later period to a small region in lower Nubia, which by the beginning of the second millennium B.C. was becoming the scene of direct Egyptian colonization. At Kerma, close to Dongola, the archaeologist Reisner excavated an Egyptian fortress dating from the Eleventh and Twelfth Dynasties, with inscriptions from which it appeared that this represented the colonial garrison of an indigenous Sudanese principality called Kush, lying between the third and fourth cataracts of the Nile. By the end of the second millennium B.C. Egyptian influence throughout all this region was much stronger. The capital of Egypt itself was by this time at Thebes, the modern Luxor; and the Pharaohs of the Eighteenth, Nineteenth, and Twentieth Dynasties, finding their traditional lines of expansion into Asia threatened by the growth of the Hittite empire, were turning their attention increasingly to the south. Nubia, between the first and third cataracts, was fully occupied, and according to one calculation its mines were yielding forty thousand kilograms of gold a year, an amount which was never again reached in world production until the nineteenth century. And beyond Nubia in Kush there was now a whole series of Egyptian towns, including an important offshoot of the Theban temple of Amon, at Jebel Barkal near the fourth cataract. It was in all probability from the high-priestly family of Jebel Barkal that there emerged, at the beginning of the first millennium B.C. the dynasty of the independent though highly Egyptianized kingdom of Kush, which was to survive, with its capital first at Napata and later at Meroe, for more than a thousand years – indeed until the middle of the fourth century A.D.

Egypt by the beginning of the first millennium B.C. was in full decline. To the north the Assyrians were succeeding the Hittites as the chief Asian power. Lower Egypt was increasingly a prey to its Libyan mercenary troops, who established a series of short-lived dynasties in the Delta. In the far south excavations by Reisner and Dows Dunham at Napata have shown that the

earliest royal cemetery there came into use early in the ninth century B.C. A century later these rulers of Kush had become strong enough to conquer Egypt, where five of their number are remembered as the Twenty-fifth Dynasty of Pharaohs. For a brief period Napata became the capital of the ancient world, and Sudanese kings intrigued with Tyre and Sidon, Israel, and Judah in a vain attempt to stem the growing might of Assyria. In Egypt the end came swiftly. In 676 B.C., in the reign of the Pharaoh Taharqa, the Assyrians under Esarhaddon occupied Lower Egypt. In 666 under Ashurbannipal they pressed into Upper Egypt, and a few years later carried out the first terrible sack of Thebes. Taharqa retreated southwards into Kush, where the Egyptianized kingdom survived. While Egypt proper fell a prey successively to the Assyrians, the Persians, the Greeks, and the Romans, its former dependency, Kush, retained practically un-diluted a sturdy remnant of Egyptian civilization. According to the traditional viewpoint of western historians, it was ancient Egypt running downhill to an inglorious and too long protracted conclusion. According to the very different perspectives of Afri-can history, it was ancient Egypt moving nearer to black Africa, at a period when at least part of black Africa was more capable than it had ever been before of experiencing the influence of an urban civilization.

Throughout its long period as an Egyptian colony, and also during the first two or three centuries of its independent existence, the population of Kush, like that of Egypt, was predominantly Caucasoid. Its centre lay across the southern trade-routes in the arid, infertile region of the Nile cataracts. Around the sixth century B.C., however, Kush began to push first its frontiers and then its capital southwards, beyond the desert and the cataracts, into what was then the well-wooded country at the northern edge of the tropical summer rains. The new frontier was probably a little to the south of Khartoum. The new capital was at Meroe, a little above the Atbara confluence. All this was the land of the blacks, and the Kushite dynasty henceforward ruled over a mixed population of Caucasians and Negroes, with the Negroes no doubt predominating. The reasons for the move

are not far to seek. With the final decline of Egypt, trade routes
were less important than formerly. Napata and its surroundings
had probably been over-grazed into barrenness. And, above all,
the Kushites had learned from their Assyrian enemies the
revolutionary technique of iron-working. While Egypt had
neither iron ore nor fuel with which to smelt it, and while
northern Kush had ore but still no fuel, the southern region of
Kush had both commodities in abundance, to such an extent
indeed that the archaeologist Sayce, on viewing the mountains
of slag that lie around the ruins of Meroe, declared that it must
have been the Birmingham of Central Africa. Equipped with the
iron spear and the iron hoe, Meroe was able not merely to pro-
vide for its own subsistence, but to trade and conquer far and
wide in the Sudanic belt of Africa.

From the archaeological evidence unearthed by Garstang and
Dows Dunham, it appears that the great period of Meroe
stretched from the middle of the third century B.C. until just into
the Christian era. It corresponded more or less with the rule of the
Ptolemies in Egypt, and was probably connected with the revival
of trade which came when Persian influence was superseded
by that of Hellenistic Alexandria. Probably Meroe grew rich by
exporting to the outside world the traditional African products
– ivory, slaves, rare skins, ostrich feathers, ebony, and possibly
gold – drawn from a wide region of inner Africa which may have
extended from the Ethiopian highlands on one side to the Niger
on the other. At all events, this period was the most prolific in
monumental building. It saw a revival of Egyptian sculpture and
a return to funerary inscriptions in Egyptian hieroglyphs. It saw
also the invention of the cursive Meroitic script, which has not
yet been properly deciphered. The iron industry was now very
fully established: one of the most important temples of the period
stands upon the top of a hill of slag. Not only Mediterranean, but
also Eastern influences were present. Fragments of cotton cloth
appear in the tombs. Tanks and reservoirs point to influence
from at least as far away as south Arabia. The sculptured relief
of a king of Kush seated on an elephant suggests the presence at
Meroe of at least one Indian artist. The basic inspiration of

Meroitic civilization remained, nevertheless, that of ancient Egypt. The gods worshipped in the temples of Meroe were the Egyptian gods. Its kings continued to call themselves the kings of Upper and Lower Egypt, and to lead the dedicated high-priestly lives of Egyptian Pharaohs, marrying their Queen Sisters, honouring their Queen Mothers, leading their people in the ceremonies of seedtime and harvest, honoured as gods by their subjects, and expected to behave with the capricious absolutism thought to be characteristic of divinity.

It is clear that by the middle of the first century A.D. the material basis of the Meroitic civilization was in decline. Of the score or so of kings who had still to reign before the extinction of the kingdom, only ten had architects literate enough to transmit the royal names to posterity, while the last six sovereigns lacked even the masons to encase their little brick pyramids with a thin façade of stone. The reason for Meroe's poverty was almost certainly the rise of a rival trading empire, with its centre at Axum in the northern corner of the Ethiopian highlands. Originally the offshoot of one or other of the Semitic Sabean kingdoms that had grown up in south Arabia during the last millennium B.C., Axum, as we know from an Alexandrian sailors' guide, by the beginning of the Christian era had become the greatest ivory market of north-east Africa. Its capital was growing into a city of splendid stone monuments – including palaces, temples, and carved stone obelisks. Its king traded with the Greeks of Alexandria, spoke their language, and ate from gold and silver plate. Armed with imported iron weapons, his hunters and caravaneers were already penetrating beyond the Nile in the latitude of Khartoum. During the second and third centuries the power of Axum rose steadily. In the middle of the fourth century its rulers became Christians, and at just about the same time its armies made their last and decisive invasion of Kush, burning the town of Meroe, and causing the final break-up of the kingdom. In the view of Dr A. J. Arkell, the foremost archaeologist and historian of the Sudan, this shattering defeat of Kush began the medieval history of the sub-Saharan savanna belt, from the Nile to Lake Chad and even beyond. The royal

family of Kush, he believes, retreated to the west, to Kordofan and Darfur, where their characteristic styles of brickwork and pottery exist in sites which have been surveyed but not yet properly excavated, and where even their royal property-marks survive in the camel brands of the desert nomads. If Arkell is right, the descendants of those who had once ruled Egypt now simply continued their rule in the region between the Nile and Lake Chad. Further archaeological investigation of this important region will very likely prove that the real course of events was more complex. It may well turn out that the widest extension of Meroitic influence occurred during that kingdom's heyday rather than during its decline. It may also turn out that the later, Christian period of Nubia was even more important for the westward spread of influences from the Nilotic Sudan than the Meroitic period. Meanwhile, Arkell's hypothesis may serve as a compass bearing, if not as an exact sign-post.

4 The Sudanic Civilization

Stretching right across sub-Saharan Africa from the Red Sea to the mouth of the Senegal, and right down the central highland spine of Bantu Africa from the Nile sources to Southern Rhodesia, we find the axis of what we shall call the Sudanic[1] civilization. The central feature of this civilization was the incorporation of the various African peoples concerned into states whose institutions were so similar that they must have derived from a common source. At the head of such states there were kings, to whom divine honours were paid, and to whom divine powers were attributed. The king led a life sedulously secluded from the common people; he gave public audience from behind a curtain; not even the most intimate of his courtiers might see him eat or drink. Each year the king hoed the first plot of farming land and sowed the first seeds. Upon his physical well-being depended the fertility of the land and the regular flow of rain. The divine king could not die a natural death. Whether in serious illness or in extreme old age, his end had to be hastened by poison or by ritual suffocation. After death the royal corpse was embalmed; funeral ceremonies often involved the sacrifice of human victims; relics, such as hair and fingernails, were preserved as part of the cult of the royal tomb. The great rituals of these divine kingdoms tended to be associated with the new moon, and sacred fire was almost everywhere kept burning and carefully guarded as the main symbol of the king's life and authority.

1. The German ethnographer H. Baumann termed it the '*neo*-Sudanese' civilization, in order to distinguish it from the older civilization of the first Negro farmers, which he termed the 'palaeo-negritic' civilization.

The divine king's subjects might number anything from a few thousand to a million, or even more. Such kingdoms tended in fact to form in clusters, with one or more large kingdoms at the centre of the cluster, and a host of smaller ones scattered around the peripheries. But on however small and ineffective a scale, such kingdoms would nearly always show at least vestigial traces of a strongly centralized political structure, contrasting sharply with the loose family or lineage institutions of those societies which had never been organized in this way. The typical 'Sudanic' state was not feudal. It was not based on the hereditary position and power of great families within the state. It was in principle something nearer to a bureaucracy – a bureaucracy without paper, ink, desks, or telephones – in which power was wielded by officials, who held their offices during the king's pleasure, and who could be transferred from post to post, promoted, demoted, and even destituted, by a nod of the divine head or a syllable from the divine mouth. Around the royal person circled a galaxy of titled office-bearers, as numerous as the economic organization of each particular state was able to support. The pre-eminent offices were nearly always those of the Queen Mother, the Queen Sister, and of a limited number of titled 'great wives' of the ruler. At the head of the administration were a few high officials, often four in number. From these depended a descending hierarchy of provincial and district chiefs, often recruited from the pages, sons, or nephews of the great, who had been educated at the royal court. The main concern of such administrations was the raising of tribute for the support of the king and of the semi-urbanized inhabitants of his capital – on the one hand, articles of consumption such as wives and labour, beer and foodstuffs; on the other, the materials of long-distance trade, such as ivory, skins, gold, copper, salt, and kola-nuts. External trade was always in some sense a royal monopoly. Artists, craftsmen, and other specialists were located at the royal capital, and were an important attribute of the royal power; there was indeed a tendency for the rulers of such states to be themselves identified at least with the mysterious craft of the smith. In a very real sense, therefore, the 'Sudanic'

state was a superstructure erected over village communities of peasant cultivators rather than a society which had grown up naturally out of them. In many cases such states are known to have had their origins in conquest; in almost all other cases conquest must be suspected. Working from his ethnographic analysis Baumann, for one, had no hesitation in saying that these were parts of Africa which had been overrun by later-comers of a higher culture than the original societies of cultivators.

It must be said at once that the ethnographic method of comparing the political institutions of a large number of states founded at widely varying periods, on the basis of descriptive information of variable quality, obtained for the most part at a late date in the history of the states concerned, is one that must be used with great caution. Such a method can only provide the first diagnosis of a problem to which history has to find an answer, so far as it can. The historian cannot be content to postulate vague notions about 'waves of conquest'. He must approach the problem through the known history of the states concerned, and must seek chronological evidence wherever it is available. Judged by this test, many of the 'Sudanic' states can be written off as comparatively recent extensions from others already existing in their neighbourhood. But in at least three geographically widely spread cases there would seem to be evidence that states of this kind were in existence by as early as the end of the first millennium A.D. The kingdom of Ghana, with its centre some five hundred miles to the north-west of its modern namesake's nearest boundary, was first mentioned in writing by an Arab author of the eighth century, al-Fazari. Three centuries later, when Ghana was well known to the Muslim world by its export of gold to North Africa, the Moorish geographer al-Bakri of Cordoba described what was still a sturdily pagan kingship ritual:

The audience is announced by the beating of a drum which they call *daba*, made from a long hollow log. When the people ... approach [the king], they fall on their knees and sprinkle their heads with dust, for this is their way of showing respect ... The religion of the people of Ghana is paganism and the worship of idols. When their king dies, they build over the place where his tomb will be an enormous dome of

saj wood. Then they bring him on a bed covered with a few carpets
and put him inside the dome. At his side they place his ornaments, his
weapons, and the vessels from which he used to eat and drink, filled
with various kinds of food and beverages. They also place there the
men who had served his meals. They close the door of the dome and
cover it with mats and materials, and then they assemble the people,
who heap earth upon it until it becomes like a large mound. Then they
dig a ditch around the mound so that it can be reached only at one
place. They sacrifice victims for their dead and make offerings of
intoxicating drinks.

The kingdom of Kanem, lying to the north-east of Lake Chad,
was mentioned, together with its Zaghawa rulers, by al-Yaqubi,
writing in the ninth century, while the tenth-century writer, al-
Muhallabi, made it quite clear that this was a divine kingdom of
the 'Sudanic' type:

The kingdom of the Zaghawa is said to be a great kingdom among
the kings of the Sudan. On their eastern boundary is the kingdom of
the Nuba who are above upper Egypt. Between them there is a distance
of ten days' journey. They are many tribes. The length of their land is
a fifteen days' journey through habitations and cultivations all the way.
Their houses are all of gypsum and so is the castle of their king. Him
they respect and worship to the neglect of Allah the most High; and
they falsely imagine that he does not eat food. His food is taken into
his house secretly, and if any one of his subjects happens to meet the
camels carrying it, he is immediately killed on the spot. He has abso-
lute power over his subjects and takes what he will of their belongings.
Their cattle are goats and cows and camels and horses. Millet chiefly.
is cultivated in their land, and beans, also wheat. Most of the ordinary
people are naked, covering themselves with skins. They spend their
time cultivating and looking after their cattle; and their religion is the
worship of their kings, for they believe that it is they who bring life
and death and sickness and health.

And finally the great traveller and geographical writer al-
Masudi of Baghdad, who himself journeyed by sea from the
Persian Gulf down the east coast of Africa to Sofala in modern
Moçambique in or about 922 A.D., clearly recorded the existence
of a substantial trade in gold and ivory, which was shipped from
Sofala to Oman and thence to China and India, and which

originated in a large African state in the hinterland of modern Moçambique. The king of this state bore sublime titles such as 'son of the great master, the god of the earth and the sky', and was the foremost of all the African rulers known to the Arabs who frequented the east coast. It is highly probable that Masudi was referring to the state whose rulers were later responsible for the earliest stages of stone building at Great Zimbabwe, currently attributed by archaeologists, on the basis of carbon-dating, to approximately the eleventh century. It is very clear, from Portuguese descriptions of the societies they found in this region five centuries later, that although political fragmentation had set in, political structure was uniform and showed most of the typical features of 'Sudanic' divine kingship.

The geographical spread of those African states for which we happen to have evidence stretching back into the first millennium A.D. is such as to make it highly improbable that they were the only states of their kind in existence, even at this early period. Rather we must assume that they were the only ones which happened to attract the attention of literate people in the outside world; and we must assume that with the further development of Iron Age archaeology in Africa, with its new methods of absolute dating, a steady stream of fresh evidence will come to light, pointing to other early centres of the 'Sudanic' civilization, and perhaps carrying its origins back to a period considerably earlier than our existing documentary references. Belgian archaeologists, for example, have recently found on the banks of the upper Lualaba extensive cemeteries, provisionally carbondated to the eighth and ninth centuries A.D., with rich burials, showing that at this period the copper of the Katanga was already being mined and forged into jewellery and into small H-shaped ingots which must have been used for currency. No distinctive royal tomb or capital site has yet been found to prove that these technologically very advanced Africans, whose skeletons do not differ significantly from those of the present Luba population, were organized into a state of the 'Sudanic' type; but judging by the historical traditions of this area, it would seem highly likely that they were so. Further north, in Uganda,

Rwanda, Burundi and the adjoining parts of eastern Zaire, the formation and re-formation of Sudanic states can be traced in some detail through five or six hundred years or so of traditional history, which is supported at some points by archaeological evidence. It is clear that, even at the start of this period, there was at least one comparatively large state extending across much of the grassland area of western Uganda. This was surrounded on every side by a myriad of small and very small states, out of which some other larger states were later to emerge.

If the antiquity of 'Sudanic' political organization in north-eastern and Bantu Africa is still (with the exception of Rhodesia) highly speculative, that of sub-Saharan Africa west of Kanem is much less so, though here again the relative precision of archaeological evidence is badly needed. Traditions recorded by literate Muslim Sudanese in the sixteenth and seventeenth centuries A.D. suggest, however, that the origins of at least one other 'Sudanic' state, that of Songhai on the eastern arm of the great Niger bend, were approximately as ancient as those of Kanem and ancient Ghana. In Northern Nigeria and the adjacent Niger Republic, the origins of the Hausa states (again from traditional evidence) are almost certainly to be placed about the end of the first millennium. The southward extension of these systems towards the lands of the upper Volta in the centre of the Niger bend, and towards Nupe and Yorubaland in central and western Nigeria, certainly occurred later, though how much later remains to be discovered.

The essential conclusions that emerge from this brief survey would thus seem to be, first, that the formation of states, alike in sub-Saharan and in Bantu Africa, was a process which involved the deployment of a considerable fund of common political ideas; secondly, that the earliest lines of deployment seem to have been interior lines, running out in two long arms westwards and southwards from a common point of origin in the upper Nile valley; thirdly, that this fund of common ideas was pre-Muslim and pre-Christian, in the sense that the basic ideas of the system ran sharply counter to the tenets of both these religions, and

therefore that if the Nile valley was the point of departure, they must have started to disperse outwards from that region before either Christianity or Islam became firmly established there. Islam did not seriously begin to penetrate the Nilotic Sudan until the eleventh century. Christianity, however, spread from Egypt to Nubia in the late sixth century, and by the seventh was strongly enough established there to resist the southward spread of Islam for more than four centuries. In our search for the sources of the 'Sudanic' civilization, we are therefore driven back to the history of the Sudan during the first six centuries A.D. At the beginning of that period the Meroitic state was still at the height of its power, and there can be little doubt that the ideas of ancient Egypt, percolating through the Meroitic filter, formed the basic element in the 'Sudanic' civilization. This, however, is certainly not the whole story. With the third and fourth century came the economic and political dominance of pagan Axum, which may account for further elements; but by the end of the fourth century Axum was beginning to be a Christian state, possessing strong political as well as religious links with Byzantine Egypt, and increasingly directing its expansive energies across the Straits of Bab-el-Mandeb into southern Arabia. It is in this direction that we must seek the third main series of elements in the 'Sudanic' civilization.

It cannot be entirely without significance that over large stretches of the central and western Sudan traditions ascribe the foundation of early dynasties to pre-Islamic immigrants from the Yemen. It is true that such traditions always come from areas where the 'Sudanic' civilization has been overlaid by Islamic influences, and that the form in which they are preserved clearly shows the influence of Arabian Muslim traditions about the pre-Islamic period. There can, in fact, be no doubt that these traditions as we know them today represent hypothetical explanations suggested by early Muslim *literati* for the situation which they found in the Sudan. Nevertheless, there are strong reasons for thinking that for several centuries before the great overspill of newly Islamized Arabs into Africa in the early seventh century, south-west Asia in general and Arabia in particular had

been emptying its surplus populations across the Red Sea and
the isthmus of Suez. The advent of the camel into Africa –
which can be clearly traced in classical sources for the frontiers
of Roman and Byzantine North Africa during the first five cen-
turies of the Christian era – was almost certainly accompanied
by human migrations, augmenting and culturally modifying the
nomadic populations of the Libyan and Saharan deserts. Again,
the period of Axumite conquest in the Yemen during the sixth
century is associated in early Muslim traditions with a time of
special famine and hardship, symbolized by the bursting of the
great dam of Mahrib some time in the third quarter of the sixth
century, which is said to have caused a great emigration of sed-
entary Yemenite cultivators across the Red Sea into the Sudan.
Next, it must be remembered that the Yemenites finally rid
themselves of the Axumite occupation by calling in the help of
Sassanian Persia, and that the Sassanid rulers Chosroes I and II
responded to the appeal not only by occupying Arabia, but also
by conquering Egypt from the Byzantines. In Egypt their rule
was confined to a brief ten years, but it may well be a fact of
decisive significance for the 'Sudanic' civilization that the rich
'X group' culture, which succeeded the Meroitic in northern
Nubia and which, for example, contains the first iron bits and
bridles found in any Sudanese sites, also shows definite traces of
Sassanian influence.

Thus, while no definite or precise account of the origins of the
'Sudanic' civilization can yet be given, there is nevertheless
enough circumstantial evidence of the various influences at work
in the Meroitic and immediately post-Meroitic Sudan to account
for most of the elements in the strange amalgam of Egyptian and
south-west Asian ideas and influences which were to penetrate,
with obvious modifications and attenuations, through so much
of the heart of Africa. Essentially the 'Sudanic' state was a
parasitic growth, fastening itself upon the economic base of pre-
existing agricultural societies. To these societies it contributed
certain new ideas of political organization, and certain new
techniques, notably in the field of mining, metallurgy, and trade.
Its earliest propagators seem to have moved south-west from the

Nile Valley, and to have established themselves, probably with the aid of the horse and of cavalry warfare, among the agricultural peoples immediately to the south of the Sahara, at points where they could control and develop the trans-Saharan trade-routes leading to Roman, Byzantine, and later to Muslim North Africa. In the Horn of Africa, pre-Christian Axum was probably the prototype of another whole series of 'Sudanic' states, established to exploit the gold and ivory of the north-eastern interior; and it was perhaps from this direction that the first miners and ivory-traders reached the Lake regions, the Katanga and Rhodesia, using their superior techniques to establish political power according to their own traditional patterns, and, as they got further south, opening new trade routes towards the seaports of the East Coast. On this side of Africa, particularly, our knowledge is still so thin that the less said the better. But it is essential, for the proper understanding of later periods of African history at least, to face the fact that the parts of the continent where the first loose agricultural societies were fashioned into states were in the central regions and not on the eastern or western peripheries. It is this fact that gives the history of Africa a certain unity, which it would have lacked if all the main motive forces had reached it across the oceans from the east and from the west.

5 Mediterranean Civilization in Northern and Western Africa

The two previous chapters have given some account of the contribution made by ancient Egypt to Negro Africa, especially of the Egyptian influences channelled through the kingdom of Kush in the Nilotic Sudan. The external influence of Egypt was, however, by no means limited to the Nile Valley. Egypt had regular contacts through maritime trade with the lands to the north, notably with Syria, Cyprus, and Crete, and thus Egyptian influence contributed powerfully to the rise of civilization in the Mediterranean. This is a story beyond the scope of this book, but African history cannot neglect the fact that for nearly fifteen hundred years, from the foundation of the first Phoenician colonies in North Africa about the eighth century B.C. until the Arab conquest of the seventh century A.D., nearly all the Africans living to the north of the Sahara belonged in some sense to this Mediterranean civilization. These peoples, of course, were not Negroes. They were the fair-skinned Caucasoids whom the ancient Greeks called Libyans, and whom they distinguished from the 'Ethiopians', the men with 'burnt faces', as they called the Negroes. The Libyans spoke languages of the Hamito-Semitic family and their purest descendants today are some of the more isolated Berber groups in the mountain regions of North Africa. Nevertheless, that the Libyan Berbers lived so long within the fringes of the Mediterranean world was not without its significance for the Negroes south of the Sahara.

It was the westward expansion of Phoenician merchants from the seaports of Syria, prosperous from their domination of the trade in the eastern Mediterranean basin, which first brought the young Mediterranean civilization to North Africa. At first

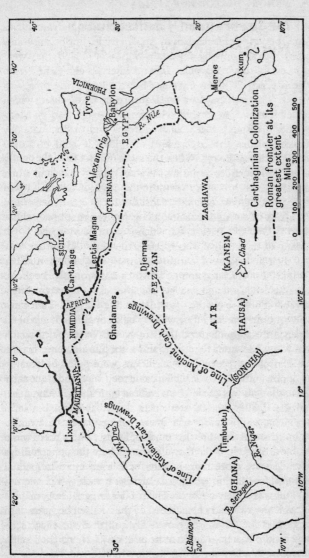

4. North Africa and the Sahara in ancient times

the Phoenicians were probably more interested in the rare metals of the Iberian peninsula than in African trade. But because they preferred to sail only by day and within sight of land, they were led to establish staging posts at short intervals along the North African coast. Of these Carthage became by far the most important. This was partly a consequence of its position, which enabled it at once to command the gateway to the western Mediterranean, through the Sicilian narrows, and to dominate the Tunisian plains, the largest area of cultivable land in North Africa outside of Egypt. When the mother cities in Syria finally lost their independence during the sixth century B.C., and when from the seventh century onwards the coast of Cyrenaica was planted with Greek colonies, Carthage became the metropolis of a series of towns stretching along the North African shore from the Gulf of Cirtes to the Atlantic coast of Morocco.

Many of the original Phoenician settlements did not far outgrow their first status of maritime staging-posts, and the number of original Phoenician colonists in Africa was probably not great. Nevertheless, Carthage and her satellites came to exert a considerable influence on the life of the native Berbers. Two categories of Carthaginian influence may be distinguished: a general influence throughout those parts of North-West Africa which were accessible from the coast, and a specific influence on the Tunisian plains. Since the Phoenicians were quick to develop any opportunities of trade which came their way, and since their mercantile skill was backed by advanced agricultural techniques, even the smallest coastal settlement tended to become a local metropolis, where Berber tribesmen could gain some knowledge of a more ordered and settled mode of living. Where there was a sizeable area of arable land available, or where the opportunities for trade were more than merely local, even more influential cities developed. The growth of Carthage herself was phenomenal. This was largely a consequence of her imperial responsibilities, which were greatly heightened by the needs of her wars with Rome, first for the mastery of Sicily and then for sheer self-preservation. Her population at its peak may have reached half a million. Such a city could only be provisioned and defended by

the extension of direct rule over its hinterland; thus the fertile northern half of the Tunisian plain became a Carthaginian estate, while its tribesmen were converted into agricultural labourers.

Thus, while throughout North-West Africa the Phoenician language, Punic, became the *lingua franca* of trade, administration, and civilized life, and while there was a general encouragement of agriculture and peaceful development, in and around northern Tunisia these processes were greatly accentuated. Here, and to some extent in other coastal regions as well, an influential class of Punicized Berbers had emerged. Two particular aspects of this Punicizing process merit especial notice. By the end of the Carthaginian period, independent Berber chieftains in the Numidian mountains adjacent to the Tunisian plain had begun to organize their semi-nomadic tribesmen into settled agricultural kingdoms. Secondly, since from the earliest times people whom we should now call Jews had been involved in Phoenician colonization, some elements of Judaic religious beliefs had been assimilated even by tribal Berbers, and especially, it would seem, by the tribes of southern Tunisia and adjacent Tripolitania.

In Sicily and elsewhere in the northern half of the Mediterranean, Greek colonies were soon competing with the Phoenicians, but the Carthaginians successfully kept them out of North Africa west of the Gulf of Cirtes. It was therefore only in Cyrenaica and Egypt that Greek civilization was able to secure a footing in North Africa. Egypt, indeed, became the major channel for Greek influence on Africa, especially after its conquest by Alexander the Great in 332 B.C. Alexander died ten years later, and the world empire he had established was shattered. But his dream of fusing the civilizations of the east and the west survived in the intellectual life of the city he had founded by the Canopus mouth of the Nile, Alexandria. Under the dynasty established by one of his generals, Ptolemy, Alexandria became the greatest of all Greek cities. The Ptolemies became wealthy, like the Pharaohs whose place they had taken, by taxing the unique agricultural wealth of the Nile valley. They grew richer still by developing and then taxing the trade in luxuries between Asia and Europe. But above all, in Alexandria the Greek civilization, its culture,

philosophy, and science, was penetrated and stimulated by the eastern cultures. Not the least of these was the Semitic. While Egypt became progressively Hellenized, its capital, Alexandria, with almost as many Jews as Greeks among its three hundred thousand citizens, became a forcing-bed for religious and philosophical debate, a role which it was to retain for the rest of the Hellenistic period and also through the vital first three centuries of the Christian era.

When in the middle of the second century B.C. the citizens of the upstart Roman republic finally humbled mighty Carthage, they had little thought of establishing an empire in Africa. They tore down the city of Carthage and ploughed its very foundations into the earth. But they appreciated the value of the Tunisian plains as a granary for the growing population of their own metropolis; and they found that to make their hold on them effective they had also to control the neighbouring territories. The Numidian kingdoms were soon conquered, and the Romans also quickly occupied the whole of the coastal strip westwards to the Atlantic plains of Morocco. But there remained the difficult problem of the semi-nomadic tribes, always seeking to encroach upon the area of agricultural and civilized life. Ultimately the only solution lay in the extension of direct Roman rule over the tribes as far as the edge of the Saharan steppes. Thus, when during the first century B.C. both Cyrenaica and Egypt also came directly under Roman control, the Romans possessed an African empire reaching from east to west for nearly 4,000 miles and encompassing all the cultivable land north of the Sahara.

This African empire had no meaning or unity of its own. It was essentially no more than the southern limit of the Mediterranean world which the Romans had mastered. Within it, however, there were two areas of particular interest to the Romans: the provinces of 'Africa' (equivalent to modern Tunisia and the adjacent coastlands of Tripolitania) and Numidia (roughly the eastern half of modern Algeria); and Egypt. In 'Africa' and Numidia, the work begun by Carthage of converting the Berbers to a settled agricultural way of life was greatly extended. Nearly fifty of the seventy or more Roman towns whose sites are known

in North-West Africa were in this region, and the bulk of their inhabitants were not colonists but Romanized Berbers. In Egypt, the effects of Roman rule seem to have been less beneficial. Though more efficient than the later Ptolemies, the Romans adapted themselves far less to the Egyptian scene. They remained foreigners in Egypt, and by ruthlessly exploiting the country in the interests of Rome and her proconsuls, they ended by exhausting an agriculture which initially they had done much to revive.

The greatest contribution of the Roman empire to Africa was the largely incidental fact that by bringing northern Africa so positively within the sphere of Mediterranean civilization, it greatly facilitated the spread of Christianity. The two great centres of the new religion were Alexandria and Carthage, and in both places, as throughout the Mediterranean world, the Jewish communities provided most of the early converts. Alexandria, traditionally the see of St Mark, was the native city of both Arius and Athanasius, whose doctrinal disagreements resulted early in the fourth century in the formulation of the Nicene Creed, still used by all the major branches of the Christian Church. The greatest of all the early Christian fathers, St Augustine, was a Libyan Berber brought up and educated at Carthage. When, however, in the fourth, fifth, and sixth centuries of its existence, Christianity became increasingly the state religion of the Roman empire, both in Egypt and in the provinces of 'Africa' and Numidia, opposition to Roman rule sought expression in doctrinal or sectarian divergences. In North-West Africa in the fourth century Donatism was less a heresy than a movement marking the resistance of many tribal Berbers, especially in Numidia, to the encroaching pressures of Roman rule. In Egypt, after the Council of Chalcedon in 451, the native Egyptians attached themselves wholeheartedly to the condemned Monophysite view of the nature of Christ, and developed a deep loyalty to their own 'Coptic' church in opposition to the orthodox 'Melkite' church supported by the Byzantine officials. In the sixth century, both churches sent missions to the Nubian kingdoms which had developed out of the heritage of ancient Meroe in the Nilotic

Sudan. The Monophysites were the more successful, converting the kings and courts of Nubia in the north and Alwa in the south, while the Melkites seem to have succeeded only in the middle kingdom, Makurra (which at some later date seems to have been merged with Nubia in a single state ruled from Dongola). Ethiopia, having been converted by Egyptian and Syrian missionaries, also followed the Monophysite path.

By the fourth and fifth centuries, in Africa as in Europe, Roman power was already shrinking. In Africa the process was hastened by the introduction of the camel from Asia during the early centuries of the Christian era. In the hinterland of Tunisia and Tripolitania, there emerged an ominous new grouping of the nomadic Berbers of the Saharan steppes. These were the Zenata, and it is possible that they gained some of their new political coherence from the assimilation of some traits of Judaism. It is certain that they quickly appreciated the opportunities offered by the camel for the development of a predatory life based on the dry fringes of the desert, from which they were able to raid the settled communities of the Roman provinces. As a result, the area under ordered administration decreased, and the whole trend of the preceding Carthaginian and Roman periods was reversed. Nomadic pastoralism began to expand, at the expense of sedentary agricultural civilization. This incipient disintegration was hastened by the invasion of North Africa from Spain by the Vandals in the fifth century and its subsequent reconquest by the Byzantines in the sixth. The Vandals, a Germanic tribe who were Arian Christians, were at first welcomed by the Donatist Berbers as deliverers from Roman oppression. But their coming initiated a period of religious persecution and civil anarchy which continued into the Byzantine period, to the advantage of none but the camel nomads.

The decay of the old Roman empire marks the beginning of the end for the 'Mediterranean period' of North African history, and this is the point at which to consider briefly how significant it was for Africa south of the Sahara. It must first be emphasized that neither Carthaginian nor Roman rule ever reached

across the desert. The Carthaginian empire was not territorial, but commercial and maritime. The enigmatic account which has survived of the voyage of Hanno in the fifth century B.C. suggests that the Carthaginians at least prospected the possibilities of trade southwards down the Atlantic coast of Africa. Interpretations of the extent of Hanno's voyage vary widely; but it is clear that in general the Carthaginian galleys were unsuitable for Atlantic navigation, and this, combined with the long barren coastline of the Sahara, prevented the extension of their regular pattern of trade and settlement anywhere south of Morocco. The Romans, if only because of their need to defend their territorial empire against the nomads, were concerned with the northern parts of the Sahara. But the evidence is that the oasis of Djerma (the ancient Garama) in the southern Fezzan marks the extreme limit of their direct occupation.

There can be no doubt, however, that indirectly the two worlds of the Mediterranean and the Western Sudan were in touch throughout ancient times. The size and evident prosperity of the Roman city of Leptis Magna, close to the modern Tripoli, can best be explained by supposing that it lay at the head of a major trans-Saharan trade-route running southwards through the Fezzan. It has similarly been suggested that the Carthaginian settlement of Lixus, on the Atlantic coast of Morocco, was the terminus of a trade-route across the Mauritanian desert. Herodotus, writing in the fifth century B.C., reported that the Garamantes, the Libyan Berber pastoralists of the Fezzan, were in the habit of raiding the 'Ethiopians', that is to say, the Negroes, in four-horse chariots. His report is amply proved by the discovery in recent years of numerous rock-drawings of horse-drawn vehicles, aligned essentially in two bands running across the desert towards the great bend of the Niger, one from the Fezzan and the other from southern Morocco. These bands correspond to two of the major caravan routes of later times, when wheeled vehicles had been superseded in the Sahara by riding and pack animals, the camel especially. Chariots would have been used for raiding, not trading, but the one can easily lead to the

other. Moreover the distribution of the drawings does tend to confirm that the contact they represent led to the emergence of major trans-Saharan trade routes focusing on Leptis Magna and Lixus.

The agents of this contact were undoubtedly the Berber pastoralists of the desert. The Berber contact with the Negroes was a very old one, which long antedated the Mediterranean civilization. It had probably been continuous since the wet phase of the sixth and fifth millennia B.C., when the Sahara was grassland and some Negroes were living in it along with Caucasoid peoples. The subsequent gradual desiccation, however, meant that these Negroes tended to move towards fellow Negroes further to the south, leaving most of the Sahara to the Berber nomads, though residual Negro farming populations remained in the oases and in Tibesti. Trade would have been a natural consequence of the different environments and ways of life enjoyed by the Berbers and the Negroes. Out of the more southerly pastoralists' contacts with their northern brethren, who moved their herds seasonally towards and away from the zone of Mediterranean agriculture and civilization, really long-distance trade across the desert could evolve. As in historic times, the main exports of the western Sudan would have been gold and slaves, ivory, ostrich feathers, and hides. A principal import would have been salt, a necessity rare in the Sudan but readily obtainable in the Sahara. It is particularly significant that both of the ancient chariot routes led to that part of the Sudan where there were deposits of alluvial gold, which the Negroes were certainly working by the beginning of the Islamic period, and which they were presumably working many centuries earlier.

Ghana, the earliest of the 'Sudanic' states known to history, lay just north of the gold-bearing river valleys of the upper Niger and Senegal, a region which became known to the Arabs as Wangara. When exactly Ghana came into being is not known, but al-Fazari's statement that it was known in Morocco as 'the land of gold' suggests that both Ghana and its links with North Africa were well established by the time he was writing, in the eighth century. It is certain that the wealth of Ghana, and of its suc-

cessor empires in the western Sudan, stemmed from its control of gold exports to the north and of the distribution of salt and other imports in the south. Trade was thus a vital element in the development of these states.

It would seem, moreover, that the northern influence was not always limited to trade. It is unquestionable that the bulk of the population of ancient Ghana were Soninke, northern members of the great Mande-speaking group of Negro peoples. By the eleventh century at least, and probably much earlier, its kings were equally Negro. But chronicles compiled from traditional sources by Sudanese scholars in seventeenth-century Timbuctu report that the first kings of Ghana were what they called 'white men' from the north. This story is not an isolated one. Thus the legends of the origin of the Hausa of Northern Nigeria, and, less clearly perhaps, those of Kanem-Bornu to the east and of the Songhai to the west, suggest that their states were the results of immigration from the north, from the desert, as well as from the east, from the direction of the Nile valley.

A definitive interpretation of these and other comparable legends is not easy at the present time, when there is little positive archaeological evidence available. But two points must be considered: first, the nature of this northern influence; and, secondly, the question of its relation to the development of the 'Sudanic' states in West Africa.

It may be said at once that although the growth of trade with the Mediterranean was important for the states of the West African savanna, and particularly so in the extreme west, the cultural influence which entered from the north was not Mediterranean but Berber. While economic currents generated by the Mediterranean civilization crossed the desert, generally speaking the Mediterranean culture did not extend beyond the limits of agriculture in North Africa. Indeed the general effect of the expansion of Mediterranean civilization was to intensify the traditional distinction between the sedentary Berbers of the plains and valleys of North-West Africa and the nomadic Berbers of the steppes and desert. This distinction was further enhanced by the introduction of the camel and by the coming of Islam. By the

beginning of the Muslim period, the Berbers of the desert were becoming recognizable as the people now known as Tuareg. Their tribal links with the sedentary Berbers were still evident; thus the Arab historians recognized both the western Tuareg and the sedentary Berbers of the Kabyles in eastern Algeria as members of the Sanhaja tribal group. But the Tuareg retained the matrilinealism which was being extinguished in the settled areas, and they alone retained (or perhaps developed) the indigenous Berber script, Tifanagh. While both the social and the political organizations of the sedentary Berbers were fundamentally democratic, those of the Tuareg were hierarchical, with distinct castes of nobles, vassals, and slaves. A major distinction of the nobility was that its menfolk were veiled, never revealing their faces below the eyes; and its principal criterion was birth, with children by non-noble women excluded. The slaves – the cultivators and artisans of the oases – seem always to have been Negroid. With the passage of time the vassal class seems to have become increasingly Negro also.

Today the Tuareg survive only in the central Sahara, roughly in the triangle Ghadames – Timbuctu – Air. On either side of this triangle the desert tribes have been Arabized. Before this occurred, however, there can be no doubt that the tribes to the west, the *mulethlemin* or 'veiled Sanhaja' of the early Arab historians, were Tuareg. It is probable that the Zaghawa tribes dominating the eastern Sahara were fundamentally not dissimilar, though distinguishable from the other desert tribes because their proximity to the Nile valley seems to have occasioned some degree of influence from its civilization and its divine kingship.

It is evident that when the legends of the western and central Sudan ascribe the origins of their dynasties to northerners, it is to ancestors of the Tuareg or to the Zaghawa that they refer. Thus we are told by al-Bakri in the eleventh century that the royal succession in ancient Ghana was matrilineal (though the name he gives for the king in his day seems certainly a Soninke one). Evidence of matrilineal influence may also be found in traditional Bornu dynasties, while some of the Hausa legends of origin even suggest something approaching an early period of

royal matriarchy. A residual veil survives as a distinguishing mark of the nobility of Hausaland and Bornu, while Bornu tradition states that between about the eleventh and the thirteenth centuries, when the state was centred in Kanem, their kings took care to marry only noble women from the north.

In fact it is clear that for centuries pastoral tribes from the Sahara, whose culture was essentially Libyan-Berber, were drifting into the western and central Sudan. It is likely also that on more than one occasion their warrior nobility, toughened by desert living, and controlling the supply of camels and good horses, were able to seize political power and to found important dynasties. But this is a very different thing from arguing, as some European writers have done most persuasively, that kingship in the western and central Sudan originated from a patron and client relationship between 'white' pastoralists and black peasants.

Kanem-Bornu and Hausaland have in effect two separate sets of traditions for the origin of their states. From these it may be deduced that desert pastoralists infiltrated into a land whose Negro peoples were already organized along divine kingship lines though their kingdoms would seem to have been of small size. Military superiority and their initial independence of local ties helped the newcomers to enlarge the scale of political organization, but culturally they could not escape becoming submerged in the earlier tradition of Sudanic kingship with its agricultural and (in this case) highly urbanized society. A similar pattern can be made out for the Yoruba to the south-west (whose society is also highly urbanized), and also, though less clearly, for the Songhai on the Niger to the west. Further west still, it would appear that the Mossi-Dagomba states of the upper Volta basin were founded by men in whom the two traditions were already fused.

As far west as ancient Ghana, however, the picture may well be different. We know little of ancient Ghana other than the accounts given of it by Arab authors towards the end of its history. If, for instance, one looks in al-Bakri for evidence of divine kingship, it can be found, as has been seen. But there is a marked difference between Arab accounts of Ghana and of Kanem. It is

not only al-Muhallabi who stresses the divine kingship element
in Kanem. Right up to Maqrizi in the fifteenth century, the
strange nature of the Kanem monarchy continues to be a domi-
nant theme in the Arab writings. The emphasis for Ghana, or for
that matter for its successor state of Mali, which was better known
to the Arabs, is quite different. The Arabs who wrote about
Ghana were quite as much impressed by its commercial wealth
and its links with the north by way of the desert Sanhaja as they
were by its pagan constitution. Thus Ibn Hawqal in the tenth
century remarks that he saw a draft made out by a Sudanese
merchant to a colleague in Morocco for the equivalent of as much
as 20,000 gold sovereigns. Al-Bakri gives details of the tolls levied
by the Ghana king on the salt, copper, and general merchandise
entering or leaving his country.

It is possible that this is no more than a Muslim view of a
state that had already been subjected to at least two centuries of
Muslim influence. Al-Bakri, for example, remarks that most of
the Ghana king's ministers were Muslims, and tells us of the
large stone-built Muslim city, with its twelve mosques, close by
the mud-built native capital. On the other hand, however, the
evidence suggests that the kings of Kanem became Muslims
before those of Ghana. It seems, in fact, as though the differences
observable between the Arab assessments of Ghana and of
Kanem were due to the much greater strength of pre-Islamic
northern influences in Ghana. Indeed, the chariot-drawings in
the desert provide considerable evidence of the great antiquity of
the western-most Sudan's contacts with the Saharan peoples,
attracted doubtless by its gold. Such an attraction did not exist
further east, and it would seem that the Saharan influences did
not enter the central Sudan until after its Negro kingdoms were
well established. But as far west as ancient Ghana, it would
seem that the type of state which had emerged by the tenth
century may have represented a more even balance between
Sudanic and Saharan traditions.

6 The Arab Empire in Africa

In A.D. 639, the first Muslim Arabs entered Egypt. By the begin-
ning of the following century they had overrun all Africa north
of the Sahara and were invading southern Europe. North Africa
was severed from the Mediterranean influences of the previous
fifteen hundred years of its history, and within a few centuries
its peoples had become firmly part of the new world and culture
of Islam. This first wave of Arab conquest did not cross the
Sahara. Arabs did not begin to penetrate the desert in the east
until after the collapse of the Nubian Christian kingdom of Don-
gola in the fourteenth century. In the west the Arabs did not
begin to enter the Sahara in significant numbers before about the
twelfth century, and the western Sudan was never theirs. But if
the Sahara served as some check to actual conquest, the religion
and culture the Arabs had brought spread persuasively from the
firm base established in North Africa deeply into Negroland,
so that the whole Sudan eventually became part of the Islamic
world.

The seventh-century Arab invasion of Africa was one of a
series of great outpourings of peoples from Arabia into the neigh-
bouring lands, which had occurred at intervals throughout his-
tory. The ancestors of both the Phoenicians and the Jews had
been part of one of the earlier emigrations. The fundamental
cause of these movements was over-population, since except for
its south-eastern fringes the greater part of Arabia is desert. The
seventh-century emigrants in fact were typically Bedouin, that is
desert Arabs. Some of these could supplement their meagre pas-
toralism by carrying or harrying the trade passing between the
horns of the Fertile Crescent which enfolded the desert to the

north, or by mercenary service in the armies of the empires that arose there. Periodically, however, the desert became too small to contain the numbers and the jostling energies of its tribes, and they would overflow to join in the exploitation of the lands of the Fertile Crescent and to contribute to its population.

The particular outpouring of peoples from Arabia which began in the seventh century was notable not only because it was to reach further afield than usual, but also because it launched Islam as one of the great world religions. Few single sentences can have had a greater impact on world history than the message preached by Muhammad to the Arab tribes between A.D. 622 and 632, the message which became the foundation of the Muslim creed – *lā ilāha illa'llāh muhammadun rasūlu'llāh:* 'there is no god but God; Muhammad is the Messenger of God'. In the doctrine of the one God and the paramountcy on earth of his Messenger, the Arabs found a brotherhood to transcend the divisions and conflicts among their tribes; and the Koran, the direct revelation of God to Muhammad, crystallized and symbolized a belief that Arabic was a perfect vehicle for the expression of true knowledge, wisdom, and beauty. Islam canalized the energies of the Arab tribes, and enabled them to explode into the outside world with a vital new unity of purpose.

Shortly after the death of Muhammad in 632, Arab bands began a series of increasingly bold excursions into the territories of the two great world empires of the time, Byzantium and Sassanid Persia. These may at first have been no more than raids, but the desert warriors quickly appreciated their ability to defeat even the greatest military concentrations that could be brought against them. The Byzantine and Sassanid armies had superiority in numbers, in arms, and in technical organization, but their conscripts could not match the compelling inspiration Islam had brought to the Arab tribesmen. Moreover, the imperial lines of communication were dangerously exposed to the hardy mobility which desert life had engendered in the Arab tribes. The Arabs who had come to raid and plunder stayed to rule and exploit in the name of Allah and his Messenger. The *jihad*, the war against the infidel, became almost as much as prayer, alms-giving, fasting,

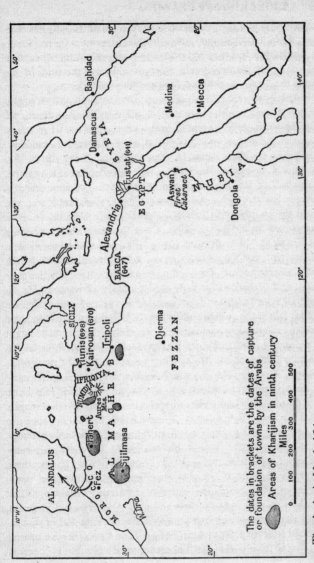

The dates in brackets are the dates of capture
or foundation of towns by the Arabs

⬮ Areas of Kharijism in ninth century

Miles

0 100 200 300 400 500

5. The Arabs in North Africa

Baghdad

Damascus

SYRIA

Medina

Mecca

Fustat (641)

EGYPT

Aswan
First
Cataract

NUBIA

Dongola

Alexandria

BARCA
(647)

Djerma

FEZZAN

Tripoli

SICILY

Tunis (698)

Kairouan (670)

IFRIQIYA

NUMIDIA

Aures
Mts.

AL MAGHRIB

Tahert

Sijilmasa

AL ANDALUS

MOROCCO

Fez

Wadi Draa

pilgrimage, and the profession of faith in Allah and his Messenger, a binding obligation upon the true Muslim.

Once Syria had been overrun (634–6), a permanent occupation of the fertile wealthy lands on either side was feasible. In the east, the Arabs conquered Mesopotamia and Persia, and were ultimately to reach the Indus and the Oxus. In the west was Egypt, whose wealth made it a natural target. Furthermore, the Arab position in Syria and in Arabia itself could not be secure so long as Byzantine forces, supplied by sea through Alexandria, remained on their flank. In 639, therefore, 'Amr ibn al-'As, jealous of the victories and profits won by other Arabs in the east, came with a few thousand men to prospect. The conquest was simple, for the Byzantine rulers of Egypt, aliens exploiting the land and people for their own and their empire's profit, were not supported by the native Copts. Once the main Byzantine army in Egypt had been defeated (640), 'Amr was able to conclude a treaty with the Copts, who agreed to pay regular taxes to the newcomers in return for freedom to practise their Christian religion, and protection for their goods, lands, and water-rights. In 641, Babylon, the great Byzantine fortress at the head of the Nile delta, fell to the Arabs, and in the following year the Byzantine forces evacuated Alexandria. This great city, the capital of Egypt for nearly a thousand years, was too Hellenistic, Mediterranean, and maritime for the Arabs. They began to build a new capital, Fustat, close by Babylon, which lay at the heart of Egypt's agricultural wealth and which also was more accessible from Syria and from the Arabian desert where lay the source of Arab strength.

With lower Egypt firmly in their hands, the Arabs soon re-established the historic southern frontier at the first cataract, garrisoning Aswan against Nubian raids. To check this nuisance, an expedition was sent into Nubia in 651–2. The northern Nubian capital at Dongola was bombarded, but the Arabs then quickly concluded a treaty with the Nubians. Their own historians indicate their respect for the Nubian bowmen, and the terms of the treaty suggest that as long as Nubia continued to act as Egypt's source of gold and slaves, the Arabs were prepared to let well alone. The treaty, which eventually governed

the relations between Egypt and Nubia for some six centuries, did not make Nubia tributary to the Arabs. Nubia was to send to Egypt 360 slaves a year, and to guarantee freedom of access and of worship to Arab traders, while in return the Arabs agreed to respect Nubia's independence and to supply its requirements of foodstuffs, cloth, and horses.

The Arab attitude towards the lands in the west, *al-Maghrib*, took longer to define. Cyrenaica was soon overrun, but five hundred miles of waterless desert intervened between its western border and the cultivated and civilized plains of Tunisia, a dangerous advance even for the Arab camelry, particularly while the Byzantine fleet survived to command the narrow road along the coast. Furthermore, as early Arab raids revealed, the temper of the Berber tribes was very different from that of the Egyptians. The conquest of the Maghrib entailed more than merely defeating Byzantine armies. As Donatism had shown, many of even the sedentary Berbers were still hostile to foreign interference, and behind them there were the nomad pastoralists, ready to take advantage of any slackening of government in the agricultural lands. In the Zenata, indeed, the Arabs faced a foe comparable to their own Bedouin in hardiness and mobility and in the tenacity with which they would fight to maintain their tribal integrity. This is probably the explanation of a story told by 'Abd-al-Hakam, the earliest (ninth century) historian of the Arab conquest of North Africa. Following his Egyptian success, 'Amr ibn al-'As apparently suggested to the Caliph 'Umar that he should continue his conquest westwards into Ifriqiya (the Arabic version of the old name 'Africa'). But 'Umar is said to have replied 'This country should not be called Ifriqiya, but rather "the treacherous land beyond the frontier". So long as I am alive, I forbid that anyone should go near it or make an expedition against it.' Ultimately, it was a nephew of 'Amr's, 'Uqba ibn Nafi', who took the first effective step towards the conquest when, in 670, he established in southern Tunisia, an advance base for further operations, Kairouan. But when, in 681–3, he ventured out on a long expedition further to the west, he and his men were trapped and overwhelmed by a coalition of

sedentary Berber tribes. For a time Kairouan was lost, and the
Arabs suffered a further disaster when the Byzantine navy
landed troops to cut the coast road from Egypt. By the end of the
century, however, both the sedentary tribes and the Byzantine
armies had been overcome. With the eclipse of Byzantine naval
power by the new Arab navy,[1] Carthage was captured, and the
new Arab city of Tunis began to rise in its place. Hitherto the
pastoral Berbers had stood aloof from the fighting, doubtless
hoping to benefit from its aftermath. But the tribes of the Aures
mountains had combined together under a redoubtable woman
leader known as Kahina ('the priestess'), and shortly after the
capture of Carthage in 695 they swept down against the Arabs
on the plains below. Much bitter fighting was necessary before
the Arabs were again in control. Not until 705 was it finally
possible for them to incorporate Ifriqiya, the most settled and
valuable of the North African territories, as a regular province of
their empire. But only in the Tunisian plains, which the Arabs
now ruled from Kairouan, with their long tradition of agriculture
and settled government descending from Carthaginian times,
was the situation at all comparable to that in Egypt. Numidia,
always a centre of opposition to alien influences, continued to
resist assimilation for many centuries. Elsewhere in the Maghrib,
however, many Berber tribes must have surprised the Arabs by
the facility with which they took to the faith and enthusiasm of
Islam, quickly grafting it on to their ancient beliefs, fundamen-
tally pagan but already prepared for Semitic monotheism through
the ancient influence of Phoenician Carthage and centuries of
Judaic and Christian infiltration. The Muslim conquest of the
Iberian peninsula, begun in 711, which was to round off the con-
quest of the Maghrib, was undertaken as much by Berbers as by
Arabs.

By this time, however, the Arab empire, in Africa as elsewhere,
was beginning to suffer strain. It had been begun in the first
flush of enthusiasm occasioned by the rise of Islam; but once the
Arabs started to settle down and to enjoy the fruits of their

1. The need for this had been evident to the Arabs in 645, when the Byzantines'
command of the sea had enabled them to reoccupy Alexandria for a short space.

conquest, their basic tribal divisions and animosities began to reappear. Sometimes, indeed, these were magnified by the larger stage on to which they had been projected. Islam was no longer the unifying force that it had been at its outset. Differences of opinion arose naturally enough when after the death of Muhammad it became necessary to define his teaching. Moreover, since Islam had become a world empire as well as a world religion, Muhammad's death also occasioned disputes over where power in the Islamic community should reside and how it should be passed on.

Some of these early divisions within Islam became of considerable significance in Africa, but a full explanation of them lies outside the scope of such a brief history as this and belongs properly to works primarily concerned with the beliefs and history of Islam.[1] Here only the crudest of outlines can be given. At first, then, Islam was governed by four 'orthodox' Caliphs who had been among the original Companions of Muhammad. The third of these, 'Uthmān, was weak and nepotic, and resentment against him arose on several sides. 'Uthmān was murdered in 656, and his successor, 'Ali, who had married Muhammad's daughter Fatimah, never won complete acceptance. In particular he was opposed by the governor of Syria, Mu'āwiya, and his army. In 657 Mu'āwiya tricked 'Ali into an arbitration of their differences. The result was unfavourable to 'Ali, and from 659 Mu'āwiya was effectively Caliph, establishing the Umayyad dynasty which ruled Islam from Syria until 750.

While most Muslims, the orthodox Sunnis (though divided into a number of schools on matters of interpretation) accepted the Umayyad succession, two major groups stood out against it. These were the Shi'ites and the Kharijites. The Shi'ites were originally no more than the political supporters of 'Ali. Among them, however, there eventually developed a doctrinal basis for their opposition to the Umayyads – the idea that the rightful rulers of Islam could only be Muhammad's lineal descendants through 'Ali and Fatimah (hence the terms 'Alids' and 'Fati-

1. The interested reader might begin with H. A. R. Gibb's *Mohammedanism* and Bernard Lewis's *The Arabs in History*.

mids'). Following the Umayyad victory, Shi'ism went under-
ground and became increasingly mystical, claiming that 'Ali's
descendants, though denied temporal power, were 'hidden *Im-
ams*', retaining true spiritual supremacy. Some Shi'ites, indeed,
borrowing perhaps from Christianity, developed the doctrine of
the Mahdi, the great leader who would manifest himself in due
time to prepare for the day of judgement. The Kharijites were
'the seceders', a group of nomad tribesmen who were also
originally supporters of 'Ali, but who broke away because they
rejected the process of human arbitration by which he was
superseded as an action contrary to the will of God. Kharijism
thus came to represent a puritan fanaticism, which Islam as a
whole has rejected, but which has often attracted closely-knit
tribal groups within it.

In the middle of the eighth century, the Arab empire experien-
ced a second great crisis, which ended in the replacement of the
Umayyad Caliphs by the Abbasid dynasty. The Abbasids ruled
not from Damascus, the strategic heart of the empire in Syria,
but from a new city, Baghdad, built in one of its richest provinces,
Mesopotamia. Firmly based on Mesopotamian agriculture and
commerce, the Abbasids brought the empire to the peak of its
civilization and sophistication. But in the process, while remain-
ing Muslim, it ceased to be exclusively or, in time, even pre-
dominantly Arab. Exploitation rather than conquest now pro-
vided the basis of wealth; power now lay not with the Arab
tribes but with professional soldiers and administrators, who
were usually chosen from among the Turkish slaves of the
Caliphate.

The eastward shift of both the centre and the spirit of the
empire had significant results in Africa. The western provinces
began to break away. Spain was never effectively part of the
Abbasid domains; from 756 it had an independent Umayyad
government of its own. In the African Maghrib, independently-
minded Berber groups began to make use of the divisions in
Islam to express their own particularisms. Many of the tribes on
the borders of the settled country, pastoralists and traders with
the Sudan, became Kharijites. In this way they could be at once

Muslim and independent of external authority, much as earlier Berbers had found in Donatism a way of being Christian without being Roman. Around Sijilmasa, the great caravan centre in southern Morocco; to the south of Tripoli and Tunisia; and above all, perhaps, around Tahert in the central Maghrib, Kharijite communities and even states flourished during the eighth and ninth centuries. Some Berbers went even further, and made use of rifts in the Muslim and Arab firmaments not merely to mark a negative tribal independence, but to develop larger intimations of statehood. Thus an Alid refugee, Idris ibn 'Abd Allah, was accepted as Imam shortly after 788 by a Moroccan Berber tribe, and with its support began to carve out a sizeable kingdom in the western Maghrib. Although the Idrisids failed to establish a lasting dynasty, the forty years of their rule provided Morocco with its first native capital city, Fez, and sowed a seed which was later to germinate into the idea of a united Moroccan kingdom.

The political changes in Ifriqiya and in Egypt were less startling. Arabs continued to rule in Ifriqiya, but in 800 the governor of the day succeeded in making his post hereditary within his family, the Aghlabids, who became independent of Baghdad in all but name. The situation in Egypt was more complex. Here the governorship became the perquisite of Turkish favourites at the Abbasid court. By the end of the ninth century, however, the nominees whom these favourites sent to govern in Egypt had tired of passing on its surplus revenues to their masters in Baghdad. They began to convert them to their own use, developing the splendid new palace-city of al-Askar alongside the older Fustat, and building up an army of Turkish and Negro slaves with which they sought to establish personal empires in Syria and the Hejaz and to withstand the armies of Mamluks (Turkish slaves) sent against them from Baghdad. By 935, Egypt had been finally lost to the Abbasids, but it can hardly be said that the Egyptian people had thereby gained their independence. They remained subject to the rule of foreigners, for whom the good governance of Egypt and the proper development of its resources were apt to be overshadowed by the struggle to maintain their position against threats from Asia and the attentions of rivals jealous of

their power at home. In the event they proved incapable of estab-
lishing a régime able to survive the ambitions of its slave ministers
and generals. The Tunisians, on the other hand, were more for-
tunate. The Aghlabids were able to keep power firmly in their
own hands and those of their Arab kinsmen. As a result they were
able to reconstruct much of the agriculture and the economic life
they had inherited from Rome, within a new Islamic frame
which, though never as splendid as that of Egypt, nevertheless
possessed a distinct intellectual brilliance of its own.

Although the Arab conquest of northern Africa did not give
rise to a lasting political empire, it nevertheless wrought a remark-
able and permanent social change. Christianity, the last and
greatest legacy of the Mediterranean civilization, both as a reli-
gion and as a way of life, had been eclipsed by Islam. In Egypt,
Christianity managed to survive as the religion only of a minority
living in an entirely Muslim world, but in the Maghrib its eclipse
was total. Some explanation of this lies in the very partial assimi-
lation of Christianity by the tribal Berbers. With them, the
Christianity which succumbed to Islam was as much a set of local
religions as it was part of the universal Church. But this cannot
explain its disappearance in the towns, especially since the
Jewish communities there did manage to retain their identity. It
is clear that the cause of Christianity had been weakened by the
Donatist schism and by the ensuing persecutions, first from the
official Roman church, then from the Arian Vandals, and finally
from Byzantine orthodoxy. Possibly the persecutions helped to
destroy the native Donatist church without strengthening the
position of the Catholics.

Certainly the position in the Maghrib was in strong contrast
to that in Egypt, where the people were so accustomed both to
Hellenistic influences and to alien oppression that once they were
presented with the opportunity of having a church of their own,
they took to it wholeheartedly. The Coptic church became an
integral part of the popular life and the channel through which
a new national language was fashioned out of the ancient Egyp-
tian tongue. The term 'Copt' in fact was synonymous with
'Egyptian'. Both materially and intellectually the Coptic church

was poor compared with the official Byzantine church, but it was the latter, not the former, which virtually disappeared following the Arab conquest. If the majority of the Egyptians eventually became Muslims, this was less the result of the failure of their church than of the pressures to which they were subjected. Deliberate persecution was at most intermittent; perhaps Christianity would have been stronger had there been more. But the majority of the Copts could not withstand the steady stream of Arabs, soldiers and clients of the innumerable governors, sometimes whole tribes, which flowed into Egypt from nearby Syria and Arabia. Inevitably more and more Copts became in one way or another involved in the new régime. Finally, during the Abbasid period, when to be an Arab was no longer to be automatically a member of the conquering and ruling caste, the greater part of the Copts began almost imperceptibly to fuse with the Arab settlers into the modern Egyptians, Arabic in speech and Muslim in faith.

Only a sturdy minority of Christians remained as evidence that for centuries all Africa north of the Sahara had partaken of Mediterranean civilization. Now the southern fringes of the old Mediterranean world were firmly part of the new world and culture of Islam. In the Maghrib, the way of the Arabs and Islam had been prepared by Phoenician Carthage. In outlook and language the Arabs were closer to the Berbers than the Greeks or Romans could ever be; they were therefore more capable of enfolding them in their own civilization. The civilization of Islam thus became much more deeply rooted in North Africa, and much more capable of expanding southwards into Negroland, than had been that of the Mediterranean. All the same, within the Muslim culture of North Africa there were still elements of the Mediterranean civilization. The Arabs themselves had learnt much from the Mediterranean empires they had overrun, particularly in Egypt, and the agents for the expansion of Islamic culture to the south were not so much Arabs as Muslims who had been Mediterranean North Africans.

7 Northern and Western Africa during the Great Age of Islam

The greatest achievements of Islam in Africa came after the break-up of the Arab empire. Indeed, they dramatically reveal the ability of African peoples to assimilate and develop for their own purposes a set of new ideas of world-wide significance. The period from about A.D. 800 to about 1300, when Islamic civilization was unrivalled anywhere in the world for the quality of its thought, art, science, and government, was also a time in which there flourished some of the most notable of all African states. The North African Berbers played a major part in the history of the western world and of nearer Asia, while behind them, south of the Sahara, lay some of the greatest and most magnificent of all the 'Sudanic' kingdoms, where Islam also had a significant role to play.

For the origins of these dramatic developments, it is necessary to go back to the major schisms in Islam. It must be appreciated that the Abbasids had risen to power with Shi'ite support, but that once they had established themselves as Caliphs of all Islam, they had kicked away this ladder in the fear that others too would seek to climb it. The Shi'ites who survived their persecution naturally redoubled their clandestine efforts against the establishment. At the end of the ninth century, one of their missionaries was sent from the Yemen to the Maghrib. There he was so successful among the Kutama, a Berber tribe of the Kabyles who had always been hostile to settled administrations, that Ifriqiya was overrun and its Aghlabid government overthrown. The Mahdi of the time soon arrived from the Yemen himself to exploit the situation. In 910 his proclamation as Caliph made it clear that he wanted much more than the leadership of a mere Berber tribal

movement. The aim of the Fatimids, as the new dynasty was called, was nothing less than the mastery of all Islam. To aid in this purpose, the Fatimid capital was soon moved from Kairouan to the eastward-looking coastal fortress of Mahdiya. Early expeditions against Egypt, however, proved premature. In order to secure a military and naval power sufficient for their purpose, the Fatimids needed to compel the support or the quiescence of the tribes throughout the Maghrib, and in this the Kutama were the first to suffer. Egypt was at length conquered in 969, and shortly afterwards both Syria and the Hejaz, the homeland of Muhammad, acknowledged the Fatimid Caliph, Al Mu'izz, who in 973 arrived at al-Kahira (Cairo), the new capital built for him alongside al-Askar and Fustat. The move was clearly meant to be permanent, for Al Mu'izz brought with him not only his court and treasure, but even the coffins of his ancestors.

The Arab conquest of the Maghrib had now been spectacularly reversed. Not only were Berber governors and soldiers ruling Arabs in Syria and even in parts of Arabia, but Berber merchants for a time took an important part in the Levant's trade with further Asia. All the same, there was to be no united Berber empire of North Africa. Fatimid Caliphs continued, at least in name, to rule in Egypt until 1171, but, as will be seen, Egypt and the Maghrib soon parted company. Under the Fatimids and their successors, especially the Ayyubids, Egypt entered upon one of the more glorious periods of her history. The revenues of the state were efficiently organized; trade flourished, with markets and shops renowned for their organization and for the excellence of their goods; and Cairo developed into a royal city in which the Caliph had some 20,000 well-built brick houses to let. One of the most notable buildings was the new mosque of al-Azhar, under the arches of which a great theological school was to develop. If the heterodoxy of the Shi'a Caliphs initially somewhat discouraged scholarship, it proved a great stimulus to literature and the arts, bringing in rich influences from Persia and Byzantium.

Although the power of the Fatimids rested largely on African troops, initially Berbers from the Maghrib, and later Negroes from the Sudan, theirs was essentially an oriental régime

embroiled in the affairs of nearer Asia, as was inevitable with their claim to supremacy throughout the world of Islam. This was ultimately to prove their undoing, both for internal and for external reasons. Internally the Fatimids withdrew within their own rich world of Cairo, entrusting the exercise of power to viziers and generals who were often recruited from Asia. Ultimately one of these, the great Salah ad-Dinn Yusuf ibn Ayyub (Saladin), a Kurd, was to take the title as well as the reality of power, initiating the new dynasty of the Ayyubids. Externally the Fatimids' main preoccupation was with Syria, a part of their empire which was never secure. The people were hostile to Shi'ism, and at first there was danger from Byzantine armies seeking to reconquer their empire. Syria was then invaded by the Seljuq Turks, who swept over the old Islamic empire from the east, took Baghdad in 1055, and entered Damascus in 1076. Finally, in 1096, the European Crusaders appeared on the scene. Ultimately Syria became a separate Muslim state controlled by the armies of Turkish or Kurdish generals who were Sunnis. These naturally sought to control Egypt also, especially when the Crusaders tried there to turn their southern flank.

Saladin first came to Egypt as the lieutenant of one of these Syrian kings. But he was able to win the confidence of the Egyptians in a way that his Shi'a predecessors had never done, and under the Ayyubids the cultural movements initiated by the Fatimids reached their greatest glory. But he spent most of his reign campaigning outside Egypt, in Syria and elsewhere, and the régime he inaugurated confirmed that Egypt's main service to Africa was one of shielding the continent from foreign invasion. The Ayyubids lasted only until 1250, but their role was more than adequately assumed by the Egyptian Mamluks, a remarkable self-perpetuating military aristocracy recruited from the slave markets of central Asia. Originally mainly of Turkish descent, though later possessing a dominant Circassian element, the Mamluks gave an appearance of legitimacy to their régime in 1261 by inviting an Abbasid refugee from Baghdad to set up as Caliph at Cairo. This puppet Caliphate remained in Egypt until after the Turkish conquest of 1517. Under Baybars (1260–77)

and Kala'un (1279–90), the Mongol hordes were kept away from Africa and the Crusaders were finally expelled. Egypt reached a peak of military power not to be approached again until the time of Muhammad Ali in the nineteenth century. From about the end of the fourteenth century, however, though the Mamluk régime maintained its outward splendour, its real power decayed. Their ceaseless struggles for office so occupied their attention that the irrigation and agriculture on which Egyptian wealth and power depended sank into ruin. Moreover, the country's role as a focus of international trade was severely damaged by Mamluk exactions and commercial monopolies.

In the Maghrib, the grand Fatimid conception of empire had held no meaning for the bulk of the Berber tribes, and did not survive the removal of the Caliph and his army to Egypt. The Sanhaja chieftain to whom Al Mu'izz had entrusted the vice-royalty soon declared his independence, but in so doing he lost control of his own homeland in the Kabyles to a rival branch of his family. The Fatimid answer to the emergence of these independent Sanhaja kingdoms was to send against them a number of Bedouin tribes who had been giving them trouble in upper Egypt. With the Banu Hilal at their head, the Bedouin began to arrive in the Maghrib in 1061. Their advent marks a new departure in the region's history. Hitherto the Arabs in the Maghrib had been a relative handful, a thin and essentially urban upper crust of the population, which had been increasingly permeated by the native Berbers. Though Islam had become the religion of most Berbers, and classical Arabic the language of education, culture, administration, and trade, the vast mass of the people were still tribesmen loyal to their own Berber dialects. But the Hilalian invasions were a mass movement of predatory, pastoral, and indeed primitive Arab tribesmen, who possessed little of the Islamic culture which had already made its mark on a Maghrib veneered by earlier civilizations. Ibn Khaldun, the greatest of Arabic historians, who was Tunisian born, described the Banu Hilal and the other Bedouin invaders as 'a swarm of locusts destroying all in their path'. The Sanhaja kingdoms were reduced to coastal principalities, and the civilization and agriculture of the

Ifriqiyan plains were severely damaged. A new lease of life was given to the Zenata, but as more and more Bedouin arrived, their tribes were penetrated and Arabized, so that Berber society began gradually to disintegrate from the east into a congeries of competitive quarrelsome Arab-Berber tribal groups. The Berber life which managed to survive in mountain strongholds like the Kabyles and the Aures was narrowly tribal in outlook. If the Maghrib were to be saved for civilization, it could only be from the west, from Morocco, where the Idrisids had already planted the idea of a larger Berber state. And here in fact a new initiative did develop, though not originally among the Moroccans themselves, but among some of the Tuareg of the western Sahara.

The early contacts between the Arabs and Islam, on the one hand, and the peoples of the Sahara and the Sudan outside the Nile valley on the other, are little documented. But during the Umayyad period, parties of Arabs had raided or reconnoitred into the Fezzan and to the south of Morocco. We know also that by the ninth century the Arabs had made contact with both Ghana and Kanem, and that two centuries later the Kanem kings became converts to Islam, almost certainly as a result of their links with Ifriqiya and Egypt. But before the Hilalian invasions, the Arabs in the Maghrib were not numerous enough to attempt direct control of the Sahara. Like the Romans and the Carthaginians before them, they tended to leave the desert and the direct responsibility for desert traffic to the Tuareg Berbers. By the eleventh century, however, in the western Sahara at least, Islamization had proceeded far enough among the members of the Sanhaja Tuareg tribal confederation which dominated the Morocco-Ghana caravan route to make it possible for them to give birth to a puritan revivalist movement. This was to have great consequences both in the Maghrib and in the western Sudan.

The traditional story related by Ibn Khaldun and other Muslim authorities starts with the pilgrimage of a desert Sanhaja chieftain to Mecca. This led him to appreciate the debasement of his people's Islam, and when he came home he brought a Muslim divine from near Sijilmasa, one Ibn Yasin, to undertake a reforming mission. The Sanhaja Tuareg at first did not take well

to Ibn Yasin's puritan principles. But after initial difficulties, he was able to train a religious and military élite capable of enforcing his disciplines throughout the confederacy. This was the beginning of the Almoravids (*al-murabitun*, 'people of the *ribat*'[1]). Once the Almoravid doctrine had been established among the Sanhaja tribesmen, they swept out from the desert to conquer both north and south. Ultimately the movement split. One wing, under Abu Bakr, struck south against the Negro empire of Ghana, and its fortunes will be followed later in this chapter. The majority, led ultimately by Ibn Tashfin, went north to Morocco and by 1069 had altogether overrun the region. They then continued east to the borders of the Sanhaja kingdoms in the eastern Maghrib. In 1086, Ibn Tashfin responded to an appeal for help from the Muslims of Spain, then hard pressed by the Christian *reconquista*, and by 1103 the whole of Muslim Spain was also under Almoravid control.

Significant though the religious impulse in the rise of the Almoravids undoubtedly was, the movement cannot be regarded simply as the triumph of a fanatical Islamic sect over effete Muslims in the Maghrib and pagan Negroes in the Sudan. It must be viewed in relation to the political and economic pressures enveloping the western Sahara at the time. Morocco was in a disturbed state. The Fatimid invasions, though militarily successful, had not really conquered the country, partly because of the innate hostility of the tribes to any alien rule, and partly because they had provoked intervention from the Umayyads of Spain. The real victors were neither the Fatimids nor the Umayyads, but the westward-moving Zenata nomads. The Zenata infiltration was significant in two respects. Firstly, much of their expansion was at the expense of Sanhaja chiefdoms in southern Morocco, and from these a call for help went out to their Tuareg kinsmen in the Sahara. Secondly, the coming of the Zenata disrupted the economy of the Moroccan terminus of the trans-Saharan trade

1. The normal meaning of *ribat* is a fortified monastery in which pious Muslims receive military as well as religious training. However, it seems doubtful whether in this instance there was such an establishment in any physical sense. *Al-murabitun* would therefore mean something like 'the body of men committed to the fight of establishing true Islam'.

which the Tuareg Sanhaja conducted. At the same time, these Saharan Sanhaja were being hard pressed by the growth of Ghana, which by the end of the tenth century had succeeded in imposing tribute on Awdaghost, their principal southern centre and trading entrepôt. Thus the ultimate response to Ibn Yasin's mission can be seen as a reaction to developments prejudicial to Sanhaja interests both in Morocco and the Sudan.

In the Maghrib, the Almoravid achievement was considerable. Presenting themselves as liberators of the people from corrupt rule, taxes unsanctified by the Koran, and alien Zenata invasions, they were able, from their new city of Marrakech,[1] to build up a magnificent and remunerative empire over the western half of the Maghrib. In so doing, however, they began to lose the simple faith and the military energy and cohesion of their desert days. They began to appear to many Moroccan tribes as foreigners restricting the liberties of the natives and fattening themselves on their tribute. The preachings of a southern Moroccan divine, one Ibn Tumart, against the Almoravids, claiming that in their later preoccupation with self-interested administration they were subverting the unique oneness of God, found ready ears among the Berbers of the Masmuda tribes scattered through the Moroccan Atlas. These were ancient foes of the Sanhaja, but had hitherto lacked unity. About 1125, Ibn Tumart established a *ribat* and proclaimed himself the Mahdi. The Almoravids failed to act against him swiftly or firmly, and the movement he had inspired, the Almohads (*al-muwahhidun*, 'monotheists'), gained increasing support among the mountain tribes hostile to the Sanhaja. By 1147, his successor, 'Abd al-Mumin, a Zenata, was installed in Marrakech as master of all Morocco, with the title of Caliph.

Although the Almohads soon superseded the Almoravids in Spain too, 'Abd al-Mumin appreciated that the greatest danger to his régime came not from the Christians of the north, but from the east. Here were Sanhaja states naturally hostile to his Masmuda-Zenata alliance, and here too was the insidious destruction of Berberdom by the advancing Bedouin. By 1159 'Abd al-Mumin

1. From Marrakech, incidentally, derives our word 'Morocco'.

had conquered as far east as Tunis and had brought the whole Maghrib under one Berber government. The Maghrib was now a major force in the Islamic and Mediterranean worlds. The Almohads created a professional civil service, which they recruited from the educated classes throughout the Maghrib, especially from Spain, while Marrakech, Fez, Tlemcen, and Rabat became beautiful and cultured cities. To pay for this and for their professional army and navy, they had the land throughout the empire surveyed and levied regular taxes on its assessed productivity. But in doing all this the Almohads were intensifying an already-apparent distinction between the original members of their confederation, who as it happened belonged mainly to the Masmuda and Zenata tribes, and all other Berbers. As their first reforming zeal began to be submerged in the legalities of an orderly administration, this distinction became increasingly dangerous. Despite their great achievements, then, the Almohads were unable to inspire any common idea of statehood among the multiplicity of Berber tribes, and this failure gravely weakened their attempts to deal with the major difficulties facing their empire: the maintenance of an orderly succession to power, the problem of Spain, and the menace of the Bedouin.

The problem of the succession reproduced in miniature the problem which had faced early Islam – was power to pass to the founder's Companions or to his descendants? 'Abd al-Mumin proved sufficiently strong and successful to set up a hereditary succession, and until 1213 the Almohad caliphs all proved capable rulers. But as a Zenata family they were bound by their very success to incur the enmity of most other Berbers. This became especially dangerous when the empire was threatened by renewed activity both from the Christians in Spain and from the Bedouin in the central Maghrib. In an attempt to deal with both threats at once, the caliph Muhammad an-Nasr (1199–1213) divided his government, appointing a viceroy from the Hafsids, one of the outstanding families in the Almohad administrative service, to command the east from Tunis. Unfortunately for the Almohads, however, the Hafsids were all too successful. The Bedouin were defeated, but the wars against them intensified the destruction of

the central Maghrib and extended it westward towards Morocco. Northern Tunisia, under the capable Hafsid administration, became an island of relative stability and prosperity cut off from the west. By 1230, an independent Hafsid monarchy had emerged, able to conclude commercial pacts with European trading states and to attract much of the trans-Saharan trade to its profit.

In the west, Almohad prestige suffered greatly from the resounding Christian victory of Las Navas de Tolosa in 1212, which marked the beginning of the end not only for the Moorish power in Spain but also for the Almohad régime in Morocco. Their kingdom disintegrated into its tribal parts, and in the confusion the Zenata nomads triumphed. One Zenata group, the 'Abd al-Wadids of Tlemcen, were by 1235 dominating the eastern approaches to Morocco. Another, the Marinids, based on the Saharan marches, gradually extended their power over the Moroccan heartland, finally establishing themselves at Marrakech in 1269 as the successors to the Almohads and what was left of their administration.

The great days of Berber empire were now over. The unity imposed on the Maghrib had now dissolved, and the three divisions which were to mark the rest of its history were already apparent. In the east, the well-established Hafsid kingdom continued until 1574, prospering from what could be recovered of Tunisian agriculture, and from its trade with southern Europe and the Sudan. In the west was Morocco, where first the Marinid dynasty and then the Wattasids (1465–1554) strove to secure the ideas of a central monarchy and a regular administration against the inroads of tribesmen from the mountains and steppes, and also against foreign invaders. In the centre lay what was eventually called Algeria, where the 'Abd-al-Wadids, themselves of nomad stock, and unsupported by the wealth or by the tradition of ordered government available in Tunisia or Morocco, proved quite powerless to check the almost complete destruction of civilized society at the hands of the Bedouin.

In the western Sudan, the Almoravids began to move against ancient Ghana about 1062. But they met with very serious

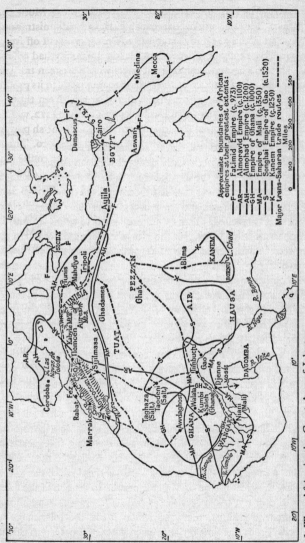

Approximate boundaries of African
empires at their greatest extent:
F—— Fatimid Empire (c. 970)
AR—— Almoravid Empire (c.1100)
AH—— Almohad Empire (c.1200)
GH—— Empire of Ghana (c.1000)
MA—— Empire of Mali (c.1350)
S—— Songhai Empire of Gao
K—— Kanem Empire (c.1250)
Major trans-Saharan trade routes ------

0 100 200 300 400 500
 Miles

6. West Africa in the Great Age of Islam

opposition, and it was not until 1076 that they were at length able
to capture and sack its capital. The length of Ghana's resistance
was a measure of the extent to which the 'Sudanic' concept of
kingship had been able to mobilize the energies and resources of
the Negroes of the western Sudan. If the desert nomads ulti-
mately won the military struggle, they proved incapable of bene-
fiting from their conquest. They were soon quarrelling among
themselves over the spoils; within a few years Ghana was able to
reassert its independence, but it never recovered all its former
power. The trans-Saharan trade, so vital to the economic strength
of the empire, had been sadly disrupted by the Almoravid out-
burst. Moreover, in the dry Sahel lands surrounding the ancient
capital, agriculture was unable to recover from the damage done
by the desert nomads and their flocks. With its economic cohe-
sion thus weakened, Ghana's empire began to break up into its
component tribal units. But the idea of empire did not die in the
western Sudan. It had been merely pushed further to the south,
into better agricultural land more remote from the desert and the
possibility of attack from its destructive pastoralists. The heritage
of ancient Ghana was eventually assumed by the leader of one of
the Mande clans in the upper Niger valley. Under Sundiata, who
reigned from about 1230 to 1255, an even greater Mande empire,
that of Mali, began to rise.

It would appear that Sundiata rose to power as a pagan, but he
and his successors seem to have been quick to appreciate the poli-
tical and economic advantages for themselves and their state in
the adoption of Islam. As has been seen, in their later days the
Ghana kings had depended to some extent on Muslim advisers,
but it is likely that at least initially these were strangers from the
north. But one result of the Almoravid conquest was greatly to
stimulate the growth of Islam among the Sudanese themselves.
Sundiata seems to have been at least a nominal convert, and
during the great period of Mali history, up to the end of the four-
teenth century, his successors as *Mansa* (emperor) were all un-
doubtedly Muslims, many of whom made the pilgrimage to
Mecca. From this time on, the major states of the western Sudan
were usually ruled by kings who professed an allegiance to Islam.

One advantage of Islam for the Negro states of the West African savanna was that it gave them an assured status with the governments and merchants of North Africa, whose goodwill was so necessary for the prosperity of the 'Sudanic' states. By about the thirteenth century onwards, the merchants of the Sudan itself were usually Muslims too, and, ranging further afield than the lands under the direct control of their kings, they became the great propagators of Islam throughout the western Sudan. Thus, for example, it was Mande merchants of the fourteenth century who introduced Islam into Hausaland.

Islam and Islamic culture also provided a useful tool in attempting to solve the major internal problem facing the 'Sudanic' empires. A king or emperor could legitimately claim the allegiance only of his own kinship unit or clan, and of such other related kinship units as could recognize his descent from an original king whom the whole group acknowledged as a great founding ancestor. But many rulers, especially those of Mali, and of the Songhai who eventually succeeded to their power, extended their dominion very much wider than this. Ghana had shown how rich and powerful a monarchy could become if it could impose its control over all the trade of a given area in the Sudan. Mali and Songhai in effect tried to control as much of the Sudan as they could. The further afield their armies could impose one system of law and order, the more their peaceable production and trade would increase. The flow of trade and tribute, clients and slaves to their capital would correspondingly increase, providing the means for even further extensions of their power.

The more widely an empire was extended, however, the more alien its emperors appeared. Local chiefs could not be trusted to remain faithful vassals; they tended instead to become rallying points for local resistance to imperial rule. This situation could be met to some extent by an emperor sending his own men, supported by an adequate number of his own soldiers, to rule outlying territories in his name. But this still did not solve the fundamental problem of securing loyalty from other kinship units. At best a provincial governor might do no more than transfer local allegiance to himself, and if he were a kinsman of the

emperor with some claim to the imperial succession, this could be extremely dangerous. Accordingly, provincial governors were often chosen from among the slaves rather than from the family of the emperor.

For the continued maintenance of a large empire, it was therefore necessary to establish an impartial central administration, with sufficient continuity and a good enough system of communication to secure a proper control over all that was happening throughout the empire; and secondly, to find some principle of allegiance which might transcend the one based on kinship. Islam could help with both. With the growth of Muslim schools and colleges in the Sudan, there emerged a class of educated, literate, and even scholarly men, who could organize imperial government and trade efficiently. Such men were not dominated by their kinship allegiances; their own interests were in fact closely tied to the maintenance of the imperial administration and peace. On the other hand, before the nineteenth century at least, Islam does not seem to have penetrated sufficiently deeply into the lives of the mass of the people to have affected the second purpose to any very great extent. Whenever the central power was weak or divided, a Sudanese empire always tended to dissolve into its basic pagan kinship allegiances.

It must be emphasized that both Mali and Songhai were considerable empires by any standard. During the fourteenth century the writ of the emperors of Mali ran from their upper Niger valley capital of Niani westward to the Atlantic over all the land north of the forest and east along the Niger valley to the borders of Hausaland. Among its principal vassals were the kings of the Songhai, who monopolized fishing and canoeing activities along the middle Niger. Control of the Songhai was essential if Mali's merchants were to have access to Timbuctu and Gao, which by the thirteenth century were becoming important southern bases for the trans-Saharan trade, and beyond them to the Hausa states. But the Songhai kings did not take kindly to subordination to Mali's interests, and were continually trying to regain their independence. Eventually a king emerged, Sonni Ali (c. 1464-92), who was able to mobilize the traditional pagan energies of

the Songhai to defeat Mali and, with the help of men experienced
in its armies and administration, to begin to convert its eastern
dependencies into an empire of his own. His successor, one of
his Mande generals, the *Askia* Muhammad (1493–1528), com-
pleted his work by more than restoring the Muslim influences
which Sonni Ali, in the first flush of Songhai imperialism, had
tended to destroy. The final result was an empire even greater
than that of Mali. Its capital was Gao, on the Niger bend, some
seven hundred miles east of Niani, and the area of its power in the
west was accordingly less. But it reached northwards to the
Saharan salt mines and almost to the confines of Morocco, while
eastwards it reached almost to Bornu.

The power, wealth, and good order of these empires excited
the admiration of Muslims from more central parts of the Islamic
world, who, confident in their own achievements, were not lightly
wont to praise those of others. Thus the great traveller Ibn Bat-
tuta, whose earlier journeys had taken him as far as China, after
a tour through the Mali empire in 1352–3, wrote that its Negroes

are seldom unjust, and have a greater horror of injustice than other
people. Their sultan shows no mercy to anyone who is guilty of the
least act of it. There is complete security in their country. Neither
traveller nor inhabitant in it has anything to fear from robbers or
men of violence.

He was continually noting evidence of the prosperity of agricul-
ture and trade, and remarked on the ease and safety with which
traders and foreigners could travel, after little advance prepara-
tion, because they could always be sure of buying food and of
finding good lodging for the night. A few years before Ibn Bat-
tuta's visit, *Mansa* Musa, probably the greatest of the Mali
emperors and certainly the best known, like many of his pre-
decessors had made the pilgrimage to Mecca by way of Cairo. He
created a most favourable impression in Cairo, and he had
brought so much gold in his train that the value of the metal in
Egypt was quite appreciably debased. This journey of *Mansa*
Musa placed the western Sudan squarely on the map of the great
states in the world of the time; quite literally, for Mali and its

'Lord of the Negroes' appear on the very first map of West Africa ever drawn in Europe (in 1375). Doubtless it was his success that inspired *Askia* Muhammad of Gao to attempt an even more magnificent display when he went to Mecca in 1495–7.

Without losing their distinctive 'Sudanic' character, the great states and cities of the western Sudan became definitely part of the Islamic world. Their mosques and schools were able to attract divines and scholars from other parts of this world, those of Timbuctu being especially famous. They even maintained their own hostels for their students and travellers in Muslim centres like Cairo. But of course it was trade more than anything else which linked the Sudan to North Africa, and there would seem to be an interesting correlation between the course of events in the Sudan and those in the Maghrib during the centuries following the Almoravid explosion. At the beginning of the Muslim period, most trade seems to have taken the western trans-Saharan road between Morocco and Ghana. Doubtless this was because the most accessible Sudanese gold lay just south of Ghana, while there were also major salt mines immediately south of Morocco. But by about the fourteenth century, Mande merchants had begun to open up a gold trade with lands to the south-east, in the Black Volta valley and beyond, and the extension of Mali power down the Niger and the subsequent rise of the Songhai empire mark eastward shifts in the centres of power in the western Sudan. The region's exports, too, began to flow east down the Niger to new centres like Timbuctu and Gao before crossing the desert along more central routes. It seems possible that this eastward shift of political and economic power in the Sudan was due first to the disruption of the old western trade routes by the Almoravids, and secondly to the fact that (after the brief flowering of the Almoravid and Almohad empires) the most stable power in the Maghrib was that of the Hafsids of Tunis. It may also be significant that the peak of power reached by the Kanem kingdom in the central Sudan during the thirteenth century, when its influence was felt as far north as the Fezzan, was also broadly contemporaneous with the build-up of the Hafsid state.

8 North-East and East Africa in Medieval and Early Modern Times

In North-East and East Africa the rise of Islam did not produce the same swift and catastrophic results as it did in Egypt and North Africa. Even the Christian kingdom of Axumite Ethiopia, which had been the oppressor of south Arabia until the eve of the Prophet's birth and was the nearest organized state to the source of the Islamic expansion, was left substantially in peace for many centuries. In the seventh century Arabian Muslims profited by a temporary weakness of the Christian kingdom to seize the port of Massawa and the neighbouring Dahlak Islands; but we know from the Arabic writers of the ninth and tenth centuries – Yaqubi and Ibn Hawqal – that at this period the Ethiopian state still dominated most of the Red Sea coast opposite the Yemen, and that its influence stretched round the shores of the Gulf of Aden as far as Zeila on the northern coast of Somalia. The coastlands, especially the ports, were occupied by communities of Muslim traders, but all these paid tribute to the king of Ethiopia, and the Muslim world did not regard Christian Ethiopia as being subject to the *jihad* or holy war.

Thus, although it may be true that the rise of Islam was the turning-point in Ethiopian history, it was so only in a remote and long-term sense. The new world of Islam cut off Ethiopia from its former Mediterranean allies. It resulted in the substitution of Muslim Arab traders in the Red Sea ports for the Egyptians, Greeks, and Jews who had been there before. But for six or seven centuries at least it did not result in permanent hostilities between Christians and Muslims as such. There was no eastern parallel to the pattern of *jihad* and Crusade which forms the medieval history of the Mediterranean. In large measure this

was because the Ethiopian Church had followed its Syrian and Egyptian teachers into the Monophysite heresy, condemned by orthodox Christendom at the Council of Chalcedon in 451, and had thus benefited from the settlement with the Egyptian Copts effected by the Arabs. Throughout the Middle Ages, therefore, even during the Crusading period, Ethiopian bishops were consecrated in Cairo, and Ethiopian pilgrims, thousands at a time, marched through Egypt on visits to the Holy Land, with drums beating and flags flying, and with regular halts for the celebration of Christian worship. In fact it was Saladin, the greatest opponent of the western Christian Crusaders, who gave the church of the Invention of the True Cross to the Ethiopian Christians as their religious centre in Jerusalem.

The real crisis of medieval Ethiopia came not from the Muslims to the north, but from the pagans to the south. Of the details of this crisis we are almost completely ignorant. One surviving letter from an Ethiopian king of the very late tenth century to his brother monarch, George of Nubia, tells the pitiful tale of a kingdom in ruins through the invasions of a neighbouring pagan state, which is probably to be identified with the Agau kingdom of Damot, lying in the great bend of the Blue Nile. The Christian kingdom's recovery must certainly have been the most heroic period in Ethiopian history, though the least known. A new dynasty of kings, traditionally known as the Zagwe, led the renascence, living the hard life of military commanders in peripatetic tented capitals, but leaving as their main monuments the magnificent rock-hewn churches of Roha. Christianity triumphed, not through the sedentary propagation of a learned faith, but rather (as in fifth and sixth century Ireland) as a Church of ascetic monks and hermits who established their influence by personal sanctity and by denial of the world. Through two and a half centuries the political and religious frontiers were pushed southwards to include the provinces of Amhara, Lasta, Gojjam, and Damot. Amhara, rather than the northern province of Tigre, became the centre of the kingdom.

This expansion of Christian Ethiopia at the expense of the pagan south was paralleled by the first serious expansion of Islam

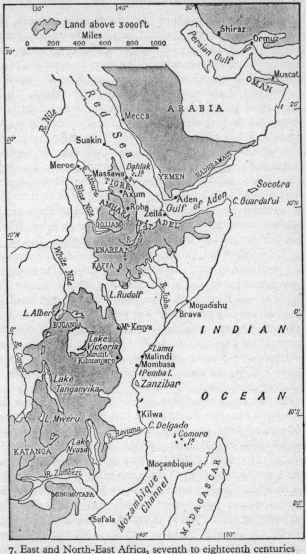

7. East and North-East Africa, seventh to eighteenth centuries

from the Red Sea coastlands into the interior, all along the
eastern frontier of the Christian kingdom. From the twelfth
century onwards there grew up a series of Muslim states, starting
from the port of Zeila, running up the natural trade-route of the
Hawash valley towards southern Shoa, and following more or
less the line of the modern railway to Addis Ababa. These
states, ruled by converted local dynasties, had as their main
concern the trade in slaves, ivory, and gold of the still pagan
and independent states of Enarea and Kaffa, lying well to the
south of Christian Ethiopia. It is possible that the relevant
trade routes stretched deep into the Nilotic Sudan, and perhaps
into Uganda and northern Kenya. All these inland Muslim
states were strongly commercial in outlook. Through them ran
the medieval counterpart of that central African trade which
had once passed through Meroe and later through Axum. Their
existence did not threaten the Christian kingdom. Indeed, it
was the restored and expanded Christian kingdom of the late
thirteenth century which under the early kings of the so-called
Solomonic dynasty started to take the offensive against the
Muslims, and through the fourteenth century succeeded in
bringing them under more or less peaceful tribute. But there
was still no overtly religious war. It was only in the fifteenth
century that growing Ethiopian domination began to make
the inhabitants of these states think and act as Muslims, rather
than as traders, and organize rebellions upon religious vows of
victory or martyrdom.

The first result of revolt was that Ethiopia blotted out the
largest of the Muslim states, that of Ifat, pursuing its king down
to the sea at Zeila and killing him there in 1415. Northern Ifat
was now incorporated under the direct rule of Ethiopia. But the
royal family and the leading Muslim elements in the population,
after a brief retreat to the Yemen, returned to a more easterly
section of the Somali coast, where they began to build up the
Muslim state of Adal, with the *jihad* against Ethiopia as its
real unifying force. When, therefore, in the early sixteenth
century, the Ottoman Turks succeeded the Mamluks in Egypt,
and brought the use of firearms and artillery down the Red Sea

ports and into Arabia, they found in the state of Adal a united Muslim community, prepared to use these weapons against the Christian kingdom of Ethiopia, with results which would certainly have been decisive but for the last-minute intervention of the Portuguese in 1542.

To move now round the sharp point of Cape Guardafui to the east coast of Africa – the main trend of recent research has been to show that here again the beginning of the Islamic era was by no means the turning-point that it used to be thought. The old tendency was to see the medieval history of the coast mainly in terms of the Arab settlements there, and, following claims in the earliest scraps of their own traditional histories, to ascribe the origins of these settlements to the early centuries of Islam. Recent archaeological work, however, has shown that only the Somali coast, as far south as the Lamu archipelago, was settled by Muslims during the early medieval period. Along the coasts of Kenya, Tanzania and Moçambique, and on the offshore islands, the Islamic civilization of the east coast dates only from the thirteenth century, and moreover it was even then a civilization having no important trade connexions with any part of the interior north of the Rovuma river. In contrast, recent discoveries of Roman coins, which show a heavy concentration in the fourth century A.D., have substantiated the two brief references to the east coast in classical sources – that in the late first-century sailors' guide called the *Periplus of the Erythrean Sea*, and especially the previously suspect passages in the *Geography* of Claudius Ptolemy,[1] which seem to indicate that Alexandrian traders of the fourth century knew of the existence of Mount Kilimanjaro and also of great lakes in the far interior where the Nile had its sources. It thus looks as though the commercial penetration of East Africa, doubtless in the interests of the ivory trade, was far deeper at this remote period than it was to be again at any time up till the late eighteenth century.

The Iron Age archaeology of the East African interior has

1. Though Claudius Ptolemy himself lived in the second century A.D., competent authorities hold the view that his *Geography*, in the form in which it has come down to us, may be assumed to represent the sum of Alexandrian knowledge in the fourth century.

made great strides in recent years. It shows that the Iron Age reached north-eastern Zaire, Rwanda, Burundi, southern Uganda, and north-west Tanzania at a period which may have been as early as the second or third century B.C. It also shows that throughout this large area the beginnings of iron technology were accompanied by pottery industries bearing the signs of a common origin, and of an origin common with the somewhat later Early Iron Age pottery of eastern Kenya, Tanzania, Malawi, Zambia, and Rhodesia. These Early Iron Age pottery traditions do not have any affinities with ceramic traditions to the north of the East African area. It is therefore reasonable to associate their appearance in East Africa with the advent of the Bantu pressing into the region on a broad front from the west. It is significant that the *Periplus*, which describes the East African coast approximately as far south as Zanzibar, makes no reference to black men. Ptolemy's *Geography* mentions their existence, but only in the extreme south of the area then known, which must have been at least as far down as the north of modern Moçambique. Further north, by implication at least, the population was of Somali or Ethiopian type. Our next literary source, the tenth-century work of Masudi, places the blacks as far north as the Juba, on the boundaries of present-day Kenya and Somaliland. In the interval, moreover, black slaves from East Africa had become known throughout the coastlands of the Indian Ocean. Seventh- and eighth-century references exist from Arabia, Persia, Indonesia, and China. A ninth-century Chinese work clearly describes the contrast between the pastoral Somali, who grew no grain and drank the milk and blood of their cattle, and the wild blacks of Mo Lin, which is probably to be identified with Malindi on the Kenya coast. The 'dark ages' of East African history would seem, therefore, to have been those when black Bantu populations were spreading towards the Tanzania and Kenya coasts, assisted perhaps by the introduction of South-East Asian food-plants such as the banana and the coconut, and when South-East Asian as well as Arab seafarers were building up an ocean-wide trade in black slaves. The Indonesian colonization of Madagascar probably

belongs to the beginning of this period. The commercial exploitation, on the other hand, is to be identified rather with the full maritime development of the Hinduized kingdom of Sri Vijaya in Sumatra, which dominated the carrying-trade of most of the Indian Ocean from the eighth century till the twelfth.

Against this wider background of Indian Ocean commerce, the more limited question of Arab settlement in East Africa assumes truer proportions. According to the traditions retained both in Arabia and in East Africa, the earliest colonists were eighth-century Shi'ite refugees from Oman, on the Arabian side of the Persian Gulf, who were followed in the ninth century by orthodox Sunnis from Shiraz on the Persian side of the Gulf. It was the Sunnis who supposedly built towns on the Somali coast, developed the gold-trade of the Zambezi region and finally founded Kilwa in order to control it. Recent archaeological research shows that, though true in outline, this sequence of events was spread over four or five centuries. On Manda island near the Kenya-Somalia frontier there have been discovered ruins of a rich town occupied from the ninth century which had close relations with the Persian Gulf. From Masudi's travels we can probably conclude that there was an Omani settlement on Pemba by the tenth century. A Kufic inscription from Zanzibar refers to the building of a mosque at Kizimkazi early in the twelfth century. The so-called Shirazi period of Kilwa, responsible for the Great Mosque and the rich palace site at Husuni Kubwa, has been dated to the beginning of the thirteenth century, and should be seen as an expansion from the northern part of the coast rather than as a direct colonization from the Persian Gulf.

In sharp contrast with the scarcity of remains for the first five centuries of the Muslim era, it is obvious from the archaeological evidence that from about the middle of the thirteenth century until the coming of the Portuguese at the end of the fifteenth the East African coast enjoyed a period of quite remarkable prosperity. All the way down the coastline of Somalia, Kenya, and Tanzania, there sprouted urbanized Islamic communities, building in stone or coral rag, and wealthy enough, for example, to import such luxury goods as the stoneware of Siam and the

porcelain of late Sung and early Ming China. The Kilwa sultans of this period even minted their own copper coinage in the earliest mint to be established anywhere in Africa south of the Sahara. There does not seem any satisfactory explanation for this prosperity in terms of the discovery of new resources in East Africa itself. Kilwa, like its northern predecessors, lived on the Rhodesian and perhaps the Katanga trade, placing its governors in the gold-port of Sofala, and levying large duties on seaborne traffic in both directions. Malindi and Mombasa had been known at least since the twelfth century for their mines of highly concentrated iron ore, which was exported to India for the manufacture of steel blades for swords and daggers. Mogadishu had its weaving in-dustry, producing coarse cotton goods and camel-hair cloth for the Egyptian market. Slaves and ivory were no doubt, as always, the staple exports of all the smaller settlements along the coast.

What happened economically in the thirteenth century, there-fore, seems to have been mainly an intensification of the already established lines of commercial exploitation. The material im-provement was impressive, but it seems that the main signific-ance of this thirteenth-century revival was cultural and religious. This was the period when from one end of the Indian Ocean to the other Islam was stretching outwards on its second great wave of expansion. The thirteenth century saw the first serious Muslim penetration of India. In Indonesia it saw the Islamiza-tion of the Hindu town cultures in Malaya, Java, and Sumatra. In East Africa it marked what was probably the first real incor-poration of the coastal region within the world of Islam. Earlier Muslim settlers had been few, and communications with the rest of Islam had been so tenuous that most of their descendants had probably lost the faith. With the thirteenth century, the bulk of the Indian Ocean trading system passed into Muslim hands, and all its participants acquired a new solidarity. In East Africa it is from this time onwards that religious monu-ments such as mosques and tombs are found all along the coast. It is probably from this period, too, that the 'Swahili' language and culture began to take shape among the Islamized Bantu people of the coastal plain.

From the evidence at present available, it seems highly unlikely that there existed any long-distance trade links between the Islamic civilization of the central part of the East Coast and the interior of East Africa. North of the Bantu sphere, there are some indications that the coastal Somalis, particularly after their adoption of Islam, traded inland with the pagan Galla peoples to the south of the Ethiopian kingdom. And again, to the south of Kilwa, land and sea routes linked the coast with the gold-producing regions of Rhodesia and probably with the Luba copper-mines of Katanga. There do not seem to have been any corresponding connexions between the Zanzibar coast and the region of the great lakes, which even at this period was probably the most populated part of East Africa, and where traditional and archaeological evidence shows that organized states were already in existence at least by the thirteenth and fourteenth centuries. At Bigo in western Uganda, the excavation of the great earthwork site, which was probably built in the fifteenth century, has not yet yielded a single coastal import – not even a bead.

The reason is, doubtless, that between the coast and the lake regions there lies a wide belt of the driest and least cultivable land in eastern Africa, which at this period was probably occupied only by sparse groups of Cushitic and Nilotic warrior pastoralists, who lacked both the inclination and the organization to supply and protect caravans. It seems that it was only in the eighteenth century that expanding Bantu populations from western Tanzania pressed into the southern part of this region as cultivators and opened the first long-distance trade routes between the coast and the interior. It is in the second half of the eighteenth century that the traditional history of the Buganda kingdom on the north-western shores of Lake Victoria records the first large-scale imports of cotton cloth and other luxury goods from the outside world.

By this time the Portuguese occupation of the Zanzibar coast had come and gone. Even on the coast it had left no deep mark; on the interior, none at all. Throughout the Indian Ocean the aims of the Portuguese were essentially commercial and maritime:

their object was to supplant the pre-existing network of Arab seaborne trade. Initially, in the early years of the sixteenth century, this carried them not only to India and the East Indies, but right up the east coast of Africa to the mouth of the Red Sea and into the Persian Gulf. In this sector they planted their first bases at Sofala, Kilwa, Socotra, and Ormuz. In 1542 a small Portuguese expeditionary force intervened decisively to prevent the overrunning of the Christian kingdom of Ethiopia by the Turkish-armed Somali state of Adal; and for nearly a hundred years afterwards, Portuguese missionaries laboured unsuccessfully to bring the Ethiopian Church into obedience to Rome. This, however, was the only Portuguese venture on the East African mainland to the north of the Zambezi. Their other settlements were virtually confined to the offshore islands – Moçambique, Zanzibar, Pemba, Mombasa, and the islands of the Lamu group. Their positive interests in East Africa were limited to the gold region of the Zambezi, and to the island base of Moçambique, from which the East India convoys sailed direct to Goa.

The diversion of the gold trade into European channels removed the lynch-pin of the East African coastal commerce: within a few years of the Portuguese occupation, Kilwa had withered to an unimportant village. North of Kilwa, the Arab settlements on the mainland, becoming increasingly merged with the Swahili Bantu, nevertheless maintained furtive links with Arabia and the Persian Gulf. In 1593, in an effort to contain the political disaffection of the coast, the Portuguese built and garrisoned the great citadel of Fort Jesus at Mombasa; but already the north-east corner of the Indian Ocean was slipping from their grasp. In 1622 they were finally ejected from the Persian Gulf. By mid-century the seafarers of the maritime state of Oman were regularly raiding as far south as Zanzibar. In 1700 they finally cleared the Portuguese out of Fort Jesus. By the eighteenth century the East African coast north of Cape Delgado had in large measure resumed the late medieval pattern of its external relationships. The wider commercial connexions with India and Indonesia, which had given its special lustre to the late

medieval culture of the coast, were now only indirect connexions. The important Rhodesian element of the East African trade was still in Portuguese hands; but the essential cultural and commercial contact with the centre of the Islamic world had been re-established. The eighteenth century saw the re-emergence of Swahili city states, mostly under Arab dynasties owing a nominal allegiance to the Ya'rubi Imams of Oman. It was from these bases that the first serious penetration of the central part of the East African interior was to be undertaken.

9 The States of Guinea

We have already seen how in response to two external stimuli, the one the arrival from the east, from the Nile valley, of the political concept of the 'Sudanic' state, and the other the expansion from the north, from across the Sahara, of international trade, the Negro communities of the western and central Sudan formed such considerable states as ancient Ghana and Mali, the Songhai empire, Kanem-Bornu, and the Hausa kingdoms. Both the formation and the existence of such states were bound to affect the Negroes living further south, in and near the great tropical forest region of West Africa which is usually termed Guinea.[1]

The early history of Guinea is necessarily more obscure than that of the Sudan. It lay beyond the limits of knowledge of the Arab authors who wrote about the Sudan between the eighth and the fifteenth centuries. From the fifteenth century onwards, European writings become of increasing value; but it was not until the nineteenth century that European observers began to penetrate inland to any significant extent. In so far as the earlier records mentioned events in the interior, it was from hearsay. The historian must therefore rely heavily upon orally-maintained traditions whose historicity cannot always be clearly established. However, in some instances archaeology has been able to confirm these traditions (and even occasionally to lengthen their meagre chronological indications).

It is clear, however, that at least by the thirteenth century

1. The term 'Guinea' was borrowed by the Portuguese from the first African tongue known to them, that of the Moroccan Berbers. Strictly speaking, *Akal n-Iguinawen* means the same in Berber as the Arabic *Bilad as-Sudan*, namely, 'land of the Negroes'. But in modern geographical usage, Guinea is reserved for the forested southern half of West Africa, just as Sudan is reserved for the savanna northern half.

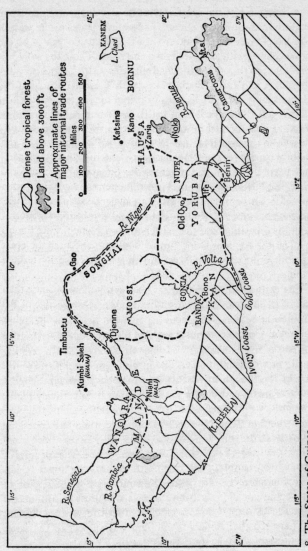

8. The States of Guinea

Legend:
- Dense tropical forest
- Land above 3000 ft
- Approximate lines of major internal trade routes

Miles
0 100 200 300 400 500

KANEM
L. Chad
BORNU
Mts.
Cameroons
R. Benue
Katsina
Kano
Zaria
HAUSA
Nok
Ife
NUPE
R. Niger
Old Oyo
YORUBA
Benin
Ife
SONGHAI
Gao
R. Volta
MOSSI
GONJA
Timbuctu
Djenne
BANDA
Bono
AKAN
Gold Coast
Kumbi Saleh
(GHANA)
Niani
(MALI)
MANDE
WANGARA
Ivory Coast
LIBERIA
R. Senegal
R. Gambia

the Negroes of Guinea had begun to develop states similar in pattern to those of the Sudan. The Guinea states to the west of the Volta river had affinities with the 'Sudanic' states of the upper Niger, with ancient Ghana and Mali. Those to the east of the Volta, on the other hand, had affinities with the states between the Niger and Lake Chad, mainly with Kanem-Bornu and the Hausa kingdoms. The legends of origin for the eastern Guinea states, and the marked similarities in their political structure, indicate that the idea of the 'Sudanic' state spread south and west from the region of ancient Kanem. According to the traditions of the Jukun people living along the Benue, and to those of the Yoruba and kindred peoples now inhabiting the forests of western Nigeria, their states were founded by immigrants from the Nile valley. Such legends are hardly to be taken at their face value, however. Probably they refer at most to small conquering minorities of the same kind as that which founded the state of Kanem. Moreover, it must certainly not be assumed that such migrants were responsible for all the more civilized aspects of Nigerian art and culture. The probability is that any immigrants from the eastern Sudan came to a region which already possessed an advanced culture. The whole of this Nigerian region south-west of Lake Chad seems to have been one in which agriculture, pottery, metal-work, and sculpture had been leading the rest of sub-Saharan Africa since the time of the Nok culture in the first millennium B.C. The magnificent naturalistic sculpture of Ife, though its practitioners may have learned the technique of metal-casting, for example, from comparatively recent immigrants, nevertheless in its basic inspiration stems from the Nok tradition. The Nile valley influence, therefore, operated primarily in the sphere of political ideas.

Further west, the traditions of origin for the Akan peoples of Ghana, for example, point due north towards the upper Niger. Here, therefore, the idea of the 'Sudanic' state would appear to have come not directly from its eastern source, but indirectly from the 'Sudanic' states established in the western Sudan, and here too the 'Sudanic' tradition was subject to the same modifications as in the states to the north.

It would seem reasonable to suppose that the agricultural skill of the Negroes of the Sudan, together with their subsequent success in establishing states capable of ruling and trading over wide areas, brought about an appreciable increase in the population of the savanna. It would equally be reasonable to suppose that this growth of population in the Sudan led to a steady infiltration of the forestlands. The botanical evidence, however, suggests that the occupation of the forest by anything like its present densities of population (which, from the Cameroons to the eastern Ivory Coast, are today among the highest in all Negro Africa) was not feasible before the introduction of the South-East Asian food-plants. Certainly it is these, together with still later introductions from tropical America, which provide the greater part of the staples of West African forest agriculture today. Early infiltration from the Sudan must therefore have been limited to small groups. The movement seems to have intensified with the growth of states in the Sudan, and to have proceeded fastest in the area between the lower Niger and the Ivory Coast, where the belt of really dense forest is thinnest.

Many of the earliest known states of peoples like the Akan and the Yoruba, whom today we think of as typical forest-dwellers, in fact originated either north of the true forest, or in its northern fringes. The earliest Akan states were Bono and Banda, founded in the orchard bush to the north of the Gold Coast forest, probably about the thirteenth century. The first southward expansion of the Akan from this region seems to have avoided the forest as far as possible by an eastward sweep to the Volta valley, which took them through the forest at its narrowest point and so into the coastal grasslands. The forest itself does not seem to have been directly penetrated to any great extent until about the fifteenth century. Ife, the traditional dispersal-point of those who founded the Yoruba states, and also of the great historic dynasty of Benin, is situated within the Nigerian forest, but close to its northern edge. Oyo, the Yoruba state which from the seventeenth century onwards held the political paramountcy, had its centre to the north of the forest, and (like the states of the Sudan)

employed cavalry, quite unsuited to forest warfare. Horses were likewise at least a ritual symbol of power for the rulers of Benin, whose capital was separated by the whole breadth of the forest from any country where cavalry could have been useful. This suggests that the founders of even the most typically forest states came originally from the savanna. The coherently preserved traditions of Benin indicate that its dynasty was founded by immigrants from Ife some three centuries before the coming of the Portuguese. Modern archaeology has indeed confirmed that Benin City was extant by the thirteenth century, and that the urban culture of Ife goes back to at least the eleventh century.

In common with the states of the western and central Sudan, the society of the Guinea states was markedly urban in character, especially in the east. Though their economy was based on agriculture, there was little of the pattern of dispersed homesteads so common elsewhere in Negro Africa. The people lived in compact settlements around the houses of their kings and elders, and sallied forth to their fields by day. The settlements varied in size from simple villages, the geographical representation of the basic kinship units, to large towns where members of many kinship units lived in distinct wards around the royal palace, and where there were also quarters set aside for stranger peoples. In the eastern states, most notably among the Yoruba, the geographical pattern was similar to that of the Hausa states further north. The nucleus of the state was a town surrounded by a wall, which enclosed an area large enough to shelter and sometimes possibly even to feed the whole population during an emergency. Most of these Guinean towns lay beyond the sphere of European observation until the nineteenth century. Benin, however, was an exception, and it is quite clear from the accounts given by sixteenth- and seventeenth-century visitors that they regarded it not only as a great city, but also as one which might quite fairly be compared with the major European cities of the time. Thus in 1602 a Dutch author observed:

The town seemeth to be very great; when you enter into it, you go into a great broad street, not paved, which seems to be seven or eight times broader than the Warmoes street in Amsterdam; which

goeth right out and never crooks ...; it is thought that that street is a mile long [this is a Dutch mile, equal to about four English miles] besides the suburbs. At the gate where I entered on horseback, I saw a very high bulwark, very thick of earth, with a very deep broad ditch ... Without this gate there is a great suburb. When you are in the great street aforesaid, you see many great streets on the sides thereof, which also go right forth ... The houses in this town stand in good order, one close and even with the other, as the houses in Holland stand ... Their rooms within are four-square, over them having a roof that is not close[d] in the middle, at which place the rain, wind, and light come in, and therein they lie and eat their meat; but they have other places besides, as kitchens and other rooms ...

The King's Court is very great, within it having many great four-square plains, which round about them have galleries, wherein there is always watch kept. I was so far within the Court that I passed over four such great plains, and wherever I looked, still I saw gates upon gates to go into other places ... I went as far as any Netherlander was, which was to the stable where his best horses stood, always passing a great long way. It seems that the King has many soldiers; he has also many gentlemen, who when they come to the court ride upon horses. ... There are also many men slaves seen in the town, that carry water, yams, and palm-wine, which they say is for the King; and many carry grass, which is for their horses; and all this is carried to the Court. ...

The two main southward-flowing streams of influence from the Sudan corresponded in historic times with two major systems of long-distance trade linking the Sudan to Guinea. The dominant traders in the east were the merchants of the Hausa states, whose activities were supplemented towards the south-west by the Yoruba. In the western half of West Africa, Mande merchants were dominant. The two trading systems met at the edge of the forest, north of the Gold Coast, and some idea of their antiquity may be gained from the traditions relating to the trade with this region. It would seem that Mande merchants were already visiting Bono, primarily for gold, about the middle of the fourteenth century, that is to say, about a century later than the foundation of Djenne, the metropolis for the trade of the western Sudan with the lands to the south. The trade from the north-east seems to have developed slightly later, with Hausa

merchants beginning to go to Gonja, north-east of Bono, in the fifteenth century.

Before the appearance of Europeans on the scene, there was thus a network of trade routes linking towns and villages throughout almost the whole of West Africa between the Sahara and the coast. Regular markets were held, often arranged in daily cycles so that neighbouring markets would not compete with one another. Although much trade was doubtless purely local in character, for example the exchange of foodstuffs for local manufactures within a particular area, the operations of the Mande, Hausa, and Yoruba merchants were truly international.

It is evident that this long-distance trade was closely connected with the existence of organized states. The regions untouched by the itinerant traders were for the most part difficult country such as marshland and mountain, in which simple kinship groupings had escaped the attention of the state-builders. By far the largest of these regions seems to have been the particularly difficult and thinly-populated forest of what is now Liberia. However, the correlation between long-distance trade and state-hood was positive as well as negative. The staples of the trade were for the most part luxuries rather than necessities. In the first place, most West African communities could grow or manu-facture enough to supply their own basic needs. Secondly, the cost of transport was high. This was particularly so in the forest, where head-loading was the rule because animal transport was inhibited by the lack of fodder and the presence of tse-tse. It was therefore economic to carry over long distances only commodities whose value was high in proportion to their bulk. A demand for luxuries, of course, implies the existence of a wealthy class. This first existed in West Africa in the shape of kings and their courts, and the specialized professions – administrators, soldiers, artists, metal-workers, court musicians, remembrancers, and the like – which they were able to support from their control of the surplus wealth produced by their subjects. This surplus flowed into each court essentially in the form of tribute, and it was doubtless accumulations of tribute in such widely-desired commodities as

gold or kola-nuts which made the initiation of international trade possible when outside demands arose.

Generally speaking, as has been seen, states developed in the Sudan before they did in Guinea, and this explains the dominating position in the Guinea trade of merchants from the Sudan. The Mande and Hausa merchants doubtless first moved southwards in response to demands coming from the north, across the Sahara, which their own states were able to satisfy only inadequately or not at all. But trade breeds wealth, and so more trade, and Sudanese merchants were soon trading to Guinea to satisfy the demands of their own growing wealthy class, of which, indeed, they themselves were becoming significant members. Nor was this all. The Guinea states also began to trade for their own enrichment, though – with the possible exception of the Yoruba – their trading remained for the most part a royal enterprise. Their merchants were at least as much agents of the kings as members of an independent class doing business on its own account.

The principal exception to the long-distance trade in luxuries alone was the trade in salt, carried into the forest both from the sea and from the Sahara via the Sudan. There was also a trade in cattle and in horses, from the Sudan into Guinea. The principal Guinea exports were gold-dust, which reached the Sudan and ultimately the Mediterranean from workings in the Gold Coast region and the earlier workings in Wangara; kola-nuts, one of the few stimulants tolerated by Islam and therefore valued throughout the Sudan, which also reached the Maghrib; and ivory, though the ivory trade was nothing like as important as it became in European times, when part of the Guinea coast west of the Gold Coast became known as the Ivory Coast. Goods which travelled mainly in the other direction, from north to south, included – besides horses and cattle and some of the salt – beads, trinkets, and other small items of metalware such as cutlasses; scarce and therefore valuable base metals such as copper and its alloys; cloth; and cowrie shells. These last, brought all the way from the Indian Ocean via Egypt, serve to remind us that West Africa had well-developed systems of

money, as also of weights and measures. In addition to cowries, gold dust, blocks of salt, and pieces of iron, of copper, or even of cloth were also recognized mediums of exchange. Not all the beads and cloth traded in Guinea, however, were imports. Some or perhaps most of the cloth had been woven in the Sudan or in North Africa, and some of the beads came from the Mediterranean region; but there was also trade in stone and glass beads and in cloth which had been manufactured in Guinea itself; Yorubaland in particular seems to have exported both.

In view of later developments, there is one striking omission from the list of commodities featuring in the early Guinea trade, namely slaves. This does not mean that slavery and serfdom were unknown. There was little or no surplus free labour in a situation where almost all men were subsistence farmers and land was abundant. The success of any major political or economic enterprise therefore depended on the extent to which a ruling group could force other men to become its servants, retainers, soldiers, craftsmen, labourers, carriers and clients. But this equally meant that there was little desire to dispose of labour for sale, at least until needs developed for other commodities which were equal to or greater than the need for men. In the West African Sudan, this situation may have been reached by the ninth century. The first Arabic reference to trans-Saharan trade in Negro slaves is of this time; from the twelfth century, such references are common. In the Guinea coastlands it seems clear that it was only with the growing European demand, from the sixteenth century onwards, that the large-scale slave trade developed. The other trades, however, were already well developed by the time of the European arrival on the coast. Thus, when Europeans reached the Gold Coast towards the end of the fifteenth century, they found that Mande merchants were already there, and that among the goods in local demand were Moroccan cloth, and beads and cloth exported from Benin but probably for the most part manufactured by such adjacent peoples as the Yoruba, Ibo and Nupe.

It was this universality of trade in cloth and other luxuries which, together with the largely urban pattern of settlement,

chiefly distinguished the Guinea region from all other parts of Africa south of the 'Sudanic' savanna belt, at least during late medieval and early modern times. In the whole of Bantu Africa, imported cotton cloth was known at the time of the first Portuguese contacts only in the urban settlements of the eastern seaboard and in a very limited inland region around the gold-producing area south of the Zambezi. But at the same period in Guinea practically every village was linked by trade of some sort with the Muslim civilization of the Sudan and of North Africa. And when Europeans arrived on the Guinea coast by sea, they accordingly found a fertile field for their commercial activities. In time, however, the entrance of long-distance trade to West Africa from the south was to bring radical changes both to its economy and to the balances of power among its states.

10 The Era of Firearms and the Slave Trade: (1) North and West Africa

As a consequence of the Arab invasions and of the ensuing spread of Islam over most of the northern third of the continent, a larger area of Africa than ever before in historic times had been brought into the mainstream of human history. At the same time, however, the Mediterranean, originally a fertile meeting-place for African, Asian, and European peoples and their ideas, had been converted into a political and ideological frontier in constant dispute between the forces of Islam and Christendom. Probably Africa lost little from this; from the eighth to the fourteenth centuries she almost certainly gained more from her partial inclusion in the civilization of Islam than she lost from lack of contact with Europe, then passing through a dark age redeemed only by the surviving light of Christianity. In any case, the Mediterranean frontier was not a complete iron curtain. The Crusades, carried to their objectives by the ships and seamen of the Italian city states, led to the development of a mutually profitable trade between southern Europe and Egypt and the Maghrib. The European side of this trade became increasingly engrossed by Venetian merchants, who proved ultimately far more successful than their rivals in establishing good relations with the Muslim powers. Thus African exports, including West African gold, and Asian luxuries too, via Egypt, continued to filter into Europe, while in return North Africa received valuable iron and timber as well as slaves and manufactures.

In the fifteenth and sixteenth centuries, new and dynamic forces, which were to affect Africa vitally, emerged from this Mediterranean combination of economic cooperation with political and military warfare. Africa north of the Sahara ultimately

became much more of a dead frontierland than before. Other parts of the continent, however, were introduced to the new European demand for African slaves, and received in return from both Europeans and Turks a new weapon, the firearm, which was ultimately to lead to considerable upsets in the balance of power in many parts of Africa.

First of the new forces was the vanguard of the new nation-states of western Europe, Portugal and Spain. Having tempered themselves in the long struggle to free the peninsula from Islam and the Moors, these nations began from 1415 onwards to follow the foe across the Straits of Gibraltar into Morocco. Despite early successes on the coast, the Iberians ultimately failed in their bid to conquer Morocco. Indeed, by the close of the six-teenth century, the principal result of their attacks seemed to have been to consolidate the Moroccan tribes in support of the Sa'did dynasty (1554–1659). Their early involvement in the Maghrib, however, gave the Portuguese new knowledge and new ambitions.[1] They learnt that across the Sahara lay Guinea, a land of gold which was beyond the control of their Muslim enemies. They also learnt that the sphere of Arab navigation included the East African coast, and that Arab geographers believed the whole of the continent to be surrounded by sea. This knowledge, with the promptings and the technical and financial assistance of mariners and merchants from those Italian cities which were being shut out of the Mediterranean trade by Venice, suggested to the popular Aviz dynasty, particu-larly perhaps to that prince whose name is remembered as Henry the Navigator (1394–1460), a grand design of outflanking Islam by circumnavigating Africa. In so doing Portugal would gain new strength from the gold of Guinea and from coopera-tion with African Christendom, the power and the extent of which were then commonly exaggerated. She would also break into the Muslim-controlled system of Indian Ocean trade. By im-porting valuable Asian commodities, especially spices, directly

1. Until 1492, the Spaniards were still to some extent preoccupied with the reduc-tion of Granada, the last Moorish emirate in the peninsula. Thereafter, of course, their external energies were mainly directed to the New World, discovered for them by Columbus in the year when Granada fell.

and in bulk, at prices which the Venetians could not match, Portugal would gain immeasurable wealth to further the expansion of Christendom in general and of her own power in particular.

This great enterprise got under way shortly after 1415 and gradually increased both in momentum and in scope. Portuguese mariners, who had already learnt to master the ocean in the hard school of the Atlantic fisheries, made their first contacts with Negro Africa in 1444–5, when they reached Cape Verde and the mouth of the Senegal. Shortly afterwards Portugal began to colonize the Cape Verde Islands as a base for trade leading inland towards Mali. By 1471 the Portuguese were at the Gold Coast. They found it so rich in gold that in 1482, at Elmina, they began the first of a series of coastal forts designed to exclude the other European seafarers, now following in their wake, from its profitable trade. By this time, at Benin and at the Congo mouth, they were also in touch with two powerful 'Sudanic' states which seemed to offer considerable opportunities for the expansion of Portuguese trade and influence. In 1488 Bartholomew Diaz rounded the Cape of Good Hope, and this, together with the explorations of Pedro da Covilhan, who had reached India and Ethiopia by the traditional routes, made possible Vasco da Gama's triumphal voyage up the East African coast to India and back again in 1497–9. Egypt and Venice quickly combined to mount a naval assault on the Portuguese in the Indian Ocean, but with the summary defeat of their fleet off Diu in 1509, Portugal's grand design seemed complete. She had gained complete freedom to penetrate Negro Africa at any point she chose from the Senegal to the Red Sea, and she seemed also to have mastered the whole trade of the western Indian Ocean.

This mastery however was soon disputed by the appearance in the Indian Ocean of the Ottoman Turks, who during the fourteenth and fifteenth centuries had built up a formidable military power in Asia Minor, and who in 1517 occupied Egypt. Possession of Egypt enabled the Turks to advance both west to the Maghrib and south-eastwards down the Red Sea; and from the seamen of their Greek coasts and islands, whose own ambitions for booty more or less coincided with the Turkish interest, they

were able to derive a seapower which at first seemed almost as formidable as their power on land.

In the east, Turkish fleets ultimately failed in their bid to crush the Portuguese in the Indian Ocean, but they effectively denied them entry to the Red Sea, while (see Chapter 8) their control of the Red Sea's African coast brought guns and fresh energy to its Muslim peoples, endangering the survival of Christian Ethiopia. In the west, the bold advance of their Corsairs gained them the control of the whole North African coastline as far west as Morocco. Here the Sa'dids, with the weight of the Moroccan tribes behind them, proved as successful in checking Turkish invasions as they were in containing the ambitions of Spain and Portugal; but Tripoli, Tunis, and the new Corsair centre of Algiers, all became pashaliks of the Ottoman empire. Had the formal seapower of the Turks not gone under to the Christian fleets at Lepanto in 1571, it is possible that North Africa might have become more effectively Turkish than it did. As things were, however, the Ottoman empire there soon became merely nominal. Pashas were regularly sent to Cairo, but the reality of power in Egypt soon reverted to the Mamluks. Bypassed by the main stream of east-west trade, whose diversion to the oceanic route round the Cape of Good Hope was finally confirmed by the Turkish naval defeats, and with its agriculture still at a low ebb, Egypt sank into insignificance until such time as Europe once more sought to open up the direct road to Asia. The Turkish soldiers who had pushed beyond Egypt up the Nile as far as the third cataract soon settled down and became no more than a ruling class among the local Sudanese. The rest of the Nilotic Sudan was left to the Bedouin tribes and to the Funj Sultans of Sennar who had succeeded to the power of ancient Alwa.

At Tripoli, the pashalik eventually became the hereditary possession of a local clan. At Tunis and at Algiers, power resided not with the Turks as such, but with self-perpetuating cliques descended from the Greek corsairs and the Anatolian janissaries[1]

1. The janissaries were the professional *élite* of the Ottoman army, composed at this time of forced levies of youths from among the Christians within the Ottoman empire, who were subjected to a rigorous military and Muslim training.

who had originally conquered them for the Ottoman empire. In Tunisia the conquerors gradually merged with the local people. By the eighteenth century (though Tunisia was nominally still subject to Constantinople) a national monarchy, the Husainid Beys, had emerged, able to resume the Hafsid policy of commercial links with the Sudan and with Europe. Between Tunisia and Morocco lay what became known as the Regency of Algiers; and here the position was less happy. In 1711, the Dey, the autocrat elected by the janissaries, finally took over the pashalik, but it can hardly be said that the Regency had a government. The Dey and his soldiers and seamen were rather a band of licensed brigands seeking to make profits, on land by periodical predatory raids against the interior tribes, and on sea by corsairing, which had now come to mean the capture of Christian ships and their goods, with the enslavement or holding to ransom of their passengers and crews.[1]

With the control of affairs in North Africa still in the hands of Muslims, largely incapable, except at first in Morocco and later in Tunisia, of maintaining the old ties with the Sudan, and with the Mediterranean after Lepanto dominated increasingly by the navies of the western European states who were developing the oceanic trade routes, the new forces of power politics and trade did not easily reach into Negroland from the north. Nevertheless, by the later sixteenth century, firearms and Turkish military instructors had passed from Egypt to Bornu with considerable consequences. During the fourteenth century, the old dynasty of Kanem had been forced to shelter in Bornu, the province of its empire to the south-west of Lake Chad, following the overrunning of Kanem by the Bulala. These were a people comparable to the Zaghawa, who were themselves being pushed to the west by Bedouin tribes overspilling from the Nile valley. The availability of musketry enabled *Mai* Idris Alooma and his immediate successors of the old Kanem line not only to make Bornu the dominant power south and west of Lake Chad, but also to assert

1. Seamen from other parts of the Maghrib also engaged in corsairing during the seventeenth and eighteenth centuries, but it never became such an essential part of the economies of Tunis, Tripoli, or Morocco as it did of Algiers.

its suzerainty over the Bulala to the north and east. Furthermore, in Bornu itself, the monarchy was now powerful enough to insist that Muslim concepts of law and government should penetrate directly into the lives of the ordinary people.

At the same time, the Sa'dids of Morocco, at the peak of their power after victories over both the Portuguese and the Turks, sought from 1590 to 1618 to take advantage of dissensions within the Songhai empire in order to secure control of the western Sudan's gold trade for themselves. Small forces of soldiers experienced in musketry and hardened in the Mediterranean wars – many of them were in fact Christian slaves or renegades – proved capable of surviving the Saharan crossing and of defeating the massed levies of the Songhai *Askias*. But with its central government destroyed, the Songhai empire dissolved into tribal kingdoms, which the Moroccans lacked the strength to police or govern for themselves. The resultant chaos upset the flow of gold and other trade into the commercial cities on the Niger – Timbuctu, Gao, and Djenne – which alone they were strong enough to hold, and where their descendants, independent of Morocco after 1660, remained, a futile and increasingly Sudanized military aristocracy. The western Sudan became a battleground in which considerable gains were made by the Tuareg nomads, encroaching from the desert, and the Fulani, Negro pastoralists infiltrating from the west. The only possible focus of stability lay in the growing kingdom of the Bambara of Segu, which had inherited some at least of the great tradition of its Mande ancestors, and which by about 1670 had imposed its suzerainty on Timbuctu and the other Moorish towns. In the eighteenth century, however, Segu was beset by internal divisions, which finally resulted in the establishment of a rival Bambara kingdom in Kaarta.

One consequence of this disruption of organized government in the western Sudan was to confirm the primacy of the trade routes across the central Sahara to Tunis and Tripoli. After the seventeenth century, when the power of Bornu began to weaken, the southern termini of these roads became firmly fixed in the Hausa states, which, with Kano and Katsina at their head, now

entered upon the period of their greatest prosperity and influence. With the principal exception of the trade in slaves to North Africa, however, the trans-Saharan roads were now becoming less significant as major arteries of international commerce, for the trade of Guinea, if not of the Sudan, was being diverted more and more towards the European traders at the coast.

Initially the coming of the European sea-traders had had little effect on the Guinean trade. West Africa, and indeed Africa generally, had less to interest the early European merchant adventurers than either of the other two continents into which they were then breaking. Pre-industrial Europe's requirements from overseas were essentially either luxury manufactures, such as silks, drugs, and perfumes, or specialized tropical crops like spices and sugar. Unlike many Asian peoples, Africans were not organized to produce these for export. On the other hand, unlike the American Indians, such was the virility and density of their population, especially in the richer agricultural areas, that, when the problems of climate, disease, and communications were also added, the Europeans were prevented from entering Africa to produce what they wanted for themselves. The plantation system was tried in West Africa during the fifteenth and sixteenth centuries, but only on its accessible and manageable off-shore islands. Indeed, it was from the Canaries that the Spaniards transported the system to the West Indies, and from the Cape Verde Islands and from the islands of the Gulf of Guinea, particularly San Thomé, that the Portuguese introduced it to Brazil. Initially, of all the commodities for which there was a steady demand in Europe, West Africa could offer little more than ivory and gold. By the eighteenth century, the supply of the first was greatly diminished; the latter came principally from the Gold Coast, which until the middle of the seventeenth century was the principal focus of European interest to the neglect of other areas. Early Portuguese interest in Benin, for example, waned in part because Portugal was able to get better pepper more expeditiously from Asia.

In the seventeenth century, however, this situation began to change with the rapid growth of the demand for labour by the

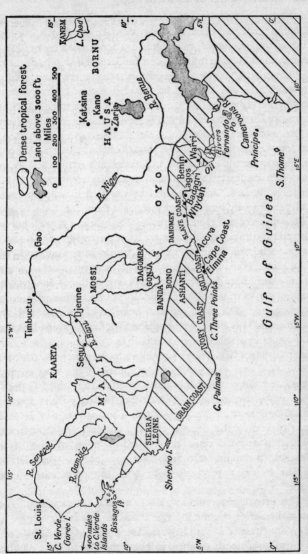

9. West Africa, fifteenth to eighteenth centuries

European plantations in tropical America. The early Spanish colonies there had been supplied with African slaves, mainly through the Portuguese, from about 1510. But it was not until the competitive irruption into the West Indies of the Dutch, French, and English in the seventeenth century, when there was a rapidly growing European demand for sugar – a crop making heavy demands on labour – that the transatlantic slave trade began to dominate European activities in West Africa. Compared with an estimate of some 275,000 Negro slaves landed overseas by 1600, the seventeeth-century figure is thought to be at least 1,340,000; the figures for the eighteenth and nineteenth centuries seem to have been at least 6,050,000 and 1,900,000 respectively. The new development was pioneered by the Dutch, who by 1642 had permanently ousted the Portuguese from the Gold Coast. The success of the Dutch provoked English and French hostility, and by the eighteenth century it was the traders of these two nations who were the principal competitors in the international trade, though the Portuguese continued with a private slave trade of their own, from Angola and San Thomé to Brazil. In terms of trade alone, victory went to Britain. By the end of the eighteenth century, her ships were carrying nearly half the slaves taken to America. This was in part a reflection of the growing maritime and commercial ascendancy of Britain in Europe, but it was also due to the fact that British activities became concentrated from the Gold Coast eastwards, on the shores of the most thickly populated and economically most developed region of Guinea. The coast between the Gold Coast and the Niger Delta, in fact, was soon known as the Slave Coast. The main area of French activity was in the Senegal-Gambia region, and though the French penetrated some three hundred miles up the River Senegal, the results were disappointing, since the westernmost Sudan was now relatively poor both in population and in trade.

The French penetration up the Senegal was exceptional. The normal practice was for the Europeans to stay at the coast – in forts like those erected in large numbers on the Gold Coast during the seventeenth century, in hulks moored in river mouths

such as those of the Niger delta, or in factories[1] in or close to the African towns which developed on the coast as a consequence of the trade. Invariably the Europeans bought their slaves from African kings or merchants. This explains the early concentration of European slave traders on the Gold Coast, for it was there that the African taste for European imports – cloth, hardware and metals, spirits and firearms – was probably better established than elsewhere, while the African traders who were already accustomed to supplying the Europeans with gold naturally began to supply slaves too when the demand for these developed. The persistent growth of the demand led to the extension of the trade, principally eastwards, towards the Niger delta and beyond, rather than towards the less economically developed and more thinly populated western coasts. The early slave trade was largely a catch-as-catch-can affair, but after *c.* 1650, as the demand for slaves increased, and as Europeans provided increasing quantities of firearms in exchange, it became a big business organized in their own interests by a series of large new kingdoms which developed close to the Guinea coasts.

During the eighteenth century, the export slave trade began to have revolutionary effects on the West African scene. It does not, however, seem to have occasioned devastation and depopulation on the scale produced in other parts of Africa, like Angola or, much later, East Africa. The reasons for this have not been unequivocally established, but it would seem that the loss of manpower from Guinea, which in the eighteenth century may have averaged 44,000 fit young men and women a year, was not a crippling rate of loss in relation to the total population.[2] Moreover, in a purely *economic* sense (if in no other), it would seem that much of this loss was made good by the increase of

1. This is the original use of the word *factory*, namely 'a merchant company's foreign trading station', the place where their *factors* (i.e. merchants) did business.

2. This estimate for the eighteenth century represents a higher rate of loss than that suggested by the overall estimates given on p. 122. But the latter are for slaves *landed overseas*, and allowance must be made for the mortality on the voyage across the Atlantic, which could be high, and must, on the average, have been at least 16 per cent. A further allowance should be made for the loss of life caused by slaving operations in Africa, but this is quite impossible to evaluate.

wealth brought to the more advanced Guinean communities through their trade with Europe. In both respects, the Angolan and East African situations were different; populations there were relatively thin, and the indigenous economies often not far removed from the subsistence level, so that even a small loss of productive manpower could be disastrous.

The general effect of the Atlantic slave trade was, indeed, to move the centres of wealth and power in West Africa away from the Sudan and towards the coast. The direct European share in this was negligible. The French, firmly established on the lower Senegal and at Gorée, and the British, Dutch, and Danes who occupied the Gold Coast forts, hardly possessed extensive political influence. Even the Gold Coast forts, impressive architectural monuments to the bitter European competition of the seventeenth century, were built on land leased from the local African states. In the last resort their lonely garrisons were unable to withstand determined opposition from the Africans of the towns which came to cluster round them. However, a community of interest existed, which came to ally the Europeans with their African neighbours when both were threatened by the growth of new states in the immediate hinterland, and from this, in the nineteenth century, the seeds of colonialism could grow.

The most impressive development of the seventeenth and eighteenth centuries was the growth of African states just inland from the coastlands. Initially the only major kingdom near the sea was Benin. But Benin, reacting to early Portuguese attempts to infiltrate its society, took little part in the new trade before the eighteenth century. The new centres of power were somewhat further inland. An early development was the short-lived empire of the Akan state of Akwamu, which between about 1680 and about 1730 expanded parallel with the eastern Gold Coast and the western Slave Coast in an attempt to engross the whole trade of their hinterlands with the south. Akwamu, however, failed to find a principle of administration capable of securing an enduring allegiance from its Ga and Ewe subjects, and its place as the major Gold Coast power was soon taken by Ashanti. In the

early eighteenth century, Ashanti, learning from Akwamu experience, began to expand to the north, incorporating or making tributary states like Bono, Banda, Gonja, and Dagomba. Then, with the trade of the interior profitably secured, she turned south to seek direct contact with the European traders. Further east, the relatively new kingdom of Dahomey among the Aja began to advance to the coast early in the eighteenth century, conquering other Aja states such as Allada and Whydah, whose political structures had been weakened by the growth of European influence on the Slave Coast. But Dahomey itself was forced to pay tribute to Oyo, the most northerly of the Yoruba states, which was its neighbour to the north-east. Oyo had begun to feel the pull of trade with the Slave Coast early in the seventeenth century. Eventually it embarked on policies of military and political expansion which led, in the following century, to the establishment of an Oyo paramountcy over more southerly Yoruba peoples, and also to the diversion of much of the local slave trade from the coast of Dahomey to more easterly ports like Badagri and Lagos.

By the end of the eighteenth century, then, over three centuries of European trade on the coasts of West Africa had led to little penetration of European influences. The Christian missionary effort in Guinea had been negligible; only the early Portuguese had been at all interested in the expansion of Christendom. Their early mission to Benin was soon withdrawn to Warri, where it lingered into the seventeenth century, but they were even less successful in creating a native Christian state here than in the Congo. Their other principal field of mission activity was in the coastlands opposite the Cape Verde Islands; here the best that could be achieved was the creation of a doubtfully-Christian class of half-caste traders. With hardly another exception, the Europeans who had gone to West Africa were interested solely in exporting its produce, and in effect only in the slave trade. Permanent European settlement on the coast, as on the Gold Coast, and at the mouth of the Senegal, did tend to produce a thin layer of coastal Africans who were partly European in their outlook and even, sometimes, in their formal education. But the vast

mass of West Africa and its peoples remained untouched by direct European influence. The principal effect of the coming of European traders to the coast, of their demand for slaves and their introduction of new goods, of which firearms were the most influential, was to stimulate in Guinea a potent new coastwards-looking manifestation of the well-established 'Sudanic' civilization.

11 The Era of Firearms and the Slave Trade: (2) From the Congo to the Zambezi

When the Portuguese discovered the estuary of the Congo in 1482, they found themselves in contact with one of the largest states in Africa south of the Sahara, and with one of the very few large states situated anywhere near the coastline. This was the kingdom of the *Ba*kongo, a Bantu people whose king, the *Mani*-kongo, had his capital at *Mbanza*kongo, the modern San Salvador in northern Angola. The Kongo kingdom was a typical 'Sudanic' state, which had been founded, probably in the late fourteenth or early fifteenth century, by a conquering group from the south-east. Possibly, therefore, it was an offshoot of the older Luba civilization of the Katanga. The founders, the true Bakongo, were remembered especially as clever smiths. On this account they had been formidable both as hunters and as warriors, and in the Kongo kingdom smiths were always afterwards treated to chiefly honours and privileges. The nucleus of the kingdom, including all that part of it which was administered directly by the Manikongo through a hierarchy of appointed chiefs and sub-chiefs, lay to the south of the Congo estuary. It was bounded, in fact, by the Atlantic, the Congo, the Kwango and the Dande, and its population was estimated by a seventeenth-century missionary at some two and a half million. Around the nucleus were clusters of smaller states, which formed part of the same complex in the sense that they had once been outlying conquests of the Kongo state, but where, owing to their distance from the centre, the appointed Kongo rulers had quickly achieved a practical independence, while continuing to acknowledge the theoretical supremacy of the Manikongo. The most important of these outlying areas were the three kingdoms of Ngoyo, Kakongo, and Loango

on the Atlantic coast, to the north of the Congo estuary; the area
known as Matamba, astride the Kwango valley to the south-east;
and the region of Ndongo, which included most of the central
part of modern Angola, on both sides of the river Kwanza. At the
time of the first Portuguese contacts the most important of many
small rulers in the Ndongo region was one with the hereditary
title Ngola, whence the name of the later Portuguese colony.

From the end of the fifteenth until the last quarter of the six-
teenth century, however, the Portuguese concentrated their efforts
not upon Angola, but upon the main Kongo kingdom. Mission-
aries were sent in 1490, with masons, carpenters, and other
skilled artisans. The Manikongo, most of his family, and some of
his great chiefs were converted; the capital was rebuilt in stone;
and many young Congolese were removed to Europe for educa-
tion. As was only to be expected, most of the early converts
proved not very serious; but concerning one of them, at least,
there was never any doubt. Nzinga Mbemba, baptized as Alfonso
in 1491, succeeded to the throne in 1507 and ruled as an ardent
and enlightened Christian until his death in 1543. It was his
wholly sincere wish to remodel his kingdom along the lines of
those of western Europe, and had the Portuguese been able to
sustain the partial altruism of their early contacts, he might have
gone far towards succeeding. Unfortunately, the extension of the
slave trade soon began to loom larger in Portuguese aims than
the creation of a Christian state in Africa.

There had been slavery in Kongo, as in every other part of
Africa, long before Europeans began to export slaves overseas;
and even Alfonso, though he made clear his dislike of the trade,
was willing to pay in slaves for the European goods and services
which he regarded as essential. The demand for labour in Por-
tugal's transatlantic colony of Brazil, however, was soon such
that it could be supplied only by more warlike means than Al-
fonso and his successors were prepared or able to employ. Though
a handful of missionaries continued to work in the Kongo king-
dom, Portuguese 'aid' soon dried up; and in 1575 Paulo Dias de
Novais was sent as a *conquistador* to inaugurate a new phase in
Portuguese relations with West Central Africa. Paulo Dias made

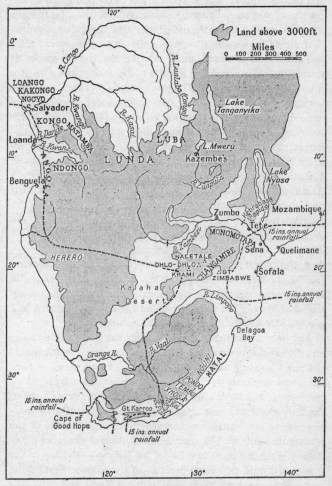

10. Africa from the Congo to the Zambezi

his base at Loanda, a little to the south of the Kongo frontier, and thence initiated a century-long war of conquest against the Ngolas of Ndongo. Officially, relations with the Manikongos remained peaceful. But the new Portuguese method of colonization, aimed principally at supplying the slave trade, was to train and arm bands of native 'allies' to make war on the peoples all round the slowly expanding frontier of the colony; and naturally it was not long before the Kongo kingdom's southern provinces became a favourite target for such forays, most of which were carried out by cannibal brigands called the Jaga or Yaka. Early seventeenth-century Manikongos, all of whom were still Christian in name, and some so in practice, addressed pitiful appeals to the Holy See through their missionaries. Several Popes showed a personal concern in the situation, and stern letters passed from Rome to Lisbon, but the Portuguese government declared itself powerless to control its subjects in Angola. Finally in 1660 the Bakongo turned to war – with disastrous results. Defeated by the Portuguese and their allies in a series of battles, the Manikongos were left too weak to maintain the internal unity of their kingdom. Peripheral provinces broke away, rival dynasties competed for the throne, even the missionary contacts with the outside world broke down; so that by the end of the eighteenth century Christianity was but a memory, and the former kingdom had shrivelled to a few villages around San Salvador.

Angola remained the supply-base for the Brazil slave trade, and during the seventeenth and eighteenth centuries was converted into a howling wilderness. The Kongo kingdom, as we have seen, was near enough to the storm to be torn apart by it. More interesting, and far less destructive, were the indirect effects of the Portuguese presence upon the peoples living in the far interior, where no Portuguese ever penetrated until the eve of the nineteenth century. The utter limit of direct Portuguese penetration in Angola was the valley of the Kwango – the first of the great northward-flowing tributaries of the Congo. Beyond the upper Kwango, between it and the upper Kasai, and eastwards again to the Lualaba, lived the Lunda. They were matrilineal Bantu peoples, not very unlike the original inhabitants of Angola

and the Kongo kingdom before their conquest by the Bakongo. From traditional history it seems that the Lunda had no large states or powerful chiefs until there appeared in their midst, perhaps towards the end of the fifteenth century, a small group of Luba ivory-hunters who proceeded, by diplomacy and prestige as well as by force, to build up a 'Sudanic' state whose kings later took the dynastic title of Mwata Yamvo. Moreover, as with other conquest states of this kind, the Mwata Yamvos' kingdom was soon surrounded by a mushroom growth of Luba-Lunda satel-lites, which by the middle of the seventeenth century covered a very large area indeed of the present southern Zaire, western Angola and northern Zambia.

Almost from the start of its existence, the Mwata Yamvos' kingdom was in indirect commercial touch with the Portuguese in Angola, and in this way was receiving firearms and powder, as well as cloth and other luxuries, from overseas. It is difficult in fact not to conclude that the larger state-building operation in this instance had an economic motive. The immediate perimeter of the Portuguese colony was dominated by the slave trade, and here warfare and destruction were the main result. Beyond this perimeter the main commodity of value for export was ivory, the hunting and handling of which, though highly lucrative, required large-scale organization of a political kind. This political and economic 'know-how' already existed in the Luba region of northern Katanga. It looks very much as though it was mainly in response to the economic stimulus provided by the Portuguese opening of the Atlantic coast that the extension of state-forma-tion into the vast area of Luba-Lunda domination was carried out.

The last large extension of the Luba-Lunda system was a south-easterly movement from the Mwata Yamvos' kingdom undertaken during the early eighteenth century, which established the important kingdom of the Kazembes, with its capital in the Luapula valley a little to the south of Lake Mweru. The Lunda of Kazembe, who established this new state with the aid of guns which came ultimately from the Portuguese in Loanda, were soon trading their ivory to the Portuguese stations on the

Zambezi. In this sense it may be said that Portuguese influence was indirectly felt from coast to coast of Africa.

South of Angola lay the parched lands of South-West Africa, with their sparse hunting and pastoral communities of Herero, Bushmen, and Hottentots. The Portuguese did not settle there, nor yet at the Cape of Good Hope, which seemed to them to answer better to its earlier name, the Cape of Storms. It was only in the middle of the seventeenth century, when the Dutch had discovered how to sail east on the trade winds, taking wide sweeps across both the South Atlantic and the south of the Indian Ocean, that the Cape acquired its unique position as the 'half-way house to the Indies'. For the Portuguese, who crossed the Indian Ocean on the monsoon from Moçambique to Goa, the Cape was merely an obstacle across their path, one apt to be the scene of shipwreck if storms were encountered on the return journey.

Most of our early information about South Africa comes, in fact, from shipwrecked Portuguese who trekked to safety across parts of the Transkei, Pondoland, Natal, and southern Moçambique. Their accounts show that at this time, contrary to the beliefs of most present-day white South Africans, South Africa was by no means empty of Bantu inhabitants. The Cape Province west of the Kei was inhabited only by Hottentots and Bushmen; but east of the Kei, peoples who can be identified as Xhosa and Tembu and Pondo and the Nguni ancestors of the Zulu lived very much where their descendants were living when they were overtaken by the Great Trek of the Boer frontiersmen in the 1830s and 1840s. Long before there were any white South Africans, the Bantu had in fact occupied the only parts of the sub-continent with a climate and rainfall suited to intensive agriculture. They had left the high and dry Karroo of the central plateau, like the deserts to the west of it, to the pastoral Hottentot and the Bushman hunter. These, therefore, were the immediate neighbours of the small Dutch colony planted at the Cape in 1652 in order to supply fresh food for the passing Indiamen. It was not until over a century later that the expanding

colonists first encountered the Bantu, near the Fish river, some five hundred miles to the east of Cape Town.

Apart from Zaire and Angola, the other principal scene of early contact between black and white was in the region of the lower Zambezi. Here, as we have seen, the Portuguese tried to take over a trade in gold and ivory which had been the main attraction of East Coast traders since the tenth century at least, and perhaps a little earlier. When the Portuguese took over control of Sofala at the beginning of the sixteenth century, they soon learned that the leading power in the interior was that of the Vakaranga, one of the Shona-speaking peoples of Rhodesia, whose ruler was known by the title of *Mwenemutapa* or, as the Portuguese usually wrote it, Monomatapa. At this period the capital of the Karanga kingdom lay a hundred miles or so to the north of modern Salisbury, at the northernmost edge of the Rhodesian plateau, which here drops away northwards to the Zambezi valley in a steep escarpment of nearly three thousand feet. This sixteenth-century capital thus lay nearly two hundred miles to the north of the main gold-bearing areas in the east and centre of the plateau. It also lay nearly three hundred miles to the north of the area of stone ruins, which coincides with the belt of boulder-topped granite hills in the southern sector of the plateau, where the land begins to fall gently towards the Limpopo in the south and the Kalahari in the west. According to their own account, however, the Vakaranga had moved north, under their Monomatapa dynasty, owing to the exhaustion of their salt supplies, only towards the middle of the fifteenth century. They remembered that in their former country the royal capital, or *zimbabwe*, had been made of stone. In all probability, therefore, the Monomatapa dynasty was in some sense the successor of that which had occupied the earliest stone-built royal capital and hill 'temple' at Great Zimbabwe, which archaeologists today attribute to a period from about the eleventh till about the fifteenth century. Among the major stone-built towns of Rhodesia, Great Zimbabwe is the main site where substantial buildings are known to date from the medieval period. Even at Zimbabwe much of the building that survives, including the most impressive structures

like the 'conical tower' and the great girdle-wall, are now known to date to the later part of the occupation, probably to the fifteenth century.

The Monomatapas, then, having moved northwards towards the Zambezi, had consolidated a very large area indeed under their suzerainty. They ruled the Zambezi valley for about seven hundred miles of its length, from the Kariba gorge to the sea. They ruled the northern and eastern parts of the great Rhodesian plateau, and the lowlands of southern Moçambique between the Zambezi and the Limpopo. The region which they did *not* succeed in ruling, or which quickly escaped from their control, was the region from which they had moved, that between Great Zimbabwe and Bulawayo. Here, at least by the late sixteenth or early seventeenth century, there emerged a rival state under rulers bearing the dynastic title of Changamire. To this region the Portuguese never penetrated. Yet it was here, and during the very period in which the Portuguese were in constant contact with the Monomatapas in the north, that most of the later developments in the region occurred, including the construction of elaborately walled 'chief's enclosures' at such places as Matendere, Naletale, and Dhlo Dhlo, as well as hill-top sites of less certain purpose, like that at Khami. The state of the Changamires was certainly participating in the external trade with the Portuguese, but it was doing so indirectly, through the 'fairs' established in the Monomatapas' dominions. And, as with the Lunda kingdoms, the stimulus of indirect trade contacts was happier in its effects than the direct Portuguese influences experienced by the Kongo kingdom and by that of the Monomatapas.

The first Portuguese contacts with the lands of the Monomatapas were with the tributary kingdoms lying in the hinterland of Sofala, and there is little doubt that Portuguese influence helped to loosen their bonds with the parent state. The next Portuguese moves were up the Zambezi, where they founded (or took over from Arab and Swahili traders) the river-ports of Sena and Tete. Here they were in territory directly ruled by the Monomatapas. Tete, occupied in 1560, was only four or five days' march from

the capital. The first Portuguese to go there was a missionary, Gonzalo de Silveira, who baptized the Monomatapa, but was immediately murdered at the instigation of the king's Muslim advisers. A series of military expeditions over the next fifteen years brought the Monomatapas into treaty relations with the Portuguese, and in the early seventeenth century this dependence was further reinforced when later Monomatapas required assistance against the rising power of the Changamires. In 1629 the Monomatapa Mavura declared himself a Portuguese vassal, and thus heralded his kingdom's final decline. On the one hand his dominion in the lower Zambezi valley was eroded by the establishment of Portuguese *prazos*, private slave-run concessions. On the other hand, more and more of his up-country subjects defected to the Changamires, who in a campaign lasting from 1693–5 finally drove the Monomatapas and their Portuguese overlords off the plateau, established a tributary dynasty in the centre of the old kingdom, and left the eighteenth-century Monomatapas to rule a tiny remnant of their former territories in the valley between Tete and Zumbo, as puny puppets of the Portuguese. The later history of the Changamires' kingdom has yet to be recovered by studying the traditional history of its surviving remnants. The short answer, however, is that it was brought to an end by the great Zulu warrior emigration from Natal during the second quarter of the nineteenth century, which will be described in a later chapter.

Viewed simply as an exercise in European colonization, the Portuguese achievement in Africa from the end of the fifteenth century until the end of the eighteenth was not great or constructive. Some of their missionary work was heroic; much more of it was mere time-serving by clergy unwanted at home. Some of its individual fruits were astonishing and impressive, but nowhere were adequate foundations laid to ensure the transmission of a faith very alien to earlier African beliefs and customs. Portuguese colonization was hardly more successful on the material plane. Angola was a mere shambles, in which the criminal classes of Portugal were employed in inciting the native peoples to make war on each other in the interests of slave labour for Brazil.

Moçambique, based on gold rather than on slaves, was a shade less bloody but hardly less vicious. The effect of the two penetrations into the African mainland was almost wholly injurious to the African societies with which they came into direct contact. The presence of the Portuguese was an advantage only to those who were fortunate enough to be a little further removed from them. Trade is always a valuable stimulus to those who take part in it: ideas are exchanged along with goods, the discoveries of one set of men are transmitted to another. It was not only that the Portuguese placed some of Africa in touch with the outside world; through the opening of new long-distance trade routes, different African societies were also placed in touch with each other. Of the imports into Africa from the outside during these three centuries, the most important were certainly the new food plants which the Portuguese introduced from South America. Three of these at least – cassava, maize, and sweet potato – made a tremendous difference to food supplies, especially in the more humid equatorial regions. There can, in fact, be little doubt that the depopulation caused in some districts by the slave trade was more than offset by the growth of population through these new means of subsistence in tropical Africa as a whole. Viewed as a period in African history, the three centuries in which Portugal was the dominant external influence were by no means insignificant.

12 The Turn of the Tide in Europe

For as long as the commercial relations between Africa and the outside world remained centred upon the slave trade, it was inevitable that contact should be slight and influence indirect. The maritime slave trader had no incentive to go inland from his coastal forts or hulks, and his operations did not make it easier for others to do so. To the inevitable difficulties of climate, disease, terrain, supplies, and insecurity, the slave trader always added the hostility of the African middleman communities, who bought cheap inland and sold dear at the coast, and were therefore quick to suspect potential competitors. Even more seriously deterrent, however, was the influence of the European slave-trading interest upon those in their own countries who might otherwise have attempted to make contacts of another sort. The slave trade was profitable enough to discourage almost all attempts to develop other kinds of commerce. Moreover, even though the absolute wickedness of slavery was a late discovery of the Christian conscience, the actual practice of the slave trade was so manifestly ugly, even to those who took part in it, that the prying eyes of the disinterested observer were very actively discouraged. In the older Portuguese colonies missionaries existed on sufferance, and the government of Portugal took the most active measures to prevent the Popes from sending to Africa missionaries who were not under its own control. Not until the anti-slave-trade movement had won a decisive victory in Europe itself was it practicable to organize from Europe any other kind of contact with Africa.

The slave-trading interest suffered its first serious reverse in Britain, mainly perhaps because it was there that it most obviously overreached itself. In the mid-eighteenth century, the

West Indies with their slave-produced sugar were described as the richest jewel in the English crown. Had the West Indian planters confined their use of slave labour to the Caribbean, it might have been much longer before they were attacked. When planters began to bring their domestic slaves back with them to England, however, they presented an obvious target for the attack of the more radical Christians, and despite the owners' care for the interests of property, the courts were eventually forced to declare that there was no such thing as slavery in English law. Lord Mansfield's famous judgment on a test case in 1772 was the first victory for a small pressure group composed mainly of evangelical Christians, who proceeded to organize a relentless campaign against the British slave trade, and later, with equal success, against the institution of slavery in Britain's overseas territories. Eventually Parliament was prevailed upon to pass a law in 1807 which made the slave trade illegal for British subjects, and to follow this up four years later with another Act imposing very heavy penalties on any who continued in it. As a result, it may be said that from 1811 Britons ceased to engage in the trade.

Nothing better illustrates the exclusive character of the slave trade than the fact that having once abandoned it, Britain immediately proceeded to attack its continued practice by other nations. This was not done out of pure philanthropy or even self-righteousness, but for sound commercial reasons. Since the trade in slaves was easier and more profitable than any other African trade, it had to be internationally suppressed before legitimate commerce between Africa and Europe could develop. The Danes had anticipated the British abolition by three years, the slave trade became illegal for the United States in 1808, and the Dutch outlawed it in 1814. Under British pressure, most of the other maritime nations followed suit after the Napoleonic wars, though at first Portugal and Spain (where the slave trade had only become *legal* in 1789) could be induced only to limit their slave trade to the seas south of the equator.

By about 1842 the carriage of slaves across the Atlantic was technically an illegal activity for the seamen of almost all European and American nations. But this did not mean the cessation

of the trade. In the first place, only Britain had both an adequate will and adequate naval means to enforce her laws on the high seas, though at times, and especially from the 1840s onwards, both France and the United States contributed some naval effort to the anti-slave-trade cause. Britain therefore engaged in a second diplomatic campaign, to persuade other nations to grant British cruisers the right to arrest slave-ships sailing under their flags. This campaign not unnaturally aroused considerable resentment abroad; little Portugal was virtually forced to comply, but France and the United States, ancient naval foes of Britain, steadfastly refused to give her the powers she sought. Secondly, while in the ancient sugar colonies of the British and French West Indies the slave interest was dying or dead, in the United States, Brazil, and Cuba it was rapidly expanding over virgin lands to meet new demands for cotton or sugar. As long as there was a profitable market for slaves in the Americas, men could be found to defy their countries' laws and to risk the British naval patrols. Though the naval measures against the slave trade began to have some effect after the 1840s, Britain became involved in yet a third campaign, to persuade or force African rulers to outlaw the export of slaves from their territories. France also acted similarly from time to time, but it was much more typically a British activity. In this way an important new element in the contacts between Europe and Africa began to develop. The presence of naval patrols made it possible for legitimate traders to operate, even in competition with slave traders, and from 1849 onwards, in addition to the cruisers there were consuls with the task of aligning African communities on the side of legitimate commerce. Ultimately, however, it was not any action in Africa which finally extinguished the slave trade, but the cessation of the demand on the other side of the Atlantic. The victory of the North over the slave-owning South of the United States in 1865 was rounded off by the final abolition of slavery in both Cuba and Brazil in the 1880s.

In Britain especially, the anti-slavery movement remained intimately linked with the religious enthusiasms of its founders.

Protestant Christianity had in general been slow to recognize its duty of preaching the gospel to every human being. For the first two or three centuries of their existence, the various reformed Churches had been almost exclusively occupied with the problems of their own survival. Towards the end of the eighteenth century, however, in pietistic circles of both Lutheran and Calvinist tendency, there swept over northern Europe a concern, almost unprecedented since the early centuries of Christendom, for the conversion of the non-Christian peoples of the world. The earliest manifestation of this movement was perhaps the formation in 1722 of the Lutheran sect later called the Moravian Brethren, every member of which regarded himself as a potential missionary to the heathen. In England the Baptists were the first to be affected and to found a Missionary Society in 1792, with British India as its primary field of operations. They were soon followed by independent and mainly Congregationalist groups who founded the London Missionary Society, which was to work first of all in the Pacific and in South Africa. In the Society for the Propagation of the Gospel, the Anglican Church already had an organization originally intended to minister to Anglican emigrants overseas, and this was to become increasingly concerned with missions to non-Christians, especially in southern Africa. In addition, in 1799 Anglicans of evangelical views founded the Church Missionary Society, which was to develop important fields of work in both West and East Africa. The early nineteenth century saw the foundation of many other Protestant missionary societies, of which the most important for Africa were the Methodist Missionary Society, with missions in West and South Africa; the Basel Society, with missions in West Africa; the Berlin Society, with missions in South and later in East Africa; the Universities Mission, a high Anglican society, with its field in the central part of East Africa; and the Mission of the Scottish Presbyterian Churches in South Africa, West Africa, and East Africa.

To the Roman Catholic Church, the idea of missions to the heathen was, of course, not a new one. Nevertheless, the missions undertaken during the sixteenth and seventeenth centuries in Asia, Africa, and the Americas had been to a very large extent

indeed undertaken by Portuguese and Spanish clergy, and in the eighteenth century the ecclesiastical effort of the Iberian countries declined along with their secular energies. In 1622 the Holy See had attempted to centralize the direction of missionary work in Rome by creating the Sacred Congregation of the Propaganda, but because of vested interests the Spanish and Portuguese colonies were excluded from its jurisdiction, and it was more than two centuries before any really fresh impetus occurred in Roman Catholic missions to Africa and the East. The most vital of these nineteenth-century movements began in France; and for Africa, by very much the most important was the re-foundation in 1848 of the Congregation of the Holy Ghost, whose members worked in West Africa, in the Gaboon, in the Lower Congo, in South-West Africa, and in the coastal regions of East Africa. A later development, again French in origin, was Cardinal Lavigerie's foundation in 1868 of the Society of Our Lady of Africa, commonly known as the White Fathers. From their original base in Algeria, the White Fathers were to undertake missions all over the centre of the continent, both in the interior of West Africa and on both sides of the Great Lakes, from Uganda in the north to northern Zambia in the south. Both of these great new orders, and their counterparts for women, were to become international in membership and in due course be joined in Africa by contingents from the older orders and congregations – Benedictines, Franciscans, Dominicans, Jesuits – as well as by those of many newer foundations such as the Society of the Divine Word and the Mill Hill Society of St Joseph.

The foundation of a great missionary society, even more than that of a government department or a great commercial company, is something which takes time to get under way. Recruits have to be found and trained for many years. Financial support has to be developed through a wide network of worshipping congregations. The setbacks arising from the first and inevitably costly ventures into the unknown have to be overcome. Half way through the nineteenth century, the missionary movement into Africa was still only beginning to gather momentum. Not until the seventies did it acquire any really impressive geographical spread. But the

existence of the movement in embryo from the end of the eighteenth century onwards was one of the great new factors in the relationship between Europe and Africa. It was perhaps through the actions of their missionary representatives as much as through the actions of their governments that the people of Europe, and later of America, were to make their influence felt among the peoples of Africa. And missionary action, unlike that of governments, was not confined to the narrow circle of the colonial powers.

Before any of these new influences, whether missionary or commercial, could play directly or strongly upon the African scene, there had to be an end to the outside world's almost total ignorance of Africa. To late eighteenth-century Europe, Africa was little more than a coastline, a coastline not very representative of the interior. North Africa was a part of the Muslim world, which was still almost closed to Christians from the west. The Barbary states, famed for piracy, were known mainly through the accounts of the few Christian slaves who had been captured by the corsairs and been fortunate enough to escape or be ransomed. A handful of Europeans disguised in Arab dress had travelled up the Nile from Cairo. One or two, including the Scottish laird James Bruce, had penetrated to the Ethiopian capital at Gondar or to that of the Funj kingdom at Sennar on the Blue Nile. Among the other great rivers of Africa, the Zambezi was known for some seven hundred miles from its mouth, and the Congo for less than a hundred. No European had yet seen the Niger, the very mouth of which was unknown. Following the mistake of Leo Africanus in the early sixteenth century, it was widely believed to flow from east to west. The only African societies known to eighteenth-century Europeans were those of the forest regions of West and West Central Africa. Despite the writings of Leo Africanus, and despite the seventeenth- and eighteenth-century probings up the Senegal by the French, it was scarcely appreciated that behind those forests to the north there lay open country where peasants grew grain crops and pastured cattle, and where Muslim town-dwellers traded their manufactures on camelback to Egypt and the Maghrib. It was certainly

unsuspected that behind the forests to the east the spine of
Africa consisted of high plateaux, four or five thousand feet above
sea level, all the way from Ethiopia to the Cape.

The European exploration of inner Africa was in large
measure yet another manifestation of the humanitarian movement
which was attacking the slave trade and seeking to put Christian-
ity and legitimate commerce in its place. The geographical
movement started just before the end of the eighteenth century,
and it took about seventy-five or eighty years for the main facts
to be established. The first probings were made from the north
and west, under the auspices of the Association for the Discovery
of the Interior Parts of Africa, a small group of wealthy English-
men of whom some were prompted mainly by scientific and
others mainly by humanitarian interests. It was the 'African
Association' which financed the notable first journey of Mungo
Park in 1795-7 to the upper Niger, an expedition which establi-
shed that the river flowed eastwards. It was the influence of some
members of the association, notably Sir Joseph Banks and Sir
John Barrow, which succeeded in implanting in the British
Government the idea that African exploration was a proper sub-
ject for official expenditure. It was in British Government pay
that Park returned to Africa, to sail down most of the course of
the Niger in 1805-6; that Denham and Clapperton explored
Bornu and Hausaland after crossing the Sahara from Tripoli
during 1823-5; that the Lander brothers traced the course of the
lower Niger to the sea in 1830; and that the great German ex-
plorer Heinrich Barth undertook his meticulous explorations in
the central and western Sudan during 1850-55.

Until the eve of their great political expansion in the 1870s, the
French contributed surprisingly little to the exploration of wes-
tern Africa, in view of the extent of their previous involvement
in the slave trade and of their earlier penetration of the Senegal.
Only the great 1827-8 journey of René Caillié, from the Rio
Nuñez to Timbuctu and across the Sahara to Tangier, really
compares with journeys such as those of Park or Clapperton, and
this was a private initiative unsupported by government. In view
of developments after 1883, however, it is worth recording the

not inconsiderable part taken by German-speakers in the European opening-up of Africa, both as explorers and as missionaries, though sometimes, like Barth, they found their opportunities under British auspices. Early German activities were by no means confined to western Africa. The pioneers both of missionary work and of the exploration of the interior on the East African mainland were two German members of the Church Missionary Society, Krapf and Rebmann, who in 1847–9 were the first Europeans to see the snow-capped peaks of Kilimanjaro and Mt Kenya. Between 1862 and 1869, Gerhard Rohlfs made very extensive journeys in the North African Sahara, and his work was later extended by other Germans, notably Gustav Nachtigal, who in 1870–4 explored the Sudan between Lake Chad and the Nile. During 1860–72, Karl Mauch was the first European in modern times to explore the region of the ancient Monomotapas. The Moravian Brethren were the first Protestant missionaries to Africa, arriving at the Cape in 1792; the Basel Mission was the first on the Gold Coast in 1828, and was followed there by the Bremen Mission in 1847, the year in which the Rhenish Mission was the first to be established in South-West Africa.

On the whole, however, it may be said that Europe's interest in the exploration of southern and eastern Africa began only when the geographical problems of West Africa were approaching solution, and that the initiative here again was a British one. It is significant that despite the existence of a colonists' frontier in the south, it was the missionaries who at every stage of nineteenth-century South African history lived farthest north; and it was a missionary, David Livingstone, who in 1853–6 travelled from the south overland to the Victoria Falls and thence westwards to Loanda and eastwards again to the mouth of the Zambezi. Livingstone published his explorations under the title of *Missionary Travels and Researches*, and it was as a missionary that he aroused the enthusiasm of Victorian England for the opening of this side of the continent to the 'Christianity and commerce' which were to relieve its inhabitants from ignorance, famine, and disease, and from the attentions of the East Coast slave-trader. The 'African Association' had by this time developed

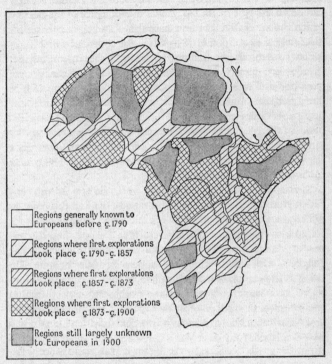

Regions generally known to Europeans before c.1790

Regions where first explorations took place c.1790-c.1857

Regions where first explorations took place c.1857-c.1873

Regions where first explorations took place c.1873-c.1900

Regions still largely unknown to Europeans in 1900

11. The discovery of Africa by European explorers

into the popular and powerful Royal Geographical Society, subsidized by the Government and with presidents who had easy access to Ministers and Departments of State. It was the Royal Geographical Society which sent Burton and Speke to Lake Tanganyika in 1858, and Speke and Grant to the Victoria Nyanza and down the Nile in 1862–4. It was the influence of the Society which procured Livingstone a consulship and the expenses for his Zambezi expedition of 1859–64, in the course of which Lake Malawi was discovered. Livingstone's last six years of journeying, in 1867–73, mostly around the upper reaches of the Congo, were undertaken at his own expense. His books had made him into a rich man, and his popularity was so great that an American newspaper proprietor was able to start the young war correspondent, H. M. Stanley, on his career as an African explorer by sending him on an expedition to find Livingstone. Stanley's famous phrase – 'Dr Livingstone, I presume' – was the climax to the scoop of the century.

Stanley's next African journey, in which he crossed the continent from Zanzibar to the Congo mouth, marked the point at which the exploration of Africa became involved in schemes for its political annexation. On his return to Europe, Stanley was met at Marseille by the representatives of King Leopold of the Belgians, with results which will appear in a later chapter. Up till then the exploration of Africa had, in mid-twentieth-century terms, been something between the world refugee problem and the conquest of space. Not in Britain only, but all over Europe and America, unknown Africa was the field in which heroism was best displayed. And yet it was a heroism deeply dyed in philanthropy, because it was a firm belief both of the explorers and of their public that the object of the exercise was the regeneration of the Negro race and its adoption into the mainstream of human progress. During the classic period of African exploration, it was seldom imagined that this process of redemption was one which would involve the taking of political power. This was the age of *laissez-faire*, and it was generally assumed that the Christian gospel, combined with the natural propensity of man to traffic and exchange, would prove a sufficient stimulus. Missionaries would

teach the Africans both to cover their nakedness and to obey the moral law. Traders would supply the means to satisfy the first requirement in the shape of bales from the mills of Lancashire, which would be exchanged for the primary produce grown by industrious, thrifty, Christian, African peasants. Tribes would combine into federations for the better advancement of commerce, and so the nations of the future Africa would be born.

Governments, in their wisdom, were perhaps a little less starry-eyed than the general public. Governments knew that in West Africa the palm-oil trader would not have superseded the slave-trader without the aid of the gunboat. Governments knew that nowhere outside eastern Nigeria was there the unique combination of an economic crop and a network of natural waterways by which it could be conveyed to the coast. Governments knew that in most parts of Africa beasts of burden, if they were introduced, died within a few weeks, and that the real opening of the African interior to trade would have to await the building of railways. Governments, had they thought about it, might well have doubted whether developments on this scale could be carried through without radical changes in political control. But governments before the middle seventies of the nineteenth century did not think these things through to their logical conclusion, because they had no intention at all of allowing themselves to be drawn into policies of territorial expansion in Africa. The whole trend of European thought was against such expansion, and certainly there seemed to be no economic wealth in Africa which could possibly justify the expense. In fact, the eyes of European governments were as always mainly concentrated upon each other, even within the African theatre. Each was content with informal and overlapping empires of 'influence', so long as the others exercised a similar restraint. The situation was nowhere vastly different from what it had been in the eighteenth century. Europe had now definitely turned its gaze upon Africa, and Africa was changing under its influence; but Europe was not yet even sharpening the sword of formal empire, and for the first three-quarters of the nineteenth century the history of Africa is by no means synonymous with that of Europe in Africa.

13 The Nineteenth Century:
North and West Africa

Towards the end of the eighteenth century, the uneasy balance of power between Christian Europeans and Muslim North Africans which had survived in the Mediterranean since medieval times began at length to move decisively in favour of Europe. While generally this was due to the growing might of material western Europe, compared with the relative stagnation of the Islamic world since the fifteenth century, it was particularly occasioned by a revival of European interest in the direct route to Asia through the Levant. Initially, following the Portuguese and Spanish example, the growing commercial and imperial energies of Europe had been diverted outwards into the Atlantic. But during the great war of 1793–1815, the global eighteenth-century struggle for oceanic power between Britain and France had been finally resolved in favour of Britain, with the result that the French were attracted to the old road to Asia through Egypt. In 1798, British naval power frustrated Napoleon's expedition to Egypt (as it was also to frustrate French ambitions in the Omani realm in the Persian Gulf and East Africa), but on land Britain thought it politic to recall to Egypt her nominal suzerain, the Ottoman Turks. The splendid medieval anachronism of Mamluk power could not survive the impact of modern arms, and by 1811, despite British interference, control of Egypt had passed to the Albanian troops of an Ottoman army commanded by Muhammad Ali.

Muhammad Ali (Mehemet Ali) was a man of quite remarkable ability, ambition, and vision. When, as a failing man of seventy-five, he handed over power to his son and lieutenant Ibrahim in 1847, he had gone far towards transforming the medieval

province of the Ottoman empire to which fortune had brought him into an independent modern state. He had been least successful in his foreign policy. Ibrahim's military successes in Syria, intended to secure the complete independence of Egypt from Constantinople by restoring her traditional empire, had been undone by European and particularly British diplomacy, which preferred that the gateway to India should remain under the weaker Turkish power. Egypt therefore stayed technically part of the Ottoman empire; Muhammad Ali was able to secure no more than the recognition of Egypt as an autonomous province under the hereditary rule of himself and his heirs (who in 1867 were granted the title of Khedive). Nevertheless the Sudan had been conquered, and the reality of Turkish power in the Red Sea had been made firmly Egyptian. Within Egypt itself, irrigation, land tenure, revenue, and administration had all been drastically overhauled, and cotton, indigo, and sugar had been developed as export crops by a system of state monopolies. The interests of European traders were to some extent protected by the institution of new non-Muslim courts, and European experts were brought in to promote educational and health reforms, and above all to help train a new Egyptian army. Muhammad Ali's régime was entirely autocratic, but the disbandment of his Albanian regiments (whose jealousy and untrustworthiness were soon manifest) and their replacement by Egyptian conscripts sowed the seeds for the growth of Egyptian nationhood in the future. Once Egyptian officers had risen to the command, ultimate power in Egypt would be in Egyptian hands, a thing which had not been known for two thousand years.

Immediately, however, the future of the new Egypt depended entirely on the personal qualities of its rulers, and Muhammad Ali's absolute power descended to heirs who could not match his drive and purpose. Foreign merchants, concession-seekers, and money-lenders were permitted to exploit the new economy. The British, concerned with passing mails and men quickly to India, gained a significant foothold in the 1850s with their construction of the railway from Alexandria to Cairo and on to Suez. In 1854 a concession was granted to a former French consul, De Lesseps,

to build and operate the Suez Canal. This was eventually completed by 1869, in the teeth of formidable diplomatic and financial obstructions created mainly by the British, who were incapable of foreseeing that developments in steam propulsion would soon totally outmode the old sailing route to India by the Cape, and mistakenly supposed that the canal would mainly benefit France. The cost of the canal to Egypt was great. The terms of the concession involved her in the loss of lives, land, and revenue, while (as Muhammad Ali had foreseen in resolutely opposing earlier projects) Egyptian independence was now at the mercy of the European maritime powers who were the canal's principal beneficiaries. The truth of this became manifest in 1879 when the Egyptian government became bankrupt, largely because of the Khedive Ismail's reckless policy of pledging the revenue to secure foreign loans (on terms which favoured only the foreign capitalists and their agents in Egypt) which were then spent on sometimes splendid but often unremunerative modernization schemes. Eventually Turkey was prevailed upon to depose Ismail, and control over the Egyptian revenue and hence ultimately over its government was given to British and French nominees.

The containment of French ambition in Egypt in 1798–1801, and Muhammad Ali's subsequent achievement there of virtual independence from Turkey, produced a chain of reactions elsewhere in Mediterranean Africa. In 1830, with no British fleet to frustrate it, and with a government anxious to secure overseas the success denied it at home, a French force occupied Algiers. The most reasonable of the various pretexts for this action was the need finally to extirpate corsairing, which had tended to revive during the years between 1793 and 1815 when the European navies were principally engaged with one another. Algiers was more vulnerable than other Maghribian states which had engaged in corsairing. In 1835–6, the Turks, frightened both by Muhammad Ali's achievement in Egypt and by the French action at Algiers, took steps to restore their authority at Tripoli, and they were kept out of Tunis only by French naval demonstrations.

The Tunisian Beys were quick to appreciate the significance of these events. They had already taken steps to outlaw corsairing,

and they now proceeded to westernize their administration. In 1857 they were in fact the first Muslim rulers ever to grant a constitution to their people. Had it not been that the Husainids' programme of modernization was accompanied by financial extravagances similar to those of the Egyptian government, it is possible that Tunis might have remained independent longer than it did, for French ambitions there were to some extent checked by rival Italian interests. But the financial embarrassment of the Bey's government eventually gave France the opportunity to proclaim a protectorate over Tunisia in 1881. Moroccan independence, however, was preserved into the twentieth century – not by her own efforts, for tribal anarchy had steadily gained ground since the great days of the Sa'dids, but by the mutual jealousies of the European powers. Her strategic position at the gateway to the Mediterranean was such that neither France, nor Britain, nor nearby Spain dared interfere in Moroccan affairs for fear of antagonizing the others.

For most of the nineteenth century, then, direct European intervention in North Africa was confined to the activities of the French in Algeria. But although it had been easy for the French to seize the town of Algiers and the person of its Bey, and then to occupy the other major ports of the territory, it was by no means easy to decide upon subsequent policy. No French government was prepared to surrender a conquest won by French arms; the question was rather how far the French were willing to go in subjugating the Arab and Berber tribes of the interior. In 1832 these showed their hostility to the foreigner by rising in a *jihad* inspired by 'Abd al-Kadir, the son of a *marabout* (holy man). The tribal attacks made any idea of occupying only the coastal plain impossible. Eventually, in 1840, General Bugeaud embarked on a policy of relentlessly expelling the tribes and replacing them by European colonists. But even this drastic policy could not provide a final answer to the problem facing the French, because it was clearly impracticable to push all the Algerian tribes into the Sahara. It became necessary for the mountains and steppes to be systematically occupied by military posts and swept by flying columns. Despite the capture and exile of 'Abd al-Kadir

in 1847, Algerian resistance did not cease until about 1879, when the French army had effectively subjugated all the tribes between the sea and the desert.

By this time the French had to think of what to do with the vast territory which 150,000 soldiers and perhaps as many pioneer colonists had died to make French. Those parts of the northern plains which received regular winter rains (the *Tell*), and which had been largely cleared of the tribes, could be colonized and assimilated to the civil government of metropolitan France. For the rest, the French were forced to recognize what Napoleon III had seen, that Algeria was not only a French colony but also 'an Arab kingdom'. Muslim tribesmen could not be quickly assimilated. The system of *bureaux arabes* initiated by the army had to be adapted into an enduring system by which French officials ruled the people through their tribal chiefs and councils. Even with this compromise, the future of *Algérie Française* was by no means assured when in 1879 military government finally gave way to civil administration. There was no clear reason why Frenchmen should want to emigrate to Algeria, where land, disease, and native peoples were all hostile, and there to try to produce crops which would only compete with those grown by established farmers in Mediterranean France. In fact, of the 350,000 Europeans who were living in Algeria by 1880, nearly half were not French at all, but Spaniards, Italians, and Maltese. Moreover, the more successful the settlers were in creating farms and dams, in building roads and railways, schools and hospitals, the more they were bound to incur the envy and suspicion of the native population, shut away in the poorer lands and, under the peace imposed by France, steadily increasing in numbers.

France sought compensation in West Africa also for the loss of her old empire, which had been finally destroyed by the British during 1793–1815. On the coast, however, the pace was increasingly set by the British, who exhibited a much firmer commercial purpose than the French, and who were thoroughly committed to the campaign to oust the slave trade and to replace it by new

trades and a new order. Over most of the interior, until the 1870s, the initiative still lay with the African peoples. In the Senegal valley, however, France had an inheritance from her old empire which she could seek to develop. In the seventeenth and eighteenth centuries, the Senegal had been remunerative merely as a highway to the trade of an independent Sudan. Attempts to create a plantation colony having failed, it was left to a young army officer, Louis Faidherbe (who in Algeria had acquired both military experience and a considerable understanding of Muslim Africans) to show what might be made of the Senegal. Appointed governor in 1854, Faidherbe undertook the systematic conquest of the Senegal basin and the conversion of its inhabitants into farmers producing crops, notably groundnuts, of value to France. When he left the colony ten years later, it was already a sure base for the later French conquest of the western Sudan with Senegalese soldiers. Indeed, the French were already matching their strength against the empire of al-Hajj 'Umar, the westernmost representative of a remarkable new recrudescence of Muslim power in the region.

Islam had initially been brought to and spread through Negro West Africa by merchants. These had little incentive to subvert the societies with which they traded. In the Sudan, as was seen in Chapter 7, kings and courts often saw advantages in professing the new religion, but both the fundamental organization of society and the means used to control it remained essentially pagan. However, the Moroccan destruction of Songhai power opened the Niger bend to domination by pastoral tribes from the Sahara. Following their conquest of the Maghrib, some Bedouin had entered the desert, and a number of its Berber tribes had become not only Muslim but thoroughly Arabized. These tribes provided a path for the establishment in West Africa of brotherhoods (*tariqa*) of divines who were committed to the achievement and expansion of a wholly Muslim society; if persuasion and education were not sufficient to this end, then *jihad* could be preached. The rulers of the major Sudanic kingdoms to the east and west of the Niger bend, the kings of the Hausa and the Bambara Mande, were obvious targets

for this new breed of clerics who were both learned and militant. In their eyes these rulers were pagans or as good as pagans.

The major agents in changing this state of affairs proved to be the Fulani, the only West African Negro people to practise pastoralism. This fact, together with a number of physical traits which tend to distinguish the Fulani from other West Africans, has led to conjectures that they were originally of Saharan origin. But their language is indubitably a Negro language, belonging to a West Atlantic sub-family of Niger-Congo along with languages like Serer, Wolof and Tucolor; indeed it is hardly distinguishable from the latter. When first met with in history, the Fulani pastoralists were living with the Tucolor, the people of the ancient Senegalese kingdom of Takrur, Ghana's contemporary and western neighbour, which had been Islamized in the eleventh century. By about the fourteenth century, however, the Fulani were beginning to spread eastwards through the Sudan as pastoralists, infiltrating themselves and their herds between the agricultural villages. By the sixteenth century they were strongly established in Massina, upstream from the Niger bend, and were penetrating Hausaland to the east of it. Two centuries later some of them were settling in Adamawa in the northern Cameroons. Most of the Fulani remained pagan herdsmen (*Fulanin boroje*) who managed their own affairs quite independently of the peoples among whom they lived. But some became not only Muslims, but also some of the most devout and learned of Sudanese clerics. There were probably a number of reasons why this was so. The Fulani maintained kinship links with the long Islamized Tucolor. Some of them settled in the towns of the Sudan, doubtless as agents for their pastoral brethren, and in this alien environment, where strangers were commonly Muslims, it would not be easy for them to maintain their traditional pastoral pagan practices. Finally, some of those who remained in the countryside as pastoralists must have felt an attraction to the *tariqa* of the equally pastoral Arabized-Berber tribes, the more so as their numbers and those of their cattle grew, and so provided increasing occasions for friction between them and the

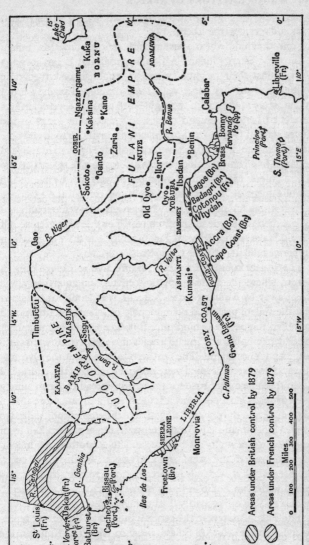

12. West Africa in the nineteenth century

pagan societies who owned the land and sought to levy rent, taxes and services from them.

From the middle of the seventeenth century onwards, Fulani in the far western Sudan, in Bondu and Futa, began to wage *jihad* against their neighbours and to establish new theocratic polities. But the first large-scale *jihad* developed in the central Sudan. Here at the end of the eighteenth century severe tensions developed between Fulani clerics and successive kings of the Hausa state of Gobir. In 1804, an exceptionally learned and able cleric, Usuman dan Fodio, saw no alternative open to him but to declare a *jihad* and to call on true Muslims to rise against all the Hausa rulers. Many Hausa commoners were not averse to the establishment of Islamic law to limit and control the exactions of their kings and nobility, but what gave the movement initiated by Usuman the single momentum which enabled it to replace all the old Hausa dynasties with Fulani emirs was the way in which the *boroje* rallied to the call of the Muslim Fulani.

The Fulani conquerors met with effective resistance only in Bornu, where the ancient but now effete Kanem dynasty was swept away by Muhammad al-Kanami, who stoutly maintained that the Fulani possessed no monopoly of Islamic rectitude, and so rallied the people behind him. But Adamawa became part of the Fulani empire, and Fulani armies also swept southwards into Nupe and Yorubaland. The northern provinces of the Oyo empire and its historic capital were occupied, and, as the emirate of Ilorin, became a firm base for the steady spread of Islam among the Yoruba. Dan Fodio was a scholar and a divine more than a statesman, and the practical direction of the empire soon passed to a son, Muhammad Bello, who oversaw its larger eastern half from Dan Fodio's new city of Sokoto, and to a brother, Abdullahi, who controlled the west from Gwandu. Both these men, Bello especially, were also extremely competent scholars, and joined with Dan Fodio in the epistolary wars which were waged against al-Kanami to justify the Fulani *jihad*.

The Fulani success in the central Sudan had important repercusions farther west. A Fulani cleric in Massina, Ahmadu ibn Hammadi, was inspired about 1818 to lead a *jihad* against its

Bambara overlords, and shortly another Muslim Fulani state had been created. Further west still, the standard of Muslim revolt was raised by al-Hajj 'Umar, a Tucolor who on his way back from his pilgrimage to Mecca had spent some time at Sokoto, where he had, indeed, married a daughter of Bello's. 'Umar followed the traditional pattern of training in a *ribat* an *élite*, which he equipped with firearms secured from the coast. By about 1850 this force was ready to move out in a *jihad*. In the upper Senegal it was checked by the French, but 'Umar's men quickly overran the Bambara kingdoms and also conquered Massina. By 1863, therefore, 'Umar possessed an empire reaching from the Senegal to Timbuctu. But, whatever his own original motives may have been, most of his followers seem to have been concerned as much with plunder as with the advancement of Islam, and there were numerous risings against him by both Bambara and Fulani. In 1864, 'Umar was killed while fighting one of these, and he left a very disturbed inheritance to his son and successor Ahmadu Seku.[1]

It is tempting to suppose that these new empires were at least in part a Sudanese reaction to the course of events elsewhere in West Africa. Considered together with the *jihads* of 'Abd al-Kadir in Algeria and of the Mahdi Muhammad Ahmad in the Egyptian Sudan, they certainly suggest that African Muslims were demonstrating their opposition to alien pressures. But in the case of the western Sudan it is not immediately obvious what these pressures were. A direct European menace can hardly have been felt outside the Senegal valley before about 1880. However, one of the principal directions of Fulani advance was south into Yorubaland, while al-Haj 'Umar's first attempts to expand were directed down the Senegal. This suggests that the increasing reversal of the flow of trade from the trans-Saharan routes towards the coast may have begun to have an appreciable effect on the economy of the Sudan, and that its peoples were accordingly reacting to some extent against the new concentrations of wealth and power in Guinea. If so, the moment was propitious. As is perhaps most obvious in the case of the Oyo empire, the general growth of

1. And, also, it may be remarked, the nephew of Sultan Bello of Sokoto.

European trade and influence at the coast was leading to a fatal undermining of the Guinean powers.

The ultimate result, of course, was to bring the Sudan eventually into a fatal headlong clash with European strength. At first, however, this was more obvious in the case of France than in that of Britain.

Compared with the French conquests on the Senegal, there was for some time little formal advance of British power in West Africa. A new colony began to take shape around Freetown in Sierra Leone at the end of the eighteenth century, but this was initially a private venture of the anti-slavery humanitarians. These had the dual aim of finding a home for a few unwanted Negro ex-slaves from Britain and North America, and of establishing a base from which legitimate trade could reach into Africa. In this latter purpose they were wholly unsuccessful, and their colony survived only with difficulty until 1808, when it was taken over by the British Government as a base for its anti-slave-trade naval patrols. Until the close of the nineteenth century, British Sierra Leone comprised only a few square miles around Freetown, but it exerted a much greater influence on the course of West African history than either of the other two settlements of freed slaves which were made on the coast in this period.

Liberia began as a venture of American philanthropists in 1821. When it was formally constituted an independent republic in 1847, it consisted of only a few thousand Negro settlers, striving to maintain themselves and their ideals against the hostility of the native tribes, with little or no outside support. Its foster-parent the United States did not even formally recognize it until 1862. Libreville, established by the French on the Gaboon in 1849, was consciously modelled on Freetown, but it remained essentially stagnant until the eve of the European partition, mainly because France's naval activity against the slave trade was only fitful. Britain, on the other hand, maintained an anti-slave-trade patrol in West African waters continuously from 1807 until the 1860s, and one important result of this was that by the mid-century something like 70,000 Negroes captured from slave-ships

had been liberated and settled in Sierra Leone. Many of these freed slaves became assimilated to European ways, especially as a result of the educational work of the Protestant missions, who deliberately chose Sierra Leone for their first footing in West Africa. Some of the liberated Africans became considerable traders along the coast, while others augmented British resources by becoming priests, doctors, lawyers, administrators, and clerks in the service of the British missions, trading companies, or Government. When, as some of them did, they returned to their homelands, especially to Yorubaland, they became agents for the further expansion both of Christian and of European influence. Sierra Leone had an even more direct influence in that its early governors soon became convinced that the most effective way of stopping the export of slaves from West Africa was by establishing British rule or protection over the principal slaving coasts. Thus, for example, in 1821 the British forts on the Gold Coast were transferred to the Colonial Office from the merchants who had hitherto controlled them.

This forward policy did not immediately bear fruit. For a Britain which was steadily moving towards *laissez-faire*, the cost of extending British rule in West Africa seemed disproportionately great in relation to the visible commercial or humanitarian benefits, and a number of early acquisitions, such as the Isles de Los (off modern Conakry), were eventually abandoned. The numbers of slaves carried more or less surreptitiously across the Atlantic in Brazilian, American, and Spanish vessels hardly decreased before the end of the 1840s, and the British trade in other commodities soon appeared to be thriving best in the Niger delta (then known as the Oil Rivers), where it had no official backing. And so when Britain became involved in war with Ashanti on the Gold Coast, and a governor of Sierra Leone was killed there (1824), official policy was reversed.

From 1830, however, an administrator nominated by the merchants, George Maclean, demonstrated how British trade and influence on the Gold Coast could increase with only negligible expenditure, through an informal jurisdiction over the coastal states coupled with a firm but peaceful attitude towards Ashanti,

and in 1843-4 official British control of the Gold Coast forts was resumed. The lessons of Maclean's time were not wholly learnt, and trade declined. The fundamental explanation for this was a perpetual conflict of jurisdiction with Ashanti. Ashanti, like Dahomey, its neighbour to the east, was now a stable military state whose days of imperial expansion were largely over and whose interests lay in the development of its foreign trade. But unlike Dahomey, Ashanti had reached the coast only after European traders had become firmly entrenched there. Thus whereas Dahomey could largely control these traders and, for that matter, continue to export slaves (mainly from Yorubaland), Ashanti could not. Instead the Europeans, more particularly the British, tended to make common cause against Ashanti with the small coastal states which, in Ashanti eyes, were her subjects through conquest. Both the Danes and the Dutch, the only other Europeans still holding forts on the Gold Coast, eventually came to the conclusion that without the slave trade their connections with West Africa were hardly profitable. In 1850 and 1872 respectively they handed over their forts to the British and left. Their departure meant that it was now possible for the British to assert their direct rule over the whole Gold Coast. An attempt by the coastal states themselves to establish their own European-style administration was thwarted; Ashanti was warned off by a punitive expedition which sacked its capital, Kumasi; and in 1874 the Gold Coast was declared a British colony.

The growth of Britain's power on the Gold Coast brought her into closer touch with the increasingly troublesome affairs of the territories further east. Here two apparently contrary tendencies were at work. On the Slave Coast, both the kingdom of Dahomey and the European exporters to Brazil and Cuba were thriving from the slave trade as never before. Most of the slaves came from a Yorubaland where the Oyo empire was collapsing into civil war and anarchy. Around the mouths of the Niger delta, on the other hand, European traders – principally British – were joining with African merchants and potentates in enriching themselves by the export of palm oil and kernels from the forests just north of the delta. African city states on the coast were

engaged in developing commercial monopolies in the interior, and were vying bitterly with each other and with the Europeans to secure the maximum profits from the trade.

Early British attempts to deal with these problems were fruitless. Diplomatic missions failed to persuade Dahomey to stop exporting slaves. In 1841 an official expedition up the lower Niger, attempting to use the Landers' experience and to by-pass the turbulent Oil Rivers by taking British trade and Christian missionaries directly into the hinterland, demonstrated only the hostility of the mosquitoes and of the established traders in the delta, black and white alike. But the interests of British commerce, of the campaign to eradicate the slave trade and to replace it with legitimate trade, as well as the concern of the missionaries, who by the 1840s were following the Sierra Leone emigrants into disturbed Yorubaland, all combined to force some action on the British Government.

In 1849 the British Foreign Office began to send out consuls to the Gulf of Guinea. These had the dual purpose of keeping an eye on the slaving activities of ports like Whydah, Badagri, and Lagos, and of trying to bring some order to the Oil Rivers, where British merchants were all too ready to try to blast their way out of disputes with the numerous African governments by calling in cruisers of the British West African naval squadron. Some of these consuls, notably the first, John Beecroft, were forceful men, and with naval backing the consular jurisdiction began to bring results. Neither funds nor force were available for a direct assault on Dahomey, but in 1851 Lagos was captured and ten years later it was formally constituted a British colony. This action, together with later coastal annexations, including that of Badagri, put an end to the export of slaves from Yorubaland and permitted a virtually complete blockade of Dahomey. In the Oil Rivers, the work of the British consuls and navy in bringing the local kings within the realm of an informal British jurisdiction gradually paved the way for an eventual British administration.

But this still lay in the future. In 1879, the year in which the French began their advance into the Sudan from the Senegal, and Goldie mobilized the British traders to force open the Niger

waterway, West Africa was still largely free of European penetration. The Senegal was firmly French, and for strategic reasons the French had in 1857 also occupied Cape Verde.[1] Britain's flag had followed her trading or humanitarian interests to the mouth of the Gambia and to the coasts of Sierra Leone, the Gold Coast, and the future Nigeria, but her power had hardly been felt inland. Ashanti was still the only major Negro kingdom to have been invaded by a European army, and after 1874 she was left alone to recover her strength. The old commercial link between Europe and West Africa had been broken with the suppression of the Atlantic slave trade, which had been practically extinguished by the mid 1860s. But few new staples of trade had been found besides the two oil crops, palm kernels, and groundnuts. The humanitarian interest apart, little had yet been done to bring West Africa into the European fold.

1. Thus acquiring an ideal site on which to build Dakar, eventually to be the metropolis of a vast French West African empire.

14 The Nineteenth Century: Southern Africa

Before the onset of the colonial fever in the 1890s, Europeans had already made substantial inroads into the southern third of Africa. During the first three-quarters of the nineteenth century, events there were dominated by the expansion of European settlement north-eastwards from the Cape of Good Hope. By 1880 this stream of settlement was already touching the Limpopo, over a thousand miles into the interior from its base at Cape Town. Indirectly its influence was being felt even further afield, with missionaries and traders from the South African colonies producing an impact as far north as the Zambezi. In particular, Livingstone's great transcontinental journey of 1853-6 was to have important consequences both for the Bantu peoples of central Africa and for the long-established zones of Portuguese interest in Angola and Moçambique.

When the Dutch East India Company founded its refreshment station at the Cape in 1652, the last thing it had intended was to become involved in the African interior. But to provide for the defence of its settlement, and to secure an adequate supply of cheap foodstuffs for its passing East Indiamen, the Company found it necessary to attract colonists to the Cape. Very soon, however, the settlement had outgrown its purpose. By the time the policy of encouraging immigrants was reversed, the colonists were already chafing at the restrictions imposed on their freedom of action by the Company, and were suffering from the inadequacy of Cape Town and its visiting ships as a market for the sale of their produce. During the course of the eighteenth century, as their numbers grew by natural increase, more and more settlers went to seek a new life in the interior, away from the

control of the Company, hunting, trading with the Hottentots for cattle, and eventually as cattle-farmers themselves. Thus there came into being the Trek-Boers,[1] sturdy pioneers who had cut adrift from the mainstream of European development and adapted themselves to the hard business of wringing a livelihood from extensive grazing on the dry grasslands of interior South Africa, in competition with its native peoples, cattle-farmers like themselves. Ultimately their descendants were to call themselves 'Afrikaners'; they differed from other Africans mainly in their individualism and in the seventeenth-century Calvinist beliefs and outlook which reinforced the conviction, born of the circumstances in which they found themselves, that they were an elect of God and that the heathen coloured folk had no natural rights against them or to the land they were taking for their own.

In this spirit the early Boers, moving east rather than north, towards the zone of higher rainfall in Natal, hunted down the primitive Bushmen and overran or dispersed the Hottentot tribes, until by 1779 they had encountered the vast mass of the strongly organized Bantu tribes, whose frontier then ran along the line of the Great Fish River. The result was the first of a series of 'Kaffir wars'[2] which were to prove a sore trial to the authorities at Cape Town for the next hundred years. At first it made little difference that during the Anglo-French wars of 1793–1815 the Cape passed from Dutch to British control. Like the Dutch Company before it, the British government valued the Cape simply for its strategic position, commanding as it did the entry to the Indian Ocean. The existence, as an appendage to the Cape, of a vast colony of dispersed settlement, reaching north to the Orange and east to the Fish River, was little more than a nuisance which the British sought to limit as best they could. In fact British rule on the frontier was more effective than that of the Company in its last years, and the independent Boer frontier republics of

1. Literally translated, the name means 'migrant farmers'.
2. 'Kaffir' which is common usage by white South Africans for a black South African, is of course the Arabic *kafir*, 'infidel'. It would seem to have reached South Africa from the East Coast, where the Portuguese took it over from the Arabs, who had applied it to the Bantu.

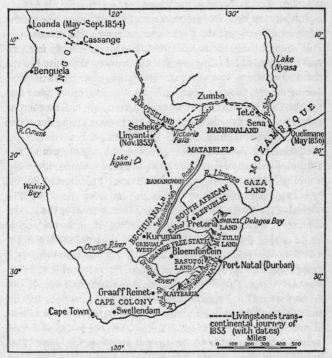

13. Southern Africa in the nineteenth century

Swellendam and Graaff Reinet, which had been proclaimed at the very end of the period of Company government in 1795, were brought under control. In 1820, Britain planted some five thousand settlers, ex-soldiers and their families, close behind the frontier, hoping in this way both to strengthen it and to provide a British leaven in the Boer mass.

Initially the most important result of the collision between the advancing Boers and the Bantu was the production of considerable strains among the Bantu tribes. The great bulk of the Bantu had been settled for many centuries in the coastal plains between the Drakensberg and the sea. This region received monsoon rains from the Indian Ocean, and was therefore much more fertile than the dry veld of the interior plateau, where Bantu settlement, like that of the Boers later, had of necessity to be much less dense. As their population and their herds gradually increased, the Bantu had always so far been able to take up more land. The Bushmen and the Hottentots had presented no more of an obstacle to them than they did to the Boers. The most profitable new lands naturally lay to the south-east along the coast. The arrival of the Boers, however, blocked this avenue for the future. The result was that tribes needing to enlarge their territory could do so only at the expense of their neighbours. By the beginning of the nineteenth century, the Zulu clan of the Nguni in Natal had produced a ruthless military genius, Shaka, capable of breaking this stranglehold. He formed the men of the younger age-sets in his patron Dingiswayo's kingdom into regular regiments living only for war, which they fought at close quarters in disciplined formations, using their assegais to stab, and not in the traditional way as not very effective long-range throwing weapons. Thus trained and disciplined, Shaka's impis carried all before them, plundering the cattle of less warlike tribes and incorporating the boys and young women they captured into their own society. After Dingiswayo's death in 1818, Shaka became the dictator of a new and inherently aggressive military nation, the Zulu. Shaka was assassinated by his half-brothers in 1828, but one of these, Dingane, proved just as powerful and ruthless as his predecessor. The Zulu homeland in northern Natal, especially to the south,

became surrounded by a no-man's-land deserted by its inhabitants and turned into a Zulu grazing-ground.

The effects of the Zulu outburst were felt much more widely than this, however; indeed they were felt throughout southern Africa. Some of those attacked by the Zulu emulated their example and set out on careers of conquest or rapine of their own. Thus the Sotho leader Sebetwane took a small group, the Makololo, northwards to conquer and rule the Barotse kingdom on the upper Zambezi, while Mantatise's basically Sotho force struck out westwards towards Botswana on an ultimately self-destructive campaign of plunder. In two areas, unusually able chiefs were able to merge refugees from the Zulu wars with their local peoples into new nations strong enough to withstand Zulu pressure. Such was the origin of Swaziland, created by Sobhuza and his descendant Mswazi just north of Zululand. Such also was the origin of the modern Lesotho kingdom to the south-west, which was the creation of the great southern Sotho king Moshesh. In addition, some Zulu formations (often those whose leaders had quarrelled with Shaka) struck out on their own. Soshangane took his people, the Shangane, northwards into Gazaland, where they conquered and largely absorbed the native Tonga. Zwangendaba and his warriors broke even further afield, sweeping destructively through the highlands between the Limpopo and the Zambezi until they eventually settled around Lake Malawi. Mzilikazi led his Matabele (more correctly Ndebele) across the Drakensberg to disperse the Transvaal Sotho westwards towards the borders of the Kalahari in Botswana and south towards Lesotho, the land of the BaSotho.

It was into this turbulent interior, from 1836 onwards, that a growing stream of Boers began to project themselves in the exodus from the Cape Colony known as the Great Trek. Trekking away from control by Cape Town was already part of the Boer tradition, and this more positive and final Trek was not occasioned by the imposition of British rule as such. So long as it gave them security against the Bantu on the frontier, while allowing them liberty to take land and to employ native labour on their own terms, British rule was neither worse nor better than Dutch

rule. But from about 1825 the character of British administration in South Africa had begun to change in a way the Trek-Boers could only regard as inimical to their interests. In part this was a reflection of new currents in Britain herself. The old authoritarian tradition of government, and of empire as a weapon in a world struggle for trade and survival, was giving way before *laissez-faire*, free trade, and a more liberal and humanitarian attitude towards subject peoples and the under-privileged, whether at home or overseas. But it was also a consequence of the establishment for the first time in South Africa of Christian missions to the native peoples, and of the success of one mission in particular, the London Missionary Society, and of its South African superintendent, Dr John Philip, in bringing pressure to bear on government and opinion at home in the interests of the South African native peoples, whose human rights had hitherto been ignored.

From 1825 onwards the British administration at the Cape began to introduce measures to give protection under the law to its non-European peoples. It also began to lose the essentially military character of its early years. Elements of democracy were introduced, and attempts were made to bring the revenue closer to the expenditure by reducing military commitments and by seeking to raise revenue from land, the only asset of an impoverished economy, by dint of regulating its acquisition and thus raising its value. The abolition of slavery throughout the British Empire in 1833 did not greatly affect the frontier Boers, since most of the twenty thousand slaves in the colony were in the settled districts near Cape Town (where they formed a vital element in the emergence of the Cape Coloured people – of mixed slave, Boer, and Hottentot ancestry). Two decisions taken in London shortly afterwards, however, did greatly affect the frontiersmen. In 1834 the Colonial Office disallowed a law passed by the new Legislative Council which would have undone part of the new legislation protecting non-Europeans. Then in 1836 it was decided that an area of the eastern frontierlands, recently annexed in the interest of security, should now be returned to the Bantu tribes in the interest of retrenchment. Since it was

already difficult for younger sons to find new farms of the 6,000 acres or so needed to support a Boer family on the veld, this denial of prospects constituted the final blow that determined many frontier Boers to band together in organized parties to trek across the Orange River. The greatest of their early leaders, Piet Retief, plainly declared the trekkers' purpose to establish new communities beyond the reach of British interference, where society could be organized on traditional Afrikaner principles.

Some Boers dispersed across the High Veld, clashing with the Matabele and forcing them north across the Limpopo to establish their hegemony over the Shona peoples, whose own political organization had already been badly shattered by Soshangane and Zwangendaba. But the main body of trekkers moved towards the area of rich grassland in Natal which had been depopulated by Zulu aggression. The Boers hoped for what Dingane at first seemed to promise, a peaceful occupation, and the ox-waggons of the Boer families rumbled over the Drakensberg to disperse over the promised land. But the Zulu nation could not tolerate such a permanent occupation of its preserves. Retief was murdered, and the impis descended on the settlers. Then a new Boer leader, Pretorius, emerged to gather the families into laagers and to strike back with mobile commandos. The guns and the mobility of the Boers overthrew Dingane's power, and in 1839 Pretorius was able to proclaim the Boer republic of Natal.

The Zulus, however, were not the only enemy the Boers had to face. The British Government took the line that in crossing beyond the Cape boundary the Boers had not thereby ceased to be British subjects. It refused to countenance an independent Boer régime which might control harbours injurious to its own Indian Ocean interests and whose expansive proclivities were certain to cause further Bantu pressures on the Cape frontiers. British troops were sent to Port Natal (the future Durban), and in 1845 Natal was formally annexed. Thus thwarted in their bid for independence, many trekkers began to move back across the Drakensberg.

The Boers were naturally opposed to restriction of their

individual rights and interests. Widely dispersed across the High Veld, each little group tended to be a law unto itself. Nevertheless, the continuing need for cooperation against the Bantu tribes made some central government essential, and the trekkers eventually came together in two major republics, the South African Republic (Transvaal) between the Vaal and the Limpopo and the Orange Free State between the Orange and the Vaal. For the most part the sum of the popular wills was ascertained through the Volksraads (People's Councils), but in times of stress the Presidents, who were also directly responsible to the all-white male electorate, possessed potentially dictatorial authority.

In 1852 and 1854 the independence of these two republics was recognized by Britain. Provided that their doings led to no serious trouble with the Bantu which would prejudice basic British interests, the British government had concluded that any advantages resulting from a further extension of its administration into Africa would be totally outweighed by the responsibility and cost, especially since both republics lacked a viable economy. While in the 1860s the economy of the Cape Colony began to expand through the development of sheep-farming for the world market, and Natal began to achieve some prosperity from sugar-planting with indentured Indian labour, the two republics, lacking both an economic agriculture and any communication with the exterior other than the long ox-waggon trails, were poor even by South African standards. But the very poverty of the small republican communities (in the 1870s, the Transvaal had only some 40,000 whites, and the Free State some 30,000, compared with nearly 250,000 in the Cape), made them incapable of coping with the wars brought about by the continual tendency of their farmers to expand into African lands. In 1871 the integrity of the Free State and of the eastern frontierlands of the Cape was saved only by the expedient of bringing Lesotho under British control. In the same year Britain annexed Griqualand West, which had suddenly acquired value with the discovery there of considerable diamond deposits. This was an area on the western boundary of the Free State, whose claim to it had long

been disputed by its Griqua inhabitants, themselves a people of Europeanized Hottentot stock possessing close ties with the Cape.

By this time the more far-seeing British officials, both locally and in London, had come to appreciate that the multiplicity of European governments and policies in South Africa was prejudicing any sane solution of the difficulties arising from the Great Trek. The Trek indeed, by throwing black and white together as never before, had demonstrated that South Africa was essentially one country. At the same time its results were causing deep instability among the Bantu peoples. Their land was being taken, and they were being left with little alternative but service in the European communities as individual labourers. Moreover, chieftainly authority was being undermined, so that the tribes could no longer be regarded as responsible units with which the British government could make treaties in definition of mutual interests, as it had tried to do in the 1830s and 40s. The ideal solution was obviously a federation of the British colonies with the republics. In 1872, the Cape Colony, whose wealth and European population were now rapidly increasing as a consequence of the trade engendered by diamond mining, was granted internal self-government, with ministers responsible to a parliament elected on a non-racial franchise. The further extension of this principle, it was hoped, would enable black and white to come together to deal with their problems throughout South Africa, thus enabling the imperial government to withdraw to its primary interest, the naval base at the Cape.

The ideal solution, however, proved impossible to achieve. The Cape Colony would have no share in it; its new rulers had no wish to see its growing wealth squandered for the benefit of the more backward communities. Nor did they wish to see the nice racial balance of their society (which had almost as many whites as non-Europeans) upset by the admission of tribal Bantu from areas like the eastern frontier or Natal, for which Britain had hitherto been responsible. The Free State, otherwise generally willing to cooperate with the Cape, had been bitterly antagonized by the annexation of Griqualand West. Since Natal

was still directly under the Colonial Office, this left the South African Republic of the Transvaal, and here, in 1877, an energetic British proconsul, Sir Bartle Frere, thought he saw a chance to force the whole issue. The republic was bankrupt, and incapable of coping with the Swazi and Zulu on its frontiers. It was therefore annexed, in a bold bid for Boer cooperation. But the plan completely miscarried. Britain became involved in war with the Zulu (with whom she had hitherto had good relations) and failed to make good Frere's promise of local autonomy for the Transvaalers. The latter, taking heart from an early defeat of British regular soldiers by the Zulu impis, rose against the British and, after a signal victory of their own at Majuba, brought Britain to reverse her policy in 1881. The independence of the Transvaal was recognized, subject only to British overseeing of her relations with foreign powers and with Africans beyond her borders, as well as to a vaguely expressed claim of ultimate British suzerainty. All Britain had succeeded in doing in the ten years since 1871 was to revive and increase the antagonisms which had first led the Boers to make the Great Trek.

Meanwhile the mutual hostility that had developed between the missionary societies and the Boers, whose own Christianity could not encompass any equality between white and black, had led the former to concentrate their efforts beyond the borders of the Cape and Natal in areas which were untouched by trekkers. Indeed the work of the missions sometimes helped stiffen the Bantu resistance to Boer pressures. They made little headway among the Nguni tribes until the final crushing of the Nguni military systems after 1890 (though Robert Moffat of the L.M.S. established a remarkable personal friendship with Msilikazi in the Transvaal, and this was later to give the Society entry to Matabeleland). Their influence in Lesotho and among the Griqua, however, was considerable. The establishment of the Transvaal republic limited further missionary expansion northwards to the narrow strip of Botswana between the Transvaal and the Kalahari, and here the Bamangwato king, Khama, unhappily sandwiched between Boers and Matabele, became a notable convert. It was along this 'missionary road' that during

the 1860s hunters, traders, and ultimately concession-seekers from the Cape began to penetrate into Matabeleland and even as far as Barotseland, and it was from the London Missionary Society station at Kuruman that Livingstone (who was Moffat's son-in-law) set out on his first journeys.

Livingstone's transcontinental journey with Makololo porters from Barotseland (1853–6) brought him into close touch with the Portuguese in both Angola and Moçambique. He disclosed to the outside world a chain of forts leading inland from the Angolan coast from which half-caste *pombeiros* ranged far in search of slaves and ivory, and of an even more disastrous slaving system feeding plantations on the lower Zambezi valley and in the Moçambique coastlands. From east and west, indeed, the activities of the *pombeiros* were reaching right across the continent. Livingstone soon realized that the consequent destruction of African society could not be stayed by an advance of Christianity and of civilizing commerce from the south, for the line of communication was too long and tenuous. But he failed to secure much more than missionary penetration up the Zambezi and Shire routes which he prospected during his second major expedition (1858–64), and then not until the 1870s. However, he did succeed in stirring Portugal to a recognition that attitudes to Africa were changing, and that in the nineteenth century *pombeiro* trading was an anachronism which would not justify Portugal's traditional claim to all the lands between the Angolan and Moçambique coasts. When, therefore, the British government in the 1880s and 1890s began to move in support of the missions in Malawi, where the Protectorate of Nyasaland was created, and the juggernaut of European settlement driven by Cecil Rhodes began to roll up the new railway lines which were spreading from the Cape to Matabeleland and beyond, they found Portuguese explorers, soldiers, and officials hard at work across their path.

In East and North-East Africa the main external factor during the first three-quarters of the nineteenth century was not European, but Arab and Egyptian. In East Africa the first half of the century saw the consolidation of the arabized Swahili-speaking population of the coast from Cape Delgado to Lamu, and of the arabized town-dwelling Somali of southern Somalia, under the suzerainty of the Albusaid dynasty of Oman on the western shores of the Persian Gulf. In theory this suzerainty had existed since the Omani liberation of the coast from the Portuguese at the end of the seventeenth century, but it was first made effective in practice by a single very gifted ruler, himself by origin a usurper, the Imam Seyyid Said, who reigned over Oman, or at least over its capital Muscat, from 1806 till 1856.

Having built up an efficient little navy, Said asserted his claims, first to tribute and later to customs, upon the trading communities of the coastal towns. He chose Zanzibar as the base for his East African operations, and on the island itself he started a plantation industry in cloves, introduced all the way from the Moluccas, with such success that by the end of his reign Zanzibar was producing three-quarters of the world's supply. Under Said's influence Zanzibar soon became the commercial entrepot for the whole of the East African coast, the rendezvous for all foreign shipping, the export market for the slaves and ivory of the mainland, and the import market for cloth and beads, guns, ammunition, and hardware from India, Europe, and America. Said spent more and more of his time there, and in 1840 finally made it his capital. A class of wealthy

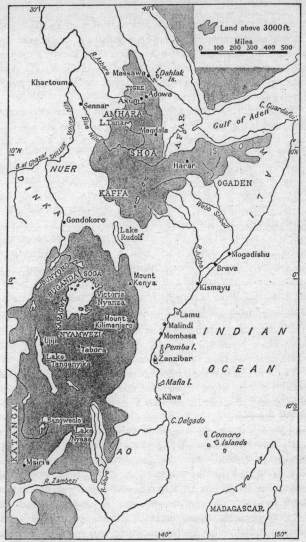

Map labels

30°

40°

Land above 3000ft

Miles
0 100 200 300 400 500

R.Atbara

Massawa

Dahlak Is.

Khartoum

TIGRE

Axum

Adowa

Sennar

White Nile

Blue Nile

AMHARA

L.Tana

Magdala

C.Guardafui

Gulf of Aden

10°N

B.al Ghazal

SHILLUK

SHOA

AFAR

S

O

M

A

L

I

10°N

NUER

Harar

OGADEN

DINKA

KAFFA

Webb Shibeli

Gondokoro

Lake
Rudolf

R.Jubba

Mogadishu

Brava

0°

BUNYORO

KARAGWE

BUGANDA

SOGA

Mount
Kenya

Kismayu

0°

Victoria
Nyanza

Mount
Kilimanjaro

Lamu

NYAMWEZI

Malindi

Mombasa

Ujiji

Tabora

Pemba I.

I N D I A N

Lake
Tanganyika

Zanzibar

Mafia I.

O C E A N

Kilwa

10°S

KATANGA

L.Bangweolo

Lake
Nyasa

C.Delgado

Comoro
Islands

Msiri's

A O

R.Zambezi

R.Shire

MADAGASCAR

40°

50°

14. East and North-East Africa in the nineteenth century

Arabs settled round him as plantation-owners on Zanzibar and Pemba, while others with their fortunes still to make were encouraged by him to begin the direct commercial exploitation of the interior, using the credit of Indian merchant financiers to stock up trading caravans with which they would disappear up-country for years at a time.

The Zanzibar Arabs and Swahili were not the first or the only long-distance traders of the East African interior. As we have seen, it was the Nyamwezi people of west-central Tanganyika who had pioneered the routes which led down to the Zanzibar coast, and throughout the nineteenth century the Nyamwezi retained an important place in the developing commerce of the region. It was they who in the 1820s and 1830s opened the trade-routes as far west as the kingdom of the Lunda Kazembes in the southern Katanga. In all probability it was they who from the late eighteenth until the mid nineteenth century organized the increasingly important trade with the large kingdoms to the west of Lake Victoria – Karagwe, Buganda, and Bunyoro. It was especially as carriers that they were unsurpassed. European travellers described how from their tenderest years Nyamwezi boys would practise carrying miniature tusks. As adults they were capable of enormous marches, travelling very light. Their profits they invested in slaves, who tilled the land while their masters travelled abroad.

To the extent that the Arabs superseded them, it was probably because of their larger organization and better credit. Where the Nyamwezi had dealt in beads and cloth, the coastmen could afford the more costly trade goods, especially the guns and ammunition so eagerly coveted by the African rulers. To some small extent the Arabs established their own political organization in the interior. At a few key-points, like Tabora in the Nyamwezi country and Ujiji on Lake Tanganyika, there were regular commercial depots where they exercised what might be described as extra-territorial rights. And, especially to the west of Lake Tanganyika, there were cases where coastmen (and Nyamwezi also) conquered the local rulers and set themselves up as political paramounts. This, however, was exceptional. In

general the Arabs obtained their ivory and slaves by trade and not by force. They armed the native rulers, and the native rulers did the rest. 'The result was a situation in which the strong became stronger at the expense of their weaker neighbours. In southern Tanzania powerful Yao chiefs preyed upon the defenceless peoples of the Malawi lakeshores. In Uganda the strong Kabakas of Buganda kept their armies raiding among the disunited Soga to the east and in the little Haya states to the south. They sold their slaves and ivory to the Arabs for good prices, receiving in return weapons for their armouries and cloth with which to reward their soldiers, their courtiers, and their state officials.

In Uganda, by the late fifties and early sixties of the nineteenth century, the expanding sphere of Zanzibar commercial influence from the east coast was approaching a rival influence simultaneously expanding southwards from the north. This was the sphere of the Khartoum Arabs, or the 'Turks' as they were usually called. Turks they were, in the sense that the Sultan of Turkey was still in name the overlord of Egypt, while the Khedives, his hereditary viceroys in Egypt, also ruled the Sudan. Muhammad Ali invaded the Sudan in 1820, deposing the Funj sultans of Sennar and installing an Egyptian governor at the new capital of Khartoum. The main object of the exercise was to gain control of the White Nile slave trade and so to ensure a regular supply of Negro slave recruits for the Egyptian army. Slave raiding was thus an official function of government, and during the next thirty years a series of expeditions ravaged the country southwards of Khartoum between the Blue and the While Niles, the homelands of the Dinka, the Nuer, the Shilluk, and the Bari. As early as 1839 an Egyptian military post was planted at Gondokoro, close to where the While Nile cuts the modern frontier between Uganda and the Sudan. By the fifties and sixties Khartoum-based private enterprise had developed and taken over from the government not only the slave trade but the even more wide-ranging search for ivory; but the methods employed were still more military than commercial. Westwards along the Bahr al-Ghazal and its tributaries, and southwards among the Nilotic peoples of northern Uganda, heavily-armed

raiding parties rounded up the cattle and held them to ransom for ivory and slaves, as well as for supplies of food and drink. The Khartoumers were astonished, when they finally encountered their rivals from the east coast, to see how the Zanzibaris paid for their purchases in solid merchandise; this was something they could never hope to compete with, owing to their much longer lines of communication.

After the Portuguese occupation in the sixteenth and seventeenth centuries, the first continuing European pressure to reach any part of this region came with the inevitable interest of the British government of the Bombay Presidency in the expanding Sultanate of Muscat and Zanzibar. The British had made their first treaty with Seyyid Said's predecessor at the time of the Napoleonic threat to the Middle East and India, and strategically it suited them well that a friendly oriental power should extend its dominion down the western coast of the Indian Ocean: better the Arabs than the French. At the same time political unity would obviously make for good trading conditions and ease of diplomatic relations. The main difficulty in attacking the west-coast slave trade had been the very large number of political authorities with whom it had been necessary to do business. The hegemony of Seyyid Said offered the possibility of dealing with the east-coast trade, and at the same time of building up a paramountcy of British influence in the region through a single local authority. In 1822, when Said was still at Muscat, the British obtained a treaty limiting the slave trade to the western half of the Indian Ocean; this was to prevent the import of slaves into British India. When Said moved to Zanzibar in 1840, the first British consulate on the East African coast was established at his court. Five years later a second slave trade treaty further limited the trade to the Sultan's African dominions. Henceforward the naval squadrons were able to operate in the western Indian Ocean and to close in on the East African coast. In 1861, five years after Said's death, the Sultanate divided, one son taking Muscat, another Zanzibar. Finally in 1873, Sultan Barghash of Zanzibar, under the threat of a naval bombardment, signed a decree outlawing the slave trade throughout his

dominions. The great slave market at Zanzibar was closed. A Christian cathedral arose on the site.

These fifty years of British diplomatic and naval effort undoubtedly had some effect upon the export of East African slaves to the former Asian markets. They had virtually none, however, upon East Africa itself. The slave trade into Zanzibar and Pemba, and into the coastal region of the mainland, was legal until 1873 and continued to be practised for many years afterwards, until the actual status of slavery was made illegal in colonial times. Moreover, even if the export trade in slaves was decreasing, that in ivory was growing year by year throughout the period. It was the search for ivory, rather than that for slaves, which took the coastmen annually further and further into the interior; but slavery and its attendant evils were almost inseparable from the ivory trade. The hunting of the elephant required arms and ammunition, which could also be used for warfare. The transport of ivory was by human porterage, much of it by slaves. These last might never cross the wide seas to an external market, but they were nevertheless removed by violence from their homes and ultimately sold, perhaps to a Nyamwezi chief in the interior, perhaps to a Swahili shopkeeper at the coast, perhaps to the Arab owner of a clove-plantation on Pemba or Zanzibar. There was in fact no East African equivalent to the palm-oil of West Africa. The European campaign against the seaborne slave trade, and the strengthening of commercial ties with Zanzibar, led merely to an intensified exploitation of the only other exportable commodity which could stand the cost of transport to the coast, with the result that the area of the coastmen's operation in the interior was vastly extended.

In the Egyptian sphere, the same was true. In Egypt British pressure had to be much more discreetly exercised than in Zanzibar. Nevertheless, the three sons of Muhammad Ali who succeeded him as Khedive were all in some degree imbued with the humanitarianism of contemporary Europe, and they would have stopped the trade if they could. All three legislated against it, and the last of the three, Khedive Ismail, went so far as to employ first the explorer Sir Samuel Baker and later General

Gordon as Governors, in the hope of evolving a new policy. In fact, however, the only new policy anyone could recommend was that the whole vast region should be brought under closer control, and this meant finding the revenue with which to control it. In the long run such a revenue could only come after mechanized transport had provided the means for the agricultural products of the interior to be marketed overseas. In the short term it could come only from the ivory trade, which was at least as destructive in its effects upon the weak societies of the southern Sudan as the trade in slaves.

Baker tried, with very limited success, to control the operation of the ivory trade by carrying the Egyptian frontier still further southward, from Gondokoro into what is now northern Uganda. Gordon, who followed him as governor of this 'Equatorial Province', grasped the one essential fact about it, that it was far more accessible from the east coast than from the north. Ismail, at Gordon's advice, sent a seaborne expedition to occupy the east coast port of Kismayu, perhaps not realizing or caring that he was invading the dominions of Zanzibar. On arrival, however, his forces were persuaded by British diplomatic pressure to make a peaceful retreat. Meanwhile, in the interior, and at the end of an impossibly long line of communication, Gordon had utterly failed in his attempt to bring the large Bantu kingdoms of Buganda and Bunyoro under Egyptian rule. Egypt's drive to the south thus petered out, some four years before the revolution of the Mahdi in 1881 put an end to Egyptian administration in the Sudan as a whole.

It could be said that in the last analysis both the Egyptian and the Zanzibar spheres of influence represented the triumph of European-manufactured firearms over the African spear and bow. It was their possession of firearms which gave to both these kinds of Arabs the confidence to sally forth among the infidel blacks; and when they encountered a well-established political unit among the Africans, it was the presence of firearms among their trade goods which enabled them to succeed in competition with earlier and less well-provided traders.

Between the Egyptian and the Zanzibari spheres there grew

up during the second half of the nineteenth century a third sphere – that of the Christian Ethiopians, who were no less successful than the Muslims of the north and east in exploiting the weakness of their pagan neighbours. The Ethiopian expansion began later than the other two, because the chaotic internal situation of the country had been growing steadily worse since the middle of the eighteenth century. By the middle of the nineteenth century the kingdom had almost fallen apart into its constituent provinces, and rival emperors had become a regular feature. Then Ras Kassa, a robber baron of the northwestern frontier, managed in 1855 to secure coronation at Axum under the imperial name of Theodore. It was Theodore who laid the foundations of something approaching a modern army, and as a result he was able to turn the tide against the pagan Galla, who had been steadily overrunning the kingdom's southern and south-western borderlands since the end of the sixteenth century. It was Theodore who thus started the reunification of Tigre and Amhara in the north with the southerly province of Shoa. It was also Theodore who, by his capricious treatment of two British envoys, provoked the first direct European interference in the region since the sixteenth century – the punitive expedition led by Sir Robert Napier in 1867 against the fortress of Magdala, in the course of which, abandoned by many of his vassals, Theodore shot himself.

The superiority of Napier's weapons made a deep impression, not only upon the succeeding emperor John IV, a Tigrean chief who fought his way to the throne with arms obtained from the British in exchange for his help in the Magdala campaign, but even more upon his vassal the young king Menelik of Shoa, who made himself so powerful that in 1878 John was compelled to recognize him as his successor. Throughout the eighties, while he was awaiting his inheritance, Menelik was building up his stock of European weapons from every available source – and not least from the Italians, whom he was ultimately to defeat with them at Adowa in 1895. Meanwhile, but more systematically, he was doing what all the successful African rulers of his time were doing: he was using ivory to get firearms, and firearms to get

more ivory. In the process, too, he was year by year expanding his kingdom eastwards, southwards, and westwards, at the expense of the Afar and Somali of Harrar and the Ogaden, at the expense of the Galla to the south, at the expense of Kaffa and the now Galla-occupied ancient Sidama kingdoms to the south-west. Menelik of Ethiopia is commonly regarded by European historians as an exceptional case, as a scrambler for Africa who happened to be an African ruler. In fact, however, Menelik of Ethiopia grew out of Menelik of Shoa, who was not essentially different from Mutesa of Buganda, Kabarega of Bunyoro, or Msiri of Katanga.

Such, then, in necessarily impressionistic outline, were the conditions in East and North-East Africa at the time when European explorers were making their journeys and publishing to the western world the first descriptions of this corner of the continent. Such were the conditions at the time when the first parties of Christian missionaries established their settlements at the coast and in the interior, gathering round themselves the small groups (often of freed slaves) who were to be their first converts, but also and inevitably playing a political role as the advisers of African chiefs, who looked to them as to the Arabs for their knowledge of the world outside East Africa. Such again were the conditions in which British and French Consuls pursued their strictly limited aims of furthering their national influence and interests from their bases at Cairo and at Zanzibar.

There was nothing in any of these still very tentative European approaches which was consciously preparing or even implying the scramble and partition which were to follow; and it would be the greatest possible error to imagine that the second phase was a necessary consequence of the first. The international hysteria which led to partition was caused not by the few European powers who already had small interests in tropical Africa, but by a sudden stampede of those powers who had previously had no interests there at all. But for this stampede, it is probable that the main patterns of pre-partition development would have been pursued for a considerable time to come. On the East and

North-East African scene, there were already in existence a few societies capable of learning from the new influences without being submerged by them, which could react positively enough to the nineteenth-century condition of half-penetration to turn it to their advantage. Had there been no direct intervention of European power, the influence of the Arabs would have consolidated itself not only on the east coast and in the northern Sudan, but in the southern Sudan also, and in many parts of East Africa and Zaire. To some extent this would have been the result of deliberate colonization by alien ruling groups, but to some extent too commercial contacts and political influence would have led to the Islamization of local institutions, as they had done in much of the Sudan in earlier times. It is doubtful whether Christian missions, starting as late as they did, would have been in time to forestall an Islamic expansion once Muslims had political power firmly in their hands. Had full-scale European intervention been delayed fifty years, not merely the northern third of Africa, but the northern two-thirds, would have belonged culturally to the world of Islam.

16 The European Scramble for African Colonies

In 1879, despite the steady increase in the power of the western European nations compared with that of other peoples in the world, only a small proportion of the African continent was under European rule. Algeria was French, but elsewhere in North Africa it was only in Egypt and in Tunis that there existed even the beginnings of European control. In West Africa, where Europeans had had commercial dealings with the coastal peoples for four centuries, it was only in French Senegal and on the British Gold Coast that there were colonial administrations ruling any considerable number of Africans. Only in the Senegal had European rule penetrated more than a few dozen miles inland. The British colonies of the Gambia, Sierra Leone, and Lagos were no more than small enclaves in a political world still dominated by African governments. In the region which was to become Portuguese Guinea, there was Portuguese influence but hardly Portuguese rule. South of the Bight of Benin, the French colony on the Gaboon consisted of little more than the small naval station and freed-slave community at Libreville. Apart from five or six coastal towns, Portuguese Angola and Moçambique were hardly colonies in the modern sense, but rather ill-defined trading preserves reaching towards the interior.

North of Moçambique, even the coast was still virtually untouched by European political power. British diplomatic influence was strong in Zanzibar. The French had occupied the Comoros and also had a foothold in Madagascar. On the mainland, however, it was only in the extreme north-east that any European flag had yet been planted. This was a consequence of

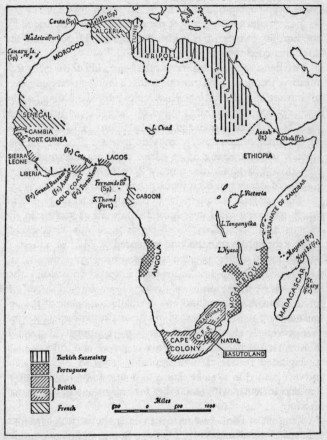

15. Africa in 1879

the Suez Canal, the construction of which had led France to seek
a counterpoise to the British coaling station at Aden by establish-
ing a base on the inhospitable Somali coast at Obok. The only
really deep penetration of Africa by European governments was
in the extreme south, but here the position was complicated by
the hostility between the British colonies on the coast and the
Afrikaner communities in the interior.

Two decades later, however, at the beginning of the twentieth
century, European governments were claiming sovereignty over
all but six of some forty political units into which they had by
then divided the continent – and of these six exceptions, four
were more technical than real. This partition of Africa at the end
of the nineteenth century was by no means a necessary conse-
quence of the opening up of Africa by Europeans during the
first three-quarters of the century. Very few indeed of the ex-
plorers of Africa had been sent by their governments to spy out
the land for later conquest. It is probably safe to say that not a
single missionary had ever imagined himself as serving in the
vanguard of colonialism. In so far as there was an economic
motive for partition of the kind suggested by Marxist writers, it
was a motive which appealed to those European powers which
had no colonies and little commercial influence in Africa, rather
than to those whose influence was already established there. The
partition of Africa was indeed essentially the result of the ap-
pearance on the African scene of one or two powers which had
not previously shown any interest in the continent. It was this
that upset the pre-existing balance of power and influence and
precipitated a state of international hysteria in which all the
powers rushed in to stake claims to political sovereignty and to
bargain furiously with each other for recognition in this or that
region.

The first of these new factors to enter the African scene was
not strictly speaking a power. It was a European sovereign acting
in his personal capacity, though using his status as a sovereign
to manipulate the threads of international diplomacy in pursuit
of his private objective. King Leopold II of the Belgians was a
man whose ambitions and capacities far outran the introverted

preoccupations of the country he had been born to rule. His interest in founding an overseas empire had started in the 1850s and 1860s when as Duke of Brabant he had travelled in Egypt and had also scanned possible openings in places as remote as Taiwan, Sarawak, Fiji, and the New Hebrides. Succeeding to the throne in 1865, he bent most of his great energies to the study of African exploration. Ten years later he was ready to act. His cover was the African International Association, created in 1876 to found a chain of commercial and scientific stations running across central Africa from Zanzibar to the Atlantic. The stations were to be garrisoned, and they were to serve as bases from which to attack the slave trade and to protect Christian missions. The first two expeditions of the Association entered East Africa from Zanzibar in 1878 and 1879, and attached themselves to mission stations of the White Fathers at Tabora and on Lake Tanganyika. From this moment, however, Leopold's interests switched increasingly to the west coast of Bantu Africa. Stanley, who in 1877 had completed his coast-to-coast journey by descending the Congo River, took service under King Leopold in 1879, and during the next five years established a practicable land and water transport system from the head of the Congo estuary to Stanley Falls, more than a thousand miles upstream, by the modern Kisangani (once Stanleyville).

Leopold, meanwhile, was deftly preparing the way for international recognition of his rule over the whole area of the Congo basin. Although his real intention was to develop his colony on the basis of a close-fisted commercial monopoly, he was successful in persuading a majority of the European powers that it would be preferable to have the Congo basin as a free-trade area under his 'international' régime than to let it fall to any of their national rivals. The skill of King Leopold's diplomacy has been widely recognized. What has received less notice is the extent to which it sharpened the mutual suspicions of the European powers about their activities in Africa as a whole. Probably it was Leopold, more than any other single statesman, who created the 'atmosphere' of scramble.

The next power to enter the African scene was Germany.

Acting with stealth and swiftness in the eighteen months from the end of 1883 to the beginning of 1885, Germany made extensive annexations in four widely-separated parts of the continent – South-West Africa, Togoland, the Cameroons, and East Africa. It was this German action which was really to let loose the scramble on a scale bound to continue with ever-increasing intensity until the whole continent was partitioned. It is therefore the more remarkable that recent historical research has tended to show that Germany entered Africa, not primarily in order to satisfy a desire for empire there, but rather as part of a much wider design to deflect French hostility against her in Europe by fomenting rivalries in Africa and by creating a situation in which Germany would be the arbiter between French and British ambitions.

The key to this situation lay in Egypt. Here in 1881 the joint Anglo-French financial control had broken down in face of the revolt of the national army, led by one of its most senior Egyptian officers, Arabi Pasha, with the tacit sympathy of the puppet Khedive Taufiq. France and Britain planned to act in concert to destroy Arabi, but on the eve of the operation a domestic crisis prevented the French government from participating. In consequence, the British invaded Egypt alone in 1882, and remained there, despite promises of withdrawal, as the *de facto* though not *de jure* rulers of the country until the declaration of a British Protectorate in 1914. The continued British occupation of Egypt angered the French and encouraged them to develop their formal empire in West Africa. This suited Germany, and it also gave Germany the means of twisting the British arm without openly supporting France, for British rule in Egypt was only possible with the support of a majority of Egypt's creditors represented on the international Caisse de la Dette, and this majority was controlled by Germany. Throughout the vital years of partition Germany supported British rule in Egypt, but at the price of British acquiescence in German actions throughout the rest of the continent. The German annexations were intended to incite the French to further action in Africa, but to action directed more against Britain than against Germany. In this way the

painful subject of Alsace and Lorraine would be forgotten in the Anglo-French rivalry over Africa.

Such then was the motivation for the scramble. To the three powers already engaged on the African coastline – Britain, France, and Portugal – there were now added two more, one of them a European sovereign in search of a personal empire, the other the strongest state in continental Europe, seeking to induce the most recent victim of its aggression to wear out its resentment in colonial adventure. In the circumstances, partition was bound to follow. Of the five powers mainly concerned, only King Leopold was positively anxious for a widespread territorial empire. Of the others, however, none was prepared to stand aside and see the continent swallowed by its rivals. And it was only a matter of time before Italy and Spain would likewise each claim a share. Deeply as it was to affect all the peoples of the continent, the partition was in its origin essentially a projection into Africa of the international politics of Europe. The new map of Africa which emerged from partition bore little relation to the activities of Europeans in Africa during its earlier periods.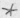

As it happened, the first to secure international recognition of a large African empire was King Leopold. In 1884, after the British merchants engaged in the Congo trade had opposed their government's intention of recognizing Portuguese claims to the lower Congo region, Portugal changed tack and instead appealed to France and Germany for support. France, seeing a chance to embarrass Britain, agreed to Bismarck's suggestion of determining the Congo question by an international conference in Berlin. And even before this conference could meet, France (having made a deal with King Leopold by which she secured the reversion of his Congo empire in case its development became too much for his resources) had joined Germany and the United States in granting recognition to the 'Congo Free State'. When the conference met in December 1884, the other powers had no option but to follow suit.

The Berlin Conference passed many high-sounding resolutions on the slave trade, on free trade, and on the need to prove effective occupation before fresh annexations were declared. In

fact, however, the six months during which the conference was being prepared had seen the most flimsily-supported annexations in the whole partition, those of Germany herself. While the conference was actually sitting, Bismarck announced his government's protectorate over those parts of East Africa where Karl Peters and his associates had obtained dubious treaties from bemused and often bogus 'chiefs' in the course of a single expedition lasting a few weeks. It was now clear to all that a quick partition of the whole continent was inevitable, and the delegates went home from Berlin at the beginning of 1885 to consider where further claims for their own countries could most usefully be developed.

The logic of earlier interests made it inevitable that the French African empire should expand first within the western bulge of the continent. By 1883 their war against Ahmadu, which they had begun in 1879, had brought the French to the upper Niger. It was natural that they should think first of expanding along the internal line of communications offered by this great river, and then of connecting their conquests with their spheres of influence on the coast. But their advance down the Niger was slow; Timbuctu was not reached until 1893. The French right flank was threatened by an adventurous soldier-trader, Samori Toure, who was building up an empire on traditional Mande lines. This was a much more formidable obstacle than Ahmadu's conquest state. Samori was not finally overcome until 1898, and it was not till some two years before this that the French were able to resume their westward advance.

During the 1880s, the future of the French Gaboon remained less certain. Although King Leopold's activities on the lower Congo had stimulated the French to develop a treaty network in the area explored by De Brazza, it was not until the nineties that they began to drive expeditions northwards to meet the expanding frontiers of French West Africa at Lake Chad, and north-eastwards up the Ubangui to threaten the upper Nile.

For Britain the strategy of expansion was by no means so obvious as for France. Southern Africa was one possible growing-point. It was also, however, a region where Britain had already

been compelled to recognize the independence of the Boer Republics, and where it was now faced with extensive German annexations on the south-western side of the sub-continent. Northward expansion from the Cape had therefore to take place through the bottleneck of Botswana, hastily annexed in 1885 to counter the Germans. Moreover, although the British government had to handle the diplomacy of partition and to acquire the nominal sovereignty, this was a region where the practical initiative necessarily lay with the Europeans of the Cape Colony. Among these the most active figure was Cecil Rhodes, a British settler who had made a vast fortune out of the amalgamation of the diamond mines at Kimberley in Griqualand West. In response to his pressure, the British government in 1888 declared the existence of a British sphere of interest between Botswana and the Zambezi. In 1889, by Royal Charter, it delegated the functions of government in this region to Rhodes's British South Africa Company.

In Africa north of the Zambezi, wider options had to be exercised. Commercially the most valuable region lay in West Africa, and there were many who thought that other interests should be sacrificed for the sake of an advantageous partition of this part of Africa between Britain and France. It is in fact probable that at any time during the eighties there would have been terms on which the French would have left the British an unbroken sphere from Sierra Leone to the Cameroons; and a British withdrawal from East Africa could probably also have produced a German withdrawal from the west coast. The first of any such terms, however, would have been a British withdrawal from Egypt, and this was a thing which no British government after 1885 would even contemplate. Indeed, Lord Salisbury, who as Prime Minister and Foreign Secretary handled the British side of partition during the decisive years from 1886 to 1892, built the whole of his African policy around the retention of Egypt. This meant in the first place a deliberate encouragement of French expansion in the west, to the point of doing nothing to prevent the encirclement of the four well-established British spheres along the coast. It meant, therefore, looking for the main

British share in the partition on the eastern side of the continent, even though it was commercially almost valueless, and even though it must in the long run prove expensive to occupy. The Germans were already entrenched on the mainland opposite Zanzibar, but in 1886 Salisbury was able to demarcate the rough limits of a British sphere of influence in what is now Kenya, while holding open the possibility of a British Uganda and of a 'back door' to the Sudan and Egypt. In East Africa, as in Zambezia and in central and northern Nigeria, a Chartered Company's willingness to take the responsibility for administration lay at the back of Salisbury's decision to negotiate at the international level.

There remained only the additional claims to what is now Zambia and Malawi, formulated in 1889–90, and Salisbury's design was complete. In 1890 and 1891 he proceeded to delimitation with Germany, France, Portugal, and Italy. The most important of these agreements was that with Germany. Though often described as the exchange of Heligoland for Zanzibar, Britain in fact ceded Heligoland to Germany as part of a settlement which defined most of the new Anglo-German frontiers in Africa in a manner satisfactory to Salisbury. The agreement with Italy fixed the frontier between the British East African Protectorate and the newly-claimed Italian colony in Somalia. The two Anglo-Portuguese agreements of 1890 and 1891, though imposed in a high-handed way by a strong power upon a weaker one, definitively settled the frontiers between British Central Africa and its Portuguese neighbours. It was the Anglo-French agreement which was the least satisfactory of the four, since it left the inland frontiers in West Africa undecided, and since it failed to touch upon the all-important question of the Sudan.

The most remarkable aspect of the first ten years of the scramble for Africa was the extent to which almost everything of importance happened in Europe. Statesmen and diplomats met in offices or country houses and drew lines across maps which themselves were usually inaccurate. Often the lack of geographical

detail was such that frontiers had to be traced along lines of latitude and longitude. In Africa itself the reality of partition was slight indeed. A dozen overworked men could make up the local representatives of a Chartered Company. A consul and two assistants might well form the government of a Protectorate. Such establishments were apt to be too busy keeping themselves alive to engage in military collisions with neighbouring governments. Even if rival teams were racing for a treaty in the same area, it was most unlikely that their paths would cross. The conflicting claims would be sorted out a year later round a table in some European capital.

As the scramble passed into its second decade, however, the activities of the men on the spot assumed a new significance. The position of interior frontiers often depended upon which of two neighbouring powers was able to create something like effective occupation. Encounters between the nationals of different European powers became increasingly frequent. They happened especially along the western frontiers of Nigeria, where (after the French had conquered the kingdom of Dahomey in 1893) fairly substantial military forces threatened to collide in the disputed territory of Borgu. The hurry to reach Borgu before the French also involved Goldie's Royal Niger Company in its first military clashes with the African states lying within its chartered sphere. To forestall the French in Borgu, it was necessary to conquer the emirates of Nupe and Ilorin.

Again, by the later nineties French expeditions were converging on Lake Chad from three directions, from the French Congo, from Algeria, and from the upper Niger, and for a brief time the dream of a vast French empire linking the Mediterranean, the Atlantic, and the Indian Ocean caught the imagination of the French public. A French occupation of the upper Nile would strike a vital blow at the British in Egypt. From 1896 until 1898, therefore, Commandant Marchand pushed a painful passage with a small company of black soldiers all the way from the Gaboon to Fashoda on the White Nile, some four hundred miles south of Khartoum. Britain in 1885 had compelled Egypt to abandon its former dominion in the Nilotic

Sudan to the forces of the Mahdi, Muhammad Ahmad, on the grounds that Egypt could not then afford the expense of re-conquest. Salisbury, however, had never lost sight of the Sudan; in 1896, after a disastrous defeat inflicted upon the Italians by the French-armed troops of Menelik of Ethiopia, the new Egyptian army trained by Kitchener was ordered to begin the southward advance. The province of Dongola fell the same year, Berber in 1897, Khartoum itself after the battle of Omdurman in September 1898. A week later Kitchener heard of Marchand's presence at Fashoda, and hastened to confront him with a vastly superior force: the 'Fashoda incident' brought France and Britain to the brink of war. This well-known fact of history has tended to obscure another, which is that Kitchener's reconquest of the Sudan, at a conservative estimate, cost the death in battle of twenty thousand Sudanese. The partition of Africa, as it approached its logical conclusion, was beginning to be a bloody business.

The crowning bloodshed, however, was that inflicted by white men on white in South Africa. Here the discovery of the vast gold wealth of the Witwatersrand in 1886 had given enormous potential power to the Transvaal, hitherto the poorest and weak-est of the European communities. And this was clearly ap-preciated by both the titans of the South African scene – by Paul Kruger, President of the Transvaal from 1883 to 1902, and by Cecil Rhodes, who had extended his mining interests from Kimberley to the Witwatersrand and who, from 1890 to 1896, was also Prime Minister of the Cape Colony. To Kruger's ambition of creating a united white South Africa under Boer republican leadership, Rhodes opposed a larger dream. He en-visaged a federation of South Africa, where Boer, Briton, and even conceivably the Bantu might achieve the closest harmony. Such a federation would be internally self-governing but would maintain a strong connexion with Britain and the British Em-pire, the extension of which Rhodes once described as his only religion. Kruger, then, represented a seventeenth-century Afri-kaner ethos making belated attempts to adapt itself to new cir-cumstances; Rhodes was the local embodiment of the new

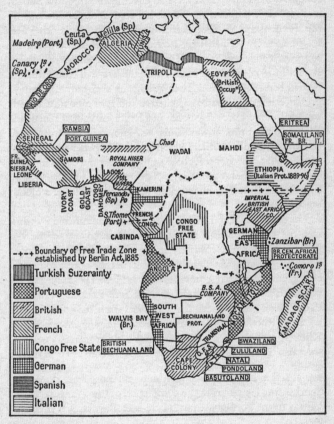

Madeira (Port.)

Canary Is (Sp.) · ·

RIO DE ORO

Ceuta (Sp.) Melilla (Sp)
MOROCCO ALGERIA

TRIPOLI

EGYPT (British Occup")

SENEGAL
GAMBIA
PORT. GUINEA

FR. GUINEA
SIERRA LEONE

LIBERIA

SAMORI

IVORY COAST

GOLD COAST

TOGO
DAHOMEY

L.Chad
WADAI
MAHDI

ROYAL NIGER
COMPANY

LAGOS
OIL RIVERS
KAMERUN
Fernando (Sp.) Po
S.Thomé (Port.)
FRENCH CONGO

CABINDA

ERITREA

SOMALILAND
FR. BR. IT.

ETHIOPIA (Italian Prot. 1889-96)

IMPERIAL BRITISH EAST AFRICA CO.

CONGO FREE STATE

GERMAN EAST AFRICA

Zanzibar (Br.)
BR. CEN. AFRICA PROTECTORATE

Comoro Is (Fr.)

ANGOLA

B.S.A. COMPANY

- + - + - Boundary of Free Trade Zone
established by Berlin Act, 1885

Turkish Suzerainty

Portuguese

British

French

Congo Free State

German

Spanish

Italian

WALVIS BAY (Br.)

SOUTH WEST AFRICA

BECHUANALAND PROT.

TRANSVAAL

SWAZILAND
ZULULAND

BRITISH BECHUANALAND

CAPE COLONY

O.F.S.

NATAL
PONDOLAND

BASUTOLAND

MADAGASCAR

16. Africa in 1891

capitalist imperialism of the late nineteenth and early twentieth centuries, which in South Africa had a predominantly British colouring.

In the opening stages of the conflict, as we have seen, Rhodes had concentrated on turning the Transvaal flank; he had helped to manoeuvre the British government into Botswana, and had obtained a Royal Charter to govern the region to the north of it. In 1890 he sent a pioneer column of policemen and settlers to occupy the Shona territories to the east and north-east of Matabeleland. In 1891 the operational sphere of his Company was extended to include most of what became North-ern Rhodesia.[1] Rhodes believed that these measures, as well as being the first steps in the northward expansion he sought for British rule, would encircle the Transvaal and so drive it into closer cooperation with the Cape Colony. He hoped that the minerals of the new territories in the north would enable the Cape to match the wealth of the Transvaal. But before the new settler colony of Rhodesia could begin to take root, Rhodes's men had first to engage in unofficial war with the Portuguese from Moçambique, then to conquer a Matabele nation bitterly resent-ful of their presence, and finally to overcome a rising of both Matabele and Shona occasioned by the settlers' demands for land and labour. Fighting did not cease until 1897. Even then, the promised gold of the Monomatapas' former empire proved disappointing, and also (until the coming of the railways from the Cape and from Beira in 1899) very costly to extract.

In relation to the Transvaal, all Rhodes had succeeded in doing was to convince Kruger that the very existence of his country was at stake, and to determine him to cut loose from the rest of South Africa by securing the completion of the Transvaal's own railway to the Portuguese port at Delagoa Bay. He was thus able to keep out of the customs union and the integrated railway system from the ports in the Cape and Natal, with which Rhodes had been hoping to enmesh him. Meanwhile, the integrity of Kruger's Boer republic was being menaced from within by the

1. In exchange for this extension of the Charter, Rhodes provided for a few years a subsidy of £10,000 a year to pay for the administration of Nyasaland.

growing numbers and wealth of the *Uitlanders*, the foreigners drawn to the Transvaal by its mining industry. The old informal Boer ideas of government had given way before a new administrative machine, staffed by educated Netherlanders, which insisted on the *Uitlanders* subscribing to Afrikaner ideals before sharing in political rights. Rhodes, always an impatient man, retaliated by mounting the Jameson Raid of 1896, in an attempt to replace Kruger's government by an *Uitlander* régime more amenable to his designs for South Africa.

The ignominious failure of the Jameson Raid ruined Rhodes politically. He forfeited all claim to Afrikaner support, even in his own Cape Colony. Indeed, he convinced Afrikaners throughout South Africa that British South Africans, supported by Britain, were aiming at the overthrow of the republics and the ideals for which they stood. This was indeed the case, for the direction of British policy in South Africa now passed to Chamberlain, who had been privy to the Raid plan, and to his nominee as British High Commissioner in South Africa, Sir Alfred Milner. Whereas Rhodes, for all his faults and mistakes, was as much South African as British, or more so, in his aims and outlook, Chamberlain and Milner cared nothing for local feelings, and Milner even more than his master was impelled by a belief that all South Africa had to be conquered and ruled until the Dutch element could be Anglicized. Milner deliberately pressed the *Uitlander* cause to the point of conflict, and war came at last in 1899. The help Kruger had hoped for from Britain's European rivals did not materialize. Only the Orange Free State stood by the side of its brother republic against the might of Britain and her empire. Independent Boer commandos continued the struggle long after the British armies had taken formal possession of the two republics, but by 1902 the majority of the Boers had had enough, and sought peace.

With the British conquest of the Boer republics, the European scramble for African colonies was virtually complete. Over large areas of the continent it was still mainly a paper transaction negotiated in the chancelleries of Europe, and it was only much later that its significance became apparent to most of the

Africans concerned. Here and there, however, it had already provoked bitter resistance. For Ahmadu and Samori in the western Sudan, for Ashanti and Dahomey and Benin, for the Arab and Swahili slave-traders of east and central Africa, for the Mahdists on the upper Nile and for the Matabele in Rhodesia, and not least for the Afrikaners in the extreme south, the coming of the European governments could only mean the destruction of their traditional ways of life and the imposition of new orders in which they could see no place for themselves. All these had fought to the best of their abilities, and lost.

Of the peoples of Africa who still remained independent by 1902, the Moroccans were sheltered for a space by the mutual jealousies of the European powers. But in 1904 Britain and France composed their differences in the Entente, and in 1911 France bought off the German interest by surrendering a large slice of her Congo territory to the German colony of Kamerun. Morocco could thus at last be partitioned by France and Spain. Only the Ethiopians had succeeded in holding back the flowing tide of European material power, forcing the Italians to limit themselves for some time to the dry and torrid coastlines of Eritrea and Somalia. In 1911, however, Italy sought her compensation in the conquest of Libya from the dying Turkish empire. Liberia also had precariously preserved her independence, from all but the European money-lenders. Elsewhere there could be no doubt that Africans were to enter the twentieth century under the firm control of one or other of the European colonial powers.

17 The Colonial Period: First Phase

Nothing so well demonstrates the element of unreality in the scramble for Africa as the thirty-five years of almost total obscurity which followed the limelight of partition. For as long as the international rivalry lasted, African questions were the most important in the world. Prime ministers spent time on them. Cabinets met over them. They coursed through almost every channel of international diplomacy; and from one point of view, it is a remarkable tribute to those involved that the partition of Africa was accomplished without involving the world in war. The international tension grew in intensity as the unclaimed areas in Africa diminished; but no sooner was the new map of Africa complete than the excitement, just as suddenly, died down. Even while the scramble was in progress, no sooner was a new colony or protectorate added to the dependencies of one or other of the colonial powers than interest in that territory dried up. The colonial powers had partitioned Africa as an insurance for the future, not because they had any present plans for its exploitation. Thenceforward, their main concern was that the annual premium should not be too high.

The ideal colony was one which was economically self-supporting. Whether it produced much or little, whether its people progressed fast or slowly, whether its economic development was undertaken by the people themselves under the guidance of the colonial government or by European settlers or mining companies, all these things mattered little in comparison with how nearly the budget could be balanced, how small the grant-in-aid could be. Early twentieth-century Europe was in no need of an increase in African products, and African markets

accounted for a negligible proportion of European exports. One day the position might be different. Till then, the less heard of the African colonies the better.

This attitude on the part of the colonial powers, which lasted until after the First World War, was one which threw responsibility squarely upon the young colonial governments, and it is astonishing to remember that colonial governments at this period consisted of mere handfuls of men. Johnston was sent out to found a colonial administration in Nyasaland with his own salary and £10,000 a year. Colvile started the protectorate administration in Uganda with a grant-in-aid of £50,000 a year. Lugard in Northern Nigeria had a little over £100,000, for a territory containing about ten millions of people. French patterns were a little less niggardly, but not basically dissimilar. In relation to Africa, France soon had to abandon her normal doctrine that the colonies should trade only with the metropolis. Any form of revenue which would reduce the financial drain on the metropolis was welcome.

With such attitudes prevailing, colonial occupation had of necessity to be a slow process. Johnston, with his £10,000, could just afford an armed force of seventy-five Indian soldiers under one British officer. Any further increase in his civil or military establishment had to be paid for out of the local revenue – when there was one. Lugard set out to rule Northern Nigeria with a staff of five European administrative officers and a regiment of the West African Frontier Force, consisting of two to three thousand African soldiers under about a hundred and twenty European officers and N.C.O.s. Any one of half a dozen of the powerful emirs in Hausaland could have put many times that number in the field against him. In these as in many other comparable cases, the colonial forces were of course much better armed and disciplined than those who tried to contest their authority. Still, forces of this size always had to be used with the greatest caution. One serious defeat, or even a successful ambush, could have wiped out the entire armed force of most early colonial governments. The Marxist stereotype, of brutal imperialists riding to power over the machine-gunned corpses of defenceless

Africans, is far further from the truth than its opposite, which would maintain that colonial occupation was a bloodless process.

Clearly the first task of every colonial government was to establish its authority over its own subjects. The touchstone of such authority was the power to tax. For as long as a colonial administration merely wished to live in the country at its own expense and without getting too much in the way of the local inhabitants, fair words were often sufficient; and in some colonies this arrangement lasted for many years. It was when a colonial government wished to recover the costs of occupation that the real test came. What every colonial government tried to do was to establish a nucleus around the capital, and to extend its influence slowly outwards as its resources increased. What every colonial government learned from experience was that the inhabitants of the peripheral areas did not simply wait peacefully until their turn to be brought under administration arrived. They traded their ivory and built up their supplies of arms. They started to form alliances against the colonial government, or to annoy the governments of neighbouring territories. They cut telegraph wires. They attacked caravans. They harboured refugees from the administered areas. Expeditions had to be sent against them long before the appointed time, and while the troops were absent on these forays, the areas within the nucleus seized the opportunity to revolt. Such was the life of a young colonial administration.

In nearly every territory of every colonial power only a serious military crisis brought forth reinforcements and forced up grants-in-aid to a level which permitted some rough policing of the whole territory. By 1900, for example, Nyasaland's £10,000 grant had risen to £100,000, and Uganda's £50,000 to £400,000. The situation in most colonial territories showed a comparable development five to ten years after the start of colonial rule. This was usually the high peak for metropolitan grants-in-aid, which from then onwards tended to decline annually as the local revenues rose, until by about 1914 they were virtually extinguished. Basically, it was because he could not provide the capital outlay represented by the period of grants-in-aid in more

conventional colonies that King Leopold's personal rule in the Congo sank to such appalling depths of maladministration. Faced by the failure of revenue to meet expenditure, he employed an ill-controlled and barbarous native soldiery to levy arbitrary amounts of tribute in rubber and ivory for the benefit of the state and the concessionnaire companies in which it held interests. Even these measures, however, failed to produce the necessary funds, and when news of the worst atrocities leaked abroad, international opinion at length forced the King to surrender his private empire to the Belgian government in 1908.

Throughout tropical Africa the termination of grants-in-aid more or less coincided with the bringing of all but the most remote of the peripheral areas under civil administration. In a sense, therefore, the grant-in-aid can be regarded as the cost of the unremunerative military policing of areas as yet unadministered. On the face of it, financial self-support was a simple product of the progress from military to civilian rule. For this reason, early colonial historians often talked of a stage called 'pacification' as preceding another stage called 'law and order'. In fact, however, the progress was very closely related to the growth of communications. Before taxes could be paid in any district, there had to be something which the people could grow and sell. But before there could be economic crops, there had to be communications to get them to the market.

The supreme example of this thesis on the one hand was the Oil Rivers Protectorate in eastern Nigeria, where (with palm-oil as an economic crop and with the Delta waterways for communication) colonial administration was set up and paid for out of customs duties without any grant-in-aid. As an example of the opposite sort, there could be no taxation in Uganda until the railway from Mombasa began to approach Lake Victoria about 1900. Before that date, the only economic export was ivory. With the railhead at Kisumu and a couple of steamers on the lake, however, hides and skins, wild rubber, beeswax, and a number of other natural products at once became marketable, while the way was opened for the introduction of cotton and coffee, the two staple crops of the Lake Victoria basin in modern

times. Thenceforward there was no problem of taxation in the nucleus of the Protectorate; but it was not for another decade, with the construction of roads and the arrival of the motor lorry, and with extensions of the railway and steamer system, that the inhabitants of the northern half of the country were able to offer to the collector anything more than their own labour services in commutation of tax. Until about 1910, therefore, this remained an area controlled mainly by military patrols, and civil administration was not finally established there until about 1919.

One of the most difficult questions about which to generalize is the degree to which the lives of ordinary people were changed by these early proceedings of European colonial governments. It is here that we encounter the apparently basic distinction between the territories where Europeans were in search of land and minerals, and those where they were seeking merely to trade and govern. The former group of territories included not only Southern Rhodesia, Northern Rhodesia, Nyasaland, and Kenya, but also the Portuguese territories in East and West Africa, the German territories in East Africa, South-West Africa, and the Cameroons, and also those parts of the French and Belgian Congo where the state and commercial companies held large territorial concessions. Here there were many hundreds of thousands of Africans who in one way or another lost the lands they had previously cultivated. Many were forced to move to new and perhaps inferior land in 'native reserves'. Many others were left in possession of the lands they were cultivating at the time of the occupation, but lost the surrounding uncultivated land which in a sense was their 'fallow'. Accordingly, when they moved, in the course of shifting cultivation, they found themselves rent-paying 'squatters' on alienated land.

It would, however, be a great mistake to imagine either that all Africans who lived in colonies of settlement or land concessions suffered in this way, or that such suffering was confined to territories where land was alienated to Europeans. In Southern Rhodesia it may well be that most of the African population suffered some disturbance in their land use as a result of European immigration; in all the territories to the north of the Zambezi,

however, the numbers of people affected were a very small proportion of the total. In German East Africa these were confined to one small corner of the northern province. In Kenya peoples as numerous as the Luo and the Baluyia were virtually untouched by European settlement, while even among the Kikuyu, who later came to nurse a special grievance on this score, it is likely that those directly affected constituted less than one per cent. Most of the land alienated in Kenya was taken from the pastoral tribes – the Masai, the Nandi, and the Kipsigis. All that white settlement did to the agricultural peoples was to block their natural expansion into land previously held at the spear's point by the pastoralists.

An indirect effect, which was somewhat more widespread, was the wage-labour demand by settlers, and above all by plantation and mining companies in all these territories. During the early part of the colonial period, such demands were almost invariably satisfied by political pressure of one kind or another. Here, however, one must remember that in all colonial territories a very large part of the demands made by governments upon their subjects were demands for labour – labour for the construction and maintenance of roads and railways, labour for the building and clearing of government stations, and (above all in the early days) labour for porterage. Nominally such labour might be given in commutation of tax. In practice, however, it was compulsory labour, imposed not upon all alike, but upon those who were detailed by their chiefs to give it, in response to the demands of government officers. Africans of this period did not perceive the difference, so clear to European minds, between compulsory labour for public and for private purposes; they were merely aware that one of the most immediate and unpleasant consequences of European rule was that the able-bodied might be enlisted for arduous labour of a kind previously considered suitable only for women and slaves.

For the African peoples the most important factor at this stage of colonial history, however, was probably not the issue of European settlement or its absence, not the relatively concrete issues of land and labour, certainly not the difference between

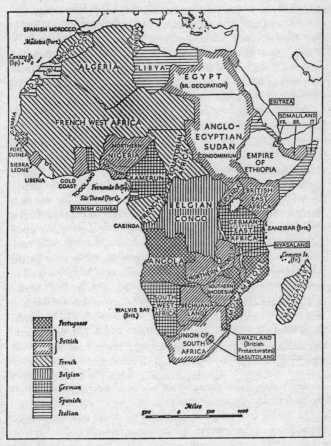

SPANISH MOROCCO
Madeira (Port.)
Canary Is.
(Sp.)

ALGERIA
TUNISIA
LIBYA
EGYPT
(BR. OCCUPATION)

ERITREA
SOMALILAND
FR. BR. IT.

FRENCH WEST AFRICA

ANGLO-
EGYPTIAN
SUDAN
(CONDOMINIUM)

EMPIRE
OF
ETHIOPIA

GAMBIA
PORT.
GUINEA
SIERRA
LEONE
LIBERIA
GOLD
COAST
TOGOLAND
KAMERUN
Fernando Po (Sp.)
São Thomé (Port.)
SPANISH GUINEA
CABINDA

NORTHERN
NIGERIA

FRENCH EQUATORIAL AFRICA

BELGIAN
CONGO

UGANDA
BRITISH
EAST
AFRICA
ZANZIBAR (Brit.)
GERMAN
EAST
AFRICA
NYASALAND
Comoro Is.
(Fr.)

ANGOLA

NORTHERN RHODESIA
SOUTHERN
RHODESIA
MOZAMBIQUE
MADAGASCAR

WALVIS BAY
(Brit.)
SOUTH-
WEST
AFRICA
BECHUANA-
LAND

UNION OF
SOUTH
AFRICA

SWAZILAND
(British
Protectorates)
BASUTOLAND

Portuguese
British
French
Belgian
German
Spanish
Italian

Miles
500 0 500 1000

17. Africa in 1914

the policy of one colonial power and another, but the far more intangible psychological issue of whether any given society or group was left feeling that it had turned the colonial occupation to its own advantage, or alternatively that it had been humiliated. To a large extent this was a result of the accidents of occupation in each particular territory. Every occupying power inevitably made both friends and enemies. Every occupying power, before it could train a local army or police force, needed native allies and was prepared to accord substantial privileges to those who would play this part.

According to the value judgements of modern Africa, such peoples were traitors and quislings; but these categories hardly fit the circumstances of eighty years ago. Then, the primary choice lay not with individuals but with their political leaders. If these were far-sighted and well-informed, and more particularly if they had had access to foreign advisers such as missionaries or traders, they might well understand that nothing was to be gained by resistance, and much by negotiation. If they were less far-sighted, less fortunate, or less well-advised, they would see their traditional enemies siding with the invader and would themselves assume an attitude of resistance, which could all too easily end in military defeat, the deposition of chiefs, the loss of land to the native allies of the occupying power, possibly even to the political fragmentation of the society or state. In trying to see the early effects of the colonial occupation upon the African peoples, it is essential to realize that the rivalries and tensions between African communities did not end with the colonial occupation. They continued, with the colonial administrations both using them and being used by them. As with the slave trade in earlier times, there were gainers as well as losers, and both were to be found within the confines of every colonial territory.

In the issue of gain or loss, there is no doubt that the presence or absence of European missionaries as precursors of the colonial régimes was one of the most important factors. At the start of the colonial period missionaries were frequently more numerous, and in many ways more influential, than the representatives of the colonial governments They knew the languages of the people

among whom they had been working, and although they often belonged to nationalities different from that of the colonial power in any particular area, they understood the new forces which were breaking in upon the African world. They were thus well qualified to be the intermediaries between the one and the other, and from now on were so not merely as the advisers of African rulers, but even more as the teachers of their subjects.

No colonial government of this period had the resources to enter upon education. Missionaries, on the other hand, were finding that all over pagan Africa the school was by far the most effective means of Christian evangelism. By the beginning of the colonial occupation there were already in existence small groups of literate converts gathered around the mission stations of the pre-colonial period. These early converts were now sent out to open schools and churches in the villages round about. However rough and rudimentary the education they offered, their pupils imbibed not only some Christian faith, and some knowledge of Scriptures and doctrines, but also at least some sense of mastery over the new conditions of life created by the colonial system. They perceived that the knowledge and skills of the newcomers were communicable. They found that for those who would learn, the new age could spell not servitude but renascence.

The first third of the colonial period, therefore, almost throughout tropical Africa from the Sahara to the Zambezi, was a period when the colonial powers had no positive policy and when colonial governments were concerned first and foremost to make their own territories economically self-supporting. Some small immediate steps in this direction could be taken by the imposition of import and export duties, by the granting of concessions, and by the lease or sale of lands and mineral rights. Essentially, however, the problem was one of creating for the inhabitants the opportunity to earn cash incomes which could then be taxed. This could be done either by stimulating them to grow economic crops on their own land, or alternatively by encouraging European settlers or companies to establish plantations, or to develop mining industries, in which Africans would be employed as wage labourers. Either way, the imposition of direct

taxation would be the incentive; but such taxation could not be imposed until governments had provided the necessary basic structure of civil administration, law and order, and communications. In consequence, it usually took between twenty and thirty years before self-support could be achieved, even on the most meagre scale of revenue and expenditure. Throughout this initial period deficiencies in revenue had to be met from imperial grants-in-aid, grudgingly given.

Where any particular colonial government placed the emphasis in its economic development, whether on immigrant enterprise or on indigenous peasant production, this followed partly from local circumstances, but also largely from the personal views of individual governors. France pursued one policy in West Africa, another in Equatorial Africa. British colonial governments encouraged European plantation agriculture in Kenya and to some extent in Nyasaland, but discouraged it in Uganda and disallowed it altogether in the West African territories. The imperial governments in France and Britain were not especially concerned one way or the other about such issues. Nor did the various policies pursued at this stage make much difference to any but a small minority of Africans living in the territories north of the Zambezi. It was only later, when settlers tried to consolidate their political influence in the face of the rising aspirations of the African majority populations, that the difference between European-settled territories and the rest became profound and serious. For the African populations of all these territories, the vital issue during the first thirty years of colonial rule was the way every particular people came to terms with its colonial government, whether early or late, whether by agreement or by force, whether advantageously or disadvantageously in relation to its African neighbours. It was within the framework of these communal changes and chances caused by the coming of colonialism that individual choices of cooperation or resistance had to be exercised.

18 The Colonial Period: Second Phase

In the years immediately preceding the First World War, colonies throughout Africa south of the Sahara and north of the Zambezi began to assume the classic forms which they were to retain until the eve of independence. The colonial governments, whether British or French, German or Italian, Belgian or Portuguese, were now the real masters of their territories. The period of resistance by traditional tribal communities was over, that of opposition by emancipated nationalism had not yet begun. Military garrisons, consisting almost entirely of African troops under European officers, were adequate to deal with any small emergencies, while sea and rail communications were so far developed that reinforcements could now be brought from one territory to another in a matter of weeks if not of days.

Civil administration was now the rule for all but the remotest districts, and under the governors and their small central secretariats the regular hierarchies of provincial and district officials were developing. These were now recruited on a professional basis, and were no longer, as their predecessors had been, seconded army officers or locally engaged traders and big game hunters. Great strides had been made in medicine and in hygiene, in so far as these affected the lives of Europeans in the tropics, and even the wives of expatriate officials were now occasionally seen in Africa. With the wives came the clubs and the social colour bar. The second generation of colonial rulers was much more firmly dug in, not only in security but also in outlook, than the first.

By the outbreak of the First World War, expatriate officials in most of the African colonies had grown in numbers from the

original dozens to a few hundred. The functions of colonial governments, however, were still extremely limited. Almost all the increase in staff made possible by the gradual growth of the revenues had until now been absorbed in building up the general administrative services. The only technical departments which had been seriously developed were those dealing with public works like railways, roads, waterways, and government buildings, including the housing of expatriate officials. Medical services were in general sufficient only for government employees. Education, as a function of government, was practically non-existent. Agricultural and veterinary services, though important results had been achieved at the level of research and experiment, had no machinery other than the occasional help of administrative officers for getting new plants and techniques into circulation.

The district administrative official, therefore, was the lynch-pin of the whole system, but even his influence had narrow enough limits. His primary duties, as the local representative of the colonial government, were to maintain law and order and to supervise the collection of the tax. In practice this meant that he exercised some control over the way local communities governed themselves. How much control, and at what level, was a thing which varied greatly not only from territory to territory but also from one part to another of the same territory. French and Belgian colonial governments had quarrelled with and deposed almost all their African kings and big chiefs. They had broken up the larger indigenous political units, ruling the divided sections through nominated chiefs. British and German governments had tended to respect the integrity of larger units, where these existed, and to rule such areas indirectly through the traditional rulers and chieftainly hierarchies. But there were many areas where political units were small and where power was divided among ill-defined groups of elders. In such areas British and German practice approximated to that of the French and Belgians.

While there were differences in the degree of interference, however, for ordinary purposes most Africans continued to be ruled by Africans. Most criminal and all civil cases were tried in

native courts and according to customary law. European administrators acted as magistrates in a few more serious cases, but most of their judicial work consisted in revising and modifying the sentences and procedures of native courts. Questions of land occupation, inheritance, marriage, birth, sickness, and death were still (apart from the Christian influences emanating from the missions) treated very much as they had been in pre-colonial days. For those who lived in the rural areas, and most areas were rural, the prohibition of warfare and the imposition of tax were the two principal innovations of the first phase of the colonial period; but the tax was usually small, and there were many who were never called upon to pay it, and many more for whom the obligation was commuted into a few days or weeks of road-making or porterage, undertaken at the bidding of the village chief. In most colonies all that had happened was that a light form of overall policing and administrative control was being undertaken by the alien governments, which after twenty years of annual deficits were now able to recover the running costs from the governed. There was no sense of any need to hasten change, however. The assumption on the part of all the colonial powers was that the colonial system would operate for hundreds of years to come. It was for governments to maintain peace and the rule of law, leaving education, morality, and even health, to the missions, and economic development to the initiative of individual producers and traders.

In the period between the First and Second World Wars, colonial governments were still essentially unhurried. There was, however, a marked change in their conception of the functions of government. In part this was the result of the first war. Having been locked for four years in internecine combat, the colonial powers were less arrogantly self-confident as to the innate superiority of the western world and in particular as to the unfettered sovereignty of its national units. In the metropolitan countries it began to be felt that colonialism needed a goal and a justifying philosophy. This need was made urgent by the decision of the

victors to break up the German colonial empire. In Africa the former German colonies of Togoland and the Cameroons were each divided into French and British spheres; South-West Africa was allocated to the Union of South Africa; and German East Africa was partitioned between Great Britain and Belgium. But the allies, though they arranged the details among themselves, did not just baldly annex these territories in the peace treaty. From the newly constituted League of Nations they accepted the duty of governing them as 'a sacred trust of civilization' until such time as they were able 'to stand on their own feet in the arduous conditions of the modern world'. The arrangement no doubt contained a large element of hypocrisy, but among those who made it there were a few men of great integrity and influence who were genuinely concerned to develop a new and more creative kind of colonialism, suited to the third and fourth generations of colonial rule.

The idea which was new and important in the Mandates system of the League of Nations – it was elaborated alike by Britain's greatest African administrator, Lord Lugard, in his *Dual Mandate in British Tropical Africa*, and by the French Colonial Minister, Albert Sarraut in his *Mise en valeur des colonies françaises*, during the years immediately after the war – was that the colonial powers had an obligation, not merely to govern justly, but also to carry the colonial peoples decisively forward both economically and politically. Both Lugard and Sarraut still visualized a long future for colonialism; but their conceptions were dynamic, not static. Moreover, both authors reached the pleasing conclusion that what was best for the colonies was also in the best material interests of the colonial powers. The time was past when Africa's productive capacity and potential markets could be held in reserve. From Europe's point of view as from Africa's, the time for economic development had arrived.

Allégé désormais des obligations de la conquête, le labeur français aux colonies peut maintenant se consacrer à l'organisation du plein rendement de sa patrimoine. L'intérêt souverain de la France, en effort de relèvement après une guerre où son héroisme a sauvé le destin de ses colonies, est aujourd'hui d'accord avec les intérêts de chaque

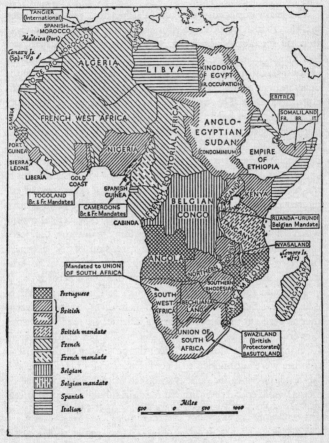

TANGIER
(International)
SPANISH
MOROCCO
Madeira (Port)
Canary Is.
(Sp.)
ALGERIA
LIBYA
KINGDOM
OF
EGYPT
(BR. OCCUPATION)
ERITREA
SOMALILAND
FR. BR. IT.
FRENCH WEST AFRICA
ANGLO-
EGYPTIAN
SUDAN
(CONDOMINIUM)
EMPIRE
OF
ETHIOPIA
GAMBIA
PORT.
GUINEA
NIGERIA
SIERRA
LEONE
LIBERIA
GOLD
COAST
SPANISH
GUINEA
TOGOLAND
Br. & Fr. Mandates
CAMEROONS
Br. & Fr. Mandates
CABINDA
FRENCH EQUATORIAL AFRICA
BELGIAN
CONGO
UGANDA
KENYA
TANGANYIKA
RUANDA-URUNDI
Belgian Mandate
NYASALAND
Comoro Is.
(Fr.)
Mandated to UNION
OF SOUTH AFRICA
ANGOLA
NORTHERN RHODESIA
SOUTHERN
RHODESIA
MADAGASCAR
SOUTH
WEST
AFRICA
BECHUANA-
LAND
MOZAMBIQUE
SWAZILAND
(British
Protectorates)
BASUTOLAND
UNION OF
SOUTH
AFRICA

Portuguese
British
British mandate
French
French mandate
Belgian
Belgian mandate
Spanish
Italian

Miles
500 0 500 1000

18. Africa after the peace settlement of 1919

possession coloniale, pour dégager avec sûreté les plans directeurs, les principes dominants, l'unité des vues, qui doivent guider et ordonner la tâche de mise en valeur.[1]

The main implication of Sarraut's doctrine, very ably stated for the British African territories in the two Ormsby-Gore Reports, for East Africa in 1924 and for West Africa in 1926, was that economic development throughout tropical Africa must be centred on the indigenous peoples, and that it must start with the development of medical services, educational services, and agricultural services. This would open to every African the possibility of bringing up a healthy family, with eyes open to the need to improve living standards. Furthermore help and instruction would be available in the rural areas to enable African peasant proprietors to become producers for the world market and buyers of imported goods. The Ormsby-Gore plan was not in the least a matter of starry-eyed idealism, but rather one of enlightened self-interest. It did not advocate large-scale metropolitan aid for the tropical colonies. It did, however, at a time when colonial revenues were just beginning to outgrow the needs of law and order, suggest a broad extension of the accepted functions of government in a way which most colonial governments would hardly have advocated of their own accord.

The outstanding example in British territories was that of education, a field in which, if left to themselves, colonial governments were apt to be particularly apathetic. In 1925 the British Government created an Advisorship and a powerful Advisory Committee at the Colonial Office; the governors of the African colonies were summoned to a conference, and a practicable and far-reaching education policy was agreed whereby colonial governments would spend their limited funds in subsidizing, inspecting, and improving the schools already operated by the Christian

1. Relieved henceforward of the obligations of conquest, French effort in the colonies can now be dedicated to the full development of its heritage. The sovereign interest of France in her struggle for recovery after a war in which her heroism has safeguarded the destiny of her colonies, is today at one with the interest of each colonial possession to lay down the secure guiding plans, dominant principles, and unity of views which must direct and control the task of development.

missions, instead of in founding rival and far more expensive systems of state education. In the following ten or fifteen years, therefore, most of the territories in British tropical Africa witnessed the development of educational systems capable of providing perhaps a quarter of their young citizens with two to four years of schooling, and a select few with eight years or even twelve. Belgian policy in the Congo was similar, but with the emphasis on primary education. The French, on the other hand, made no use of the pre-existing missionary foundations, but set up state schools in which a very small minority of Africans followed the curricula of metropolitan France. Numbers, however, were hardly the most significant issue at this stage. What was of overriding importance was that all over tropical Africa it was being shown that Africans were as capable as anyone else of becoming educated, efficient, and responsible, able to carry out the most exacting tasks that have to be performed in any modern state. From this moment the ultimate future of the African in most of his own continent was never in serious doubt.

At the theoretical level, during these inter-war years, there appeared to be a fundamental difference between British colonial policy and that of all the colonial powers of Continental Europe. France, Belgium, Portugal, and Italy all in theory maintained the doctrine of assimilation. Despite the rise and fall of earlier French empires in Canada and India, French Africa was bravely known as France Outremer. In theory, Senegalese were to be taught to think of themselves as Frenchmen, Congolese as Belgians, Angolans as Portuguese, and Somalis as Italians. In theory Africans in French and Portuguese territories, whenever their economic and educational attainments justified it, could aspire to transfer from the status of subjects to that of citizens, bound by metropolitan and no longer by customary law, and with representation in the metropolitan government as a right more essential than representation in the local councils of the colony. In none of these Continental countries was there, between the wars, any serious proposal that the African colonies should at any stage become independent of the metropolitan countries; their inhabitants would merely grow into citizens of a

greater France, a greater Belgium, a greater Portugal, and an Italy more reminiscent of the Roman Empire. In contrast, Britain between the wars was not thinking in terms of a greater Britain. Even the Commonwealth was a new idea, formulated for the first time in the Statute of Westminster in 1930, and it was by no means certainly envisaged that it would come to include India, much less the African colonies. There was no feeling that Africans should be turned into Britons. On the contrary, talk was all of allowing them to 'develop on their own lines', though in the absence of any clear idea about what those lines should be, British patterns were apt to emerge.

While the centralizing and assimilationist policies of the Continental powers were just as unrealistic as the empirical and decentralizing practice of the British, the Continental Europeans were at least spared the constitutional wrangles over the political rights of white settlers in Africa which occupied so much of the surface of British relations with the African colonies from the 1920s until the eve of independence. The doctrine that a colony was, or was destined to be, politically integrated with the metropolitan country was sure to prove fallacious; but while it lasted it assuaged the worst anxieties of European residents in the colonies. British empiricism, however, encouraged British settlers in East and Central Africa to believe that their political future depended on their own efforts, and that if they could gradually manage to take over control of the colonial governments from the expatriate colonial civil service, they would be able to guide their own and their African fellow citizens' destinies for an indefinite period. In fact, of course, this was a complete illusion. Everywhere north of the Zambezi, British colonists were so thin upon the ground that, whether they realized it or not, their position depended entirely upon the presence in the background of British imperial power. Had they succeeded in removing that power, they would have been quite incapable of controlling the vast African majorities among whom they lived. Nevertheless, British African policy, following the example of the older colonies rather than that of British India, gave them votes and representatives in the legislative councils of the colonial governments. It encouraged

them to embark on their hopeless struggle for power, perhaps without any clear idea of where that struggle would lead.

The Union of South Africa apart, it was only in Southern Rhodesia that there occurred a full devolution of political power to a local European minority. This followed from the special circumstances of Southern Rhodesia's occupation, in which private settlers had from the very beginning been the strong right arm of the Chartered Company. When the Charter expired in 1923, therefore, it would have been difficult to institute a colonial government in its place. The white Southern Rhodesians were offered amalgamation with the Union of South Africa, or internal autonomy on the basis of an income suffrage high enough to exclude all but the merest handful of black voters. They chose autonomy, and by concentrating all their policies during the next thirty years on the promotion of further white settlement, they succeeded in building up their power and their economic predominance to a point from which it needed more than an ordinary nationalist movement to oust them.

Elsewhere in Central and East Africa, by comparison, settler politics presented no more than a temporary façade. Their first centre was in Kenya, where in the period before 1914 a handful of wealthy and well-connected settlers, led by Lord Delamere, had acquired considerable influence in the government of the territory. British settlers were to remain prominent in Kenya politics until the late fifties, but the real turning-point of their influence came in the early twenties. An attempt at a substantial increase in white settlement in the years from 1919 to 1922 overreached itself, and was successfully attacked by those who believed it was hindering the development of the African population. In 1923 the British government stated that in Kenya, as in Uganda and Tanganyika, African interests were to be treated as paramount, and that while European interests would be respected, responsible government on the Southern Rhodesian pattern was not to be expected. From that time forward, settler influence entered a slow decline.

In East Africa, as in Nigeria, the Gold Coast, and the more prosperous French territories such as the Senegal and the Ivory

Coast, the really significant factor for the future was the small but growing number of Africans entering secondary schools and thus approaching the educational standards of many of the immigrants and expatriate officials. North of the Zambezi, it was only in Northern Rhodesia, with the growth of the copper-mining industry in the late twenties and early thirties, that immigrant Europeans were able to gain any considerable increase in political power. Their opposite numbers in the older-established copper industry of the Katanga had already been firmly told by the Belgian government that they might expect privileges but not political rights.

Superficially, the period between the two world wars of 1914 and 1939 was the period above all others when all important initiatives in Africa were taken by Europeans. During this period there were hardly any Africans in positions of real responsibility in their own countries. In 1936 even the ancient kingdom of Ethiopia went down before the invasion of Mussolini's Italy. Everywhere colonial governments were at the zenith of their power. African kings, where they survived at all, had been reduced to the position of either figureheads or subordinate civil servants. Even the successful battles fought in defence of African interests against those of immigrant communities were fought not by Africans but by European missionaries and colonial officials, as well as by liberal forces in the metropolitan countries. Such people were staking their judgement on a belief that the inhabitants of 'darkest Africa' were potentially as capable as any other set of human beings, and therefore that what was required in the long run was not to bring in more masters but to train up more men. During this period a new generation of Africans was putting itself to school, and from it a few were to emerge equipped not merely for participation but for leadership in the new Africa. Some white men in Africa began to speak scornfully of 'trousered blacks' and 'handfuls of examination-bred students'; yet during this second phase of the colonial period their appearance was the most important event in African history.

19 The Colonial Period: Third Phase – Economic Development and Welfare

Until the 1920s the theory of the colonial powers, and until the 1940s their practice, did not include any financial assistance to stimulate the economic development of the colonial territories from the outside. Essentially this was a projection into the colonial field of the limited view of their economic responsibilities in their own countries taken by most European governments, a view which lasted until about the same period. In Africa the colonial powers had been prepared to subsidize the primitive colonial revenues until such time as these were sufficient to cover the bare minimum of administrative expenses. In the way of capital expenditure metropolitan governments had here and there made outright grants towards the cost of strategic railways – the Uganda Railway was an early example, and the railways of German East and South-West Africa were greatly extended in the years immediately before 1914 – but only after the failure of other methods of financing them had been clearly demonstrated. With these exceptions, colonial governments were expected to live on their own meagre revenues, and to limit their borrowing to the measure of the security provided by those revenues.

Considering these limitations, it was remarkable how much was achieved. By the 1920s, for example, the railway map of Africa had virtually assumed its modern shape. The resulting economic development, though occasionally impressive, was, however, not as great as it should have been. In the first place, systems of transport designed to meet the needs of government were not always efficient for commerce. Thus government launches could navigate the Senegal and Niger rivers between railheads, where boats carrying useful amounts of cargo could not.

The rail and water transport system of the Congo required a vividly uneconomic amount of unloading and reloading from train to steamer and steamer to train. Again, for want of funds, the construction of ocean ports capable of handling any substantial amount of trade engendered by the railways tended to lag far behind the railways themselves. Even in the comparatively wealthy colony of the Gold Coast, for example, the deep-water harbour necessary to serve the Ashanti Railway was not opened until 1928, although the railway had been completed in 1903.

Railways, moreover, were not an automatic means of promoting economic growth. Obviously, such growth followed most easily and naturally in areas already initiated into the business of production for trade. Railway-building produced greater results more rapidly in West Africa than in East Africa. Within West Africa the results were more appreciable in the coastal colonies than in the remote territories of the western Sudan. The peoples of the southern Gold Coast and Nigeria soon realized the advantages of the new transport systems for the exportation of cocoa, timber, and palm produce. Senegal was not far behind with groundnuts, and the economies of the Ivory Coast and French Guinea were also among the first to stir. In East Africa one of the greatest obstacles to development was that the railways had to run through hundreds of miles of arid and sparsely-inhabited country in order to tap the agricultural produce of the well-watered and densely populated Lake Victoria basin. A partial solution was found to the economic problem of the Uganda Railway in the policy of white settlement in Kenya. In German East Africa, the Tanganyika of 1919–63, not even this solution was possible for its vast desiccated central area, and railway development reaching to the south of the Lake Victoria basin was in consequence delayed by twenty years. South-West Africa offered perhaps the prime example of an extensive railway system, built for largely strategic reasons across vast tracts of barren underpopulated country, which could never pay its way commercially.

At the time of the scramble for Africa, high hopes had been placed in the economic stimulus of private European settlers.

After thirty or forty years, however, the results were seen to be meagre. Although nearly fifty million people emigrated from Europe to other continents between 1880 and 1930, few of these migrants found their way to Africa, and most of those who did so settled either in Algeria or in South Africa. North of the Limpopo and south of the Sahara the European population of Africa amounted in the early thirties to a mere sixty thousand. Most of Europe's emigrants were surplus labourers possessing few skills and no capital. There were few openings for such people in tropical Africa, which needed capital and technical skills but had plenty of indigenous unskilled labourers. Many mistakes were usually made, and many lean years experienced, before the European farmer with capital, working with an African labour force, learned what crops could be grown and what animals reared; and the same considerations militated against collective European investment in plantation agriculture. With some exceptions – such as tobacco in Southern Rhodesia, tea in Nyasaland, and sisal in Tanganyika – the most successful plantation crops could be produced almost as well, and usually more economically by African farmers working on their own account and on their own lands. If Europeans wished to invest their money in Africa – and, until the 1920s, investment in other continents usually promised less risk and better returns – it was more profitable to support companies engaged primarily in buying from and selling to African producers, rather than those which themselves engaged in agricultural production.

The great exception to this rule, both as a foundation for European settlement and as an attraction for private European capital, was mining. It was the diamond and gold discoveries of the 1870s and 1880s which caused the emergence of a considerable urban and industrial community in South Africa. It was the promise of gold and other minerals which enabled this community to expand into Southern Rhodesia in the nineties, and into the copperbelt astride the Zambezi-Congo watershed in the first three decades of the twentieth century. The importance of mineral wealth, and of the industrialization which followed in its train, was graphically illustrated by Professor

S. H. Frankel in 1938, when he published figures for the capital so far invested in Africa south of the Sahara. Of the estimated total of £1,222,000,000 – a sum almost equally divided between private investment and public loans – no less than £555,000,000 had been invested in South Africa. A further £102,000,000 had been invested in the Rhodesias, and £143,000,000 in the Congo. In other words, two-thirds of the European investment had been in territories whose economies were based on mining.

In southern Africa the economic momentum was such that even costly installations like railways could be financed and built by private enterprise. Private enterprise also created the towns which grew up around the mining-camps and deeply affected the lives of whole populations in these areas. Only in the Belgian half of the Katanga did the mining companies pursue a policy of stabilized labour, encouraging all their employees to bring their families to the mining towns and to settle down there as a permanently urbanized class. In South Africa and the Rhodesias, the existence of European settlement before the establishment of the mining industry made it impossible for the mining companies to develop a stable African labour force. White trade unions feared lest the Africans should acquire experience and training which would enable them to challenge the white monopoly of technical skills. Most Africans in the mining industry were therefore 'migrant labourers', recruited on a temporary basis from rural areas for hundreds of miles around, who left their families on the land and came for a year to live in the 'native compounds' established by the mining companies. Unsatisfactory though this was socially, and in the end economically also – for short-term contract labour, though paid low wages, was inefficient and therefore not cheap – it did mean that experience of urban life became very widespread. By the late 1930s there were probably few African families between the Cape and Malawi who did not have some of their members away at work in the towns.

Moreover, although there was an enormous differential between the earnings of African labourers and those of European managers and skilled artisans, African cash incomes became significantly higher on the average than anywhere else in black

Africa. Together with the presence of a sizeable European population, this made it possible for European enterprise to develop secondary industries producing for the local market. Such industries became a feature of the South African scene in the 1920s and of the Southern Rhodesian in the late 1940s. This growing industrialization greatly increased the flow of African labour to the towns, and also tended to make its urbanization permanent. The European masters of southern African society had never envisaged the development of a black proletariat on this scale, and hundreds of thousands of Africans were eventually living in appalling shanty towns round the fringes of the major European centres.

This genuine industrial revolution, though creating grave new tensions, gave southern Africa a very different economy from that of the rest of black Africa. By the mid-1930s, the Union of South Africa alone was responsible for more than half of the whole international trade of Africa south of the Sahara; the Union's foreign trade amounted to some £22 per head of population, while that of Tanganyika was only £1½ and that of all French West Africa even less. Elsewhere, only the larger British West African territories, which possessed some mineral wealth as well as expanding communities of peasant farmers producing for export, had really even begun to join the world economy. Before the world slump of the 1930s severely depressed the demand for their agricultural exports, their share of sub-Saharan Africa's trade had been as high as a sixth. Even in 1936, the richest of them, the Gold Coast, still had trade worth £7 per head of population.

It was indeed the world slump which first suggested to the European powers that they could not expect the economies of their African territories to expand usefully through the efforts of their inhabitants themselves, with the sole aid of private European investors and settlers. In 1929, for example, the British Government for the first time took general powers to lend or even give money to colonies in order to help stimulate their economic development. This was not altruism but self-interest. During the depression, Britain had a pressing need to increase her own

foreign trade, and the stagnant colonial economies seemed a suitable outlet conveniently within her reach. But in those years money was naturally scarce, and the results were not spectacular. By 1938, the British dependencies in Africa had received only £4,000,000 from the new Colonial Development Fund, a sum equivalent to the addition of only about 1% to their combined annual revenues.

A real understanding of the extent to which the potentialities of colonial Africa had remained undeveloped came only with the Second World War. Older lines of supply were disrupted by transport and currency difficulties; there was a greatly increased demand for the strategic raw materials Africa could supply; and postwar shortages of foodstuffs and of many raw materials were to be expected. The colonies suddenly became of immense economic value. For Belgium, and to a lesser degree France, the African territories held during 1940–44 almost the only resources which could be contributed to the war effort.

The consequences of this new situation were often remarkable. The mining industries of Northern Rhodesia and the Belgian Congo, whose earlier development had been greatly frustrated by the depression, entered upon a fantastic boom. By 1953 the value of the Congo's exports had increased *fourteenfold*, and her government revenue had been multiplied *fourfold*. Northern Rhodesia experienced a *ninefold* increase in her exports – almost entirely of copper – and a *twentyfold* increase in revenue. From being, with Nyasaland, the Cinderella of British Central Africa, she suddenly became by far the richest territory. In British West Africa, the establishment of government purchasing agencies for vital produce like oil crops and cocoa broke the hold on the peasant economies the European trading companies had so far maintained. These agencies paved the way for postwar marketing boards under local control, which guaranteed the farmers a price for their produce free from world market fluctuations, and were able to build up substantial reserves to cover lean years. These reserves in fact were soon so substantial that it became possible to lend or grant large sums from them for local schemes of economic and social development. Moreover, during the war and

up to the 1950s, European industry was unable to supply the African territories with all the manufactured capital and consumer goods their greatly-increased purchasing powers could command. Many colonies were therefore enabled to build up substantial credit balances in Europe.

After the war, then, it became possible for the richer colonies to embark on ambitious development schemes which they knew they could to some extent finance from their own resources. Nor was this all. Throughout Africa there was a great stepping-up in private European investment, which was now shut out from many of its former profitable fields in the Americas and Asia. North American capital also became increasingly available. Moreover, the governments of Europe sometimes attempted to meet their own particular needs by embarking directly on ambitious African projects, which if undertaken at all in former years would have been left to private enterprise – though some of these, most notably the over-ambitious scheme for the mechanized production of groundnuts in East Africa, were not always very well conceived.

The Atlantic Charter and the concept of the United Nations demonstrated a change in the political climate also, and the rapid economic and social development of the African territories came to be pursued not only because backward colonies were of no value to the powers possessing them, but also because the powers felt a moral obligation towards their colonial subjects. By the end of the war, in the words of Sir Keith Hancock, one of the foremost advocates of a progressive colonial policy, 'vigorous State action to promote colonial development and welfare' had become 'the new orthodoxy'. In Britain, the colonial-development principle initiated in 1929 was extended to cover schemes for social as well as economic advancement. The permissible annual expenditure rose from a maximum of £1,000,000 to £5,000,000 a year (1940), and then to £12,000,000 or even more (1946). With this available to supplement local resources, even the weaker British territories were able to join with the more fortunate in development plans providing for the expenditure of a total of some £210,000,000 during 1946–55. For French Africa, where the rate

of investment, especially from private sources, had so far been much lower, the change was even more startling. The development plans for the nine West African territories alone totalled £277,000,000 for the same period, with a much higher proportion of the funds provided by the colonial power. In the Congo, the Belgian colonial government was hard put to it to expend all the money which by the end of the war Belgium had come to owe to her colony.

In many ways, the most striking results of this new approach to colonial development were social rather than economic. At least for the richer territories, much of the economic advance, even where consciously planned by governments, followed naturally enough from the new economic circumstances. But it was not so in the social field. The European governments had been awakened to the extent to which their African subjects needed more doctors, welfare workers, and trades unionists, better water-supplies, sanitation, and housing, and above all many more and better schools. The new development plans, therefore, were very consciously aimed at social as well as economic betterment. The need for expansion in education was especially stressed. In 1943, for example, the British Government even began to contemplate the goal of universal literacy in its African empire. Shortly after the war it embarked on the establishment of colonial universities, a step which necessarily involved the strengthening of all the lower rungs in the educational ladder. The French and Belgian governments were little if at all behind, though their methods were often different. For the French, and equally for the French Africans, the peak of educational advance remained attendance at a university in France. Almost throughout colonial Africa, an educational and social revolution began to accompany the economic revolution.

The consequences of this revolution were by no means the same throughout the continent, and some of them were quite unexpected. They varied in accordance with the ultimate aims of the colonial powers, and also with the extent to which local administrations were subject to European settler influence. In British Central and East Africa, therefore, where settlers often

had a considerable voice in the conduct of affairs, and also in the Belgian Congo, where there was no plan to accompany the often very impressive economic advance with political progress, the stress in educational policy lay on the improvement of African primary and vocational schooling. In both regions it was thought dangerous to allow the African to advance too far or too quickly.

In view of the earlier shortage of educational facilities for Africans, it was possible to implement the extensive plans for social and economic advancement only by greatly increasing the numbers of Europeans in the field. Hitherto – apart from settlers, where they existed – the Europeans in Africa had been engaged in only three major activities, trade and other economic exploitation, missionary work (which of course covered almost all the early work in education), and the administration of government and the services essential to it. It was now necessary to import large numbers of school teachers, university lecturers, social welfare officers, labour organizers, rural water engineers, surveyors, builders, and so on, as well as innumerable sorts of researchers and planners and advisers. All these people drew large salaries and generous travel allowances to enable them to enjoy regular leaves in Europe. They also had to have houses and services provided for them, so that they and their families could live in as good conditions as they were used to in their own countries, or better. Thus a sizeable proportion of the moneys made available for African development seemed to disappear into European pockets.

In West Africa, by and large, the Africans were able to take this in their stride. Shortly after the war they could already see the way to control of their own territories opening before them, and they knew that before long they would be able to replace many of the new European 'experts' while keeping the remainder under due control. Elsewhere, however, the new European invasion of Africa always widened and sometimes deepened the tensions between Africans and Europeans, especially when the newcomers came to swell an already established settler population. At best the invasion might help to encourage or even create African demands for political advancement. Sometimes, and

especially towards the south, it unfortunately tended to do little more than make the gulf in wealth and education between the Africans and their European masters seem even wider and more difficult to cross than ever before.

It is clear that colonial Africa in the 1940s and 1950s was moving very quickly away from the stagnation of the previous half century. The increase in wealth combined with a great improvement in communications – symbolized by the new motor roads which began to reach even the smallest and remotest villages – and with the growth of education, to promote a new social mobility which weakened old tribal cohesions and created many fresh problems for the future. Both the physical face of the continent and the outlook of its peoples were changing on a scale and at a rate unprecedented in previous history. Unevenly, and often with serious growing-pains, Africans were once more catching up with the rest of the world. They still had a long way to go. African economics were still far too dependent on the export of only a few major primary products. National incomes per head, so far as they could be calculated in territories where most people were still producing mainly for subsistence, were still very low by European standards, if not by those of some Asian countries. As against typical western European figures of more than £300 in the mid-1950s, the figures for Tanganyika and Nyasaland were only £17 and £7 respectively, while for territories like Somalia or Upper Volta they were still hardly measurable. The best Africa could show was a mean of £115 a year very unevenly divided between the different races in South Africa, and £75 a year for the Africans of the Gold Coast. Nevertheless, in innumerable ways a climate was being created in which the continued political domination of Africa by Europe was bound to be challenged.

The general disintegration of the colonial system in Africa –
initiated in 1957 when the British colony of the Gold Coast
became independent Ghana – was essentially a feature of the
tropical African scene, following from the economic and social
developments just discussed. At the two ends of the continent,
the timing and the circumstances of independence tended to be
different. Thus, the four British colonies of European settlement
in South Africa had come together as early as 1909, in a Union
which was a self-governing Dominion of the British Common-
wealth, and in 1923 a status not far short of this was accorded to
the other major settlement colony in the south, Southern Rho-
desia.

The self-government gained by the Union of South Africa and
by Southern Rhodesia, however, was in effect self-government
for their white inhabitants alone. The South African war of
1899–1902, which converted the two Afrikaner republics into
British colonies, had been an attempt to resolve the issues be-
tween the two white stocks. Indeed, when white South Africans
then talked about 'race relations', they nearly always meant
merely the relations between Briton and Boer. One of the terms
on which the Boers had accepted peace in 1902 was that votes
for the Bantu inhabitants of the ex-republics would not be raised
as an issue until the two territories had once again become self-
governing. Local autonomy was in fact granted to the Transvaal
and to the Orange Free State as early as 1906 and 1907, mainly
because the British Liberal government that took office in 1905
was dominated by men who had bitterly opposed Chamberlain's
South African policy, and the resultant war, as an unjustifiable

attack on the liberties of the small Afrikaner nation. These Liberals were so obsessed by this Gladstonian principle (which was astutely exploited by the new Boer leaders of the Transvaal, Generals Botha and Smuts) that they forgot the obligations Britain had towards the non-European inhabitants of South Africa, Bantu, Coloured, and Indian. The new constitutions for the Transvaal and Orange Free State colonies enfranchised only white men.

When, therefore, the political leaders of the Cape Colony, Natal, the Transvaal, and the Orange Free State combined in 1908–9 to argue out the terms of Union, all except the Cape delegates represented only white electors. The Cape utterly failed to persuade the others to accept its tradition of voting-rights for men of all races who satisfied a given income or property qualification. Although the need for a common 'native policy' was one of the factors which had led to the constitutional convention in the first place, agreement on a Union was reached only on the understanding that 'the native problem' would be left till later. One consequence of this was that the three British protectorates, Basutoland (the modern Lesotho), Bechuanaland (Botswana), and Swaziland, remained outside the Union. Another was that there was no common franchise for elections to the first Union parliaments: the *status quo* was preserved, with no vote for Africans outside the Cape Province. Moreover, although Cape statesmen, Afrikaans as well as English speaking, thought that their tradition of granting this franchise to 'civilized' non-whites was right and should prevail, it was necessary to protect this tradition by one of the 'entrenched clauses' in the Union constitution, alterable only by a two-thirds majority of both houses of parliament sitting together.

The subsequent political history of South Africa revolves around the campaign of Afrikaner nationalism to redress the defeat of 1902 and to re-establish the principles of the Great Trek. The franchise for all non-whites in the Cape was first whittled away and then abolished, while from 1948 onwards the majority of electors repeatedly voted for *apartheid*, the theory that black and white in South Africa should be totally separated (or separated

as totally as is practicable). The South African Republic which came into existence in May 1961 was committed to the exclusion of all non-whites from any share in its political life, and to the relegation of the Bantu to separate areas ('Bantustans'), where it was supposed that they would one day form separate nations.

The establishment of the Republic was manifestly the apotheosis of Afrikaner nationalism. The development of mining and industry, followed by Union, involved the economic and political leadership of white South Africa passing from the Cape to the Transvaal, from a relatively outward-looking community which could afford liberal principles since – for most of its history – there were relatively few blacks in it, to the land in which the most diehard trekkers had struggled to create their own society in the interior of Bantu Africa. For the Afrikaners, politics were an in-bred tradition; most English-speaking whites were content to enjoy the fruits of a developing economy, and the franchise was slanted against the towns in which they lived. All South Africa's premiers from Union onwards were Afrikaners, and so too were the bulk of their ministers. Avowedly Nationalist governments held office during 1924–33 under General Hertzog, and after 1948, led successively by Malan, Strijdom, Verwoerd and Vorster. The other major white political grouping, first called the South African and later the United Party, never opposed the Nationalists on the basic goal of segregation. Rather it urged the advisability of proceeding with caution, of not wholly alienating the Coloured population, or of securing a closer understanding between Afrikaners and English-speakers. Its leaders were also Afrikaners, notably Generals Botha (prime minister, 1910–19) and Smuts (1919–24 and 1939–48), while in 1933–9 it joined under Hertzog in a coalition government.

The division between the Afrikaners and the English-speaking whites, which had engrossed the attention of politicians throughout the nineteenth century, ceased to be a major issue, and by the 1960s was disappearing altogether. This trend first became apparent in 1924, when Hertzog's first Nationalist government secured power only with the support of the white trade unionists,

at this time predominantly English-speakers. They wanted to
preserve their jobs from competition by non-Europeans, who
could do the same work for smaller wages, as much as the Afri-
kaners wanted to preserve white control of land and the franchise.
From this time on, self-interest always led some English-speakers
to give at least tacit support to the Nationalists. As black op-
position to increasingly severe policies of segregation in land,
urban residence, mobility, employment and education began to
become more active and violent, so the two sections of the white
community drew closer together in the one *laager* mentality.[1]

African opposition to white policies was of course originally
tribal and military, and warfare between black and white con-
tinued until the suppression of the major Zulu rebellion which
took place in Natal in 1906–7. By this time, however, the South
African Asians, led by Mahatma Gandhi, were already demon-
strating the possibilities of organized, non-violent opposition. In
both the Cape and Natal, appreciable numbers of Africans had
received education from Christian missions; some indeed had
shown their desire for independence of white control by found-
ing their own 'Ethiopian' churches. Pioneers like J. T. Jabavu
and John Dube were beginning to form African opinion through
Bantu language newspapers. The Asian example and the com-
plete disregard for non-European opinion in the formation of the
Union were obvious incentives for African political organization.

An African National Congress was founded in 1912. For most
of its career, the leaders of the A.N.C. believed that discussion
and negotiation would suffice to improve the African lot. How-
ever as early as the 1920s, the brief success of the Industrial and
Commercial Workers' Union (I.C.U.), led by Clements Kadalie,
demonstrated that there would be increasing support for more
direct action. The conditions of life for Africans were being
radically altered. The native reserves, the basis for the future
Bantustans, were only 13 per cent of the total land area, and
were ever less capable of supporting the African population,
which outnumbered the whites by more than three to one, and

1. *Laager* means camp, and more specifically the circle of trek-wagons formed to
resist attack on the trekkers.

which by 1970 would grow to fourteen millions. Though the Africans were in a sense better off than the 2,000,000 Coloureds and 500,000 Asians, who had no 'tribal homelands' at all, the majority of them were bound to seek work in the white economy, and increasingly in its towns and industries. Indeed their labour – and, increasingly, their aggregate purchasing power – were essential if the European economy was to prosper and the whites were to maintain their living standards. But in this white South Africa, non-Europeans came to be treated as total strangers. They were subjected to humiliating pass laws which restricted their freedom of movement and employment, and they could legally reside only in locations or distressing shanty towns outside the towns proper and often miles from their places of work. Violence could never be far below the surface in this situation in which black and white became economically ever more dependent on each other and yet politically and socially ever more apart. Even when black resentments were expressed passively, violence could readily arise through white actions based on fear of it. When, in 1943, it became apparent that African trade unions were not to be recognized, and when in 1948 the Native Representative Council (a palliative instituted in 1936 when the assault on the non-European franchise began) ceased to function, there were really no milder alternatives for the non-Europeans than active non-cooperation, and for the whites than the erection of a police state.

The attempts of liberally-minded people to establish political parties with philosophies more progressive and humane than those of the Nationalists or of the bulk of the United Party members, secured no significant support from an all-white electorate. The A.N.C. became involved in a policy of boycotts, strikes and mass protests, but even so it seemed too moderate for many Africans; in 1959 a radical alternative appeared in the form of the Pan-African Congress, which chose pass-burning as its first weapon. This led in 1960 to the massacre at Sharpeville and a massive African demonstration in the centre of Cape Town. For a brief moment the whites seemed to hesitate. But their ranks were quickly closed; any dissent from the majority

white opinion by men of any colour was viewed as treason. Many dissentients chose to emigrate or were forced into exile; those who remained in South Africa were subjected to various forms of arrest or prohibited from public expression of their opinions. The whites settled down in their *laager*, taking good care that they were adequately armed and organized to resist any attack on it.

One consequence of the increasingly nationalist, republican Afrikaner trend in South African affairs was to confirm the growing white and predominantly British population of Southern Rhodesia in its wish to stay out of the Union. On the other hand, however, this white minority was determined that power in central Africa should remain in the hands of 'civilized' men, which for the foreseeable future meant themselves. Thus they largely frustrated the vote for non-whites which they had inherited from the Cape, and embarked on a segregationalist policy. The Southern Rhodesian whites thought that both their objectives would be secured if they could engineer a British Central African Dominion incorporating the two Rhodesias and possibly Nyasaland also. This, they hoped, would at once rid them of the British Government's nominal surveillance of native policy, which was enshrined in their 1923 constitution, and create a bloc strong enough to withstand the political and economic strength of the Union. The Southern Rhodesian settlers soon received support from the white community which was developing along the Northern Rhodesian copperbelt and which had become alarmed by the British Government's 1930 declaration of the ultimate paramountcy of African interests in its central and east African dependencies. Initially the settlers' plans were frustrated by the British Government's recognition (in the Bledisloe Report of 1939) that the Africans of the two northern territories were steadfastly opposed to any closer association with Southern Rhodesia and its segregationalist policies. After the war, however, the campaign was renewed, with stress on the economic advantages of a federation. It was pointed out that both Rhodesias looked to Nyasaland for much of their labour force; that Northern Rhodesia's copper mines were dependent on Southern Rhodesian coal, and that the new wealth flowing from them could be used to

help develop the poorer territories; that Southern Rhodesia's new industries regarded the northern territories as a natural market for their growing output. It was asserted that a central African federation would integrate all these resources and would attract more capital (and settlers) for their further development, to the advantage of Britain, of the Commonwealth, and of its own peoples.

This argument, forcefully presented by settler representatives and their allies in Britain, was accepted in 1953 by the British Government, and the Federation of Rhodesia and Nyasaland came into being. But African opposition had grown even more intense and outspoken than before. It was in no way assuaged by the provision of a minority of seats for Africans in the Federal parliament, by the exclusion of affairs touching on African interests in the two northern territories from the competence of this parliament and the government responsible to it, or by the British Government's retention of a theoretical final control over general native policy in the Federation. The federal constitution thus fell considerably short of settler ambitions, yet provoked strong African nationalist movements committed to its destruction and to the establishment of independence for the two northern territories.

In northern Africa the course of events was coloured by two currents of virtually no significance elsewhere in the continent – the direct political and military conflicts between European states, and even more importantly the growth of Arab nationalism.

During 1940–43, British, French, and American armies fought those from Italy and Germany over almost the whole length of the North African coastlands, while the British also encompassed the destruction of the Italian empire in North-East Africa. The more senior members of the imperial club, notably Britain and France, had regarded Mussolini's conquest of Ethiopia in 1935–6 as an anachronistic display in very bad taste, made even worse by the fact that Ethiopia, even if regrettably uncertain in her attitude to such matters as slavery, was a fellow-member of the

League of Nations, just as much as Italy or themselves. By 1941, Italian soldiers and administrators had been evicted from all their East African territories. Ethiopia resumed its status as an independent state and its Emperor, with a renewed sense of urgency, returned to the problems of how to modernize his medieval kingdom without thereby losing control over it. At first Eritrea and Italian Somaliland remained under British military administration; in 1952, however, it was possible to federate Eritrea with Ethiopia. The traditional and active hostility of the Somali nomads forbade any such solution for Somalia, and in 1950 the United Nations entrusted its administration for ten years to the Italians (who had indeed done much to provide the material groundwork for a modern state in Eritrea and Ethiopia). At the end of this period, Somalia joined British Somaliland in the independent Somali Republic.

The Italian colony of Libya was also involved in the Anglo-Italian conflict. It passed under British military administration in 1942, and nine years later its three component parts, Tripolitania, Cyrenaica, and the Fezzan, were federated into a united kingdom under King Idris al-Sanussi, the spiritual leader of the Sanussi, a Muslim sect which had been the main cohesive element in indigenous opposition to Italian rule.

Elsewhere in North Africa, the effects of the European fighting were more indirect, but none the less important. The British protectorate over Egypt, declared because in 1914 Britain had found herself at war with Egypt's nominal suzerain Turkey, had been concluded in 1922. The country had then become a nominally independent monarchy under King Fuad, a son of the Khedive Ismail, though British troops remained in occupation to guard the Suez Canal. This occupation was naturally not to the liking of the Egyptian nationalist party, the Wafd, which had developed from student opposition to British rule, already manifest in the prewar years. This opposition in turn was largely a consequence of the fact that although, under Lord Cromer's autocratic guidance, British officials had done much to reform and modernize Egypt's administration, army, and police – as

well as her whole economy – little had been done to develop an educational system capable of training young Egyptians to take over from the British.

Whenever free elections were held after 1922, the Wafd was returned to power, only to find its aspirations blocked either by the British or by Fuad, who liked to rule as well as reign. The Egyptian government would then pass into the hands of 'moderates', the rich property-owning interests, who in turn would fail because they commanded neither popular nor royal confidence. A period of palace rule would then ensue, until the Wafd and the moderates could combine to force free elections again. During the 1930s, however, both the Wafd and the British began to moderate their views, and the result was the Anglo-Egyptian treaty of 1936. The two countries became partners in an alliance under which British troops were to be withdrawn to a narrow zone on either side of the Suez Canal. Long before this withdrawal could be completed, however, the whole of Egypt had become a vital base for the British armies in their campaigns of 1940–43. Initial Axis victories suggested to the new young king Faruq, and his palace clique, that the final liberation of Egypt was at hand. In 1942 Britain used force to impose a Wafd government on Faruq. But by 1945 the positive energies of the Wafd were devoted to the formation of the Arab League and the problem of Palestine. At home it had become as corrupt and self-seeking as the palace party or the other parliamentary groups. The incompetence and corruption revealed in the political direction of the Arab war on Israel at length persuaded a group of young army officers, inspired by Colonel Gamal Abdul Nasser, to assume the inheritance of Muhammad Ali and Arabi Pasha. During 1952–3 they finally swept away the old parliamentary and monarchical régime.

Nasser's military government undertook basic reforms over the whole field of Egyptian life, especially in land tenure, which secured him the wholehearted support of the Egyptian masses. Externally his career was more chequered. His ambition to lead a united Arab world was frustrated by the continued existence of Israel and by the fraternal jealousies of the Arabs themselves.

Moreover, his foreign policy inevitably annoyed western powers slow to forget the past or to recognize the moral strength of Arab nationalism. All the same, Nasser finally succeeded in ridding Egypt of the last legacies of European domination. Britain was eventually persuaded to withdraw her troops from the Canal Zone, and soon afterwards, in 1956, Nasser declared the Canal itself nationalized. Britain and France attempted military intervention, but were forced by world opinion, more particularly by that of the United States, to withdraw. Nasser's act of brigandage thus turned into a great moral victory, which placed him for a time at the head of the anti-colonial struggle in Africa as a whole. Long-term, however, the removal of the British from the Canal brought Egypt face to face with Israel in a contest of great danger for the peace of the world, in which the opening moves were to the advantage of Israel. In a six days' war fought in the summer of 1967 Israel inflicted an almost total destruction upon Egyptian forces and occupied the Sinai peninsula. Russia re-armed Egypt – the United Arab Republic as it had been called since 1958 – but Nasser's prestige was gone.

One of the more difficult legacies of the past inherited by the Nasser régime was the Sudan, since Egypt naturally wished to control the upper Nile valley and its waters. The Sudan had been reconquered from the Mahdi by a combined British and Egyptian force, and in 1899 it had been agreed that it should be an Anglo-Egyptian Condominium. The Governor General was appointed by the Egyptian government on Britain's recommendation, and had Egyptian as well as British officials and troops under him. But in 1924, in reprisal for the assassination in Cairo of Sir Lee Stack, who was both Governor General of the Sudan and Commander-in-Chief of the Egyptian army, Britain had barred Egyptians from any responsibility for the government of the Sudan. From this time onwards, the Sudan was ruled by an efficient bureaucracy, British in its higher direction though increasingly Sudanized from below, in what the British conceived to be the Sudanese interest, and with scant regard for the interests of Egypt. Part of the Nile flood was devoted to the Gezira scheme, an impressive exercise in cooperative agriculture, and the success

of its cotton crops gave to the Sudan the foundation of a viable economy. With the growth of wealth and education, a professional class with nationalist aspirations emerged. This soon split between those who aimed at simply taking over control from the British, and those who thought it necessary to call in Egypt to get the British out. Both the old Egypt of King Faruq and the new Egypt of the young officers were prepared to fish in this troubled stream. In 1953, however, Britain and Egypt agreed that the Sudanese should be allowed to decide their own future after a three-year transitional period of self-government under international supervision. And when the time came in 1956, the Sudan voted to become an independent republic. With a militant Egypt in the north, and with the pagans and Christians of the southern Sudan actively opposed to an essentially Muslim government, the early years of independence were not happy. There was open revolt in the south from 1955 onwards, and in 1958 discontent with the ineffectiveness of party political government occasioned a take-over of power by the army under General Abboud. Effective government was restored in the north, but the attempt to subdue the south by force proved disastrous, much of the population fleeing into the bush or across the frontiers. With much of his army committed in the south, Abboud failed to control mounting northern criticism of his régime, and there was a return to parliamentary government in 1964. When this produced no better result, power was seized in 1969 by a group of young officers led by Colonel Numeiry. But renewed efforts to force the southerners to submit to Khartoum had little result other than to intensify international criticism, especially from Christian churches within and without Africa, who came to see the cause of the southern Sudanese in much the same light as they saw that of the blacks in southern Africa. In 1974 therefore, Numeiry, accepting international African mediation, agreed to grant autonomy to the southern Sudan.

By the time France was engulfed in the Second World War, her policy in North Africa had shown itself to be completely ster-

ile. Algeria was considered part of metropolitan France; but eight million out of Algeria's nine million people enjoyed little or no say in its government, since Muslims could not then acquire the status and rights of French citizenship unless they agreed to abandon their own Muslim law. Therefore, in so far as the territory was not governed in the interests of France, it was governed in the interests of the European settlers. Nor had the settler presence brought an increase in the economic opportunities available to the Muslims sufficient to compensate for the loss of their best lands; there was, in fact, a steady flow of Algerian emigrants seeking work in France.

Tunisia and Morocco were still protectorates, which France claimed to administer on behalf of their traditional rulers. The administration of both territories was essentially absolutist; even the 400,000 Europeans in Morocco and the 250,000 in Tunisia had no political rights. In Tunisia this absolutism had by 1934 occasioned the formation among the French-educated Tunisians of a movement for national liberation, the Neo-Destour,[1] led by Habib Bourguiba. Within four years, Bourguiba was in jail and his party proscribed.

The issues in Morocco were not at first so straightforward. When the French arrived in 1911 the Sultan's writ hardly extended beyond the plains, and until 1934 they were primarily occupied with the conquest of the mountain tribes. An effective nationalist movement could hardly exist until there was an all-embracing French administration to conspire against, and until the structure of a modern state to be taken over had itself been built. Even as late as 1953, it was still politically possible for the French to use the traditional hostility of the Atlas Berbers towards any Moroccan government as an excuse to secure the deposition of the Sultan, who then seemed unduly sympathetic to the aspirations of the Istiqlal, the independence party formed in 1944.

Of the three territories, Morocco was the least affected by the

1. *Destour* means 'constitution'. There had been an earlier Destour Party formed by educated Tunisian, who resented the way French rule was subverting the constitution which the Bey of Tunis had granted to his people in 1857.

war and by the loss of prestige which the French incurred through
their collapse in 1940 (though Spain seized the opportunity to
take over the international city of Tangier, and doubtless hoped
that an ultimate German victory would later give her the whole
of Morocco). Algeria and Tunisia, however, were extensively
fought over, and French opposition to the Anglo-American lan-
dings in 1942 finally convinced North Africans of the obscuran-
tism of French policy. For a short time it appeared as though
Germany and her allies would serve as liberators; during the
brief German occupation of Tunisia, Bourguiba was released
and the Bey was allowed to appoint Neo-Destour ministers. But
by 1943, despite the Atlantic Charter, despite the Casablanca
conference and the interest of Roosevelt, the local victory of the
Allies had put the French firmly back in the saddle. With the
formation of the Arab League, the North African nationalists
naturally began to look to Egypt for help in their struggle. In
1945 Bourguiba established the pattern which the Algerians were
shortly to follow, of organizing propaganda and resistance against
France from Egyptian soil.

Active hostilities first developed in Tunisia in 1952, after
French moves towards a compromise with the nationalists had
been sabotaged by the local Europeans. After two years of guerilla
warfare, the French agreed that Tunisia should have local
autonomy, and in 1955 Bourguiba returned to head the govern-
ment. In Algeria, the Front de Libération Nationale (F.L.N.),
an eventual coalescence of parties of opposition to European rule
– all of them consistently oppressed by France since their first
appearance in the 1920s – declared open war on the French in
1954. In the following year, another movement of revolt demand-
ing the return of the Sultan, whose deportation had made him
a national hero, broke out in Morocco. With Tunisia already on
the way to independence, the French saw the futility of fighting
to maintain their position in Morocco. It seemed desirable to
concentrate their efforts on Algeria, whose considerable settler
community possessed an effective voice in French politics. The
Sultan was therefore returned to his throne and in 1956 full
sovereignty was granted to Morocco, which shortly afterwards

secured the accession of Tangier and the Spanish protectorate. Tunisia could not lag behind, and so asked for and received her independence. In 1957 the Bey was deposed and Tunisia became a republic with Bourguiba as President.

France now had only one war to fight, but it proved her most bitter African struggle since her original conquest of the Algerian people during 1840–79. She was, in fact, fighting that war all over again. But the circumstances were now very different. The F.L.N. had moral support from the whole Muslim world and from all independent black Africa, and it received aid from Egypt, Tunisia, and Morocco. Only the employment of close on half a million troops could enable France to hold her own. But the cost of this effort was great, politically as well as in men and money. In 1958 the French army in Algeria rose against the conduct of affairs there by the French parliamentary régime, and placed General de Gaulle at the head of the French state. But, contrary to the expectations of some army officers, de Gaulle was as convinced as most metropolitan Frenchmen had become that it was futile to try and continue to maintain the French hold on Algeria by force. In 1959 he recognized the right of the Algerians to self-determination, and in 1962 his government finally succeeded in negotiating a cease-fire with the nationalists. France's main problem was then one of securing the acceptance of her policy by the Algerian colonists, among whom there were extremists prepared to use terrorism – against France as well as against the Muslims – in a desperate final attempt to frustrate the setting up of an independent Algeria which the Muslim majority would control. Eventually, however, an Algerian republic was recognized with Muhammed Ben Bella as President. During the first three years of its independent existence Algeria pursued a strikingly militant course in the pan-African freedom movement. In 1965, however, Ben Bella was ousted by Colonel Boumedienne, under whom internal affairs took precedence over adventures abroad.

In the strongest possible contrast with Africa north of the Sahara, where European colonists were defeated in war and

driven to emigration, the white communities in Africa south of the Zambezi consolidated their position during the 1960s. Paradoxically, one factor in this was the break-up of the Federation of Rhodesia and Nyasaland. Having established their framework for the domination of British Central Africa, the settlers in Southern Rhodesia had swung far to the right. The multi-racial ideals proclaimed by Garfield Todd, the one-time missionary who was prime minister from 1953 till 1958, were no longer supported by the essentially white electorate. His successor, Sir Edgar Whitehead, though colder-blooded, was still a multi-racialist, but was soon overtaken on the right by Winston Field, preaching permanent white supremacy in face of the demands for 'one man one vote' put forward by the new generation of black Rhodesian nationalists.

In Southern Rhodesia the activities of the African nationalist parties could be contained by ever more drastic police measures. But in the two northern territories of the Federation serious strains became evident following the uncompromising stands of non-cooperation taken up by Kenneth Kaunda's Zambia National Congress and Hastings Banda's Malawi Congress Party. These strains led the British government in 1960 to appoint a Commission under Lord Monckton, which recommended that African political representation should be rapidly increased, and also that each territory should be given the right to secede from the Federation. Following this, new constitutions were negotiated for all three territories. For Nyasaland and Northern Rhodesia this led to the control of the administration by the elected representatives of the African majority, and to their emergence in 1964 as the independent republics of Malawi and Zambia, with Banda and Kaunda as their first presidents.

The new constitution which Southern Rhodesia received in 1961 was euphemistically described by the British government as a first step towards complete multi-racial government. The white Rhodesians agreed to a second electoral roll with lower qualifications, which for the first time enfranchised some thousands of Africans. But there were only fifteen seats guaranteed to African members in a legislature of sixty-five, in which the right to

amend the constitution rested with a two-thirds majority – in effect with the Europeans. For this reason, the African nationalists in Rhodesia would have nothing to do with the new constitution, pressing instead for full equality on the basis of 'one man, one vote'. But with the breaking-up of the federation bringing independent black African states all the way to their Zambezi frontier, the white Rhodesians became virtually solid in their opposition to the African claim for advancement. They swept aside any leader who showed the slightest sympathy towards multi-racialism, and demanded complete independence on the basis of the 1961 constitution. In 1965, when it became clear that Britain would not agree to independence without evidence of at least substantial and continuing progress towards true majority rule, a new prime minister, Ian Smith, with the greater part of the settlers solidly behind him, unilaterally and illegally proclaimed a Rhodesian 'declaration of independence'.

This action placed the British government in a difficult position. Virtually all the independent African states, many of which were Commonwealth members, were firm in the opinion that there should be no recognition for the independence of Rhodesia until majority rule had been established, and argued that the settler rebellion must be put down by force. But the settlers possessed military and air strength of their own. Neither the military force to resume control of Rhodesia nor the means of getting it to this landlocked territory were readily available to the British, and it was also questionable whether public opinion in Britain would have countenanced its use against the settlers. It was eventually accepted that action against the Smith régime should take the form of sanctions against Rhodesian trade. But while Rhodesia had free access to the ports of Moçambique and South Africa, and the governments of these territories were sympathetic to her, such sanctions were difficult to enforce.

However, South African attitudes were changing. By the 1960s, the country's economy was so buoyant that its Afrikaner inhabitants had ceased to be an impoverished, embittered, exclusively rural community. Brimming with success and self-confidence, they were now able to draw the English-speakers into

their own concept of one white nation, secure in its own destiny. There was no longer any sense of fighting simply for survival: the economic and military strength of white South Africa grew year by year until it more than rivalled the combined resources of the rest of the continent. The assassination of Verwoerd in 1966 was an isolated incident which occasioned no change in the policy of *apartheid*. Rather the white community drew even closer together to support successors who implemented it even more rigidly; such critics as still remained continued to be muzzled by restrictive laws, or sought freedom of expression outside their own country.

But the new confidence did bring with it a new and more sophisticated attitude towards the march of black nationalism outside South Africa. There could be little objection to the constitutional advancement of the British South African protectorates, of which Bechuanaland and Basutoland achieved independent status, as Botswana and Lesotho respectively, in 1966, and Swaziland in 1968. The situation of these landlocked territories was such that they had little alternative but to be economically associated with the Republic; to South African eyes, indeed, they were little more than extensions of the Bantustan principle. What was newer was the appreciation that the day of colonialism further afield in Africa was irretrievably past, and that South Africa's best interests lay in reaching an accommodation with some at least of the new African rulers. This made sound political and economic sense. Hostility towards the new African states, with their natural leanings towards socialism, might tend to drive them to look for more, and more militant, aid from Russia and China. From the economic point of view, the newly independent African countries, essentially still all exporters of primary products, were now natural trading partners for the prime industrial powers on the continent, and increased trade with them should help to strengthen them against involvement with communist powers.

A vital question arising from this new foreign policy was where to draw the line between white and black Africa. Instinct inclined the South Africans to make common cause with the

white Rhodesians and with the Portuguese régimes in Moçambique and Angola. However, a more realistic appraisal of the Rhodesian situation and of the ceaseless warfare which the Portuguese were having to wage against African nationalists, continually supported from independent African states, suggested that the real boundary was not the Zambezi but the Limpopo. The most that could be hoped for between the two rivers was a delaying action while the white bastion in the south made itself even more impregnable. By the end of the 1960s, whatever the feelings of white South Africans, it was becoming clear that their government was counselling Ian Smith towards moderation.

In 1974, the situation in southern Africa was dramatically altered when the strain of Portugal's African wars upon her economy and society brought about the overthrow of the so-called 'New State' under which that country had been governed since 1928. A junta of young army officers, with marked left-wing tendencies, granted immediate independence to Portuguese Guinea (control of which had already been virtually lost), and quickly sought accommodations with the nationalists in Moçambique and Angola. A transfer of power was quickly arranged in Moçambique, which became independent in 1975. In Angola, however, independence had to await the outcome of an armed struggle between the M.P.L.A. (People's Movement for the Liberation of Angola), the F.L.N. (National Liberation Front) and U.N.I.T.A. (Union for the Total Independence of Angola). Support for the two latter was essentially regional, but each provided an entry for outside interests seeking to influence affairs in Angola. The F.L.N. was based in the north, among the Bakongo, and its main support came from across the frontier in Zaire. U.N.I.T.A.'s strength lay in the south, among the Ovimbundu in particular, and it proved attractive to southern African interests. The issue was decided following the incursion of a South African military column from South-West Africa, ostensibly in defence of the South African position there. This led to a great rallying of active support for the M.P.L.A. from Communist Bloc countries, spearheaded by troops and technicians from Cuba. In the face of this, the South Africans thought it

politic to withdraw. The M.P.L.A. was then free to scotch all opposition from the F.L.N. in the north and, by extending its control over the greater part of Angola, it received general recognition as the successor to the Portuguese colonial authority.

Once Moçambique was under African rule, the whites in Rhodesia became much more vulnerable than before to military pressures. Earlier guerrilla attacks on them from across the Zambezi in the north had been spasmodic and ineffective. The main effort of the African nationalists, whether within or without Rhodesia, who were seeking to secure the vote for all the people of Zimbabwe (as they had renamed Rhodesia), had remained political rather than military. But after 1975 the Rhodesian authorities had to cope with a long eastern frontier with a territory whose rulers had had ten years' experience of successful military action against European imperialism. Guerrilla warfare threatened to become endemic over large areas of Rhodesia outside the larger towns. This placed considerable strain on the human and financial resources of the relatively small white community, which was now also suffering from the world economic recession of the 1970s – exacerbated in its case by the cumulative pressure of sanctions. By 1977, this combination of military and economic difficulties was sufficient to suggest to Ian Smith that the should give way to Anglo-American diplomacy and announce a belated acceptance of the principle of majority rule for Rhodesia. He hoped by this means to buy time to reach an accommodation with at least some of the by-no-means united African nationalist leaders, and thus avoid the risk of white Rhodesia being overrun and destroyed by a totally militant black nationalism supported by, and possibly receiving military aid from, Communist Bloc countries.

By this time, the South African government of Balthazar Vorster was also engaging in measures intended to diminish mounting international hostility while at the same time defending what it saw as its vital interests. It began, with the Transkei, to redeem its promise to grant legal independence to its Bantustans, and it also convened a multi-racial conference to plan for independence for South-West Africa. South Africa had never acknowledged United Nations authority over this former

League of Nations mandate, and had come to govern it as though it were part of the Republic. This occasioned bitter opposition from its indigenous peoples, especially the Ovambo of the far north, nearly half of the total population. These provided the main strength of the South-West African People's Organization, which came to be accepted by black African countries as providing the government for an independent state of Namibia. But the South Africans excluded S.W.A.P.O. from their constitutional discussions. It therefore seemed likely that the outside world, which had already refused to recognize that the Transkei was independent, would equally refuse to countenance the South African initiative in South-West Africa.

The root cause of these refusals by the international community to recognize these gestures was that Vorster's government was not prepared to allow any significant relaxation of *apartheid* in South Africa itself. Civilized opinion throughout the world had been alerted to the horrors of this system by the massacre of black demonstrators against it at Sharpeville in 1960. The South African government had subsequently sought to avoid such open clashes for the future by outlawing all black political organizations. But the fundamental tensions remained, and indeed grew as the prosperous 1960s gave way to the depression of the 1970s. Denied formal political structures, opposition to *apartheid* began to be manifested in new, broader forms of black consciousness, in particular in resistance to the separate Bantu education system by the teeming youth of such segregated black townships as Soweto. By 1977, possibly fearing that the ever-growing sense of black community and opposition would more or less spontaneously expand into a withdrawal of labour, the Vorster government was actively repressing almost any overt sign of black organization. Foreign criticism of South African policy was now no longer confined to the new nations that had arisen from colonialism in Africa and Asia or to the countries of the Communist Bloc. Even conservatively minded European and North American statesmen were beginning to talk of the possibility of some kind of economic sanctions against South Africa.

21 Independent Africa (2)

In tropical Africa the first opposition to European rule was of course that of traditional African societies, resentful of the new moulds into which the colonizing powers sought to force them. This kind of opposition was mainly characteristic of the more remote areas of colonies, and of their early days; but sometimes the cohesion of a traditional society was so strong that in the end colonial government had to compromise with it. In such cases, traditionalism may still be politically relevant as it has been with the Baganda, for example. But generally, as European administrations became more firmly established, and as the economic and social climate also began to change, so new types of opposition began to emerge.

Some of these were not overtly political. Thus in eastern, central, and southern Africa, where Christian missions often preceded European administration, and where the development of European settlement could lead to severe maladjustments in African society, African opposition sometimes found expression in 'Ethiopianism' – the formation of separate and specifically Negro Christian churches in which beliefs and practices learnt from the missions were often coloured to suit local ways. The members of such churches might on occasion break out into blind revolt against the European administrators and settlers, who generally regarded them with suspicion and hostility. One of the best-known examples of this was in the 1915 rebellion led by John Chilembwe in Nyasaland. In a different way, the Mau Mau movement among the Kikuyu of Kenya in 1952–6 was also perhaps as much a psychological and magico-religious as a political reaction to alien pressures.

Ultimately much more significant, however, were the move-ments of political protest. In tropical Africa these developed first in the West African coastlands, where the long contact with Europe before the opening of the colonial period ensured that the development of colonial administration took place at more or less the same time as the growth of a European-educated African professional class. As European political control tightened and the pace of colonial development quickened, so that more and more Europeans came to dominate African affairs, this class felt increasingly frustrated and shut out. Its members began to turn their minds to acquiring control over the new institutions of government Europe had imposed on Africa.

The directions initially taken by this opposition were to a considerable extent determined by the nature of the colonial policies pursued by the two major powers concerned. In British West Africa the practical direction of affairs lay in the hands of the local governors advised by executive and legislative councils, the former composed entirely of officials, but the latter contain-ing a few African nominees. Here, then, the objectives of the politically-minded Africans became first the conversion of the legislative councils into African parliaments, and then the con-version of the executive councils into African ministries respon-sible to such parliaments. Political associations working towards these objectives had already begun to appear by the 1890s, and this was manifestly the general programme of the West African National Congress formed in 1918. In the French colonies, however, authority was much more effectively centred in France. Moreover, as early as 1848 the principle that Africans could become French citizens, able to share in elections to the French metropolitan parliaments, had been established in the Senegal settlements. Thus the early political aspirations of French Africans tended to be directed towards securing greater influence in Paris. Political associations of French Africans, affiliated to metropolitan parties, began to be significant during the 1930s.

These early political associations, however, carried little weight

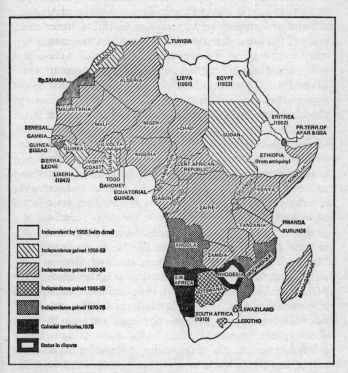

19. Africa: progress to independence

Legend:

- Independent by 1955 (with dates)
- Independence gained 1956–59
- Independence gained 1960–64
- Independance gained 1965–69
- Independence gained 1970–75
- Colonial territories, 1975
- Status in dispute

Map labels:

TUNISIA
MOROCCO
ALGERIA
LIBYA (1951)
EGYPT (1922)
Sp. SAHARA
MAURITANIA
ERITREA (1952)
FR. TERR. OF AFAR & ISSA
SENEGAL
MALI
NIGER
CHAD
SUDAN
GAMBIA
GUINEA-BISSAO
GUINEA
U. VOLTA
NIGERIA
ETHIOPIA (from antiquity)
SOMALIA
SIERRA LEONE
IVORY COAST
GHANA
TOGO
DAHOMEY
CAMEROUN
CENT. AFRICAN REPUBLIC
UGANDA
KENYA
LIBERIA (1847)
EQUATORIAL GUINEA
GABON
CONGO
ZAIRE
TANZANIA
RWANDA
BURUNDI
ANGOLA
ZAMBIA
MOZAMBIQUE
MADAGASCAR
S.W. AFRICA
RHODESIA
BOTSWANA
SOUTH AFRICA (1910)
SWAZILAND
LESOTHO

in either British or French West Africa, mainly because the practical attainment of political freedom for Africans then appeared so very remote. In the French territories, only those few Africans who had actually been born in one of four communes in the Senegal could acquire French citizenship of right, and until 1947 the British had granted self-government only to colonies of European settlement. Against such a background, many of the eventual leaders of the new Africa appeared at first more in the guise of intellectuals than in that of practical politicians. Léopold Senghor, for example, was a notable Senegalese French poet before he became an effective nationalist leader. Fodeba Keita first gained international renown as director of Les Ballets Africains. J. B. Danquah, the first leader of the movement to turn the colonial Gold Coast into the new Ghana (a name which he himself had deliberately chosen), was also the author of books on Akan custom and religion. Such men usually spent a period studying and working in and around universities in France, Britain, or the United States. Almost invariably, they became converts to the intellectual socialism current among university students at the time. They were also caught up in the excitement of the Negro renaissance in America and the West Indies, led by men like W. E. B. DuBois and Marcus Garvey. From this flowed the first ideas of pan-Africanism, though it was not until the last in the series of Pan-African conferences held under the inspiration of DuBois – that at Manchester in 1945, which involved the significant conjunction of George Padmore, Kwame Nkrumah, and Jomo Kenyatta – that pan-Africanism began to take shape as an effective political movement. The main concern of Negro leaders on either side of the Atlantic was to establish a respectable intellectual and moral station for their people in a world which seemed excessively dominated by the traditions and values of western Europeans. The forging of concepts of *négritude*, of *la présence africaine*, of the 'African personality', seemed an essential prerequisite for effective African action in the political field.

This intellectual concentration of the early nationalists was

also a consequence of the situation facing them at home, where indeed their first political groups had as much the character of debating societies as of political parties. They could hardly appeal for popular support, since few Africans beyond their own small circles had had much or indeed any opportunity to learn the language, let alone the ideas, of nationalist politics. Moreover, there were as yet few means or none by which an African public could effectively influence a colonial administration. And so the early African politicians addressed themselves as much (or more) to European as to African ears, arguing with and sniping at the local administrators, or trying to mobilize support for their ideas in Europe. This last tactic was obviously appropriate for French Africans; but delegations and cablegrams to London remained a prime political gambit in British West Africa also, even into the 1950s.

The Second World War radically changed the picture. Africans and Europeans alike learnt that European empire was not an immutable monolith in the landscape of world history. This was most drastically demonstrated in Asia, first by the Japanese occupation of many valuable colonial territories, and then by the British, Dutch, and French themselves, who recognized in their different ways and at their varied paces, that even though their side had eventually turned the tables on Japan, they could not simply begin again in their Asian colonies where they had been forced to leave off in 1941. Within a few years of the end of the war, a host of southern and south-east Asian peoples – Indians, Pakistanis, Burmese, Indonesians, Indo-Chinese – had either secured their independence or were on their way to it. Africans began to ask why they too should not follow into the equal world of the United Nations, where the new Asian states soon became a significant group dedicated to anti-colonialism – a cause already supported, in their several ways, by the American republics and by the Communist states.

There was no comparable direct shock of war for the colonial régimes in tropical Africa. But the German occupation of

France in 1940, and the subsequent division of Frenchmen into Vichyites and Gaullists, had important repercussions for the French territories. The policies of Nazi Germany had been widely and unfavourably publicized. The French West African administration's declaration for Vichy therefore led many Africans to suspect it of Nazi racialism. This combined with some of its political actions to create a new sense of unease, which was heightened when the much less advanced Equatorial African colonies, under the inspiration of Félix Éboué, a West Indian Negro who was then Governor of Tchad, declared for de Gaulle and Free France. Éboué was soon Governor General, and under his dynamic leadership French Equatorial Africa became a bastion from which African and French soldiers sprang to share in the liberation of North Africa. By 1942 the French in West Africa appreciated the need to change sides, but the initiative in determining French policy in Africa had already passed from them. In 1944, at Brazzaville, Free French politicians and colonial officials from all over black Africa, inspired by Éboué and his friends, drew up a blueprint for the future of French Africa. Their most vital decision was that African representatives should share in drawing up the postwar constitution for France; the ultimate effect of this, combined with the specific Brazzaville proposals, was the transformation of the colonial empire into the French Union, in which the 'overseas territories' were to be 'partners' with France. All Africans became citizens and were thus able to share in French parliamentary elections. More significantly, perhaps, the empire began to be decentralized, more authority being given to the territorial administrations, and elected assemblies possessing some control over finance being introduced.

The emergent African leaders now had an exploitable political status. The most widely supported of the newly-emerged parties was the Rassemblement Démocratique Africain, an interterritorial party which under the leadership of Félix Houphouet-Boigny of the Ivory Coast soon began to play a leading political role, in France as much as in Africa. In 1948–50, however, its militant agitation and close association with the French Commu-

nists led to suppressive measures against it by the administrations in Africa.

At this point the French Africans were rescued from their political cul-de-sac of regarding France rather than Africa as the main battleground, by the consequences of what was happening in the adjacent British West African territories. Here the war and its aftermath had induced considerable economic and social tensions, especially in the coastlands of the Gold Coast and Nigeria, the regions most closely linked to the outside world. As has been seen, wartime conditions and postwar shortages of tropical produce had greatly increased the incomes both of African producers and of the colonial governments. At the same time, the war had brought many Africans into much closer touch with events and currents of opinion in the outside world than ever before. Many West Africans had served on terms of equality with British soldiers in other parts of the world, notably in the Burma campaign. Many more had seen the old stereotype of the European as solely an administrator, or a director of African labour, smashed by the presence in their own countries of appreciable numbers of British or American servicemen. Great expectations were aroused by talk of the Atlantic Charter and the new United Nations, by Asian independence, by the new British plans for colonial development and welfare. But both in the personal and in the public sphere the immediate postwar years brought disappointment. West African producers felt cheated because there were serious shortages in the consumer goods they could now afford, and they suspected the European importers of exploiting them through high prices. The development plans both of governments and of private European enterprises were delayed, since capital goods too were in short supply. At the same time, however, they still involved the bringing in of more European advisers, technicians, and supervisors. In every direction, the expectations of Africans who had acquired new skills, new outlooks, new wealth, and new standards of living were cruelly frustrated.

The tensions boiled over first on the Gold Coast. In 1948 there was a widespread boycott of European traders, and then rioting

in the major towns. Effective capital was made of these troubles by the nationalists, for in the previous year Danquah and his colleagues had brought back from England Kwame Nkrumah, in the radical vanguard of the new pan-Africanism, to help in the organization of popular support for a nationwide political party demanding self-government. The official inquiry into the riots reported their underlying cause as growing African frustration, stated that the new constitution which the Gold Coast had received only two years earlier – and in which, for the first time in colonial Africa, Africans had been granted a majority in the legislative council – was 'outmoded at birth', and recommended a rapid advance towards responsible government. In 1949 the Governor appointed an all-African committee to devise a new constitution to this end.

The old school of Gold Coast nationalists shared in the composition of this constitution. Nkrumah and the new vanguard, however, struck out on their own, declaring that nothing short of 'Self-Government now' would do. The mass following Nkrumah had built up was soon transferred to himself and his new Convention People's Party, and in the first general election held under the new constitution (1951), the popular vote went overwhelmingly in its favour. By this time Nkrumah was in gaol for sedition, but the new Governor, Sir Charles Arden-Clarke, assessed the situation correctly. Nkrumah was released, and he and his colleagues were given the leading posts in the new administration. By 1957 the combined efforts of Nkrumah, his party, and the British had converted the Gold Coast into the independent Commonwealth country of Ghana.

The British Government knew that once the colonial dam had been broken in the Gold Coast, it was impossible to maintain it elsewhere in British West Africa. It needed little prompting from local nationalists to place Nigeria, Sierra Leone, and the Gambia on comparable paths to independence. If the pace was somewhat slower, this was mainly a consequence of peculiar local circumstances. The size of Nigeria, and the considerable differences among its three major regions in outlook and wealth, necessitated the development, by trial and error, of a federal

How were boundaries est'd? In colonial period. Part 3

system with local autonomy for the regions before full independence for the whole could be reached (in 1960). Sierra Leone also had factional differences to be overcome, in this case between the Creoles (the descendants of the liberated Africans) who had hitherto dominated African politics, and the much more numerous natives of the interior. But in 1961 she too secured independence under the leadership of the first of the latter to gain a university education, Dr Milton Margai. Finally, in 1965, it was agreed that, despite their fewness and the poverty of their country's resources, what had been allowed to other West Africans must not be denied to the Gambians.

It is doubtful whether the British Government appreciated the radical effect that its new West African policy was to have elsewhere in tropical Africa. The most immediate consequences were in French Africa, since if those West Africans who had been under British rule were to be accounted fit to manage their own affairs, presumably the same was true for their neighbours under the French. This was immediately apparent in French Togoland where, since some of the people of the former German colony were incorporated in the emergent Ghana, almost complete self-government was granted in 1955. More generally, the aspirations of the French West African nationalists and the direction of French policy both began to change, the latter more slowly than the former. Although the R.D.A. shortly recovered from the disaster brought on it by its earlier tactics, and developed a new policy of advance through mutual understanding with the French, it was now facing competition from local nationalist parties in a number of territories. Thus, when Houphouet-Boigny took office in a French Socialist government in 1956, he became instrumental in drafting the *loi cadre*, an outline law which gave the French Government power to grant to each territory a considerable degree of local self-government. Territorial assemblies and councils of ministers began to assume many of the powers formerly exercised by the French in Paris, Dakar, or Brazzaville.

Both Houphouet-Boigny and the *loi cadre*, however, incurred increasing criticism from those nationalists who felt that French

Africa was being broken up into units too small and insufficiently autonomous to be really free of French control. Within the R.D.A., Sékou Touré, a Guinean descendant of Samori and the leader of a strong inter-territorial African trades union movement, began to urge a union of territories much more firmly independent of France. Similar arguments were also presented by Senghor in the Senegal, the one territory where the R.D.A. had never been strong, and where his Bloc Populaire Sénégalais had come to power following the *loi cadre*.

The next advance, however, came from the French in 1958, when the new de Gaulle régime, brought into power by events in Algeria and seeking to ride the whirlwind, gave all black African territories the choice of complete independence, or autonomy as separate republics within a French 'Community' dealing with foreign policy, defence, and several other common matters. This initiative appeared to succeed, for in the ensuing referendum all the territories except Guinea, where Sékou Touré's influence secured an all but unanimous vote for independence, voted for autonomy within the Community. Guinea's action, however, led to the virtual destruction of the Community as de Gaulle had envisaged it. In 1959, Senegal and the French Sudan asked for complete independence *within* the Community, as the Federation of Mali. When this was granted, the territories still within Houphouet-Boigny's sphere – the Ivory Coast, Niger, Dahomey and Haute Volta – felt they had to go one better, and secured independence *outside* the Community, as a preparatory step to achieving an understanding with France. By the end of 1960, all the former colonies of both French West Africa and French Equatorial Africa had become technically independent of France.

When Guinea declared its independence, the whole of the French administration was immediately withdrawn and all French financial and economic aid stopped. The greater part of Guinea's consequent need for assistance was met from communist sources, the U.S.S.R., Czechoslovakia, China, and East Germany. The most immediate and dramatic offer of assistance, however, came from Nkrumah's Ghana, with whom a form of

union was shortly proclaimed. It was now obvious that Nkrumah regarded Ghanaian independence merely as a means to a greater end, the complete liberation of Africa from colonialism and the achievement of the widest possible measure of unity among the African peoples. With this in view, he could tolerate no disunity in Ghana, which he shaped into a monolithic republic under the complete control of his party and dominated by his own personality as President (1960). The whole energies and resources of the state were to be directed outwards to the anti-colonial and pan-African cause. In 1958, Accra was the scene both of the first conference ever held between the governments of independent African states, and also, perhaps even more significantly, of the first All African Peoples' Conference, attended by the representatives of the nationalist movements of twenty-eight African territories, many of them still under colonial rule. From now onwards it was abundantly clear that the African revolution would not be confined to West Africa. Indeed, there were at this time many well-informed people who assumed that it would sweep onwards with gathering strength into the strongholds of white supremacy in the far south.

The most immediate consequence of the All African Peoples' Conference was felt in the Belgian Congo, the rulers of which had scarcely begun to relax a rigid paternalist control which, though often enlightened in its care for African economic advance, allowed no political scope whatsoever to Africans (or for that matter to Belgian settlers either). After 1955 the Belgians had begun to take a little note of what was happening elsewhere in Africa, especially in French territories just across the lower Congo and Ubangui. Their cautious reappraisal had permitted the emergence of a number of African political associations, but these – in so vast a land, where few Africans had had any contact with the outside world or any higher education, and where none had held any post of responsibility – were organized for the most part on a regional or even a tribal basis. Independence still seemed a long way off – indeed, when a young Belgian professor, A. A. J. van Bilsen, published in 1956 a plan for the

political emancipation of the Congo in thirty years, he was bitterly attacked for his imprudence. In 1958, however, Patrice Lumumba, the only Congolese leader with any pretence to more than a purely local following, went to the All African Peoples Conference in Accra, where his radical and unitary approach to the problem of Congo independence secured immediate recognition, so that for pan-Africanists he became the hero of Congo nationalism. 1959 was a year of mounting disturbance in the Congo, and in 1960 the Belgians concluded that their best chance of retaining their great economic interests in the territory lay in the grant of free elections and immediate independence.

Lumumba duly became the first Premier, but his government depended on the parliamentary support of politicians of very different ideas from his own, and he could govern only with the help of the Belgian civil service and the Belgian-led army. When, seeing no independence for themselves in the continued presence of their white officers and N.C.O.s, the soldiers of this army mutinied, the whole edifice collapsed. Fighting broke out between tribes anxious to repay old scores. The Katanga province, vital to the whole Congo economy, and itself controlled by an unholy alliance between the Belgian mining interests and local African politicians led by Moise Tshombe, declared its independence. Belgium used force to protect her citizens and interests. At first the independent African states scored a great success through their insistence that order should be restored only by their own soldiers acting under United Nations control. But they soon began to differ among themselves over the extent to which it was legitimate to intervene in the affairs of a fellow African state. One group, including Guinea, Ghana, and Egypt, clung to the strict pan-African line that the Lumumba government was the only legitimate government in the Congo, and after Lumumba's murder in Katanga this group became bitterly critical of the United Nations. Other states such as Tunisia, Nigeria, and the Sudan saw the need for some compromise – for some coalition of the various contending Congolese factions, able to command a firm majority in the National Assembly, and

also perhaps, to reach a constitutional adjustment between the unitary demands of Lumumba's supporters and the federalism sought by other influential Congo leaders. The situation was further complicated during 1960 by the attainment of independence by many French territories, which – being nearer to the Congo and more closely allied with the west than other independent African states – thought that both the Pan-Africanists and the United Nations were unduly interfering in matters which were best left to the Congolese and themselves.

Ultimately the Katanga secession was ended and a semblance of order imposed on the Congo by the troops and officials brought in under United Nations auspices. But these could not stay for ever (financing their operations all but wrecked the United Nations themselves). When they withdrew, the government under President Kasavubu was faced with armed resistance at a number of points – whether from Lumumbists, or from dissident tribesmen, or from gangsters or would-be war-lords. Kasavubu's most original tactic for dealing with this situation was to invite the hitherto arch-dissident, Tshombe, to become his prime minister. Tshombe's links with the western world enabled him to secure the resources, including white mercenary troops, to establish a crude control over virtually all the Congo except the remoter rural areas. But neither Tshombe nor Kasavubu inspired political confidence among Africans whether within or without the Congo, and in 1965 their futile attempts to secure a working form of parliamentary government were swept away by the commander of the Congolese army, General Mobutu, who eventually succeeded in establishing a firm government over the whole country, which he shortly renamed Zaire.

The independence of Zaire in 1960 was shortly followed by that of the four East African territories of Tanganyika (1961), Uganda (1962), Kenya (1963), and Zanzibar (1963). Here, there is no doubt that the British government would have preferred to play a much slower game, using a system of 'multi-racial'

constitutions to protect the European and Asian minorities until such time as racial distinctions had become blurred by intermarriage. Such a policy was defensible so long as West Africa was the only standard of comparison. With an independent Congo and an independent Somalia (see p. 236), it ceased to be so. Moreover, by the late 1950s the African political parties of East Africa were beginning to show their mettle. The Tanganyika African National Union (TANU), founded by Julius Nyerere in 1954, rapidly became as effective as Nkrumah's Convention People's Party as a mass party incorporating all earlier political associations. Also Nyerere found in Sir Richard Turnbull a governor of the same pragmatic outlook as Nkrumah had found in Arden-Clarke. Within weeks of his appointment in 1958, Turnbull had ditched the multi-racial policy of his predecessors. Where Arden-Clarke had held Nkrumah to an apprenticeship of seven years, Turnbull settled with Nyerere for three.

The other East African territories, because of their internal dissensions, moved just a little more slowly. Uganda, though without European settlers and though much further developed economically and educationally than Tanganyika, had been held back by the unwillingness of Buganda to surrender the privileged position which it had enjoyed under the colonial regime. When the Democratic Party eventually emerged as a nation-wide party willing to challenge the colonial government, leading Baganda organized the Kabaka Yekka Party to oppose it. Only when Milton Obote founded a third effective party – the Uganda Peoples Congress, based in the less developed northern part of the country – were the Baganda supporters of Kabaka Yekka persuaded to enter a coalition with the U.P.C. against the Democratic Party, and so to create a grouping strong enough to achieve independence in 1962. Having won power in this way, Obote set himself to attract members of the opposition as individuals to join his ranks, with the result that by 1965 he was strong enough to turn the tables on his former allies and establish a one-party state. Five Cabinet ministers were arrested on charges of conspiracy; the army was sent to attack the

Kabaka's palace; the Kabaka fled the country; and Obote took his place as President of Uganda.

In Kenya the main delaying factor was of course the need to smooth a little the withdrawal of British support for the hitherto privileged minorities of Europeans and Asians, who had acquired over the years a considerable stake in the government of the country, and whose peaceful cooperation in the new scheme of things was very much to be desired. In the event it was remarkable that, despite some talk of betrayal, more than half of the Europeans and the great majority of the Asians remained in Kenya when the country passed under African rule in December 1963. Jomo Kenyatta, the veteran East African nationalist who had only recently emerged from eleven years of imprisonment and detention following his involvement in the Mau Mau rebellion, proved a singularly unresentful and conciliatory leader of one of the most stable and successful of African governments.

Pre-independence hopes that the East African territories might come together in a federation, which might then be further extended to include Malawi and Zambia, were not in the event fulfilled. The psychological moment was missed, and in some measure this was probably due to developments in Zanzibar, where the independence constitution of 1963 was violently overthrown in the following year by a communist-inspired revolution of the Africans against the Arabs, which drove out the Sultan and massacred or expelled most of the Arab population of the island. In a bid to keep some control over what was happening on his offshore islands, Nyerere organized a union between Tanganyika and Zanzibar, thus forming the new state of Tanzania. Though the union was little more of a reality than that between Ghana and Guinea, it marked a leftward turning-point in Nyerere's policy which was to carry him far away from his two northern neighbours. In the western world outside Africa Tanzania kept a circle of discerning admirers who saw there an African government which seemed uniquely concerned with the greatest happiness of the greatest number of its citizens, where there were no presidential palaces or conspicuous motor-cars and where the party maintained its contact with the grass

roots of society instead of turning itself into a remote and privileged élite.

In external affairs, Nyerere began to look increasingly towards the south. In part this was because his Tanzania became one of the principal champions (and most practical helpers) of militant black resistance to white oppression in southern Africa. But it was also because circumstances began to shape Kaunda's Zambia into the partner he had sought in vain in East Africa. Kaunda was originally an empirical black nationalist, but he had to face up to the fact that at independence the major source of wealth in his country, its copper mines, was controlled by foreign companies who had developed a settler society to help them exploit it. Mere political independence was therefore not enough, the more so since these alien forces were in control in the countries south of the Zambezi on which Zambia depended for its supplies of energy, and communications with the outside world and its markets – communications which were completely at risk after Rhodesia's U.D.I. in 1965. Kaunda therefore had no real alternative but to build up his party as the sole focus for national aspirations, to secure state control of the economy and to divert mining profits to develop alternative sources of power and to improve agriculture, and to develop closer relations with Tanzania. The 1,116 mile Tanzam railway, built with Chinese aid to the Tanzanian port and capital of Dar es Salaam, was the spectacular physical fruit of this cooperation. Though it could hardly compete economically with the railways through Rhodesia to ports in Moçambique and South Africa, it served to cement an alliance already manifest in his and Nyerere's common approach to the problem posed by settler power in the south.

The Congo crisis had already indicated that African states were by no means united in their ideas of what independence really meant. This was demonstrated in 1961 by the holding of *two separate conferences* of independent African states, one at Casablanca and one at Monrovia. In *black* Africa the leading powers in the first and smaller group were Guinea, Ghana, and the new Mali.[1] The leaders of these states, together with those of

1. This was the former French Sudan. Feeling itself too much at the economic

Morocco and Egypt, believed that, even apart from Portuguese Africa, Rhodesia and South Africa, the struggle to establish the independence and personality of Africa had by no means already been won. Many of the new states were too small, too poor, or too divided. The Congo débâcle and the dependence of so many former French territories on budget subventions from France were merely the more obvious examples of what they called 'neo-colonialism'. Their answer was a positive pan-Africanism directed towards the emergence of larger political units and ultimately of a United States of Africa strong enough to stand alone, or, where outside aid was still necessary, strong enough to secure it without obligation, through an ability to negotiate impartially with both the communist world and the west.

The Monrovia grouping, comprising most of the rest of black Africa, was more cautious. While seeing the need for inter-African co-ordination, the Monrovia states wished to solve their own internal problems first, and for this many of them felt they still needed the cooperation of those European states on which their countries' economies so largely depended.

More fundamentally, this division was between those states – both Negro and non-Negro, such as Egypt, Ghana, Guinea, and Mali – whose governments were pursuing an active economic and social revolution to complete the political revolution, and those where power still rested in the hands of the essentially middle-class *élite* which had grown up in the colonial era. In most of the newly-independent African countries, this very small educated *élite* had stepped all too easily into the positions of privilege formerly occupied by the colonial officials. Despite the poverty of the population as a whole, the earnings of the professional class continued to stand at levels originally fixed with a view to attracting expatriates from overseas. The new rulers moved into the actual houses of their predecessors, employing the same servants, driving the same large cars. In most parts of Africa life in the ordinary village went on much as

mercy of Senegal, whose own economy was too closely allied with that of France, it had in 1960 broken the original Mali federation and joined the Ghana-Guinea union.

before, even though the District Commissioner was black and not white.

All the new African governments, indeed, whether they professed radical socialism or were empirical and conservative in their approach to their problems, experienced great difficulty in fulfilling the expectations aroused in their citizens by the ending of colonial rule. Fundamentally this was a measure of the weakness of the African economies, and the poverty, or lack of development, of their resources. In 1965, for instance, north of the Limpopo, only one African territory, Gabon, was thought to have a national income per head as high as $280. Five others – Ghana, Algeria, Rhodesia, Libya, and the Ivory Coast – were in the range of $200–230. None of the rest could achieve more than about $170, and twenty – half of the total – had only between $85 and $40 per head. Such figures may be compared with $530 per head, however unevenly divided, for South Africans, and something like $1500 and $3000 respectively for the United Kingdom and for the United States. In such circumstances, the cutting of the colonial links, however desirable and inevitable politically, was no guarantee at all that Africans would be materially any better off. In the later 1960s it was in fact noticeable that radically minded independence leaders, like Modibo Keita in Mali and Sékou Touré in Guinea, were moving cautiously towards establishing closer links with their old colonial mentor, France. On the other hand, too close a connexion with a former colonial power could also produce difficulties, as was apparent in Senghor's Senegal when France began to cut her commitments there.

One very common means by which the new African leaders, whatever their ideological orientations, sought to grapple with the basic problems of independence was to call for a government of national unity. It was argued that the underlying economic situation was such that party politics were a luxury which could not be afforded. Political competition would direct attention away from urgent problems of development. A strong single party should strive to represent – sometimes, indeed, to identify itself with – the nation as a whole. This would ensure the

stability needed to plan the development of the economy, and to attract much-needed aid and investment from the richer nations of the world. It was also argued, with some conviction, that such single-party rule was the modern equivalent to traditional African systems of government. Many pre-colonial African societies were essentially democratic, but they did not decide the national policies to be pursued by periodic counting of votes. Instead the elders of the nation acted upon what, after popular debate, they conceived to be the general consensus of opinion.

But the institutionalization of this theory in the single parties favoured after independence did not automatically lead to greater political stability and to greater or more successful development. Succeeding, as has been seen, to the inflated salaries and living standards and, above all, to the vast and virtually untrammelled political power of the former colonial administrators, the new politicians and their political machines all too often became an all-powerful vested interest more or less isolated from popular opinion. Ordinary men and women commonly found that they were no better off under their African rulers than they had been under colonial governments. Sometimes, indeed, they felt that they were worse off; that too much of what money was available was going to support the panoply of power in the new capitals, into the presidential palaces, embassies, national air lines, and the new armies and air forces which sovereign states seemed to require, or even into the pockets of dishonest politicians and their friends.

Since the single party had a monopoly of political power, it was at first difficult to see how it could be challenged. But in many African countries it shortly became apparent that the self-perpetuating machine could be challenged, and indeed overthrown, by a rival *élite*, that of the government services, headed usually by officers of the army and sometimes also of the police force. Military takeovers were not new in African history, and reference has already been made to those in Egypt (1952), in the Sudan (1958 and 1969) and in Zaire (1965). The army had also intervened in politics in 1963 in both Togo and Dahomey, to relinquish power almost immediately to alternative civilian

governments. But from 1966 onwards, and especially during 1966–9, there was such a flood of military takeovers as to suggest that it was almost a rule of African politics that dissatisfaction with the administration of those who had taken over from the colonial régimes was likely to come to a head within about ten years. Discounting unsuccessful coups, there were further military interventions in Togo (1969) and in Dahomey (1965, 1967, 1969, and 1972), and there were also coups in Congo-Brazzaville (1963 and 1968), Nigeria (1966 and 1967), Burundi (1965–6), the Central African Republic (1966), Ghana (1966 and 1972), Upper Volta (1966 and 1974), Sierra Leone (1967 and 1968), Mali (1968), Somalia and Libya (1969), Uganda (1971), Madagascar (1972), Niger and Ethiopia (1974), and Chad (1975).

At first sight, this catalogue might seem to lend support to the beliefs held by whites in southern Africa that Africans cannot maintain effective and dispassionate governments, and that their part of the continent is the only one which has been preserved from chaos and bloodshed. Quite apart from the fact that the order on which they pride themselves (as also that which the old colonial governments maintained) is entirely the result of the coercion of the majority of the inhabitants of their countries, this belief is not in accordance with the facts. Of the twenty countries named above, only six (Sudan, Zaire, Nigeria, Burundi, Uganda, and Ethiopia) have really experienced a major breakdown of order or bloodshed on a large scale. In three of these cases (Sudan, Zaire and Nigeria) the result could be tentatively assessed as the emergence of more effective or fairer governments than they had when colonial rule was terminated (and in the others the end result is yet to be seen).

The fundamental difficulty in most of these countries is, of course, that they tend not to command resources sufficient to make it easy for any leader, of whatever political philosophy, to meet all the popular expectations raised first by the colonial period and then by independence. Thus in the extreme case of Dahomey, which is very poorly endowed with natural resources, but in which the colonial situation happened to provide a relatively high level of education and employment expectations,

a coup seems to have become as natural a way of ousting the government of the day as an election in more fortunate lands. Less extravagantly, Mali and Somalia are examples of poor territories in which the post-independence form of government was unable to live up to its promises, and came to be seen as obstructive of the welfare of the community, even though in the first case a radical socialist administration was replaced by a more empirical one, and in the second a conventional parliamentary régime gave way to a radical socialist one.

But some variations on this theme can be more complex. Thus the fall of Nkrumah in Ghana in 1966 would seem to be the prototype for the fall of Modibo Keita in 1968 or of Hamani Diori in Niger in 1974. But Nkrumah's all-embracing party had not only become self-perpetuating, and corrupt and ineffective in dealing with Ghana's problems, it had also mismanaged, indeed squandered, relatively considerable resources. The solution favoured by both the army and the people was therefore to return, in 1969, to democratic, parliamentary government and to elect more conservative politicians to office. But this also failed: Dr Busia's parliamentary administration could hardly show whether it was more efficient and honest than Nkrumah's single party because it was crippled by the empty treasury and the debts this had left behind. So in 1972 the army took over once again.

Sierra Leone and Nigeria seem at first sight to be examples of armies overthrowing functioning democratic parliamentary régimes. But in Sierra Leone, Albert Margai, who became prime minister after his brother's death in 1964, was much more of a party man. He tried to make his party the only legal party, and thus heightened dissatisfaction with its inefficiency and venality. The army intervened when the 1967 general election appeared not to produce a clear result, though had there been complete freedom at the polls, the opposition, led by Siaka Stevens, would have won handsomely. Some senior officers acted to maintain Margai in power. Other officers then took over with a 'Reformation Council' which banned all political activity, but then became so political themselves that in 1968 they were over-

thrown by their own N.C.O.s. Deciding that civilian politicians might be a lesser menace than army officers, these enabled Siaka Stevens to assume office.

In federal Nigeria, there was the appearance of parliamentary democracy at the centre, but each of the three major regions was effectively dominated by one political party. In the north, which had half the seats in the federal assembly, political power was monopolized by the Northern People's Congress. This was not a democratic party, but the creature of the traditionalist and Muslim Fulani-Hausa emirs whose 'native administrations' had been fostered by British indirect rule. In order to rule at the centre, the Northern People's Congress needed the support of one of the other regional parties. A marriage of convenience was therefore arranged with the radical nationalist National Council of Nigerian Citizens, which effectively maintained a single party government in the predominantly Ibo east, to control the federal government. This alliance broke up in 1964, and the Northern People's Congress then sought to impose its will on the Yoruba of the western region, maintaining there a puppet government of dissidents from the main Yoruba party, the Action Group. The results were a general breakdown of law and order in the west, and increasing dissatisfaction among civil servants and army officers, many of whom were Ibos, with the disingenuity of the federal politicians. In January 1966, young officers assassinated the leader of the Northern People's Congress, the Sardauna of Sokoto, and some of his principal agents, including the federal prime minister, Alhaji Sir Abubakar Tafawa Balewa, also a northerner, and the puppet prime minister of the western region. Shortly afterwards the Commander in Chief, General Ironsi, set up a military administration.

The immediate result seemed beneficial. The disorders which had plagued the western region rapidly ended. A new constitutional order was proclaimed in which the apparatus of federalism was dismantled and the over-mighty regional governments replaced by twelve provincial administrations. But the young officers of the coup were largely Ibos; Ironsi, also an Ibo, seemed to rely excessively on Ibo political advice. The new order was to the liking neither of the rank and file

of the fighting troops, who were mainly northerners, nor to the surviving leaders of the traditionalist north, who had lost the ability to command the country by their manipulation of federal politics, and who feared that their own territory would now be controlled by educated, pushful Ibo Christians. In July 1966, Ironsi and many of the leading Ibo officers were killed in an army mutiny. When discipline had been restored under General Gowon, a Christian northerner, he was faced by a growing hostility of the northerners towards the Ibos who played such a prominent role in the administration, technical services, and commerce of their region. Ultimately many thousands were massacred, while perhaps a million refugees poured back into the already crowded Ibo homeland. For the Ibos and for the military governor of the east, Colonel Ojukwu, who had engineered the January 1966 coup in the north, the wheel had come full circle. The scheme to end the federal system, involving the division of the east into three separate provinces, seemed to be a plot to perpetuate northern, Fulani-Hausa domination. On 1 June 1967, Ojukwu declared the secession of the east as the independent state of Biafra, and a month later a bloody civil war began.

The Biafrans showed their contempt for the existing state of affairs in Nigeria by striking out towards Lagos, hoping to arouse the westerners to make common cause with them against the north. But this bold move failed and, failing too to get formal recognition from more than a handful of African states, they found themselves ever more closely beleaguered by the large armies which Lagos could recruit and arm. Despite spectacular international attempts at relief by air, a disastrous food shortage developed, and in January 1970 Ojukwu fled and the remaining secessionists agreed to return to the Nigerian fold. Thereafter the reins of power remained with the federal army, though the actual business of governing, both at the centre and in the new states (increased to nineteen in 1976) was shared by the army officers with civilian commissioners. By 1977-8 a return to civil government was being planned.

In Uganda, Obote's use of the army against the Kabaka of Buganda in 1966, followed almost immediately by his suppres-

sion of the three other traditional kingdoms of Bunyoro, Ankole, and Toro, meant that his increasingly personal and erratic rule ceased to have any significant political support in the developed southern half of the country. He became dangerously dependent on the army, which was mainly recruited from northern ethnic groups. In 1971, the commander who had led the assault on the Kabaka's palace, General Idi Amin, judging that more of the army would be loyal to him than it was to the President, ousted Obote and took his place. This move was initially welcomed both at home and abroad. But Amin had even less idea than Obote as to how to employ his power constructively. Cheap popularity could be gained in the short run by his wholesale expulsion of the Asian community, but this was hardly conducive to the maintenance of a productive economy. Eventually Amin's main activity seemed to become the conducting of savage vendettas and pogroms against any individual or group, civil or military, that could be suspected of denying him the absolute devotion he demanded.

One major army takeover, that in Ethiopia in 1974, occurred in a country which in the strictest sense had only experienced colonial rule for the short period 1936–41. But its emperor, Haile Selassie, was heir to the régime initiated by Menelik, which certainly was colonial in the sense that Amhara rule was established by conquest over other ethnic groups. Haile Selassie was determined to modernize the structure of this empire. He succeeded in the sense that he created a modern army and an educational machine capable of providing a modern bureaucracy. But he was reluctant to share authority at the centre with his new *élite*, while control of the provinces was still entrusted to governors who seemed to their peoples to be little different from the feudal lords of the older empire. Younger members of the new *élite* were clearly dissatisfied with this situation by 1960 (when there was an abortive coup); thereafter, increasing strains were evident as the emperor, who was born in 1892, became less capable of dealing with the problems afflicting his régime. Two of these, a swelling revolt in Eritrea (which had lost its federal status in 1962 and had since been treated simply as one of four-

teen provinces), and the substantial loss of life in 1972–3 caused by famines resulting from droughts exacerbated by landlordism, seem finally to have determined the army to revolt and its younger officers to take over power.

Some of the original independence leaders were able to retain power into the mid-1970s by shrewdly combining political manipulation and autocracy. Senghor in Senegal and Sékou Touré in Guinea would certainly seem to come into this category, perhaps also Banda in Malawi, none of whom had much in the way of real resources to support their régimes. Kenyatta (in the same age-group as Haile Selassie) in Kenya and Houphouet-Boigny in the Ivory Coast seem to have managed in a somewhat similar fashion. But both operated from positions of greater economic strength. While Kenyatta was careful not totally to estrange the Europeans and Asians who had dominated the colonial economy of his country, Houphouet positively encouraged western, especially French, interests to bring about an economic revolution in the Ivory Coast comparable to that which Ghana had experienced prior to the Nkrumah débâcle.

The Ivory Coast was not alone in harnessing economic power to ensure the survival of its régime. Generally speaking, world prices for primary products were improving in the earlier 1970s. This could not, of course, help countries such as Upper Volta, Mali, or Somalia, which had little to offer to world markets. However the problems for producers of minerals like copper (e.g. Zambia and Zaire) or of crops like cocoa, cotton, and coffee (e.g. Ghana, Sudan, Ivory Coast) were to some extent eased. But there were really only two primary products which could give African countries the chance of breaking free from the dependence on the world economy that had been imposed on them in the colonial period. During the Arab-Israeli war of 1973, the Arab nations realized that the extent to which the developed western economies depended for their vital supplies of energy on imported mineral oils placed a major politico-economic weapon in their hands, and the price of oil was raised to unprecedented levels. By the 1970s, five African countries had become significant oil-producers – Libya, Algeria, Nigeria, Gabon, and,

potentially, Angola. In Nigeria, soaring oil revenues greatly facilitated economic development, while Libya (where in 1969 the conservative, western-allied régime of King Idris was swept away by socialist young army officers led by Colonel Gaddafi) suddenly found itself possessed of a G.N.P. per head ($2000 or more) vastly greater than any other African territory, ranking it indeed with the developed countries. Similar if less spectacular results could be expected from the exploitation of the major deposits of phosphates (in growing demand as an agricultural fertilizer) in Morocco and the Saharan territory just to the south which was divided between Morocco and Mauritania when Spain withdrew from empire in Africa.

Most African territories could not expect the economic largesse offered to the possessors of oil or phosphates; their continuing poverty was bound to place obstacles in the way of their political development and their achievement of true nationhood. But, on the larger scale, they were capable of achieving a remarkable sense of *African community*. In part, of course, this was derived from their common experience of colonialism, and it was further cemented by their community of opposition to the continuing presence of white domination in the south of the continent. This sense of community in face of a western world which, it was felt, had only grudgingly admitted Africans to equality – and was still denying this in southern Africa – enabled the Casablanca and Monrovia groups of states to meet together at Addis Ababa in 1963, and there to establish the Organization of African Unity, which soon became a remarkably effective body both within and without the continent. Nevertheless, to a historian it is apparent that the African sense of community has much deeper roots than those of its temporary tutelage to Europe. Before Arab or Portuguese navigators had opened the African coastline, Africa's lines of communication were interior ones, and it is along these ancient established interior lines that there have travelled the basic influences which have created the sense of an African community.

Suggestions for Further Reading

Chapters 1 to 4

The general reader who wishes to go deeper into African history may need first to widen his knowledge of the African peoples, their geographical environment, their cultures, their languages and their social institutions. Unfortunately the many times reprinted short guide by C. G. Seligman, *Races of Africa* (most recent ed., 1966) is based on a totally misleading understanding of African history. Cautious use may be made of G. P. Murdock, *Africa – its Peoples and their Culture History*, 1959, which is at once stimulating and contentious. H. Baumann and D. Westermann, *Völkerkunde Afrikas*, available in French as *Les peuples et les civilisations de l'Afrique*, 1948, is solid and reliable if now a little old-fashioned, while J. L. Gibbs (ed.), *Peoples of Africa*, 1965, is perhaps the best introduction in English though, unlike the other works, it does not attempt to be comprehensive, but consists of a number of selective studies. Though his classification is by no means universally accepted, the most modern general work on the languages, and one which is historically very important, is Joseph H. Greenberg, *The Languages of Africa*, 1963; there is also a useful collection of papers edited by David Dalby, *Language and History in Africa*, 1970.

The period of African prehistory outlined in Chapter I is admirably synthesized in J. Desmond Clark's *The Prehistory of Africa*, 1970, while there are more detailed discussions in the three Pelican volumes, *The Prehistory of Southern Africa*, also by J. Desmond Clark, 1959, *The Stone Age of Northern Africa*, by C. B. M. McBurney, 1960, and *The Prehistory of East Africa*, by Sonia Cole (revised ed. 1964), and in the book by Oliver Davies, *West Africa before the Europeans*, 1967. As these become outdated, their place will be taken by *The Cambridge History of Africa*, Vol. I, edited by J. Desmond Clark – a large collaborative work with extensive bibliographical surveys, covering the period to 500 B.C. (in press).

The food-producing revolution and the beginnings of the Iron Age have been studied in a number of articles in the *Journal of African History*, notably those on the history of African food crops collected in Vol. III, No. 2 (1962) and those now reprinted in *Papers in African Prehistory*, edited by J. D. Fage and Roland Oliver, 1970. A synthesis of recent research on the Early Iron Age by an archaeologist and a historian working in collaboration is *Africa in the Iron Age*, by Roland Oliver and Brian Fagan, 1975. R. Mauny, *Les siècles obscurs de l'Afrique noire*, 1970, covers some of the same ground, while P. L. Shinnie (ed.), *The African Iron Age*, 1971, is a collection of shorter regional syntheses for Sub-Saharan Africa. A more extensive collaborative work on the period from 500 B.C. to 1050 A.D. will be found in *The Cambridge History of Africa*, Vol. 2, edited by J. D. Fage, 1978.

For the origins of Egyptian kingship and political institutions W. B. Emery's *Archaic Egypt*, Penguin Books, 1961, is of great interest and should be compared with Chapter V of V. Gordon Childe's classic *New Light on the Most Ancient East* (revised ed., 1954). The best short account of ancient Egyptian civilization is Cyril Aldred, *The Egyptians*, 1961. For Egyptian colonization up the Nile Valley and the history of Kush, there is A. J. Arkell's excellent *History of the Sudan to 1821*, 1955, and P. L. Shinnie, *Meroe*, 1968. For the Ptolemaic period, Edwyn Bevan, *A History of Egypt under the Ptolemaic Dynasty*, 1927, is still unrivalled. For Ethiopia during the pre-Axumite and Axumite periods Sergew Hable Sellassie, *Ancient and Medieval Ethiopian History*, 1972, provides a useful conspectus of the main sources, while for the background to Monophysite Christianity in Egypt, Nubia, and Ethiopia, W. H. C. Frend, *The Rise of the Monophysite Movement*, 1972, is a work of fundamental importance. The best general study of Christian Nubia is still that by U. Monneret de Villard, *Storia della Nubia Cristiana*, 1938.

Chapters 5 to 7

The reader interested in ancient North Africa cannot do better than to start with Herodotus: there is a Penguin Classics translation by Aubrey de Selincourt. Thereafter, the long sequence of colonization by Carthaginians, Greeks, Romans, Vandals, and Byzantines is best studied in C.-A. Julien, *Histoire de l'Afrique du Nord*, Vol. I, 1951, for the Maghrib, and in H. Idris Bell, *Egypt from Alexander the Great to the Arab Conquest*, 1948, for Egypt and Cyrenaica. Donald Harden, *The Phoenicians*, 1962, is the best book in English on Carthage. B. H.

Warmington, *The North African Provinces*, 1954, is a study of Roman colonization in Africa. For early Christianity in North Africa, C. P. Groves, *The Planting of Christianity in Africa*, Vol. I, 1948, is useful, and W. H. C. Frend, *The Donatist Church*, 1952, is essential. For the intriguing question of Jews and Judaic influences, H. Z. Hirschberg, *A History of the Jews in North Africa*, 1968, is invaluable. For Roman influences in the Fezzan and beyond, Mortimer Wheeler, *Rome beyond the Imperial Frontiers*, 1954, makes an alluring introduction.

For the background to the Arab conquests, a start can be made with H. A. R. Gibb, *Muhammedanism*, 1949, and Bernard Lewis, *The Arabs in History*, 1950. P. K. Hitti, *History of the Arabs*, 1946, and C. Brockelman, *History of the Islamic Peoples*, English edition, 1949, are standard works. An important modern work is *The Cambridge History of Islam*, 2 vols., 1970, edited by P. M. Holt, Ann K. S. Lambton and Bernard Lewis, of which Vol. I deals with the Central Islamic lands, including Egypt, and Vol. II with the Further Islamic lands, including the Maghrib and Africa south of the Sahara. Though old, S. Lane Poole, *A History of Egypt in the Middle Ages*, reprinted 1968, is still a useful narrative. Y. F. Hasan, *The Arabs and the Sudan*, 1967, is the standard work on the Arab penetration and settlement of Christian Nubia. E. F. Gautier, *Le passé de l'Afrique du Nord: les siècles obscurs*, 2nd edn., 1952, is a stimulating discussion of the changes in the Maghrib between Roman times and the Hilalian invasions, while Vol. II of Julien's *Histoire*, revised edn. by Roger Le Tourneau, 1952, provides a general narrative and good bibliographies for the period up to 1830; an English translation, edited by Charles Stewart, was published in 1970 under the title *History of North Africa: Tunisia, Algeria, Morocco from the Arab Conquest to 1830*. J. Abun Nasr, *A History of the Maghrib*, 1971, offers a shorter, though well reflected synthesis. H. Terrasse, *Histoire du Maroc*, 1949–50, and R. Brunschwig, *La Berbérie orientale sous les Hafsides*, 2 vols., 1940–9, are important works, while S. Lane Poole, *The Barbary Corsairs*, 1890, is still useful.

The development of trans-Saharan relations during the early centuries of Islam is intimately linked with the growth of states in the savanna belt of West Africa. The subject is attractively introduced by E. W. Bovill, *Caravans of the old Sahara*, 1933, and *The Golden Trade of the Moors*, new edition (with Robin Hallett) 1968. J. S. Trimingham, *A History of Islam in West Africa*, 1962, provides a short conspectus, by no means limited to the religious aspect. On the economic side, the widest survey of both archaeological and documentary evidence is R. Mauny, *Tableau géographique de l'ouest africain au moyen âge*, 1961,

although its lay-out as a work of historical geography presents some difficulties for historians. N. Levtzion, *Ancient Ghana and Mali*, 1973, though very concise, is the most authoritative study of the western part of the region, while his chapter on 'The western Maghrib and Sudan, 1050–1591' in *The Cambridge History of Africa*, Vol. 3, edited by Roland Oliver, 1977, provides the most detailed account of the Songhai empire and offers a new and exciting synthesis of events on both sides of the western desert. The same volume contains a parallel chapter on 'The eastern Maghrib and central Sudan' by H. J. Fisher. For the early history of states in Kanem-Bornu and Hausaland, the chapter by H. F. C. Smith in J F. A. Ajayi and Michael Crowder (eds.), *History of West Africa*, Vol. I, 1972, should also be consulted.

Chapters 8 to 11

The only short introduction to Ethiopian history in English is A. H. M. Jones and E. Monroe, *A History of Ethiopia*, reprinted 1960, but un-revised since the original edition of 1935. However, the medieval and early modern period is now covered in detail in three excellent monographs by Ethiopian scholars. Sergew Hable Sellassie, *Ancient and Medieval Ethiopian History*, 1972, deals with the period till 1270. Taddesse Tamrat, *Church and State in Ethiopia 1270–1527*, 1972, is a work of outstanding merit, as is that by M. W. Aregay, *Southern Ethiopia and the Christian Kingdom 1508–1708*, 1975. J. S. Trimingham, *Islam in Ethiopia*, 1952, deals with the history of the Muslim states to the east and south of the Christian kingdom. Richard Pankhurst, *The Ethiopian Royal Chronicles*, 1968, provides an anthology in English translation of the most important indigenous historical writings from the late medieval period onwards. C. F. Beckingham and G. W. B. Huntingford (eds.), *The Prester John of the Indies*, 2 vols., 1961, is an English translation of Alvares' narrative of the Portuguese embassy to Ethiopia of 1520–26: this gives a unique glimpse of the kingdom in its late medieval glory, before the Muslim invasions which began in 1527. Richard Pankhurst, *An Introduction to the Economic History of Ethiopia*, 1961, is largely concerned with the period from the 16th to the 18th century. M. Abir, *Ethiopia: the era of the Princes*, 1968, concentrates on the period 1769–1885. Donald Crummey, *Priests and Politicians*, 1972, is a study of the impact of European missions on the Ethiopian Church during the period 1830–68. The chapters by Tamrat in Vol. 3 and by Abir in Vol. 4 of *The Cambridge History of Africa* (edited by J. R. Gray, 1975) break new ground

by including the peripheral areas, especially Somalia, within their survey.

For East Africa in pre-colonial times there are two well-established collaborative works, the *History of East Africa*, Vol. I, edited by Roland Oliver and Gervase Mathew, 1962, and *Zamani: a Survey of East African History*, edited by B. A. Ogot and J. A. Kieran, revised edition, 1974. G. S. P. Freeman-Grenville, *East African Coast*, 1962, is a useful anthology of the main written sources in English translation. The archaeology of the coast and islands is surveyed by H. N. Chittick in *The Cambridge History*, Vol. 3, and more briefly in *Zamani*. His *Kilwa*, 2 vols., 1975, is the definitive record of seven seasons of excavation at the most important of the coastal sites. Justus Strandes, *The Portuguese Period in East Africa*, first published in German in 1899, English translation 1961, is still the standard work. The interior of East Africa from about the 15th century until the 19th is known mainly through studies of oral tradition, for which the accepted methodological guide is J. Vansina, *Oral Tradition*, English translation, 1965. Vansina's *L'évolution du royaume rwanda des origines à 1900*, 1961, was among the earliest of a series of monographs based on fieldwork, which now includes B. A. Ogot, *History of the Southern Luo*, 1967; D. W. Cohen, *The Historical Tradition of Busoga*, 1972; S. K. Karugire, *A History of the Kingdom of Nkore*, 1971; M. S. M. Kiwanuka, *A History of Buganda*, 1972; Godfrey Muriuki, *A History of the Kikuyu*, 1974; I. N. Kimambo, *A Political History of the Pare*, 1969; Steven Feierman, *The Shambaa Kingdom*, 1974, and Aylward Shorter, *Chiefship in Western Tanzania*, 1972.

For the Guinea coastlands, J. D. Fage, *A History of West Africa: an introductory survey*, 1969, can be compared with J. F. A. Ajayi and Michael Crowder (eds.), *A History of West Africa*, Vol. I, and with the relevant chapters of H. Deschamps (ed.), *Histoire Générale de l'Afrique noire*, Vol. I, 1970. A. G. Hopkins, *An Economic History of West Africa*, 2nd edn. 1975, is the first work by an economic historian to establish its base firmly in the pre-colonial period. The Iron Age archaeology of the region is in general little developed and obscurely published, but there are notable exceptions in Frank Willett, *Ife in the History of West African Sculpture*, 1967, and Thurstan Shaw, *Igbo-Ukwu*, 2 vols., 1970. In the field of traditional history there are some important collections by amateur historians, such as Samuel Johnson, *History of the Yorubas*, 2nd edn. 1956, and Jacob Egharevba, *A Short History of Benin*, revised edn., 1960, and also a few modern professional studies such as Michel Izard, *Introduction à l'histoire des royaumes Mossi*, 2

vols., 1970, and Robert Smith, *Kingdoms of the Yoruba*, 1969. Eva L. R. Meyerowitz, *The Early History of the Akan States of Ghana*, 1974, is largely based on traditional evidence. However, the main thrust of research has so far been in European archival sources. The outstanding monographs include Walter Rodney, *A History of the Upper Guinea Coast 1545–1800*, 1970; B. A. Oloruntimehin, *The Segu Tukolor Empire*, 1972; K. Y. Daaku, *Trade and Politics on the Gold Coast 1600–1720*, 1970; Ivor Wilks, *The Northern Factor in Ashanti History*, 1961; J. K. Fynn, *Asante and its Neighbours 1700–1807*, 1971; I. A. Akinjogbin, *Dahomey and its Neighbours 1708–1818*, 1967; Alan Ryder, *Benin and the Europeans 1485–1897*, 1969, and A. J. H. Latham, *Old Calabar 1600–1891*, 1973. Thomas Hodgkin, *Nigerian Perspectives*, new edn., 1975, Freda Wolfson, *Pageant of Ghana*, 1958, and Christopher Fyfe, *Sierra Leone Inheritance*, 1964, provide excellent anthologies of the main documentary sources.

For West Central and southern Africa, the introductory synthesis provided by Roland Oliver and Brian Fagan, *Africa in the Iron Age*, 1975, is amplified by the same authors in Vol. 2 of *The Cambridge History of Africa* and continued by D. B. Birmingham and Shula Marks in Vols. 3 and 4. Brian Fagan, *Southern Africa during the Iron Age*, 1965, deals with Zambia, Rhodesia, and South Africa. Peter S. Garlake, *Great Zimbabwe*, 1973, is the most up-to-date work on this outstanding site. J. Vansina, *Kingdoms of the Savanna*, 1966, deals with the emergence of states to the south of the Congo forest, while Joseph Miller, *Kings and Kinsmen*, 1976, traces the same process in central Angola. Richard Gray and David Birmingham (eds.) *Pre-colonial African Trade*, 1970, is a collection of essays on early long-distance trade routes. The best overall account of Portuguese contacts with this part of Africa is Ronald L. Chilcote, *Portuguese Africa*, 1967, while V. Magalhaes Godinho, *L'économie de l'empire portugais du XV et XVI siècles*, 1969, is of great importance for the economic background of Portuguese imperialism. More particular studies of the Afro-Portuguese contact are Phyllis M. Martin, *The External Trade of the Loango Coast, 1576–1870*, 1972; J. Cuvelier, *L'ancien royaume du Congo*, 1941; J. Cuvelier and L. Jadin, *L'ancien Congo d'aprés les archives romaines 1518–1640*, 1954; Georges Balandier, *Daily Life in the Kingdom of the Kongo*, 1968; D. B. Birmingham, *Trade and Conflict in Angola*, 1966; Eric Axelson, *The Portuguese in South-East Africa 1488–1600*, 1973, and *The Portuguese in South-East Africa 1600–1700*, 1960; M. D. D. Newitt, *Portuguese Settlement on the Zambezi*, 1973, and Allen F. Isaacman, *Mozambique; the Africanization of a European*

institution; the Zambezi Prazos, 1750–1902, 1972. The most important studies of oral tradition for peoples not directly in contact with Europeans are M. Plancquaert, *Les Jaga et les Bayaka du Kwango,* 1932; E. Verhulpen, *Baluba et Balubaïsés,* 1936. I. Cunnison, *The Luapala Peoples of Northern Rhodesia,* 1959; A. D. Roberts, *A History of the Bemba,* 1973; and D. P. Abraham, 'Ethno-history of the Empire of Mutapa' in J. Vansina, R. Mauny and L. V. Thomas, *The Historian in Tropical Africa,* 1964, pp. 104–21. For the southern part of the region, Monica Wilson and Leonard Thompson (eds.), *The Oxford History of South Africa,* Vol. I, 1969, is important; also the collection of essays edited by Thompson, *African Societies in Southern Africa,* 1969.

Chapters 12 to 15

The changing European attitudes to Africa described in Chapter 12 are part of European history as well as of the history of Africa. The latest study is Roger Anstey, *The Atlantic Slave Trade and British Abolition, 1710–1810,* 1975. Philip D. Curtin, *The Atlantic Slave Trade, a census,* 1969, is a definitive assessment of the volume of the trade at different periods, while his *Image of Africa: British Ideas and Action, 1780–1850,* 1965, is an important study of the changing attitudes referred to above. Another important synthesis for the whole European approach to Africa in the nineteenth century is H. Brunschwig, *L'avènement de l'Afrique noire,* 1963. An overall guide to European missionary expansion is C. P. Groves, *The Planting of Christianity in Africa,* of which Vol. I (1948) goes up to 1840, Vol. II (1954) covers the period 1840–78 and Vol. III (1955) 1878–1914. M. Perham and J. Simmons, *African Discovery,* first published in 1942 and often reprinted, is a most readable anthology of the principal British explorers, for whom it supplies the main bibliographical details. A. Adu Boahen, *Britain, the Sahara and the Western Sudan 1788–1861,* 1964, and two books by Robin Hallett, *Records of the African Association, 1788–1831,* 1964, and *The Penetration of Africa* (Vol. I, to 1815), 1965, are important studies. For the southern half of the continent the career of David Livingstone is crucial. The best short study is J. Simmons, *Livingstone and Africa,* 1955. Livingstone's own *Missionary Travels and Researches in South Africa,* originally published in 1857, and the edition of his *Missionary Correspondence* by I. Shapera, 1961, may be read with pleasure and profit.

For 19th century Egypt, there is P. M. Holt, *Egypt and the Fertile*

Crescent, 1516–1922, 1966, which has an excellent bibliography. H. H. Dodwell, *The Founder of Modern Egypt; Mohammed Ali*, 1931, and John Marlowe, *Anglo-Egyptian Relations 1800–1953*, 1954, are still useful. For North Africa, there are excellent chapters by A. Raymond and A. Nouschi in the *Cambridge History of Islam*, Vol. II. C.-A. Julien, *Histoire de l'Algérie contemporaine*, 1964, is a work of major importance covering the period 1827–71. C. R. Ageron, *Histoire de l'Algérie contemporaine 1830–1965*, 1966, and Y. Lacoste, A. Nouschi and A. Prenant, *L'Algérie passé et présent*, 1960, deal with the colonial period as a whole. For Morocco, there is J. L. Miège, *Le Maroc et l'Europe 1830–1894*, 1961–4, and for Tunisia, J. Ganiage, *Les origines du protectorat français en Tunisie, 1861–1881*, 1969. For 19th Century West Africa, the best general work is J. F. A. Ajayi and M. Crowder (eds.), *History of West Africa*, Vol. II, 1974. The second volume of Deschamps' *Histoire Générale*, 1971, is clearly the leading work in French, with excellent bibliographies for every chapter. John D. Hargreaves, *West Africa, the former French states*, 1967, and his anthology of documents, *France and West Africa*, 1969; Bernard Schnapper, *La politique et le commerce français dans le Golfe de Guinée de 1838 à 1871*, 1961; R. Cornevin, *Histoire du Togo*, 1962, and *Histoire du Dahomey*, 1962; and C. W. Newbury, *The Western Slave Coast and its Rulers*, 1961, are especially recommended. For the exceptionally industrious reader, Yves Person, *Samori, une révolution dyula*, 3 vols., 1968–75, and Ivor Wilks, *Asante in the nineteenth century*, 1975, will be correspondingly rewarding. For Gambia and Sierra Leone there are J. M. Gray, *A History of the Gambia*, reprinted 1966, and Christopher Fyfe, *A History of Sierra Leone*, 1962. For Ghana a brief reading-list should include W. E. F. Ward, *A History of Ghana*, 2nd edition, 1958; G. E. Metcalfe, *Maclean of the Gold Coast*, 1962; David Kimble, *A Political History of Ghana, 1850–1928*, 1963. And for Nigeria a comparable list would be Michael Crowder, *The Story of Nigeria*, 1962; K. Onwuka Dike, *Trade and Politics in the Niger Delta 1830–85*, 1958; S. O. Biobaku, *The Egba and their Neighbours, 1842–72*, 1957; J. F. Ade Ajayi, *Christian Missions in Nigeria, 1841–91*, 1965; E. A. Ayandele, *The Missionary Impact on Modern Nigeria, 1842–1914*, 1966; J. F. Ade Ajayi and Robert Smith, *Yoruba Warfare in the Nineteenth Century*, 1964; S. A. Akintoye, *Revolution and Power Politics in Yorubaland 1840–1893*, 1971; R. A. Adeleye, *Power and Diplomacy in Northern Nigeria 1800–1906*, 1972; S. J. Hogben and A. H. M. Kirk-Greene, *The Emirates of Northern Nigeria*, 1966, and Murray Last, *The Sokoto Caliphate*, 1967.

For Zaire and Angola, the later chapters of Vansina, *Kingdoms of the Savanna*, should be supplemented with the chapter on 'West Central Africa 1800–1880' in Roland Oliver and Anthony Atmore, *Africa since 1800*, 2nd edition, 1972, and with the chapter by David Birmingham in *The Cambridge History of Africa*, Vol. 5 (edited by J. E. Flint), 1976. Roger Anstey, *Britain and the Congo in the Nineteenth Century*, 1962, and Richard J. Hammond, *Portugal and Africa 1815–1910*, 1966, are also useful.

For southern Africa, in addition to the cooperative history edited by Monica Wilson and Leonard Thompson listed above, C. W. de Kiewiet, *A History of South Africa; social and economic*, 1941, E. A. Walker, *The Great Trek*, 1934, and J. D. Omer-Cooper, *The Zulu Aftermath*, 1966, are essential reading. Also to be recommended are E. A. Ritter, *Shaka Zulu*, 1955, W. M. Macmillan, *Bantu, Boer and Briton*, 1929, C. W. de Kiewiet, *The Imperial Factor in South Africa*, 1937 and S. D. Neumark, *Economic Influences on the South African Frontier*, 1957. M. V. Jackson Haight, *European Powers and South-East Africa*, reprinted 1967, examines the interacting influences of British, French, and Portuguese in South-East Africa from 1796 till 1856.

The standard works on the East African coast during this period are still those of R. Coupland, *East Africa and its Invaders* (to 1856), 1938, and *The Exploitation of East Africa, 1856–90*, 1939. The *History of East Africa*, Vol. I, edited by Roland Oliver and Gervase Mathew, 1962, contains three substantial chapters by J. M. Gray, Alison Smith, and D. A. Low on the period from 1840 to 1884, which treat the history of the East African peoples and the Arab penetration of East Africa much more fully than Coupland, whose work will, however, remain of importance for the study of British policy in this region. For the Nilotic Sudan in the 19th century there is Richard Hill, *Egypt in the Sudan, 1820–81*, 1959; P. M. Holt, *The Mahdist State in the Sudan, 1881–98*, 1958; and J. R. Gray, *A History of the Southern Sudan, 1839–89*, 1961.

Chapter 16

There is not as yet a single satisfactory modern study of the partition of Africa. The nearest to it is perhaps *Africa and the Victorians* by Ronald Robinson and John Gallagher, 1961, but this is weak on the aims and diplomacy of some of the continental European powers, and should be supplemented by W. L. Langer, *The Diplomacy of Imperial-*

ism, 2nd edition, 1951, and also perhaps by the same author's *European Alliances and Alignments 1871–90*, 2nd edition, 1950, and with the relevant chapters by F. H. Hinsley and R. E. Robinson in the *Cambridge History of the British Empire*, Vol. III, 1959. This should be compared with the summary written later by Robinson for the *New Cambridge Modern History*, Vol. X, 1963. Other important studies are Henri Brunschwig, *French Colonialism; Myths and Realities*, 1966; G. N. Sanderson, *England, Europe and the Upper Nile*, 1965, and Eric Axelson, *Portugal and the Scramble for Africa, 1875–1891*, 1967.

For West Africa alone, there are John Hargreaves, *Prelude to the Partition of West Africa*, 1963, and *West Africa Partitioned, Vol. I; The Loaded Pause, 1885–89*, 1975, A. S. Kanya-Forstner, *The Conquest of the Western Sudan*, 1969, and from another point of view altogether, the essays edited by Michael Crowder under the title *West African Resistance*, 1970. Other aspects of the scramble are best appreciated in biographies, such as J. G. Lockhart and C. M. Wodehouse, *Rhodes*, 1963; Margery Perham, *Lugard*, 2 vols., 1956 and 1960; J. E. Flint, *Sir George Goldie and the Making of Nigeria*, 1960; John S. Galbraith, *Mackinnon and East Africa 1878–1895*, 1972, and Roland Oliver, *Sir Harry Johnston and the Scramble for Africa*, 1957. The best study of the origins of the South African War is J. S. Marais, *The Fall of Kruger's Republic*, 1961, and for its immediate political consequences L. M. Thompson, *The Unification of South Africa, 1902–10*, 1960.

Chapters 17 to 21

The reader who wishes to form a comprehensive view of the colonial period in Africa south of the Sahara cannot do better than to steep himself in Lord Hailey's great *African Survey*, using and comparing the editions of 1938 (reprinted 1945) and 1957. S. H. Frankel, *Capital Investment in Africa*, 1938, is an important special study that was undertaken in connexion with the Hailey *Survey*. R. L. Buell, *The Native Problem in Africa*, 2 vols., 1926, although old, is invaluable for its carefully documented account of publications of colonial governments in Africa prior to its date of publication. The best modern overview is probably that by J. Ganiage, H. Deschamps, and Odette Guitard, *L'Afrique au XXᵉ Siècle, 1900–1965*, 1966. W. K. Hancock, *A Survey of British Commonwealth Affairs*, Vol. II, Part 2, 1942, subtitled 'Problems of Economic Policy 1918–39' is a brilliant analysis of problems aroused by the expansion of white settlement in southern Africa and by the expansion of trade in West Africa. Among recent

collaborative works, Prosser Gifford and William Roger Louis (eds.), *Britain and Germany in Africa*, 1967, and *France and Britain in Africa*, 1971; Robert I. Rotberg and Ali Mazrui (eds.), *Protest and Power in Black Africa*, 1970, and the first four volumes of L. H. Gann and Peter Duignan (eds.), *Colonialism in Africa*, 1969–75, contain many excellent chapters by leading authorities, while Vol. 5 of the last series has the best bibliographical studies of the colonial period.

South Africa is largely anomalous with the rest of the continent both in periodization and historiography, and we confine our suggestions to a few items of outstanding interest for the history of the 20th century. First and foremost is Vol. II of the *Oxford History of South Africa*, 1971, edited by Monica Wilson and Leonard Thompson, which was the first comprehensive work to attempt an approach comparable to that of other modern African historians. Significantly, the chapter on African Nationalism from 1910 till 1964 had to be omitted from the version sold in South Africa. W. K. Hancock, *Smuts*, 2 vols., 1962 and 1968, is a great biography by a great historian, which covers most of the period, while Alan Paton, *Hofmeyr*, 1964, is also outstanding. D. W. Kruger (ed.), *South African Parties and Policies 1910–1960*, 1960; W. H. Vatcher, *White Laager; the Rise of Afrikaner nationalism*, 1965, and Peter Walshe, *The Rise of Nationalism in South Africa: the African National Council, 1912–1952*, 1970, are all useful. Edward Roux, *Time Longer than Rope*, reprinted 1964, and Mary Benson, *The African Patriots*, 1963, are sympathetic and scholarly studies of the African struggle for equal rights. B. G. M. Sundkler, *Bantu Prophets in South Africa*, 1948, is a famous study of the effects of white rule upon African Christianity, while Shula Marks, *Reluctant Rebellion*, 1970, is a detailed study of the Zulu revolt of 1906–7. Gwendolen M. Carter, *The Politics of Inequality*, 1958, is a classic analysis by a first-rate political scientist. For South West Africa, there is Helmut Bley, *South-West Africa under German Rule*, 1971, and Ruth First, *South-West Africa*, 1963.

Central Africa is well served with A. J. Wills, *Introduction to the History of Central Africa*, 1964, as a regional survey, and territorial studies which include L. H. Gann, *A History of Southern Rhodesia*, 1965; Philip Mason, *The Birth of a Dilemma*, 1958; Richard Gray, *The Two Nations*, 1960; L. H. Gann, *A History of Northern Rhodesia*, 1964; Robert I. Rotberg, *The Rise of Nationalism in Central Africa; the Making of Malawi and Zambia, 1873–1964*, 1965, and T. O. Ranger, *Revolt in Southern Rhodesia, 1896–7*, 1967. For Portuguese Africa in the 20th century, Ronald L. Chilcote, *Portuguese Africa*, 1967, and

Douglas L. Wheeler and René Pelissier, *Angola*, 1967, are the most useful works in English.

For East Africa, regional studies include *A History of East Africa*, Vol. II, edited by Vincent Harlow and E. M. Chilver, 1965; *Zamani*, edited by B. A. Ogot and J. A. Kieran, 1968; K. Ingham, *A History of East Africa*, 1962; Roland Oliver, *The Missionary Factor in East Africa*, 2nd edition, 1965; J. Spencer Trimingham, *Islam in East Africa*, 1965; F. Welbourn, *East African Rebels*, 1961, and J. S. Mangat, *A History of the Asians in East Africa, c. 1886–1945*, 1969. For Kenya during the colonial period there is G. H. Mungeam, *British Rule in Kenya*, 1968; Elspeth Huxley, *White Man's Country* (the life and times of Lord Delamere), 2nd edition, 1953; George Bennett, *Kenya; a Political History*, 1963; Carl G. Rosberg and John Nottingham, *The Myth of Mau Mau*, 1967, and Anthony Clayton and Donald C. Savage, *Government and Labour in Kenya, 1895–1963*, 1974. For Uganda there are K. Ingham, *The Making of Modern Uganda*, 1958; Walter Elkan, *The Economic Development of Uganda*, 1961; David E. Apter, *The Political Kingdom in Uganda*, 2nd edition, 1967; James Barber, *Imperial Frontier*, 1968, and D. Anthony Low and R. Cranford Pratt, *Buganda and British Overrule, 1900–1955*, 1960. For Tanzania, the German period is studied in Fritz Ferdinand Müller, *Deutschland-Zanzibar Ostafrika*, 1959, while John Iliffe, *Tanganyika under German Rule, 1905–12*, 1969, is a brilliant monograph on the governorship of Rechenburg; Wm. Roger Louis, *Ruanda-Urundi 1884–1914*, 1963, deals with that province of German East Africa and Ralph A. Austin, *Northwest Tanzania under German and British Rule*, 1968, is a valuable local monograph. Kathleen M. Stahl, *History of the Chagga People of Kilimanjaro*, 1963, though beginning before the colonial period, is of special interest for the adaptation of tribal politics to the colonial situation. For colonial Zanzibar there is L. W. Hollingsworth, *Zanzibar under the Foreign Office, 1890–1913*, 1953, and Michael F. Lofchie, *Zanzibar: Background to Revolution*, 1965. I. N. Kimambo and A. J. Temu (eds.), *A History of Tanzania*, 1969, contains some useful essays on different aspects of the colonial period by various hands.

For North East Africa, I. M. Lewis, *The Modern History of Somaliland*, 1965, deals with both Italian and British Somaliland. Richard Greenfield, *Ethiopia*, 1965; Margery Perham, *The Government of Ethiopia*, 1948, and Christopher Clapham, *Haile Selassie's Government*, 1964, are the most useful works for the 20th century in Ethiopia.

For West Central Africa, Ruth Slade, *King Leopold's Congo*, 1962,

and Roger Anstey, *King Leopold's Legacy*, 1966, provide between them an excellent introduction to the Belgian Congo. P. Ceulemans, *La Question Arabe et le Congo, 1883–1892*, 1958, is a special study of great interest, as are R. O. Collins, *King Leopold, England and the Upper Nile, 1899–1909*, 1968, and Ruth Slade, *English-speaking Missions in the Congo Independent State*, 1958. René Lemarchand, *Political Awakening in the Belgian Congo*, 1964, and Crawford Young, *Politics in the Congo*, 1965, are both useful studies of the period leading up to independence. For the former French Equatorial Africa, C. Coquéry-Vidrovitch, *Le Congo au temps des grandes compagnies concessionnaires 1898–1930*, 1972, is an outstanding work of scholarship, which may be supplemented by Pierre Kalck, *Histoire de la République Centrafricaine*, 1974, and by Brian Weinstein, *Eboué*, 1972. For Cameroun, Harry R. Rudin, *Germans in the Cameroons, 1884–1914*, 1938, is still the best book in English, though superseded by Karin Hausen, *Deutsche Kolonialherrschaft in Afrika; Wirtschaftsinteressen und Kolonialverwaltung in Kamerun vor 1914*, 1970. For Equatorial Guinea, there is René Pelissier, *Les territoires espagnols d'Afrique*, 1963.

Curiously enough, it is West Africa that is least well provided with historical studies of the 20th century. Michael Crowder, *West Africa under Colonial Rule*, 1968, is the only general work which provides a valuable comparison between French and British systems. Robert W. July, *The Origins of Modern African Thought*, 1968, is a unique and valuable study of the intellectual history of English and French-speaking West Africa during the colonial period. R. Delavignette, *Freedom and Authority in French West Africa*, English translation, 1950, has an excellent discussion of French colonial policy between the wars; but readers who want more general accounts of the French territories during the colonial period are probably best advised to look in the relevant volumes of the *Encyclopédie de l'empire française*, published during the later 1940s, or the highly critical Marxist work by Jean Suret-Canale, available in English as *French Colonialism in Tropical Africa, 1900–1945*, 1971. V. Thompson and R. Adloff, *French West Africa*, 1958, and *The Emerging States of French Equatorial Africa*, 1960, are encyclopedic surveys of these two areas from the time of the Brazzaville Conference in 1944 until shortly before the dates of publication, though for political history the former has been largely superseded by Ruth Schachter Morgenthau, *Political Parties in French-speaking West Africa*, 1964. For English-speaking West Africa the situation is better only in relation to Nigeria, for which the works by Flint on Goldie and Perham on Lugard listed in

the previous sections are both relevant. E. D. Morel, *Nigeria: its Peoples and its Problems*, reprinted 1968, is a survey of the country in 1911 by a leading authority and colonial reformer. E. A. Ayandele, *The Missionary Impact on Modern Nigeria, 1842–1914*, 1966, and J. B. Webster, *The African Churches among the Yoruba, 1888–1922*, 1964, are both important monographs. F. D. Lugard, *The Dual Mandate in British Tropical Africa*, 1922, the classic statement of the indirect rule policy, was written with Nigeria mainly in mind, while Margery Perham, *Native Administration in Nigeria*, reprinted 1962, examines that system as it was operating in the middle of the 1930s. Another perspective is provided in the collection of essays on *West African Chiefs*, 1970, edited by M. Crowder and O. Ikime. James S. Coleman, *Nigeria; Background to Nationalism*, 1958, is the universally admired analysis by a leading American political scientist of the situation during the last decade of the colonial period. Walter Schwarz, *Nigeria*, 1968, deals with the first decade of independence; *Crisis and Conflict in Nigeria*, 1971, is an extensive collection of essential documents assembled by A. H. M. Kirk-Greene. For Ghana, there is Kimble's *Political History* mentioned above, to which may be added W. Tordoff, *Ashanti under the Prempehs 1888–1935*, 1965; R. E. Wraith, *Guggisberg*, 1967; F. M. Bourret, *Ghana; the Road to Independence, 1919–57*, 1960; David E. Apter, *The Gold Coast in Transition*, 1955, and Dennis Austin, *Politics in Ghana, 1866–1960*, 1964. For Liberia, see J. Gus Liebenow, *Liberia: The Evolution of Privilege*, 1969.

For Egypt and the Sudan in the 20th century, a select reading list would include P. J. Vatikiotis, *A Modern History of Egypt*, 1969; John Marlowe, *Arab Nationalism and British Imperialism*, 1961; J. N. Ahmed, *The Intellectual Origins of Egyptian Nationalism*, 1960, and J. S. R. Duncan, *The Sudan's Path to Independence*, 1957. For North Africa there are Nevill Barbour, *A Survey of North West Africa*, 1959; Jacques Berque, *French North Africa; The Maghreb between two World Wars*, 1967; R. le Tourneau, *Evolution politique de l'Afrique du Nord musulmane, 1920–1961*, 1962; E. E. Evans-Pritchard, *The Sanusi of Cyrenaica*, 1954; Dwight Ling, *Tunisia from Protectorate to Republic*, 1967; Pierre Bourdieu, *The Algerians*, 1961; Mostefa Lacheraf, *L'Algérie; nation et société*, 1965; Franz Fanon, *A Dying Colonialism*, 1970; Douglas Ashford, *Political Change in Morocco*, 1961; Albert Ayache, *Le Maroc: bilan d'une colonisation*, 1956, and J. L. Miège, *Le Maroc*, 1962.

The swelling literature on contemporary Africa necessarily contains much that is ephemeral, and much that belongs more to the field of

political science than of history. Nevertheless, Ronald Segal, *Political Africa*, 1961, and Colin Legum (ed.), *Africa: a Handbook to the Continent*, 1961, are still valuable guides to the politics and personalities of the late 1950s. Thomas Hodgkin, *African Political Parties*, 1961, and his earlier *Nationalism in Colonial Africa*, 1956, are excellent and may be supplemented with Edward Mortimer, *France and the Africans 1944–1960*, 1969; Ruth Schachter Morgenthau, *Political Parties in French-speaking West Africa*, 1963; William Foltz, *From French West Africa to the Mali Federation*, 1965; James Coleman and Carl G. Rosberg (eds.), *Political Parties and National Integration in Africa*, 1964; William H. Friedland and Carl G. Rosberg, *African Socialism*, 1964, and Aristide Zolberg, *Creating Political Order: the Party States of West Africa*, 1965. Immanuel Wallerstein, *Africa: the Politics of Independence*, 1961, and *Africa: the Politics of Unity*, 1967, are both of value, as are Gwendolen M. Carter (ed.), *African One-Party States*, 1962, *Five African States*, 1964, and *Politics in Africa*, 1966. Colin Legum, *Pan Africanism*, revised edition, 1964, is a useful introduction to this subject, which can be supplemented by Immanuel Geiss, *Panafricanism*, English translation, 1974. W. F. Gutteridge, *The Military in African Politics*, 1969, and *Military Regimes in Africa*, 1975, and Ruth First, *The Barrel of a Gun: political power in Africa and the coup d'état*, 1970, discuss this increasingly important aspect of African affairs. René Dumont, *False Start in Africa*, English translation, 1966, though very opinionated, presents an honest criticism of the economic policies of African states since independence; Guy Hunter, *The New Societies of Tropical Africa*, 1962, is a rather more optimistic attempt to look forward; these may be compared with Basil Davidson, *Which Way Africa?*, 3rd edition, 1971. For specifically economic questions, Andrew M. Kamarck, *The Economics of African Development*, 1967, is a good, short, introduction, while P. Robson and D. A. Lury (eds.), *The Economics of Africa*, 1969, presents a number of case studies. For developments in the religious field in contemporary Africa, there are the reports of two seminars organized by the International African Institute: I. M. Lewis (ed.), *Islam in Tropical Africa*, 1966, and C. G. Baeta (ed.), *Christianity in Tropical Africa*, 1969. D. B. Barrett, *Schism and Renewal in Africa*, 1968, is also an important study. Finally, for the most recent period of all, the most useful record of events is to be found in the ongoing series, *African Contemporary Record*, edited by Colin Legum and published biennially since 1969.

Index